Praise for *Fragile Cargo*

"A fascinating and inspiring story of triumph and the tragedy of war . . . A story better than *Monuments Men*."
—*The Wall Street Journal*

"Art lovers and WWII buffs will devour this riveting and bittersweet history."
—*Publishers Weekly* (starred review)

"Gripping and meticulously researched."
—*The Times* (UK)

"Thrilling . . . [Brookes] has uncovered the kind of history deserving of a cinematic blockbuster."
—*Literary Review*

"A riveting read . . . With his meticulously researched and detailed writing, Adam Brookes takes us on a compelling journey through this extraordinary chapter of Chinese history. *Fragile Cargo* reads like a thriller. . . . Gripping stuff."
—Alexi Kaye Campbell, writer of the feature film *Woman in Gold*

FRAGILE CARGO

The World War II Race to Save the Treasures of China's Forbidden City

ADAM BROOKES

ATRIA PAPERBACK

New York • London • Toronto • Sydney • New Delhi

An Imprint of Simon & Schuster, Inc.
1230 Avenue of the Americas
New York, NY 10020

First Atria Paperback edition October 2023

ATRIA PAPERBACK and colophon are
trademarks of Simon & Schuster, Inc.

For information about special discounts for bulk
purchases, please contact Simon & Schuster Special Sales at
1-866-506-1949 or business@simonandschuster.com.

The Simon & Schuster Speakers Bureau can bring authors to your live event.
For more information or to book an event, contact the
Simon & Schuster Speakers Bureau at 1-866-248-3049
or visit our website at www.simonspeakers.com.

Manufactured in the United States of America

1 3 5 7 9 10 8 6 4 2

Library of Congress Cataloging-in-Publication Data has been applied for.

ISBN 978-1-9821-4929-1
ISBN 978-1-9821-4931-4 (pbk)
ISBN 978-1-9821-4930-7 (ebook)

For S.

A work of art is an object, but it is also an encounter with time.

André Malraux, 1935

Contents

Map x–xi

A Note on Romanization 1

Prelude: The Forbidden City 3
 1 First Glimpse of the Imperial Collections 13
 2 The Shabby Professor 29
 3 Peace, and War 44
 4 Evacuation 68
 5 Shanghai 82
 6 To London 94
 7 The Southern Route 117
 8 Fleeing Nanjing 143
 9 The Central Route 165
10 The Northern Route 193
11 A Sort of Sanctuary 218
12 The Unforgettable Day 254
13 Exile? 275
14 Hunting Tigers 295

Acknowledgments 327
List of Illustrations 331
Notes 333
Selected Bibliography 347
Index 349

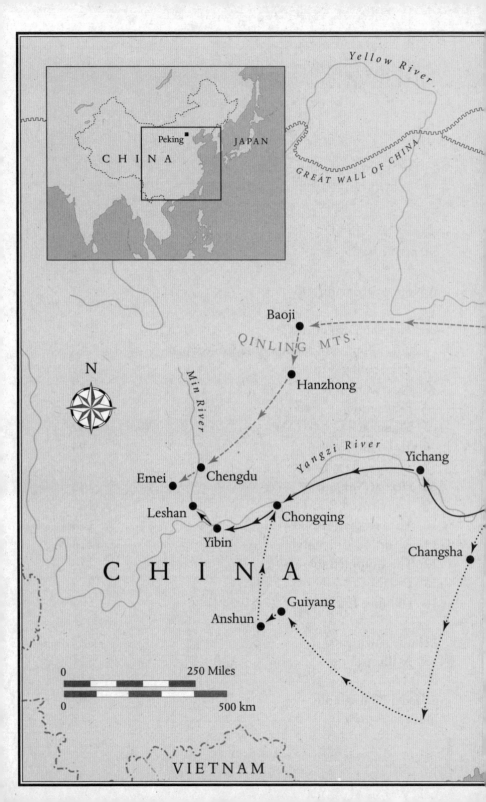

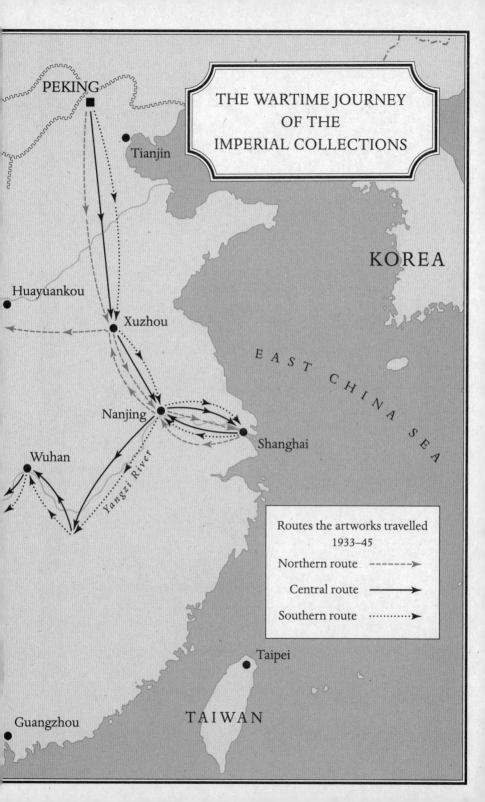

THE WARTIME JOURNEY
OF THE
IMPERIAL COLLECTIONS

PEKING

Tianjin

KOREA

Huayuankou

Xuzhou

E A S T

C H I N A

S E A

Nanjing

Shanghai

Wuhan

Yangzi River

Routes the artworks travelled
1933–45

Northern route ------→

Central route ——→

Southern route ·········→

Taipei

Guangzhou

T A I W A N

FRAGILE CARGO

A Note on Romanization

Chinese can be rendered in the Roman alphabet in several ways. The most common romanization system in use today is the Pinyin system, and I have used that, without diacritics, for the majority of Chinese words and expressions in the text. I have chosen, however, to render some words, mostly proper nouns, in the Wade-Giles system in use at the time about which I am writing. Hence I refer to a central character in the book as Na Chih-liang, as that is the way he himself romanized his name, and not Na Zhiliang. I have opted to refer to the city that is home to the Forbidden City as Peking for much of the narrative. When the narrative reaches the founding of the People's Republic of China in 1949, I change to Beijing.

Prelude

THE FORBIDDEN CITY

Peking, January 28, 1765

We begin in a silvered winter darkness, the air tingling with frost. Mounds of old, hard snow fill the imperial courtyards. Great, glistening icicles hang from the eaves of the palaces. The lakes are frozen over. The Forbidden City lies behind its towering, protective walls of ocher red. The halls and temples, gardens and alleyways wait, silent, suspended in night.

At 4 a.m., a sign. Light from a candle flickers in the Hall of Mental Cultivation. The emperor of the Qing, whose vast territories we today call China, is awake. The palaces stir. Imperial eunuchs—men castrated when boys—in long, silken gowns run to their posts, their reedy cries echoing through the halls: *Wansuiye jixiang!* Great fortune to His Majesty! Eunuchs rush from the kitchens to the emperor's sleeping quarters bearing a pail of hot water. The emperor descends from his *kang*, the raised, heated bed, and chambermaids bustle in to tidy his quilts. The emperor washes. A eunuch brings shaving tools wrapped in silk of imperial yellow, and shaves the emperor's face, chin, and the front half of his scalp. The eunuch brushes

3

out the emperor's hair and weaves it into a long braid in the Manchu style.

The emperor dresses himself. On this day he puts on a gown of yellow silk, thick white silken trousers, and socks of white velvet. Around his shoulders he drapes a cape trimmed with sable fur. At his waist he fastens a belt of emeralds and pearls. He wears black boots lined with wool and a fur cap of sable. Outside, in the predawn darkness, a heated litter waits to carry him through the courtyards. Eunuchs bear him across the icy flagstones, breath steaming in the cold air as their tiny, lantern-lit convoy creeps beneath the looming palaces. These palaces have been the seat of emperors since their construction by a million conscripted laborers in the early fifteenth century. The wider imperial precincts are home to government and bureaucracy, but this, the Forbidden City, is the red-walled inner sanctum of the empire, a sacred core where none but the emperor's household may live and move freely.

The emperor has many names. His family name is Aisin Gioro Hongli, which tells of his ancestry among the Tungusic tribes that dwelled in the wintry mountains and steppe of the region known as Manchuria, far to the northeast. Aisin Gioro Hongli's forebears unified the tribes politically and militarily, under a common identity: the Manchus. In the seventeenth century, as the Ming empire ailed, the Manchus swept south and proclaimed a new ruling dynasty, the Qing. Qing armies, led by Manchu generals, took Peking in 1644. Over the decades, the Qing has come to dominate a huge tract of Asia, from tropical southern seas through the Chinese-speaking heartland to the Tibetan highlands and the great central Asian deserts, a mighty conglomeration of geography, ethnicity, languages, and cultures.

Aisin Gioro Hongli, more commonly known by his reign name, Qianlong, is the sixth emperor of the Qing.[1] As he sits

4

in his heated litter on that winter morning in 1765, Qianlong is ending the third decade of his reign. He is fifty-three years old, a tall man whose portraits suggest fine features, perhaps a prominent nose, a strong chin. He reigns in a period of nascent industrialization and globalization. In Britain James Watt is designing the steam engine. The young prodigy Mozart is performing across Europe. Louis XV is at Versailles. In America colonists are violently resisting taxation by the British crown. Japan is closed and isolated.

The eunuchs bearing Qianlong's litter set him down at the Palace of Earthly Tranquillity. It is still dark. Inside, shamans conduct the rites of the morning, secret ceremonies presided over by women, conducted in the Manchu language according to Manchu tradition, accessible only to those of Manchu ancestry. A part of the palace serves as a kitchen to cook great slabs of meat as offerings to the Manchu deities. Qianlong communes with his ancestors for an hour. The air is filled with ritual music, smoke, and the smell of boiled pork.

At 5 a.m. Qianlong takes a drink of sweetened swallows' nest soup. The eunuchs bear him out of the Forbidden City through a western gate to the Lake Palaces. At six he breakfasts in the Studio of Convivial Delight, the dishes—meats, dumplings, soups—prepared in a kitchen with a hundred stoves and brought to the table in wrappings of yellow silk. The setting for the emperor's breakfast is magnificent. He eats from dishes of silver, and from porcelain manufactured in the imperial kilns, with implements of silver, gold, and jade. He eats alone, and quickly. After fifteen minutes he is gone, his leavings distributed among his family and household.

As dawn breaks, the litter brings Qianlong back into the Forbidden City, to his study in the Palace of Heavenly Purity, where, surrounded by books and maps and paintings, he passes some time reading. He reads, in classical Chinese, from texts

on history and government, immersing himself in the precedents set by his forefathers, learning from their reigns. The emperor has many faces, and he must be master of them all. To his Manchu-dominated court and military, he is the scion of a conquering dynasty. To the Chinese-speaking bureaucracy and elites, and hundreds of millions of his subjects, he is a ruler in the Confucian tradition of ethics, statesmanship, and ritual, a bringer of moral order, stability, and prosperity. To Tibetans and Mongolians, he is a devout Buddhist, studying the scriptures and worshipping at the shrines of the Buddha and the bodhisattvas. Qianlong is divine ruler, soldier, scholar, and arbiter of tradition and culture for the entirety of the diverse, polyglot Qing empire.

Between 8 and 10 a.m. the emperor changes his clothes and sits with some of his favorite courtiers drinking tea and composing poetry. At ten he returns to his office at the Hall of Mental Cultivation, and the day's work begins. He reads reports from all corners of the Qing empire, responding to them with brush and ink in his clear, fluid calligraphy. He receives officials to discuss matters of governance and appointments to bureaucratic positions. At around 3 p.m. he is served another meal and naps for a while. At 4 p.m. he eats pastries with Fuheng, a trusted military commander.[2] Perhaps they discuss their plans for the campaign in the south against the Burmese that is to begin later in the year.

By 5 p.m. the day's business is done. The emperor withdraws into the Room of the Three Rarities, a small, cozy study near his sleeping quarters, where he sits cross-legged on a warm *kang*. The room is named for three exquisite works of calligraphy that Qianlong has installed there, and it is where the emperor indulges in one of his greatest pleasures, viewing the art and antiquities of the imperial collections.

On this day he passes two hours in the company not of

courtiers or consorts but of objects, handling them, holding them, considering them. Sometimes he impresses his seal upon a painting or composes a poem inspired by a bronze or a piece of porcelain. We do not know exactly which pieces he views on January 28, 1765, but in the days around this date he views a painting called *The Stag Hunt*, attributed at the time to an artist working in the tenth century CE. The painting depicts a lean, vigorous huntsman, perhaps of the Mongolian steppe, astride a furious, charging horse. Bow in hand, the huntsman leans over the horse's neck, oblivious to everything but the chase. A wounded stag lies prostrate, in its death throes. The painting is a startling study of motion and balance, violence and pain. Qianlong, deeply impressed by the work, imprints his scarlet seal upon *The Stag Hunt* and writes a poem in its praise. Around this time he views and affixes his seals to landscapes by masters whose work dates from the fourteenth century. He composes poems extolling an ancient ritual axe in jade, and a beautiful jade bowl, and delicate porcelain.[3] Qianlong is liberal with his poetry and with his seal; some of the greatest masterpieces of China's art are festooned with his mark.

Such masterpieces arrive in the Forbidden City by many different routes. Over preceding centuries Qianlong's predecessors built their own collections, some of whose works survived dynastic collapse and war and have been passed down to him. Many works come to Qianlong as tribute from far-flung regions of the empire or as gifts from officials and nobles seeking favor. Others are commissioned; the imperial painting academy, kilns, and workshops are busy producing objects to the exacting specifications of the imperial household and the emperor himself. Over Qianlong's sixty-year reign, the imperial collections will grow into a vast amalgam of more than a million objects. Qianlong's taste shapes the collections

and will influence the sense of succeeding generations as to what constitutes the art of China.

The antiquities and objects brought before the emperor this January afternoon are for him alone. Secrecy and hiddenness are crucial components of the imperial mystique, and the imperial collections, like the Forbidden City itself, are a secret to all but the emperor's household and the court. They are never displayed to the public. Large parts of the collections remain locked away in storage, their riches invisible even to the inhabitants of the Forbidden City. These are not collections in the way a European art collector might understand the word. Many objects are not decorative but functional. Fine porcelain from the imperial kilns might be used at the altar of an elaborate Confucian or Buddhist ritual, ancient bronze bells for sacred music. Calligraphy provides moral and aesthetic example. Painting depicts the universe and acquaints the emperor with his subjects. Bronze vessels bear inscriptions dating from deep antiquity that contain philosophical or metaphysical significance. The collections are tightly entwined with the majesty and legitimacy of the emperor's rule. Qianlong, sitting in the Room of the Three Rarities as evening falls, does not conceive of himself as viewing what we think of as "fine art." He sees in these objects the physical manifestation of a higher cosmic order, their beauty and complexity nourishing and strengthening his sense of his own centrality to the universe. In the stroke of the brush, in the fall of light on worked jade, Qianlong discerns the shape of time, the pulse of power.[4]

At 8 p.m. Qianlong retires to his sleeping quarters, his day at an end. He will rule for another thirty years. The Qing empire will never again attain the stability and grandeur of his reign.

*

Within a few decades of Qianlong's death in 1799, the Qing empire falls into its long decline, weakened from within by rebellion, battered from without by war with Britain and other colonial powers. Invaders instinctively grasp the symbolic power of the imperial palaces and the priceless, fragile collections hidden within them. In 1860 British and French troops loot the Summer Palace just to the west of Peking, stuffing their backpacks with jade and jewels and smashing the porcelain on the flagstones before the British set the buildings on fire. A British officer, Captain J. H. Dunne of the 99th Regiment of Foot, finds a litter of Pekingese puppies in the ruins and takes one all the way back to England to present to Queen Victoria. The dog becomes a royal favorite. Its name: Looty.

In 1900 the British and French soldiers are back, with Americans, Japanese, Russians and Germans, Italians and Austro-Hungarians this time, to inflict multinational punishment on the Qing court for its support of the Boxer uprising. The Boxers—bands of impoverished, marginalized men afire with xenophobic, mystical millenarianism—murder foreigners and Chinese who associate with them, and have laid siege to the foreign legations in Peking. The foreign army marches on Peking, relieves the legations, and loots the city in a welter of murder and rape. Soldiers force their way deep into the Forbidden City, sending terrified eunuchs and concubines fleeing through the courtyards and passageways. For the troops, Peking and its palaces are the stuff of Victorian dreams, treasure houses of a corrupt and decaying imperium ripe for plunder. British regiments hold "prize auctions" to sell off and profit from their loot. Shrewd collectors pick up masterpieces for a pittance. One American diplomat needs an entire railway car to haul away his gains. Some of the loot will end up in museums and private collections across Europe, America, and Japan.

In 1911 Qing troops mutiny, and Chinese nationalists who revile Manchu rule seize their moment. The Qing empire comes to its anticlimactic end, and with it millennia of monarchy. The following year sees the founding of the Republic of China, a delicate, sickly child of a state, afflicted by factionalism, splintered into cliques, and ruled by regional warlords. The last emperor, Qianlong's great-great-great-grandson Pu Yi, remains in the Forbidden City amid a shrunken, faded imperial household, presiding over a court that no longer wields any power. Over the years, the palaces fall into disrepair, yellow tiles tumbling from the pitched roofs, weeds sprouting in the courtyards. The imperial collections, shorn of their traditional meaning, untended in the decaying buildings, are a tempting source of private profit in uncertain times. Princes and eunuchs and palace functionaries quietly make off with works of art to sell in the antiques markets. Pu Yi, who seems to consider the collections his personal property, ships priceless pieces out as financial security.

What will become of the vast holdings of the Qing imperial house—the delicate paintings, sweeping landscapes on silk, intimate studies of birds and children and flowers, portrayals of life in the cities and villages and on the rivers teeming with energy and movement, the fragile carvings in jade and ivory, the ancient libraries of philosophy and philology and science, the scrolls of calligraphy adored by emperors, the robes and furs and tapestries, the snuff bottles and jewels and ornate hairpins of pearl and gemstone worn by the court ladies, the thrones and armor and swords, the significant collection of clocks, the mountains of porcelain, teacups and vases, and ewers and bowls glazed in luminous imperial yellow and startling copper red—in a new, fragile Chinese republic striving to cast off the imperial past and create a modern present?

Nobody knows.

But in the years to come, the imperial collections of China—these hundreds of thousands of irreplaceable objects—will undergo a series of strange, transformative journeys through time and space. They will travel thousands of miles by steamship and bamboo raft, by train and truck, and on the backs of straining, sweating porters, across mountain ranges, up roiling rivers, through burning cities. They will voyage through a war whose scale and savagery staggers the imagination, yet whose course and import is little known or understood in the wider world.

Through it all, the collections' survival will depend upon the labors of a small band of anxious, exhausted museum curators led by a quiet, conscientious scholar of ancient inscriptions, whose unstinting devotion to the task will extract a grievous personal cost. And the imperial collections will undergo too a journey in meaning, as those who care for them—and those who covet them—reimagine them as potent embodiments of a cultural heritage and national ambition that will shape modern China.

1

FIRST GLIMPSE OF THE IMPERIAL COLLECTIONS

On November 5, 1924, the last emperor of the Qing, Pu Yi, sat in the Hall of Mental Cultivation, deep in the Forbidden City, eating fruit. He was eighteen now and married. His empire was long dead, but by agreement with the government of the young Republic of China, he remained in the palaces of the Forbidden City. His remaining courtiers and eunuchs still treated him as an emperor, kneeling before him, trailing after him, bringing him delicacies. Some among them dreamed of his restoration to power and his leading China in a great rebirth, just as the Meiji emperor had done in Japan in the late nineteenth century. Others pilfered and planned for the day some warlord or other would throw them out of the palaces and into the street in the name of the republic. Pu Yi had installed a telephone in the Forbidden City and bought a car. A British tutor, Reginald Johnston, taught him English and educated him in the ways of the world. Still, Pu Yi spoke of feeling confined and controlled, his modernizing impulses stifled, his role vague and undefined. Could he become a constitutional monarch? What was to be learned from the Japanese monarchy or the British royal family? Often the warlords who vied for control of the

government of the republic failed to forward funds to support his household. Palace officials would "sell or mortgage paintings, antiques, calligraphy, gold or silver objects, and porcelain from the palace every year" to meet operating expenses, he later wrote.[1]

Even if Pu Yi had a conception of his future role, no one was listening. China was at war again that year. The warlords of Manchuria, armed and backed by Japan, battled those from the south-central provinces for control of north China. Half-trained armies surged back and forth across the countryside and streamed through the cities, dragging their artillery with them, breaking open granaries, stealing livestock, leaving ruin behind them. The warlords themselves—men with noms de guerre like the Tiger of the North, the Jade Marshal, and the Dog Meat General—spun tortuous plots and counterplots of alliance, deception, and betrayal. Factions and cliques formed and broke apart. The endless conflicts were "so wildly complicated," lamented the *North China Herald*. "They go on and on in jealousy and intrigue and war because, somehow, having begun they cannot stop."[2] For years the republic's weak and chaotic parliamentary politics was eclipsed by the violent quarreling of the power-hungry warlords.

Just such an act of betrayal by a warlord would change the Forbidden City, and the fate of the imperial collections, forever. The so-called Christian General, a man named Feng Yuxiang, had marched to support the south-central alliance in its bloody war against the Manchurians. The Christian General's men were comparatively well trained and had accepted weapons and advisers from the Soviet Union. But at the last moment, in an act of jaw-dropping brazenness, Feng Yuxiang switched sides and aligned himself with the Manchurians. He diverted his troops and launched what was in effect a coup

d'état, marching into Peking and installing himself as de facto ruler in the name of the republic.

At nine o'clock on that November morning in 1924, as Pu Yi ate an apple and chatted with his wife, a detachment of the Christian General's soldiers forced its way into the Forbidden City and ordered Pu Yi's guards to disband. They accosted members of the imperial household and presented them with a document that canceled all previous agreements between the household and the republic. Pu Yi wrote that officials of the household rushed into his rooms "in great disorder." "I jumped up at once, dropped my half-eaten apple to the floor, and grabbed the document."[3] The order directed Pu Yi to leave the Forbidden City. He had three hours to get out, or artillery would commence firing on the palaces. Pu Yi consented to leave.

The Christian General's troops drove the bewildered young man and his little retinue out of a northern gate to a mansion in north Peking. Pu Yi's tutor, Johnston, no doubt thinking of the murder of Tsar Nicholas II's family in Russia six years earlier, begged foreign diplomats to intervene. The Japanese saw an opportunity and offered Pu Yi protection. They gave him a house in the coastal city of Tianjin, where he would remain for seven years under the watchful eye of the Japanese consul. Japan had plans for Pu Yi, and for China.

In China and abroad Pu Yi's eviction from the Forbidden City evoked shock, perhaps tinged with a sense of its inevitability. The Hong Kong–based *South China Morning Post* wrote that the Christian General, a committed republican, "desires to impress upon the country that the monarchy is dead."[4] The *North China Herald* discerned a more cynical motive. Feng Yuxiang "will profit immensely from the acquisition of the Manchu treasures, which are worth many millions of dollars."[5] The imperial collections, and knowledge of their

value, figured large in the political imagination of the moment, hovering behind every crazed twist and turn of Peking's factional politics. Wild rumors spread that the Christian General was assembling camel and mule trains to cart the collections away. But this time the *Herald*'s cynicism was misplaced; Feng Yuxiang did not plunder the Forbidden City. On the contrary, even as Peking seethed under his rule, the ensuing months saw an extraordinary effort at conservation and curation.

The Christian General, on taking control of Peking, had appointed a cabinet to cement his control over the shaky republican government machinery. Within days of Pu Yi's eviction, the cabinet in turn assumed control of all the old imperial properties, including the Forbidden City and its priceless contents. The Committee for the Disposition of the Qing Household, consisting of fifteen worthies drawn from the republican government and the old Qing court, took charge. Its first order of business was to establish exactly what the palaces contained. Officials fanned out through the courtyards. By December 1, 1924, every building that housed elements of the imperial art collections had been inspected, locked, and sealed with a strip of paper pasted across the doors, inscribed with the mark of the official responsible, so if any were opened it would be immediately obvious.[6] But how could a full inventory of every object in every palace, hall, and storehouse be accomplished? Who had the expertise to describe and catalog every book, every painting, every exquisite piece of worked jade, every piece of jewelry, every bronze? More importantly, in this time of political chaos and shifting allegiances, who could be trusted not to steal them? The answer, the committee's members decided, was to be found in Peking University, China's first modern university, which had opened in 1898. The committee invited professors—experts in history and literature, calligraphy, antiquities, and archaeology—and some

reliable students to join the inventory. Ministries also loaned officials, and police and soldiers were assigned to the effort.

On December 23, 1924, the first inventory teams, bundled in padded gowns and scarves against the freezing cold, made their way through the great gates in the towering vermilion walls, across the deserted courtyards, and into the dim, silent palaces, and began cataloging.

The first inventory workers into the Forbidden City remembered those strange, frigid days with awe. To enter the palace complex, they made their way along the long, deep passage at the northern Gate of Divine Prowess. The winter wind howled through the passage, buffeting them. "It was almost impossible to walk. You could say I 'swirled' into the palace," remembered one. Once inside the Forbidden City, looking on the palaces and courtyards for the very first time, the catalogers were struck by the bleakness of the scene. The silent courtyards were overgrown with weeds, so thick and tall in places they needed a scythe to cut their way through.[7] Inside the dark, echoing halls the cold was intense.

The teams were six or seven strong, so that their members could keep a wary eye on each other. They assembled every morning. The committee organizers assigned each team a hall to work in and issued the keys. The team made its way to its designated hall and checked that the seal was intact. If it was, the team could open up, go in, and begin the enormous task of identifying, numbering, and cataloging every single item within. The team members had specific jobs. The investigator selected an object, identified it, and provided any relevant information about it. The logger wrote down everything the investigator said in a register, assigning to each object—be it a painting, a carving, a book, or an elegant Ming period chair—a serial number. The labeler wrote the serial number on a label

and attached it to the object. A particularly important piece would be photographed as well. The recorder kept an overall written account of the doings of the group.

Besides these core members, each team was assigned an official to act as sort of overseer and guarantor of the team's honesty. There might be a policeman or a soldier too, and a laborer to help move and carry. At the end of the day's inventory, the team laboriously double-checked every entry. The team had to stay together; individuals were forbidden to move around by themselves. All team members had to wear special outer clothing, the sleeves tied tight with string, making it impossible to slip a small precious object—a piece of jade, perhaps, or a porcelain teacup—into them. Smoking was absolutely forbidden.[8] The very first hall the teams entered was the Qian Qing Gong, the Palace of Heavenly Purity, one of the monumental central structures of the Forbidden City, where the emperors of the Ming had lived and conducted the business of imperial governance for centuries. The very first item called out and noted down in the register, object number one in the entire inventory, was a small, two-stepped wooden stool. The stool was used to reach the top fastenings of the Palace of Heavenly Purity's great double doors when they were closed at dusk.[9]

A young student of archaeology at Peking University named Chuang Yen wrote of the anticipation and enthusiasm of those first days, "It was so cold we couldn't move our hands. Our ears and noses and feet tingled . . . but all the inventory workers were so excited we barely noticed. We just ignored our hunger and the cold and took enormous joy in what we were doing. Everybody harboured the same desire to see and understand the way life had been lived in the court and in the palaces, how it really was, and this drove all of us on."[10]

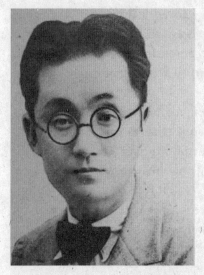

Chuang Yen (1899–1980)

Chuang Yen was twenty-five years old, a slight, bespectacled man with a deep and all-encompassing fascination for antiquity. He had been born an only child at the turn of the century, amid the bloody turmoil of the Boxer uprising. When he was just a year old, his parents fled the violence in their home city of Changchun, in the country's far northeast, for Peking. There, his mother died of illness. Despite such a desperate start in life, Chuang Yen grew into a studious, conscientious child, and his father ensured his education. As a teenager, he acquired a deep Buddhist faith. He was vegetarian and spent hours in meditation and studying the scriptures. To his father's alarm, he considered becoming a monk, but such piety did not last. On entering Peking University in 1920, as his descendants remember, Chuang Yen was powerfully impressed by the urban sophistication of his professors, some of whom were only a few years older than he was. He quickly abandoned his ascetic Buddhist lifestyle and bought a Western suit to wear on campus. Meat was back on the menu, and Chuang Yen resolved to learn how to smoke and drink as soon as possible. He would from here on comport himself as a citizen of a republic with modern tastes. His transformation reflected the times. China was changing, and the way an ambitious young scholar comported himself—in clothes, bearing, and intellectual outlook—was changing too. But perhaps it was also a function of his maturing

personality: all his adult life he loved a drink and a raucous game of *majiang*. As the years passed, and China descended into total war, Chuang Yen was to demonstrate a personal strength and a rigorous practicality that belied his slight frame and gentle nature.

As the young Chuang Yen made his way through the palaces at the end of 1924, he sought to reconcile the legends and myths surrounding the Forbidden City with its reality. In the Palace of Heavenly Purity, the great throne room whose sweeping yellow-tiled roofs are supported by great scarlet pillars of hardwood, he got down on his knees to test the floor, tapping his way across the flagstones. Legend held, he later recounted, that one of the flagstones was hollow. Officials sought out this hollow stone when they performed the *koutou* before the emperor, kneeling and striking their head on the floor. The hollow flagstone, held the legend, rang especially loud, and thus demonstrated loyalty. Chuang Yen searched but never found the sonorous flagstone. He did, however, find the apple that the last emperor had been eating when the warlord's troops burst in on him. It lay dried and half-consumed on a table in the imperial apartments.[11]

Not everyone considered the task a joy. Another student, Na Chih-liang, had only just left high school when he joined the inventory teams. His family were residents of Peking, his father a teacher of modest means. The young Na Chih-liang fought his way through a charity school funded by donations from overseas, and excelled. His quick mind and good calligraphy caught the eye of his teachers, and the school's principal recommended him for the Forbidden City inventory. At just eighteen, with no higher education and few resources, Na Chih-liang's prospects would have been limited, but in early 1925, due to his principal's intervention, he found himself working alongside professors and graduate students of the

elite Peking University, and living on his wits. He was a stocky, square-faced lad, with an attractive, self-deprecating sense of humor and an unvarnished frankness. He had a solidity and steadiness that others seem to have appreciated.

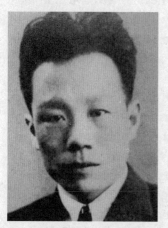

Na Chih-liang
(1908–1998)

On his bewildering first day at work Na Chih-liang was made a logger on the team responsible for the inventory of the Zhai Gong, the Palace of Fasting, a walled complex of low, pillared halls and spacious courtyards built in the early eighteenth century, accessed by an imposing red gate. The emperor resided here for days in advance of performing important rituals, abstaining from wine, meat, onions, garlic, and sex as an act of self-purification. The halls were filled with porcelain, and Na Chih-liang remembered rooms of vases patterned in snowy white and radiant blue. The stoves were unlit, and it was desperately cold. Na Chih-liang was given ink and a writing brush. He readied himself to note down the identification of each object as it was called out and to assign each a serial number, but when he opened the pot, the ink inside was frozen solid, and the brush was so stiff with cold as to be unusable. The team leader gruffly informed him that, given the conditions, of course the ink would freeze. Na Chih-liang's only solution, said his leader, was to place the brush in his mouth and suck on it, in the hope that when applied to the ink, it might melt a few drops at a time, unless Na Chih-liang had any better ideas? Na Chih-liang remembered struggling through the day, sucking on his brush, the ashy taste of ink in his mouth, the cold penetrating his marrow, and his written

characters so faint on the page as to be barely readable. At one point a more learned colleague turned to him and asked him if he was interested in the extraordinary antiquities they were handling. " 'No!' I replied. 'All this porcelain! How are these bowls and teacups any different to the ones we have at home?' Everybody laughed. 'Because the bowls and teacups you have at home are worth twenty or thirty cents, and these are worth tens of thousands!' 'Why are they worth so much?' I asked. 'Study!' they said. 'Then you'll know.' "[12]

When Na Chih-liang's team had finished for the day, they locked and sealed the Palace of Fasting and made their way through the deep chill and the gathering dark to the administrative offices. In the warmth of the offices he experienced an awful itching sensation in his feet. His colleagues, alarmed, informed him that this could be a sign of frostbite, and ordered him home to soak his feet in warm water. They told him to come properly dressed the following day. Na Chih-liang remembered feeling exhausted and unwell and resolved to find a way to protect his feet from the cold.

It was an inauspicious beginning to an extraordinary career. This dispirited teenager who could not tell the difference between imperial porcelain and his mother's rice bowls would spend his entire life with the imperial collections. His lack of formal training never held him back; he was to develop deep curatorial expertise, especially in the complexities of works carved in jade. But Na Chih-liang was a confident, robust, and decisive man, and those are qualities that, in the dislocation and uncertainty of war, when survival turns on decisions taken in a sliver of a moment, come into their own. In the terrible years ahead Na Chih-liang's strength and good humor would help sustain everyone involved.

*

Among the magnificent works of art that the inventory teams found in the palaces during that winter of 1924–5 was a painting, a handscroll some twelve feet long and a thousand years old. Its title can be translated as *Early Snow on the River*. A Chinese handscroll comes rolled up tight and fastened with a cloth tie. To view it, you lay the scroll on a flat surface, unfasten the tie, and unroll it from right to left, a little at a time. The eye of the viewer hovers above the scroll, floating from passage to passage in the painting. The experience is utterly unlike looking at a European painting, where the viewer looks at a framed image from a single point, as if looking through a window at a single scene. A Chinese handscroll invites you to move as you look, to move in toward the painting's surface to capture its detail, to move out for the larger composition, and to move along, from right to left, to see the work develop and change, and to see the narrative elements—its story—unfold. In a strange way, viewing a handscroll is a temporal, as well as a visual, experience.

As *Early Snow on the River* spools out, the painting reveals a world complete unto itself: a river in winter, with fishermen, and travelers making their way along the bank among ancient, knotted trees. The world is caught in a cold snap. A biting wind ruffles the water, rustles the reeds, chills the fishermen as they pole their skiffs across the river and peer in their nets. The travelers pick their way along a riverside path. First comes a gentleman on horseback and his elderly retainer. The gentleman's two concubines follow, mounted on visibly unhappy donkeys. Their robes billow in the wind as they complain to each other. Behind them, two miserable servant boys trudge along on foot. One blows forlornly on his hands to warm them. The central notes of the painting are water, wind, reeds, and the closely observed lives of the fishermen, their boats, their complex nets and fish traps, the huts of woven matting in

which they huddle for warmth. The painting could be a study in cold and gloom, but it is not. The portrayal of the fishermen and their way of life is expressive and loving, and the painter lightens the mood by dusting the branches and grasses with snow, vivid and surprising in the dark.

The painter of *Early Snow on the River* was a man named Zhao Gan, who lived and worked in the tenth century CE, during a period known as the Five Dynasties and Ten Kingdoms, when a profusion of quarreling, short-lived states grew and faded following the collapse of the mighty Tang empire. Zhao Gan was an inhabitant of a kingdom called Southern Tang that emerged briefly amid the watery, lush eastern regions just to the south of the Yangzi River. Southern Tang did not last long, just four decades from 937–976 CE, before it was conquered by the mighty armies of the Song, whose empire would last for centuries. Southern Tang's last ruler, Li Yu, who reigned from 961–976, was a complicated man who neglected his kingly duties and wrote beautiful poetry instead. Song troops captured Li Yu, let him live, but humiliated him by confiscating his palaces, art, and libraries, and forcing his young wife into the Song imperial harem. Li Yu died in 978, at around forty years of age. According to some sources, the Song emperor ordered him poisoned, though others hold that he died of illness.[13]

In his troubled fifteen-year tenure as the last ruler of Southern Tang, Li Yu was a great patron of the arts. He maintained a painting academy that produced monumental works, a few of which have survived—*Early Snow on the River* among them. We know this from a terse inscription at the head of the handscroll, attributed to Li Yu himself, which reads, "*Early Snow on the River*, painted by Zhao Gan, a student at the academy." So we know exactly where and when the painting originated,

but there is much more to learn about all that happened to it. We know that it spent time in the imperial collections of the Song emperors because it appears in an enormous catalog assembled by some diligent souls early in the twelfth century. And when, in 1127, the Song emperors lost a huge swathe of territory to marauding horsemen from the north known as the Jin, we can make the fairly safe assumption that *Early Snow on the River* was among the treasures the Jin took for themselves; the seal of a Jin emperor, Zhangzong, is there on the painting, in the shape of a peanut shell.

The Jin state fell to a Mongol onslaught in 1234, after two decades of war, and *Early Snow on the River* passed into the Mongol imperial collections. Right in the middle of the scroll sits the seal of the Mongol emperor Jayaatu Khan, who ruled between 1328–1332. Next to it, written in the emperor's hand, are three tiny characters. The characters mean something like "work in the highest tier of excellence"; a Mongol emperor is praising a work of the subjugated Chinese, perhaps to show his own discernment and culture. Then the painting seems to have passed into private collections for a period—the seals of prominent collectors tell us so—but the huge attention-grabbing seals of the mighty Qianlong inform us that by the eighteenth century *Early Snow on the River* had passed back into the imperial collections in the Forbidden City. Perhaps Qianlong viewed the painting, sitting cross-legged on his warm *kang* in the Room of the Three Rarities one snowy evening.

The painter, Zhao Gan, used brush, ink, and a little pigment on silk to create *Early Snow on the River*. He made thousands upon thousands of brushstrokes, articulated every ripple on the river's surface, the wavelets around the prow of a skiff, every windblown reed. There is no room for error in a traditional Chinese painting. The artist cannot paint over a mistake

or scrape off the pigment and try again. One botched stroke is final, the painting ruined. The degree of control required of the artist over the brush is absolute, and it is difficult to conceive of the extremes of discipline Zhao Gan imposed upon himself back in the tenth century, amid the frightening, waning years of the Southern Tang kingdom, to achieve the technical mastery he did.

When the inventory team came upon *Early Snow on the River* on one of those cold, dreary days in the Forbidden City, carefully unrolled it, and encountered the fishermen and the reeds and the freezing wind and water, they were almost certainly seeing the painting for the first time. They may not even have known of its existence until that moment. Yet a knowledgeable curator would have been able instantly to see the painting's journey through time and space traced in the seals and inscriptions that adorned the handscroll. As the weeks went by, the inventory teams encountered thousands upon thousands of astounding, ancient, deeply fragile works of art that had endured centuries of war, upheaval, and change. In the dim recesses of one palace, Na Chih-liang and his colleagues came upon wooden chests sealed with wire and brass locks. The team members forced them open and found dozens of paintings, masterpieces among them. It seemed to them that someone—perhaps the last emperor, Pu Yi, himself?—had been preparing to spirit them out of the Forbidden City for sale, and Na Chih-liang reflected that the inventory teams had arrived just in time.

The lowly loggers and labelers carried on their strange, intricate work in the chill palaces. The months passed, winter lifted, and through the early months of 1925 the inventory grew to hundreds of thousands of objects, named, numbered,

and identified in light, crisp brushstrokes in the registers by the young high school graduate Na Chih-liang and the thoughtful archaeologist Chuang Yen and others like them. The more experienced members of the inventory teams began to grasp the vastness and profundity of the imperial collections. Where before they had only glimpsed the collections through individual pieces that had emerged from the palaces by theft or gift, now they began to see the entirety of what lay in the Forbidden City. The collections, they came to understand, were a kind of map of an entire intellectual universe, a vast resource in the search for the origins and course of a civilization.

Na Chih-liang and Chuang Yen both wrote detailed, moving memoirs of this time, and of the years that followed. Their recollections are crucial in understanding everything that was to come. But working beside them on the inventory teams was a man who, for most of his life, left little in the way of personal reminiscence. Though he stands right at the center of this extraordinary story, we see him only refracted through the memory of others, and through official documents. He was a quiet, mild-mannered professor from Peking University named Ma Heng. Professor Ma Heng was a wealthy man, short in stature, highly cultured, with a penchant for tailored suits and cigars. His family came from the coast, near Shanghai. His abiding love in life was epigraphy, the study of inscriptions, words inscribed on durable material like stone or bronze that could relay the history, language, and philosophies of antiquity. Ma Heng had immersed himself in the study of such inscriptions since he was a boy, and he dreamed of life as a scholar.

Ma Heng had little interest in politics, and none in war, yet those were the forces that would define his life. He gave his all to protect the imperial collections from pillage and destruction. His final reward was to be pain and humiliation.

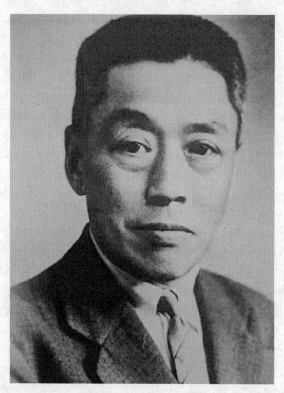

Ma Heng (1881–1955)

2

THE SHABBY PROFESSOR

Professor Ma Heng made his way into the Forbidden City and began work cataloging the imperial collections in 1924 as a succesful man in early middle age. Born in 1881, when China was still the Qing empire, he grew up in a family that was, for a while, well-to-do; his father was a government magistrate just outside Shanghai, a post that brought the family a steady income and some social status. Ma Heng's father was unusual. He had been born into poverty and had little education. He was apprenticed to a rice business at the age of fifteen, poling a little boat along the waterways that crisscrossed the region, selling rice in market towns. He came to know the business and the rivers, and this knowledge would serve him well when the country erupted in civil war.

In 1850 an armed movement known as the Taiping emerged. Marching through south-central China, it amassed a fervid following. Its leader, convinced of his own divinity, declared himself the brother of Jesus and preached a bowdlerized message of Christian redemption. The Taiping launched a crusade to bring down the ruling Qing dynasty and build a "Heavenly Kingdom." The civil war that ensued lasted more

than a decade and measured the depths of human barbarity. Untold millions died as armies ground across the country, burning and killing, picking clean towns and villages. The Taiping war was contemporaneous with the civil war in the United States and is in some ways comparable to it but was by far the crueller.

Ma Heng's father, the rice trader, found opportunity and advancement during the Taiping war by placing his knowledge of the rice business and the rivers at the service of the Qing military. For ten years he worked to secure financing and foodstuffs to keep the Qing armies functioning in their fight against the Taiping rebels. In recognition of his service, the Qing awarded him a coveted government position. At the war's end, he was a man transformed. The boy who had poled a little rice boat along the rivers was now an eminent official of the Qing bureaucracy, a magistrate, and as such implemented the law, oversaw local government, and wore a pheasant feather in his hat. He married three wives and fathered nine children, all of them sons. Seven survived. Extraordinarily, five of them became professors in Peking.[1]

We have scant knowledge of Magistrate Ma's character and inclinations. His experiences, though, suggest worldliness and practicality. His experiences during the Taiping war must have given him a visceral sense of danger, of what happens in conflict, of how quickly a civilization can stutter and lurch toward catastrophe.

The young Ma Heng was the third of Magistrate Ma's seven surviving sons. He was a quiet, bookish boy, and dutiful. He was short and slender and had delicate features. Magistrate Ma, mindful of his own lack of education, hired a tutor for his boys, a man named Ye Haowu. Teacher Ye was progressive in outlook, and later in his career founded one of China's first schools for girls. With the boys he went through the primers

of literacy and Confucian philosophy that every student was expected to learn by heart, and he taught them mathematics and calligraphy. When it came to the study of ancient inscriptions, the boys were bored; perhaps this felt for them a little like Latin did for generations of restless European schoolchildren. Of all the brothers, only Ma Heng took to the study of inscriptions, the deciphering of ancient, unfamiliar writing, piecing together fragments of meaning from the deep past.

Teacher Ye quickly recognized Ma Heng's affinity for classical learning and began to instruct him in seal cutting, working stone with a tool to engrave it with characters. Seal cutting is a high art. A seal can carry a name or a sobriquet or a phrase, sometimes an image. Usually, a seal cutter will carve archaic characters imbued with ritual and philosophical significance. The seal artist turns words into beautiful, abstract form, the way a calligrapher does. A finished seal is dipped in a sticky paste of scarlet and used as a stamp, leaving a vivid block of color and pattern that draws the eye irresistibly. The seal can signify authority or ownership, or sometimes just indicate personal presence at a place and time. A Chinese painting without the blocky scarlet seal of the painter looks incomplete.[2] The owner of a painting or a piece of calligraphy would often stamp his own seal on the work, the way the emperor Qianlong did on *The Stag Hunt*. The scrolls of great masterpieces are covered with seals, the marks of long-dead emperors, collectors, and connoisseurs, that sometimes impinge on the work itself. Ma Heng would cut and collect seals all his life.

When he was twelve, Ma Heng was betrothed. His father had become friendly with a very wealthy businessman, Yeh Ch'eng-chung, who ran a chain of hardware stores in Shanghai and for a while represented the huge American corporation Standard Oil in China. Standard Oil's kerosene lit lamps across the country, and Mr. Yeh had the license to distribute

it, which he did in five-gallon tin containers. It made him a multimillionaire. His name, wrote the *North China Herald*, "has become synonymous with kerosene in every city of the empire."[3] Later, he expanded into banking, factories, and mills, and became wealthier still. The Yeh family lived in prosperous, modern Shanghai. The match was made. Ma Heng found himself betrothed to Mr. Yeh's nine-year-old daughter, Yeh Wei-ch'ing. They would marry on reaching adulthood.

In 1895, when Ma Heng was fourteen, the Ma family's circumstances changed dramatically. Magistrate Ma died unexpectedly, and the loss of income threatened to reduce the family to penury. Ma Heng's in-laws-to-be, the wealthy Yeh family, were generous with their support, but there would be no more lessons with expensive private tutors. The resourceful Ma boys went to read in a public library, the older boys helping the younger.

In 1899 Ma Heng passed a set of civil service exams, but decided that a government career was not for him. A photograph taken of him around this time shows him in a long robe and a silken cap, sitting in a garden, looking neutrally at the camera. He wears his hair in the approved Qing style, shaved at the front, long and braided at the back. He is a young Chinese man of the late nineteenth century, of the Qing empire in its dying moments. According to family accounts, he had grown into a dutiful, reserved adult, a man averse to confrontation, quietly spoken, strict with himself in the way of the Confucian intellectual. Later that year, Ma Heng left home for a prestigious school in Shanghai, the Nanyang Public School. While seven hundred miles to the north the soldiers of Britain, France, America, Japan, and the other colonial powers ravaged Peking and pilfered in the Forbidden City, Ma Heng studied science and economics, subjects selected to prepare him and

his country for industrial modernity. However, he stayed at the Nanyang School only a few semesters. Family duty called; the time had come to marry.

Ma Heng's wealthy father-in-law-to-be died at the end of 1899. His death meant that Ma Heng's future wife stood to inherit enormous wealth and part of a business empire, but Yeh Wei-ch'ing had to wed to receive her portion. She and Ma Heng married in the spring of 1902 at a lavish ceremony in Shanghai. The young couple—he was twenty-one, she was eighteen—moved into a large, comfortable house in Shanghai. Ma Heng became a director of the Yeh family business, for which he received a generous salary. It was a gilded life, marred for him by a single, irredeemable flaw.

In a traditional Chinese marriage, the bride joined the groom's family, but Ma Heng had done the opposite. He had moved in with the bride's family, a decision that carried with it a faint air of humiliation, even emasculation. The Chinese expression *yu gong* refers to an official living and working far from his ancestral home, but it is also a condescending euphemism for a man who leaves his family for that of his wife. Ma Heng perhaps felt himself tainted with the sense of being *yu gong*, not only by living as an appendage of the Yeh family but also in turning his back on the life of full-time classical scholarship that he craved.

For fifteen years, as the Qing empire gave way to the young, chaotic Republic of China, Ma Heng worked dutifully in the Yeh family business. He visited the hardware stores and the match factories, came to know the family's banking concerns, and saw how the businesses navigated China's industrialization. Shanghai was a great port and a cosmopolitan, international city. Life here, for those with means, was fast and glamorous. Parts of Shanghai—the French Concession and the International Settlement—were run entirely by foreigners.

They had their own courts, councils, police, and militias. The concessions—there were many more up and down the coast, controlled by Britain, Japan, Germany, and other colonial powers—had been wrested from China in the nineteenth century in the aftermath of the Opium Wars. For some Chinese people, the concessions were painful reminders of China's weakness and exploitation at the hands of foreigners. For others, they were islands of prosperity and connectedness that forced China to encounter and reckon with the outside world.

Ma Heng's life in Shanghai was colored by the wealth and the brash modernity that the foreign concessions brought to the city. But the prejudice and snobbery exhibited by the foreigners who inhabited them—the so-called Shanghailanders—infuriated the Yeh family. Despite his wealth, one of Ma Heng's brothers-in-law was repeatedly rejected for membership of the exclusive Shanghai Race Club, a foreign-run racecourse in the International Settlement. The Yeh family, in response, decided to start its own racecourse. Their club opened its doors in Jiangwan district at a ceremony in 1910, its new clubhouse "tastefully decorated with small flags, bamboo foliage, evergreens and bunting."[4] The track, said the organizers pointedly, would be open to everyone, Chinese and foreigner. It was a success. On quiet days Ma Heng and the Yeh brothers would exercise horses, taking them out to canter on the track. Ma Heng, the bookish scholar-turned-businessman, became something of a horseman.

Ma Heng's marriage, however, was fraught. Family accounts portray Ma Heng's young wife as troubled. They describe her as angry and unpredictable. She was "pampered and spoiled from an early age."[5] She smoked opium, a habit Ma Heng "detested,"[6] and she spent a great deal of time at the *majiang* table. When things did not go her way, she would "fly into a rage, hurl things and tirelessly curse everything." It got to the

point that during her bouts of anger family members would hide valuable objects for fear they would be broken.[7] Ma Heng, the story goes, would play *majiang* with her to calm her, and then would do the rounds of the family, apologizing. Ma Heng never faulted his wife, but rather sought to placate her. The marriage lasted, perhaps due in part to Ma Heng's accepting, even passive, nature. But these accounts of Yeh Wei-ch'ing's unpredictability and anger are narrated by others, and always by men. Her voice is absent, and her state of mind—and possible addiction to opium—remains unexamined. She bore ten children, four sons and six daughters, nine of whom survived. Late in life, long after the Second World War, long after his wife's death, Ma Heng had only two photographs hanging on his wall. One was of the racecourse at Jiangwan, where as a wealthy young businessman he had cantered around the track. The other was a portrait of Yeh Wei-ch'ing.

Throughout his years in Shanghai, even as he worked in the Yeh family business, Ma Heng fervently pursued his interest in antiquity in China's great tradition of scholar-gentlemen. His substantial salary meant he could acquire artifacts and inscriptions from across China and study them in depth, exploring the contours of early language and thought. This style of scholarship had been practiced for centuries. It was known as *jinshixue*, the study of bronze and stone, for its emphasis on the inscriptions found on early bronze artifacts and stone tablets. The *jinshi* scholar avidly collected such inscriptions, seeking out the bronze vessels, platters, and goblets that peasant farmers dug up in their fields or that came on to the market after robbers plundered ancient tombs. Scholars haunted the markets and marveled at each other's collections, taking rubbings, writing commentaries, assembling narratives of the past. An accomplished *jinshi* scholar could take an ancient

jade funerary object or an inscribed water vessel and tease out its meaning and historical significance, place it in a dynastic history, compare it to other objects and texts, and weigh its importance as evidence of one or another theory of civilization's origins.

Jinshixue is often translated as "antiquarianism," and for much of China's history its practice dominated the scholarly understanding of the past. Ma Heng seems to have found release and solace in his studies, and among his antiquarian colleagues. He continued his seal cutting as well, helping to found the Xiling Seal Art Society, dedicated to the study of these artifacts. One of his colleagues in the society carved a seal especially for him. The characters read *Fanjiang Zhai Zhuren*, which translates to something like "Master of the *Fanjiang* Studio." The term *fanjiang* refers to an ancient literary text, the *Fanjiang Pian*, a sort of reading and writing primer dating from the second century BCE, of which only tiny fragments remain. By styling himself a scholar who named his studio after the *Fanjiang Pian*, Ma Heng evoked the world of classical learning and the partial, fragmentary nature of his own knowledge. It was a clever, yet modest, sobriquet, the characters worked beautifully in stone, another indicator that, for all the wealth and ease of his life in Shanghai, Ma Heng coveted the life of a scholar.

In 1917, after a decade and a half with the Yeh family businesses, Ma Heng decided to change his life. He was thirty-six years old. The young man in a silk gown and braided hair was gone. Ma Heng now comported himself in a style in keeping with a citizen of a modern republic. He had long ago cut off his braid and grown his hair into a short, dapper brush cut. He wore a jacket and tie, sometimes a vest. Photographs of him taken around this time show a sophisticated, wealthy urbanite, a man of contemporary fashions, despite his love of classical

learning. He is handsome, with well-defined features, full lips, and an open, warm-eyed gaze. The photographs also suggest a calm or quiet quality to him that echoes the family's account of his retiring nature. They hint at a sense of fastidiousness too, and meticulousness.

Ma Heng's older brother had taken up a post at Peking University several years earlier. Under a dynamic, reformist university president, the institution was undergoing radical change, expanding and hiring new faculty. Ma Heng saw his moment. In August 1917 he resigned from the Yeh family businesses and moved to Peking to become a true scholar.

Peking lay at the edge of the desert, a flat, ancient city of frigid winters and blistering summers, blanketed by dust. On a clear day, low blue mountains rose out of the plain to the west. The city had not industrialized; beyond the imperial precincts at its heart, it was a place of alleyways jammed with commerce, similar businesses clustered together in raucous display and competition: this street for gorgeous multicolored lanterns, that one for jade, another for furs or lacquerware. Narrow thoroughfares heaved with carts and carriages, rickshaws, food stands, and peddlers. Caravans of camels padded the streets, bringing goods from Mongolia. Befitting a city of learning and tradition, Peking was rife with publishers and printers, merchants of paper, brushes, inkstones, and seal paste. Dealers in antiquities offered myriad objects, those of imperial provenance the most sought after—and the most forged. A thieves' market thrived during the hours of darkness, then vanished at dawn.

At night theaters rang with the clatter and song of opera, and the evening air carried the drifting aromas of every cuisine of China. At the Restaurant of Accumulated Virtue, crispy roast duck in the Peking style was the house speciality; at the

Prosperous Spring Forest, peppery steamed chicken and turtle from Sichuan; at New Canton House, pig's tripe and trotters in soy with bamboo shoots. Outside the city gate at Ch'ienmen lay the *pan* houses, where sing-song girls would, for a fee, sit with a patron and drink and flirt and gamble until daybreak. But since the fall of the Qing, the city had changed. Old, narrow streets had been widened for imported automobiles; modern buildings in the European style, banks and hotels, rose flat-roofed and obtrusive above the old cityscape. Residents lamented the piles of ancient brick and gorgeous yellow-glazed tile lying shattered and discarded beside the new, choked roads. The sounds of Peking were changing too, the calls of the hawkers and peddlers, the murmur of the market crowd in the warm, dusty air, the temple chants all drowned out by the rattle of streetcars, the honking of traffic.

When Ma Heng arrived in Peking, he stayed at the residence of his older brother, who headed the Chinese Department at Peking University. Ma Heng threw himself into his work on archives newly consigned to the university and taught equestrianism, a fortuitous consequence of the Yeh family's investment in horse racing. His wife seems to have disliked Peking and mostly remained in Shanghai. Yeh Wei-ch'ing was unimpressed at his new career and referred to him as a "shabby professor." Ma Heng should have gone into banking, she said.[8] His salary was a fraction of what he had earned working in the Yeh family business, but his private wealth meant that, far from appearing shabby, he appeared prosperous and well dressed in comparison with others on campus.

Peking University at the moment Ma Heng arrived was a crucible of radicalism. Students and scholars raged at China's weakness, at its rapacious warlords, at the poverty and illiteracy that blighted the country, at the humiliating treaties imposed by colonial powers. What was it about China, they

demanded to know, that had rendered it so enfeebled, so vulnerable? And what was to be done?

The furious search for answers became known as the New Culture movement. New Culture thinkers argued that the ancient ways of China—its traditions, its classical learning, its Confucianism, its class attitudes, religions, and superstitions—had suffocated and suppressed the people for too long. One writer referred to tradition as a "four thousand–year-old garbage can on our backs." The time had come to throw it off and begin anew. Peking University's students fell ravenously upon foreign philosophy, scientific method, and political thought. What lessons did Japan's startling rise to industrial and military power hold? What might be learned from the European Enlightenment? Could American constitutional democracy provide a structural answer to China's political failures?

New Culture thinkers imagined a reborn China, with new thinking and behavior, even new ways of speaking and writing. Ma Heng became friendly with the writer, poet, and philosopher Hu Shih, who was at the forefront of New Culture thinking. Hu Shih believed passionately that a new nation demanded a language that all its citizens could learn to read and use. He argued that the classical and literary Chinese of the elites was valuable and beautiful but had no place as the language of government or of a new, vital literature. Only plain, clear language, written as spoken, could propel the citizenry into literacy and learning; only then could China rise as a modern nation. Hu Shih and his colleagues began writing and teaching in vernacular Chinese. It was a revolutionary moment, the shedding of an elitist literary tradition's stifling strictures, and a brave, democratizing assertion of the creative possibilities of the individual. "You cannot write my poetry," went one of Hu Shih's verses, "just as I cannot dream your dreams."

Peking University was also home to other, even more

revolutionary, currents of thought. In 1918 the university's chief librarian, Li Dazhao, wrote the first substantial account in Chinese of the Bolshevik revolution in Russia. He gave seminars on a German economist named Karl Marx and collaborated in publishing leftist magazines with Chen Duxiu, who would become a founding member of the Chinese Communist Party. In the winter of 1918, for a short while, a young man held a junior post in Li Dazhao's library, signing readers in and out of the periodicals room. The young man, brooding, troubled, himself wrestling with the great questions of China's future, read Peter Kropotkin and Thomas Huxley and Adam Smith in translation, and attended seminars on political philosophy. He tried to talk to the great men of the moment, men like Hu Shih, on their way in and out of the library. He would surely have encountered Ma Heng. But the young man's lowly position and his speech, heavy with the accent of south-central China, led the great men to ignore him.[9] His name was Mao Zedong, and he never forgot the humiliation.

On May 4, 1919, students at Peking University took to the streets in their thousands in protest against the signing of the Treaty of Versailles. The treaty dictated that Germany's concessions in China—those outposts of foreign territory on China's land—should, following Germany's defeat in the First World War, pass to Japan. China's students and activists erupted in fury at the news. Why should Japan inherit defeated Germany's colonial possessions? Why should they not be returned to Chinese sovereignty? The protests grew into nationwide demonstrations. Workers went on strike, and shopkeepers closed their businesses in protest at what felt like an enormous betrayal, the colonial powers colluding to keep China weak and divided. The protests became known as the May Fourth Movement.

Here Ma Heng was witnessing the true formative moments

of China's twentieth century. The New Culture movement, the May Fourth Movement, and the intellectual ferment they engendered nourished the twin roots of politics in modern China: one nationalist, one communist. For Ma Heng and the new generation of intellectuals in China's universities, it was a tumultuous, cosmopolitan, outward-looking time—a time whose heady atmosphere of experimentation and renewal is perhaps hard for later generations to grasp, eclipsed as it is in memory by the wars and turmoil that followed it.

Ma Heng played his part in this historic intellectual and political upheaval. His contribution, in keeping with his disposition, came through quiet scholarship rather than noisy protest, but he was nevertheless drawn into the larger, loaded questions of the moment. Was the *jinshi* tradition, with its emphasis on individual artifacts and inscriptions, on the word of the connoisseur, sufficient to examine and describe the past? Or was *jinshi* scholarship merely another of the stifling, stale traditions that the New Culture movement sought to cast aside? Scholars at Peking University, Ma Heng among them, understood that the tumultuous moment they inhabited demanded new, rigorous approaches to understanding China's past. To that end, in 1922 Ma Heng helped establish the Institute of Archaeology at Peking University.

In 1923 the new institute received word that farmers in central China, near the town of Xinzheng, had dug up from their fields fine bronze vessels that seemed to date back as far as the Spring and Autumn period (770–476 BCE). The artifacts were fast disappearing, sold on the art market. Ma Heng traveled to Xinzheng and pieced together what had happened, recording what objects had been dug up and pinpointing where. The ground was littered with tombs, hinting at the ruins of ancient cities. At Xinzheng, and on other visits to sites scattered around

central China, Ma Heng saw that when artifacts were removed from the context in which they were found, valuable information disappeared forever. The *jinshi* idea—that artifacts and texts alone could unlock the past, no matter how they came to light—was dying in him. From this point on, Ma Heng was passionately committed to careful, disciplined, documented excavation. The time had come, he realized, for the antiquarian collectors of old to give way to geologists, archaeologists, and anthropologists, all carefully trained in methods of excavation and the analysis of their finds. He argued publicly in favor of new laws that would bring state protection for archaeological sites.[10] Ma Heng would retain a foot in the *jinshi* tradition, but he was among the founders of modern Chinese archaeology, which identified its findings as belonging not to the art market or to connoisseurs or elites but to the nation.

This transformation in Ma Heng mirrored that of China. The leaders of the young republic were seeking to implant in China's people an awareness of nationhood, a way to conceive of themselves not as subjects of an empire but as citizens of a modern nation-state, sharing a common identity that transcended yawning differences in class, region, and language. Such a shared national identity required a shared sense of national history—something that, many historians surmised, the Chinese people had never before possessed. Simply put, the idea of a Chinese national history or national heritage had not existed before the twentieth century because China had never conceived of itself as a nation, but rather as the center of the vast, all-encompassing world order, known as *tianxia*, "all-under-heaven."[11]

When Ma Heng and the inventory teams ventured into the gloomy, cold halls of the Forbidden City in 1924 to count, identify, and catalog the imperial collections, they were seeking an expression of a national heritage they could call Chinese.

In the artifacts and objects and libraries that once served the emperor's purposes, that Qianlong had viewed and eulogized in his study on snowy afternoons in the eighteenth century, Ma Heng and the inventory teams were searching for an enduring "Chinese-ness" to nurture the new nation's sense of self. The imperial collections, once the mystical, hidden hoard of emperors, would from here on serve a different cause, that of the awakening of the Chinese nation.

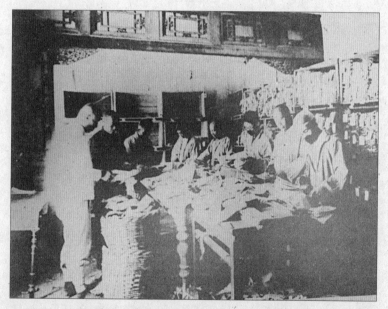

Workers of the Palace Museum sorting the
Forbidden City's vast archives in the 1920s

3

PEACE, AND WAR

At the end of summer 1925 Ma Heng and the inventory teams in the Forbidden City completed their work. In ten months they had noted and described 1,170,000 objects, books, and documents. The catalog ran to twenty-eight volumes.

As they pondered the scale and the breadth of the imperial collections in their charge, the members of the Committee for the Disposition of the Qing Household made a decision that would alter the cultural landscape of post-imperial China forever. Since its inception a year earlier, the committee had envisioned the Forbidden City as a museum, a place for the citizens of a young republic to witness and ponder their imperial past—with the emphasis firmly on "past." Now the committee decided to make its vision a reality, and fast. At the end of September 1925 it ordered that, on October 10, the republic's national day, just a week and a half away, the Forbidden City would open its doors to the paying public. The dream of a great national museum to rival the Louvre or the British Museum was to become a reality. The decision sparked a mad dash to ready the halls and palaces, and to install display cases and select objects for exhibition.

Na Chih-liang remembered that the hasty decision grew out of political, as much as cultural, concerns. Rumors were roiling Peking that loyalists of the fallen Qing dynasty might attempt to retake control of the imperial palaces and even bring Pu Yi back. "Old imperial diehards and idiotic politicians were stirring up trouble," he wrote. Na Chih-liang clearly felt that the sooner the Forbidden City was stripped of its power as a symbol of the old order, the better.

At eight in the morning on October 10 the Forbidden City and its astounding contents opened as the Palace Museum. Admission that day was free, and a curious, fascinated public descended on the imperial precincts, thirsty for a glimpse of a past they had never seen.[1] Peking's citizens came in their tens of thousands, jamming the approaches to the Forbidden City's gates. Na Chih-liang, on his bicycle, forced his way through the crowds. His station for the day was in the Hall of Mental Cultivation, where the emperor Qianlong had resided. Visitors surged into the hall in a feverish crush. Few could even see the exhibits, let alone appreciate them. Jammed shoulder to shoulder, people found themselves helpless in the heaving crowd. Na Chih-liang stood on a stool, shouting for people to keep moving, but "nobody paid me any attention." He watched a gentleman in glasses propelled through the room by the crowd, craning his neck to catch a glimpse of the exhibition cases, and failing. "What he thought he was doing there, I have no idea," Na Chih-liang wrote.

If the exhibition spaces were ramshackle and overcrowded, the objects exhibited were stunning. The great American scholar and collector John C. Ferguson, an early visitor, was dazzled by what he saw. "In a rude case, in a badly lighted room, I recently saw a row of Sung dynasty pottery the like of which could not be equaled anywhere."[2]

The Palace Museum struggled to establish itself in its early

years. Its finances were shaky; Ma Heng joked that seeking funding to conserve the museum's priceless collections was like "begging for alms with a golden bowl."[3] Its position was precarious amid the tumultuous politics of Peking and China. Strikes and demonstrations rocked cities all over the country, the crowds demanding that the colonial powers leave China. The republic's central government was weak. Regional strongmen vied for power and resources; some refused to recognize the authority of the government altogether and raised armies of illiterate men from poor, far-flung villages to secure their domains through violence. The Chinese Communist Party, founded in 1921, was only a few years old, but already posed a threat to the stability of the republic. Party operatives and agents from Moscow worked secretly to build its presence in the nation's political life and plotted revolution.

Through the upheavals of the mid-1920s Ma Heng continued his work, his progress traceable from a trail of scholarly undertakings and official positions. He worked at the Palace Museum, and he taught at Peking University. He published learned articles decoding and discussing inscriptions dating from antiquity, some found carved on stone tablets, others scratched into animal bones during ancient ceremonies of divination. He collaborated with John Ferguson. Together they would go on to deduce from ancient excavated artifacts a scale of measurements used during the Bronze Age, an important piece of scholarship. Yet even as he disdained politics, Ma Heng played his part in the slow, chaotic awakening of national consciousness in China. He campaigned against the removal of antiquities from archaeological sites by foreign "explorers" and adventurers. In 1928 he showed bravery in confronting a troublesome warlord whose troops broke into and desecrated the Qing imperial tombs southwest of Peking. The troops rampaged through the tomb of the emperor

Qianlong and of Cixi, the formidable Empress Dowager who had dominated the Qing court in the empire's closing years. They reportedly stripped the Empress Dowager's corpse of her funeral clothes and carried away pearls, jewels, and silks.[4] When looted objects began appearing in the Peking antiques markets, a dealer tipped off Ma Heng, who went straight to the authorities. Later, he testified against the looters at a military tribunal. The warlord, Sun Dianying, infuriated at Ma Heng, sent men after him. Ma Heng, fearing for his safety, fled first to the coastal city of Tianjin, then to Shanghai. His friend, the scholar Hu Shih, accompanied him part of the way, traveling with him by steamer down the coast. To keep his whereabouts a secret, Ma Heng registered at hotels under a false name, calling himself Ma Wujiu, which translates to something like "Blameless Ma." He took to this new sobriquet, cut it into a seal, and sometimes used it to sign his name later in life. Weeks passed before he felt safe enough to return to Peking. The episode reveals in this retiring man a considerable reserve of courage, a virtue that the coming years would demand of him in full.

As he reached his late forties, Ma Heng was a respected academic and an established curator and administrator at the Palace Museum, working amid the faded grandeur of the Forbidden City and immersing himself in the scholarship he loved. Whatever his wife may have thought of his chosen career—she stubbornly remained in Shanghai—he was now a member of Peking's scholarly and societal elite, and socialized with prominent writers and artists. A beautiful portrait of him dates from around this time, drawn in pencil and charcoal by his friend Xu Beihong, the famous artist. Ma Heng sits in a chair, his posture informal, relaxed. He looks straight ahead, his gaze poised between warmth and solemnity, touched with curiosity. He wears a comfortable suit of soft cloth, a tie, and a stiff collar. In his left hand he holds a cigar. The artist has captured a

certain quiet in him, a stillness. Those who knew him remembered that in conversation Ma Heng would respond slowly, drawing on his cigar, exhaling through the nose before speaking. His was a comfortable, secure life, but it was not without disappointment.

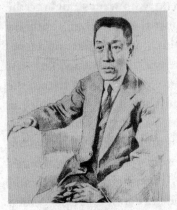

Portrait of Ma Heng in pencil and charcoal, by the artist Xu Beihong (1895–1953)

Despite his prominent role in the opening of the Palace Museum, his work establishing modern archaeology in China, and his supervision of important excavations, in 1928 Ma Heng was passed over for China's top job in archaeology at the august research institute Academia Sinica. The position instead went to Li Chi, the Harvard-trained anthropologist who would go on to manage one of the twentieth century's greatest excavations, at Anyang. Why did Ma Heng not get the job? Perhaps because he never studied abroad; perhaps because he was seen as remaining too close to the *jinshi* tradition. Ma Heng's path was to follow a quite different direction, and forces far beyond his control were to drag this well-tailored, reticent, cigar-smoking professor away from the scholarship he loved through thickets of dangerous politics, and onto the fields of war.

During 1925, as Ma Heng and the inventory teams worked their way through the Forbidden City, profound political change was brewing more than a thousand miles away, in China's far south. On July 1, 1925, in the southern coastal city of Guangzhou, a young political party called the Kuomintang,

or KMT, often referred to in English as the nationalists, proclaimed a new government led by a political council with ambitions to rule all of the Republic of China. To many it seemed an unlikely ambition, but the KMT possessed a capable army, the core of which was well trained and loyal. The army's commander, General Chiang Kai-shek, an austere soldier with a formal, sometimes awkward, humorless manner, was in his late thirties. He was a shrewd, stubborn man who rose at five every morning to perform calisthenics and who combined authoritarian leanings with a surprising capacity for compromise when it suited him. He was nationalist and anti-imperialist to his core and viewed the behavior of the colonial powers toward China with loathing. "The stupid British," he wrote in his diary, "regard Chinese lives as dirt."[5] He despised the unequal treaties forced on China that had ceded Chinese territory to foreign occupiers. The presence of foreign troops—British, French, Japanese—on Chinese soil enraged him, but the weak and disunited Republic of China was powerless to evict them.

Chiang Kai-shek's intention was to march north, force the regional warlords that dominated the country into submission, and unify China under strong, central KMT rule. His goal was a sovereign China free of foreign manipulation and exploitation. His ambitions lay close to, if never quite fully aligned with, those of the Soviet Union and the young Chinese Communist Party. Chiang Kai-shek accepted Soviet advisers and weapons, and took Chinese communists into his military—for the time being.

In the summer of 1926 Chiang Kai-shek's army, 85,000 strong but still hugely outnumbered by the armies they would face, marched. They carved their way into the warlord-controlled provinces, confronting opposing forces with massed infantry, discipline, and resolve. Victories came quickly as warlords capitulated, often joining forces with his troops. The Northern Expedition,

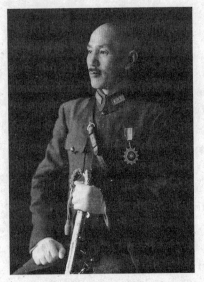

Chiang Kai-shek,
leader of the Republic of China

as it became known, was brutal, complex, and marked by vicious rivalries among KMT leaders, but it was a success. By spring 1927 forces under Chiang Kai-shek's command, in their gray uniforms bearing the emblem of a white sun on a blue background, had taken southern China and the great cities of Shanghai and Nanjing. Now Chiang Kai-shek turned on his communist allies, KMT agents arresting and murdering thousands of party operatives.

On the morning of June 8, 1928, Peking fell peacefully to KMT troops, who marched into the city from the south in dusty uniforms, carrying Mauser rifles and "potato masher" grenades.[6] For a moment it appeared that Chiang Kai-shek and the KMT might leave behind the blood-soaked legacy of factionalism and civil war in China's young republic, that a unified state might finally take the vast, splintered country in hand.

In the Palace Museum a creeping, cautious optimism began to take hold. The museum was officially incorporated into the government of the republic and restructured, gaining for the first time a formal director who could represent the museum's interests in the corridors of power. Yi P'ei-chi, a scholar and former minister of agriculture and mines, assumed the post in 1929, although his tenure was to be troubled and short.

For a few years the Palace Museum seemed almost to flourish, though its finances remained parlous and overdependent

on donations and ticket sales. Ma Heng was deputy director of the museum's Antiquities Department, with particular responsibility for its bronzes, while Na Chih-liang was busy organizing the museum's holdings of jade. He described this brief period at the end of the 1920s as an exciting, ambitious time, and claimed credit for putting on public display an exquisite jade carving of a long, leafy Chinese cabbage. The carving, which dates from the Qing period, is small, less than eight inches long, but the color of the jade perfectly mimics that of the vegetable, a pure white turning to a rich, luscious green along the length of its stalks. Insects, a locust and a cricket, hide among its leaves. Public reaction to the piece took the curators by surprise. "No one expected it to create such a stir," a bemused Na Chih-liang wrote. "In Peking, everyone immediately fell in love with it." The jade cabbage quickly became—and remains today—one of the most viewed pieces of the imperial collections, and perhaps the most beloved by the public. "These were our happiest days," wrote Na Chih-liang.

Chiang Kai-shek announced that the republic's capital would move away from the dusty, semidesert climes of Peking to Nanjing, the warm, sedate city far to the south on the Yangzi River. In the following years, the KMT attempted to forge a more durable, stable government for China, and to build the roads and railways, ports, parks, and schools that a modern nation demanded. This brief period became known as the Nanjing Decade. But powerful forces continued to work against Chiang Kai-shek's ambitions, not least the KMT's own militarism and corruption. Two great forces would decide Chiang Kai-shek's fate and the fate of modern China. One was the Chinese Communist Party, whose leadership had retreated to a sanctuary in the remote mountains of east-central China to plot their own revolution and path to power. The other: the empire of Japan.

*

Since the late nineteenth century, Japan had been gnawing at the territory of China. In the vicious war of 1894–5 the Japanese military mauled the forces of the Qing empire and gained control of the island of Taiwan and dominance over the Korean peninsula. In 1904 tensions between Japan and Russia exploded into war between them. Japanese battleships shattered the Russian navy; thousands of Russian sailors drowned in the freezing waters off the Chinese coast. The Western powers reeled as they watched the upstart Japanese tear the Russian bear apart. Japan projected its increasing power further into continental Asia, seizing more Chinese territory. At the end of the Russo-Japanese War, Japan was granted control over the strategically vital Liaodong Peninsula, which juts into the Yellow Sea, and the port city of Dalian.

Emboldened by military victory and rapid industrialization, Japanese ideologues imagined a vastly enhanced position for Japan in the world. Over the years of the late nineteenth and early twentieth centuries they wove a tapestry of colonial ambition into fantasies of cultural and racial purity. "Asia is one," wrote Okakura Kakuzō, the thinker best known outside Japan for his enduringly popular introduction to Japanese culture, *The Book of Tea*. "It has been, however, the great privilege of Japan to realise this unity-in-complexity with a special clearness." Okakura wrote that the Japanese race and its "singular genius" made Japan the "real repository" of all Asian culture and the true steward and arbiter of Asian identity.[7]

The scholar and diplomat Nitobe Inazō, flushed with Japan's success in its war against Russia, made Japan's aspirations explicit in English for the Western reader: "Russia, which has been in the habit of despising us, has now learned to do otherwise. Germany and France, which have never taken us seriously, will cease to look upon us as a joke. England and America, which have patronized us as a child-nation, will

regard us as an adult. The whole of Asia, which has looked upon us with suspicion and condemned us as traitors to Asiatic tradition, will follow us as their guide."[8]

To the new Japanese nationalists, their neighbors in China and Korea were weak and degenerate, incapable of resisting Western colonialism or modernizing themselves. China had "no landmarks" to remind her of her former greatness "save her literature and her ruins." Chinese scholars, noted Okakura, came to Japan to seek "the fountainhead of their own ancient culture."[9] Koreans were "a poor effeminate people" with "no intellectual ambition," wrote Nitobe, who advocated the settling of the Korean peninsula by Japanese migrants.[10] It fell to Japan to rescue the failing countries of Asia from themselves and from Western colonialism, and to rescue the ancient cultures of Asia from irrelevance and degeneration. Japan's destiny was to save Asia by becoming its master. For many in the young Chinese republic, Japan's ambition was frightening, and frighteningly near China's borders.

During the First World War, with the Western colonial powers preoccupied with the carnage in Europe, Japan moved vigorously to expand its hold on China. By the mid-1920s, as Emperor Pu Yi was evicted from the Forbidden City and Ma Heng worked on the inventory of the imperial collections, Japan controlled wide swathes of Chinese territory and much vital infrastructure in the north and east. It controlled key railway lines, coal mines, and steelworks, the strategic city of Dalian, much of Shandong province, and concessions in trading ports. Unruly, rapacious Japanese military units were garrisoned on Chinese territory. The Kwantung Army, as these units were known collectively, was a hotbed of Japanese expansionism and extremism. In their bases on the Liaodong Peninsula, just a few hundred miles from Peking, Kwantung Army officers hankered after the violent annexation of all of China, starting

with the northeastern provinces, that great expanse of fertile land and tempting natural resources known as Manchuria.

In the late summer of 1931 a bomb exploded next to a Japanese-controlled railway line in southern Manchuria. The line was undamaged in the explosion, but Japanese officers accused Chinese nationalists of sabotage. In retaliation, Japanese troops occupied Mukden, the most important city in the region. In reality, radical officers of the Kwantung Army had set the bomb, and the explosion provided a threadbare excuse for a full-scale Japanese invasion of Manchuria. Trainloads of Japanese infantry poured into the region, and within weeks occupied an area of northeast China roughly the size of France and Germany combined. They disarmed Chinese police, confiscated property, and took over banks. The invasion took place without the approval of the Japanese government in Tokyo; it was entirely a concoction of the Kwantung Army's officers. Nonetheless, in March 1932 Japan declared Manchuria a state independent of China.

In one of the strangest twists of the time, Japan installed Pu Yi, the last of the Qing, as the "emperor" of Manchuria. But Pu Yi exerted no power over Manchuria's thirty million people, and political and economic power was held and exercised by Japanese military officers and bureaucrats, businessmen and gangsters. All of whom quickly got to work exploiting the territory's rich resources, building roads and railways, ramping up industrialization, helping to lift Japan's economy out of the Great Depression. Manchuria became in effect a colony of Japan, ruled by a puppet. Waves of settlers came from Japan to work and farm, lured by promises of opportunity on a new colonial frontier.

Japanese corporations set to work building Manchuria's economy using slave labor; perhaps ten million Chinese were

forced to work in the fields and mines and steel mills. The new state established a monopoly that profited directly from sales of opium, heroin, and morphine. Drugs swamped cities in Manchuria and beyond, creating a generation of impoverished, desperate addicts. Manchuria was a grim experiment in industrializing colonialism and witnessed some of the most grotesque excesses of Japanese militarism. Unit 731 was Japan's secret biological warfare program, based near the Manchurian city of Harbin. Its "scientists" would over the years perform experiments on thousands of living people, most of them Chinese, some Russian, infecting them with diseases such as anthrax, bubonic plague, and syphilis. Officers of Unit 731 released bioweapons among the general population, contaminating wells with cholera and typhoid, dropping plague-infected fleas from aircraft, even lacing bottled lemonade and chocolate with bacteria to test their effects.[11] Unknown numbers died of disease.

Japan's seizure and colonization of Manchuria sparked rage across the rest of China, but the republic was still weak; war against Japan was impossible. Chiang Kai-shek and the leadership of the republic viewed the loss of Manchuria to Japan as a serious blow but not a catastrophe and played for time. Besides, Chiang Kai-shek's thinking went, the communists posed the most serious threat to the republic, even greater than that of Japan. The republic's troops were, he believed, better employed rooting out communists than launching suicidal attacks on Japanese forces.[12] In an interview with an American journalist, Chiang Kai-shek summed up his view in a formulation that became infamous: "The Japanese are a disease of the skin; the communists are a disease of the heart." His relentless campaigns against communist insurrection, known in China as the Ten Year Civil War, meant few resources and little effort were devoted to resisting Japanese expansion.

In the cosmopolitan, international city of Shanghai, where Japanese commerce had a pronounced presence and Japanese troops were stationed, tensions ran feverishly high. In January 1932 a group of Japanese ultranationalist Buddhist monks of the Nichiren sect held a demonstration, screaming provocative slogans. Fighting broke out between the monks and Chinese factory workers, and a monk was killed. Japanese intelligence officers had engineered the confrontation,[13] and, true to their plan, the fighting started to escalate. Japanese nationalists burned down a Chinese factory. Riots erupted, and boycotts of Japanese goods and businesses took hold.

By January 27, twenty-three Japanese warships were moored along Shanghai's waterfront and offshore, their guns trained on the city. Among them was the *Notoro*, a seaplane tender, whose agile aircraft carried bombs beneath their wings. Chinese troops moved into Shanghai and took up positions, hacking trenches in the cold ground, hastily erecting fortifications in the streets. Thousands of the city's Chinese residents— laden with babies, bags, and bundles—streamed toward the foreign concessions seeking refuge. On the twenty-eighth, just before midnight, this volatile slurry of racial tension and colonialist ambition ignited. Japanese marines backed by light tanks advanced into the teeming district of Chapei, supposedly to protect Japanese lives and industrial property. Chinese resistance was far stronger than many had expected. The soldiers of the republic fought stubbornly from behind their barricades and sniped from windows. Fires took hold, and Chapei blazed in the night. The Japanese advance stalled.

The next day dawned gray and wet, but the Japanese navy was in no mood for restraint. Its warships opened up with their heavy guns, bringing high-explosive shells screaming into the city. The *Notoro* launched her seaplanes; they droned over Shanghai unopposed, seeking targets, unloading

their bombs on densely populated areas, though avoiding the foreign concessions.[14] Over the following days, the fighting in the streets grew bloody and intense, machine guns raking the narrow thoroughfares and shop fronts, opposing infantry fighting with grenade, rifle, and bayonet. For thirty-four days, Shanghai endured bloody combat. More than 60,000 troops of the republic were engaged, and historians estimate that up to 30 percent of them became casualties.[15] Only at the beginning of March did Chinese resistance start to crumble. The republican forces withdrew, and a nervous cease-fire followed, the Japanese insisting that Shanghai become a demilitarized zone, in effect banning Chinese forces from a Chinese city.

The terrible events of 1932 in Shanghai are little known or understood outside China, yet they hinted ominously at the shape of the global conflagration to come. Here was a taste of modern urban war, and here, for the very first time, was protracted aerial terror bombing of a civilian population.[16] The aircraft of the Japanese navy bombed Shanghai for weeks, killing an untold number of civilians, traumatizing many more, wrecking precious infrastructure, eviscerating society, destroying culture.

In the earliest days of the bombing, Japanese aircraft struck the building occupied by the Commercial Press, a well-known and respected publisher that produced about 75 percent of all China's educational texts. Six bombs "blew the building skyward" and killed ten people. The publisher's archive, known as the Oriental Library, was burned to the ground. Half a million volumes went up in smoke, some of them rare texts and documents dating back centuries used as precious sources for reproduction. Thousands of irreplaceable maps, charts, and paintings burned.[17] It was, wrote a local newspaper, "a tremendous blow to Chinese education and culture."[18]

In Peking the Palace Museum's directors and staff fretted

over the safety of the invaluable collections in their charge. Ma Heng cannot have failed to notice the destruction of the Commercial Press and the Oriental Library. The new and terrifying destructive potential of air power was all too apparent. He and his colleagues were aware of Japanese nationalists speaking openly of their desire to dominate Asia, and to appropriate and administer Asia's material culture. If Japan were to launch an all-out invasion of China, a scenario that seemed increasingly plausible, what would become of the Forbidden City, the Palace Museum, and the imperial collections? Might Peking be bombed from the air, like Shanghai? If Peking were to fall, how would the occupiers behave when faced with the imperial collections? Would they plunder, as they had in 1900, when, alongside the troops of America, Britain, France, and other colonial powers, they had looted the city?

At some point in late 1931 or early 1932, the museum's directors, Ma Heng among them, made a fateful decision. To leave the vast, fragile collections where they were, in the palaces of the Forbidden City, was too dangerous. For their own protection, they would have to be evacuated.

The task was monumental in scale and extraordinarily difficult in its details. The million objects in the catalog ranged from thrones to encyclopedias, from carved ivory picnic baskets to clocks, from a thousand-year-old handscroll such as *Early Snow on the River* to mountains of imperial porcelain bowls. Which objects should be taken away? Where could they be hidden? And how on earth could they be safely packed and transported?

Director Yi P'ei-chi quickly realized two things. If the collections were to be evacuated, packing could not wait. Curators needed to start immediately so that, should the order come, the artifacts would be ready to move. Second, evacuating

the collections in their entirety was impossible. Museum staff would have to choose the most significant and irreplaceable pieces to pack. The rest would have to remain in the Forbidden City and take their chances.

The curators set themselves to selecting which pieces to pack and planning how to do so. In the Archives Department and the Library Department the task would be relatively straightforward. Packed books and documents do not break if dropped and can be piled on top of each other in a case; if they are immobile and protected from damp, their chances of surviving transport are good. It was in the Antiquities Department, headed by Ma Heng, where the real difficulties began. Here, the curators would have to pack priceless porcelain, jade, paintings, and bronzes. To pack objects of such fragility was an awesome, complex responsibility. If, in the process of transporting the objects to safety, poor packing led to their damage or destruction, the consequences, and the irony, would be too great to contemplate.

Na Chih-liang, the young student whose feet had frozen during the inventory in the winter of 1924–5, was in his late twenties now, trustworthy, practical, and a full-time member of staff at the museum. He was detailed to work on packing in the Antiquities Department under Ma Heng's leadership. So too was the young bespectacled archaeologist from Peking University, Chuang Yen, who had found the last emperor's half-eaten apple in the imperial apartments. They and the rest of the department staff pondered the best way to pack objects of wildly different size, shape, weight, and fragility. Chuang Yen sought advice in Peking's antiques markets, questioning the dealers as to how they packed pieces for shipment. He brought dealers to the Forbidden City to give demonstrations of the best techniques.

The curators also looked for answers deep in the Forbidden City's own storage facilities. There, sitting dusty on the

shelves, were shipments of porcelain from the imperial kilns at Jingdezhen, far away in east-central China, which had made the treacherous, thousand-mile journey to the Forbidden City but had never been unpacked. For many decades, these had sat untouched in the dark recesses of the imperial warehouses. Na Chih-liang and Chuang Yen dug out some of these shipments and opened them carefully, noting every aspect of the packing. They found that the workers at Jingdezhen had separated porcelain bowls from one another with handfuls of straw, then wrapped the entire stack tightly in a thick straw layer so that each piece was completely immobile. Finally they had jammed each straw-bundled stack of bowls into a wooden bucket and poured in rice husks to fill the gaps. If porcelain had come to the Forbidden City packed in this way for hundreds of years, surely, thought Na Chih-liang, this was the optimal method. Nevertheless, the curators decided to add extra material. In addition to the straw and rice husks, they would use cotton wadding, paper, and cotton cord for additional protection. To make doubly sure that the packing was done correctly, they hired workers from the antiques markets who had experience preparing valuable antiquities for shipment.

By spring 1932 the selection of objects for packing was well underway. The museum ordered packing materials and purchased hundreds of wooden cases previously used to transport cigarettes. The curators and hired workers met in designated halls deep in the Forbidden City and set to work amid paintings that depicted the court life of long-dead dynasties, ritual jade, bronze funerary objects from the tombs of ancient kings, and porcelain so fine as to be translucent. With infinite care, they lifted and wrapped, bound and bundled. At stake was nothing less than the safety and integrity of a civilization's greatest artifacts.

*

It was a disaster.

The wooden cases the museum had bought were flimsy. When packed, they creaked and shuddered and could not withstand the slightest rough handling, let alone being dropped. The cotton wadding was secondhand and had lost all its elasticity, making it next to useless. When the curators handled it, the air filled with cotton filaments, making breathing difficult. Worse, it stank. The curators realized that the wadding had come from discarded winter clothing, old cushions, and even children's diapers. The stench was intolerable. Na Chih-liang finally lost patience when the workers hired from the markets adopted a "very condescending attitude" and lectured him pompously and inaccurately about the provenance and significance of the jade carvings they were packing. Dejected, the curators went to Director Yi P'ei-chi and declared that, the way things were going, they could not guarantee the safety of the objects. The museum went back to the drawing board. The hired workers were fired. The museum ordered thousands of new wooden cases and fresh cotton. Ma Heng, Na Chih-liang, Chuang Yen, and the other curators would do the packing themselves.[19]

"It was all about the smallest details," wrote Chuang Yen. As the weather grew warm that spring of 1932, and Peking's peach blossoms and willow fluff filled the air, the curators worked on in the cool palaces. Na Chih-liang reduced the packing process to two principles: "tight" and "separate." The curators wrapped objects tightly in cotton wadding and heavy paper, then bound the whole bundle with cord. On the outside of the bundle they wrote which objects, and how many, were contained within. They lined the wooden packing cases first with rice straw, then with a layer of cotton wadding. The bundled objects were laid carefully inside so they did not touch. The curators then jammed great handfuls of wadding and

straw between the bundles, rendering them immobile. Chuang Yen decreed that pieces be packed only with other pieces of similar material and composition. A porcelain vase should on no account sit in a packing case next to a heavy, bulky bronze vessel or a stone tablet. This rule, however sensible, meant that heavy objects were packed together, leading to much grumbling from the porters who struggled to lift the weightiest cases. Once packed, the wooden cases were nailed shut and a paper seal applied. On the exterior of every case were written characters indicating which department was responsible for it, and from which palace or hall in the Forbidden City it had originated. Every case was numbered, the number corresponding to an entry in a catalog that detailed precisely the contents of each. If the imperial collections were to survive travel, the packing of the cases and obsessive attention to record keeping would be crucial.

Amid the work, a joke circulated. The surname Chuang sounds identical in Chinese to the verb "to pack." Chuang Yen found himself the object of warm, respectful humor as everyone began calling him Old Mr. Packer. Someone even cut a seal for him playing on the pun, which he loved. He surely earned the nickname, immersing himself in the packing process and urging on the curators to ever greater care and precision. The joke lasted a lifetime. In old age Chuang Yen would look back on it fondly and reflect on how it captured a season of his youth.

A piece of porcelain of great rarity and beauty was among the objects painstakingly swaddled in cotton wadding and placed into one of the thousands of wooden cases that spring. The piece is known as a monk's cap ewer. A small vessel, the ewer stands about eight inches high and is shaped like a jug

or pitcher, with a handle and a spout. The ewer has a characteristic lid shaped in a way reminiscent of a Buddhist priest's hat, hence "monk's cap." It was manufactured in the first half of the fifteenth century. The ewer's shape is complex. Its body is rounded, not quite a perfect sphere but slightly compressed. Out of the body rises an elegant, cylindrical neck of beautiful, clean lines that flare slightly outward and away toward a curving spout. Atop the neck is a collar with steps rising away from the spout.

The piece is perfectly proportioned, its lines graceful, but what makes it so special and so highly prized is its color. The glaze is of a deep, luscious, complex red, and it covers all the ewer's exterior but for narrow bands at the collar and the foot, where the snowy whiteness of the porcelain shows in startling contrast. This red—known in Chinese as *xianhong*—was extraordinarily difficult to achieve and is vanishingly rare. The color comes from a tiny quantity of green copper oxide. The ewer's makers, working some time around the year 1430 CE, mixed a tiny pinch of copper oxide into the liquid glaze. They coated the ewer with the glaze and took it to a kiln for firing. The kiln had to burn extremely hot, at around 2,400 degrees Fahrenheit, and the kiln master had to manipulate the atmosphere inside the kiln to rid it of oxygen, a technique known as firing in reduction. Only if the glaze was of the exactly correct composition, the fires that burned in the kiln correctly managed, and the oxygen levels inside the kiln precisely controlled would the green copper oxide work its alchemy and transform the glaze into a rich, powerful red. The minutest error could be disastrous, leaving the fired piece a murky gray or even entirely without color. So treacherous was the process that for every successful firing hundreds would fail, the pieces smashed and thrown away.

This tortuous process of producing a copper glaze of such rich red was perfected in the early fifteenth century. The finest monochrome red glazes come from the ten-year reign of the Ming emperor Xuande and are revered by collectors and art historians. Not long after Xuande's reign, the process somehow fell into decline and eventually stopped altogether. Such Ming-style copper-red glazes did not appear again for nearly three hundred years. The imperial collections' monk's cap ewer is a product of that brief flowering in technique and technology under the Ming empire.

The manufacture of such refined, rarified beauty was rooted in dust, smoke, flame, and back-breaking labor at the kilns of Jingdezhen that long supplied the imperial palaces with porcelain. Jingdezhen is a natural center for porcelain production. Nearby mountains hold deposits of kaolin and mica that, when properly combined and fired, produce a porcelain of dazzling white. Jingdezhen porcelain is translucent and strong, and produces a ringing tone when gently struck. The techniques of its manufacture developed about a thousand years ago, and for centuries were known only to Chinese potters and kiln masters.

Staggering amounts of labor went into porcelain production. Generations of men trekked deep into the mountains to mine clays and minerals, hauling enormous weights on shoulder poles down the winding paths to the kilns. Forests were cut for fuel, the timber floated upriver and stacked in vast piles to season. Professional craftsmen spent their lives mixing and refining the clays. Families of potters shaped the pieces. The production of saggers—clumsy ceramic containers that encase and protect the porcelain during firing—was an industry in itself. For centuries Jingdezhen was home to hundreds of kilns that burned for days at a time, the roaring flames leaping into the night sky. Hundreds of pieces were fired at once, the kiln

masters braving the searing heat to peer in, gauging temperature and oxidation by eye alone.

Jingdezhen was an infernal place of noise, smoke, ash, and clay dust. It became perhaps the world's first industrial city, where a highly specialized labor force mass-produced goods for a market that, by the sixteenth century, was going global. Europeans developed an insatiable appetite for its gorgeous ceramics, whose whiteness, purity, and translucence were unlike anything they had ever seen. Dutch, Portuguese, and British ships returned from Asia laden with porcelain, and aristocrats across Europe filled their homes with vessels and dinner services from the kilns of Jingdezhen. The porcelain trade altered forever the way Europeans viewed the relationship between art and functionality. Through the elegant Ming and Qing vases that populate mantelpieces and museums in Europe and America silently resound the ancient roar and clatter and stink of the kilns at Jingdezhen, and the clamor of the lives of those who worked them.[20]

The very finest of Jingdezhen's products did not go for export or even to wealthy Chinese consumers; the most perfect porcelain the kilns could produce was reserved for the emperor. For hundreds of years boatmen poled shipments of exquisite pieces north on the Grand Canal to Peking. The monk's cap ewer with the rare copper-red glaze made that journey, and would probably have stood on an imperial altar for use in rituals associated with Tibetan Buddhism.

Sometime in early 1932, snug and immobile in straw and cotton wadding wound about with cord, labeled and noted in the catalog, the monk's cap ewer disappeared into its case. The curators continued through the summer and autumn of 1932 and into 1933. They crated up an astounding number of objects. In the Antiquities Department, the quiet, scholarly Ma Heng; the careful Chuang Yen; and the cheery, practical

Na Chih-liang oversaw the packing of nearly 28,000 pieces of porcelain, 8,369 pieces of jade—carvings like the jade cabbage, cups and vessels, ritual funerary objects, and jewelry—and 8,852 paintings and pieces of calligraphy. They bundled up seals, beads, bronzes, teapots, lacquerware, writing materials, ivory, enamelware, furniture, and swords. In total, the Antiquities Department packed some 63,500 objects.

Over in the Palace Museum's Library Department, the curators packed huge encyclopedias and collections of literature and philosophy, science and medicine. They crated the Qianlong Tripitaka, 7,000 volumes of Buddhist texts assembled and printed by the emperor in the greatest days of the Qing empire. In the Archives Department, they stowed many of the imperial records of the Qing empire. They packed imperial edicts, court diaries, genealogies, portraits of the emperors and empresses, costumes, and ritual implements.[21]

In all, the Palace Museum packed 13,401 cases. Elsewhere in Peking, other museums and archives were packing thousands more. The mountains of cases grew, waiting for the evacuation order.

As the curators worked on, the military position of the republic became ever more grave. By the end of summer 1932, troop movements in Manchuria—now a Japanese colony—appeared ominous. Japan, it seemed, was positioning itself to strike farther into China.[22]

The larger tensions of the time seeped down into the life of Peking and complicated the work of the museum staff. The museum had become desperately short of funds, and to raise money Director Yi P'ei-chi ordered the staff to sell objects found in the Forbidden City deemed to have no historical or artistic importance. Silks, furs, tea leaves, medicinal herbs and compounds, and some gold—"a lot of useless things," Na

Chih-liang called them—were put up for sale. The sale raised a substantial amount of money, but as news of its success filtered out, wild rumors started to spread through Peking: The museum was selling off the imperial collections! The museum was packing the collections not in order to evacuate them to safety, but to ship them abroad as security for bank loans! The collections were to be taken to Hong Kong and sold to foreigners! In September a group of university professors wrote an open letter to the government of the republic demanding that on no account should the imperial collections be allowed to leave Peking.[23] Na Chih-liang received telephone calls in the Forbidden City in which furious citizens threatened bomb attacks on any train carrying cases from the museum out of Peking. Yi P'ei-chi became mired in damaging allegations and poisonous personal rivalries. He found himself accused of managing the museum improperly and even of stealing objects. His position atop the republic's most important cultural institution grew shaky.

For a few brief years the Palace Museum had realized its place in the Republic of China as a repository of scholarship, beauty, and cultural memory befitting the capital of a new, reforming nation. As 1933 began, that moment of relative stability was ending. Wooden cases—nearly 20,000 of them—packed with objects from the Palace Museum and other museums and libraries across Peking lay stacked in the halls of the Forbidden City, ready to evacuate. As Japanese troops massed and maneuvered to the north, the moment for the imperial collections to leave Peking was approaching.

4

EVACUATION

Any lingering uncertainty concerning Japan's intentions was dispelled in the early days of 1933. Just 200 miles to the east of Peking, on the coast, the final reach of the Great Wall of China juts out into the sea at Shanhaiguan. The town of Shanhaiguan was home to a Chinese garrison, some 3,000 poorly equipped troops clustered within gray-walled fortifications. The troops had a strategically important task: to guard the Great Wall and a vital railway line against further Japanese incursions. Nearby, just to the north of the wall, lay a Japanese garrison, its officers itching for a fight.

On New Year's Day rifle fire crackled across the town's rooftops, followed by the thump of exploding grenades. Furious Japanese officers claimed the Chinese troops had fired on them. The Chinese denied it and refused to withdraw. Shanhaiguan exploded into violence. Two Japanese destroyers moored just off the coast opened fire, pouring high explosive and shrapnel into the Chinese positions and the neighborhoods that surrounded them. The Japanese deployed armored trains, light tanks, and infantry.

One nameless Chinese soldier gave an account of the

Japanese attack to the Peking papers. He described going to bed at 8 p.m. on January 1, only to be woken by an air raid and machine-gun fire. For the next two days, he and his platoon cowered beneath the bombardment and fought off Japanese assault troops, hurling down hand grenades from their positions on the Great Wall. On January 3, bombing breached the wall, and the defenders met the Japanese attack—with swords. "Our platoon commander, fearing the enemy would attempt to enter the breach, drew us up in two lines armed with big swords. At 2 p.m. a force of about 300 Japanese infantry made a first assault on the breach. We rushed at them with our swords and drove them back with a loss of over twenty men," the unnamed soldier recounted. The soldier described neighborhoods going up in flames, Japanese tanks pushing through the town, and the deaths of all the Chinese platoon commanders, his own "blown to pieces by a shell" while directing the defense. "Under this terrific fire we fell back in confusion . . . the whole city was by then one raging sheet of flame and smoke." The Japanese attack, in its ruthlessness, was an early taste of the years to come. "The poor people in the city who had been unable to make their escape all perished in the flames," wrote the soldier.[1] By January 5, Japan held Shanhaiguan, its railway, and a strategic route into the heart of China.

In Peking the significance of the attack on Shanhaiguan seems to have taken a while to sink in. "After a few days of stupor," wrote one haughty English-language columnist, "the inhabitants of Peking—that is to say the official and wealthier classes—seem to have wakened to the impending dangers of the situation and been seized by a panic." Fear of air raids swept the city. As much as the Japanese were to be dreaded, residents also worried about defeated Chinese soldiers pouring in and causing havoc. The hotels in Peking's Legation Quarter—where guards and extraterritoriality might give a measure of

protection—were booming and charging outrageous prices. The trains out of town heading to safety in China's south were crowded. And, the columnist noted, "another political barometer is provided by the Museum curios," their packing a sign of "a general and undefined fear that there is going to be trouble here."[2]

The first shipment of cases was scheduled to leave Peking on the night of January 31, 1933. Their destination was to be Shanghai, a strange choice, perhaps, given the violent Japanese incursion and aerial bombing there just a year earlier. The museum's reasoning seems to have been that the collections could be stored safely, at least for a while, in the foreign concessions. The Japanese military, went the museum's thinking, would not dare attack the French Concession or the largely British-administered International Settlement.

Director Yi P'ei-chi had carefully devised plans to transport the thousands of cases out of Peking. These were supposedly secret, though the whole city seems to have known what they entailed, with the press gleefully reporting every detail. The plans called for porters to assemble a first shipment of 3,000 cases near the south gates of the Palace Museum and then load them onto vehicles for the short journey to Ch'ienmen railway station. Police were to clear the route to the station of pedestrians and other vehicles, and 1,500 police, some armed, were to take up positions in the dark streets. A train consisting of more than twenty freight cars with armed guards aboard would await the cases. As soon as it was loaded, the train would steal out into the night and head south, far away from the encroaching Japanese. Such was the plan, but as the deadline for departure approached, things unraveled.

Porters began hauling the cases across the vast courtyards of the Forbidden City, pushing them on handcarts or carrying

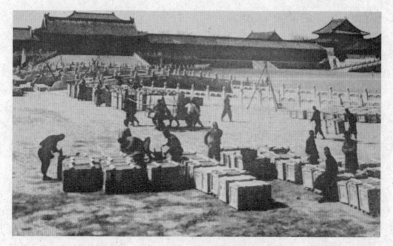

In the Forbidden City, porters ready cases for evacuation
from Peking, 1933

them suspended from shoulder poles, three or four men to a case. It was back-breaking work in the Peking winter, the air icy cold, the flagstones slippery. Porters were hard to find. The museum had managed to hire 600, but as the day wore on, they put down their tools and demanded an extra five yuan each in pay. The museum met this demand, a newspaper reporter wrote wryly, but they "still refused to work as directed. They moved the cases from here to there but the treasures never got anywhere outside the museum quarters throughout the whole night."[3]

To make matters worse, garages and freight companies all over the city refused to provide trucks to transport the cases to the station. The rumors that the imperial collections were destined for sale abroad or some other nefarious fate had spread through the city. Some of Peking's citizens seem to have felt that their departure was simply defeatist. No one was cooperating. Director Yi P'ei-chi managed to muster a grand total of three trucks, two motor cars, and 200 rickshaws. Another

rumor spread that explosives had been placed on the railway line,[4] and to top it all off, trade unions threatened to send hundreds of demonstrators to block the loading of the train. Desperate, Yi P'ei-chi telegraphed the capital for instructions. The government in Nanjing authorized postponing the departure.[5] The 1,500 police who had spent most of the night out in the freezing cold were told to stand down and go home.

In the ensuing days, opposition to the shipment became more muted. At least one vocal opponent of the shipments found himself under arrest, and threatened demonstrations failed to materialize. An elderly waiter named Wang kneeled at the Forbidden City gates, weeping and imploring the museum to abandon its plans. It was "a pathetic scene," wrote a reporter. Waiter Wang was unceremoniously "kicked out" by palace guards.[6]

On the evening of February 4, 1933, Director Yi P'ei-chi tried again to set his plans in motion. The 3,000 cases still sat in the courtyards, but by now the museum had requisitioned every military truck in Peking for the task, and a train was standing by. Workers had lit the route from the Palace Museum to the station with floodlights and flares.[7] At 9 p.m. 2,000 police closed the roads to traffic and took up their positions in the streets. At 10 p.m. the first trucks rumbled out of the palace grounds.[8] All night, trucks, cars, and carts pulled by donkeys hauled cases to the railway station. By dawn, the porters had loaded 2,118 cases aboard the freight cars.

On the morning of February 5, 1933, at seven o'clock, a train consisting of twenty-one cars pulled out onto the Peking–Hankow main line. The flower of China's imperial collections—bundled, bound, straw-stuffed, crated, and sealed—was on the move, leaving behind the vermilion-walled precincts that had sheltered them for centuries. The

journey was to last sixteen years, and would take the collections unimaginable distances, up rivers and across mountain ranges, through famine and war, and even to the other side of the world. A part of the collections—some would say their heart—was never to return.

The museum leadership chose a respected curator named Wu Ying to take charge of that very first shipment to Shanghai. Wu Ying was a short, rotund man possessed of a combustible temper and more than a little self-regard. His writings show him suspicious of his coworkers and dubious of the museum leadership, including Ma Heng. The prospect of escorting the first shipment, given the opposition it had encountered in Peking and the publicity surrounding it, was terrifying, and Wu Ying portrayed himself as reluctant to shoulder the responsibility. Only after the leadership begged him did he assent, he wrote. His reluctance was understandable, given the journey's perils. On its journey south to Nanjing and then east to Shanghai, the train and its cargo would have to traverse stretches of country where the rule of law was fragile. China's hinterland away from the cities could feel to an urban intellectual like a desolate, unpredictable country, a place of unintelligible dialects, venal local officials, poverty, lice, filthy food, and marauding bandits who preyed on the populace. A tree trunk across the line at night, armed thugs emerging from the fields, the cases broken open and thousands of pieces of art carried off—these things were utterly imaginable, and, as Wu Ying read the politics of the situation, those aboard the train would surely shoulder all the blame.

Wu Ying's lack of illusion about the dangers of the journey and his prickly personality probably served him well. He handpicked members of the museum security staff and insisted

they go with him. They were supplemented by a hundred armed police to act as lookouts and guards. Every carriage had a machine gun mounted on its roof and carried police "with weapons loaded." Wu Ying installed himself and other museum staff in first class. He put the commanders of the police contingents in second and third.

Among the treasures in that first shipment under Wu Ying's baleful eye was an edition of the Siku Quanshu, the Complete Library of the Four Branches. This was a colossal collection of texts assembled in the eighteenth century by the emperor Qianlong. The emperor and his editors sourced books from all over the empire. Fifteen thousand calligraphers then worked for years with brush and ink copying them for inclusion in the Library, more than 3,000 works in 79,000 volumes, some in multiple editions, along with catalogs and the commentaries of eminent scholars.[9] There were dynastic histories; biographies of emperors, empresses, and statesmen; tracts of philosophy, ethics, and cosmology; works of the great poets, of science and medicine and literature. The texts of each of the Four Branches of scholarship were covered with jackets of a designated color: green for the classics, red for histories, blue for philosophy, and gray for literature.

The Siku Quanshu was a dazzling assemblage of knowledge, a map of the intellectual universe that Qianlong and his court inhabited at a moment when the Qing's imperial grandeur was at its height. Only seven copies were ever produced. Of the seven, two burned during the ruinous fighting of the Taiping Rebellion in the 1850s. British and French troops destroyed a third in 1860 when, in that act of astounding vandalism, they looted and set fire to the Summer Palace outside Peking. In 1933 only four copies of the library remained in existence. In the freight cars of Wu Ying's train was the Palace Museum's copy: nearly 80,000 volumes on fragile paper a

century and a half old, wrapped in oilcloth inside their packing cases.

The train left Peking behind and rattled south across the dry, gray plain, frigid at that time of year, the winds blowing in from Siberia and central Asia, whipping up dust or bringing bouts of cold rain. The chosen route was circuitous, taking the artworks away from the coast for fear of the Japanese troops operating around Tianjin. As night descended, Wu Ying ordered that all lights be extinguished, and the train moved on in darkness, "as if on military operations." The first leg of the journey, to Nanjing, was to take four days. Wherever the train stopped to take on coal or water, the local authorities had posted sentries, and officials would come aboard to check on their progress. In some places Wu Ying glimpsed escorting mounted troops, the horses cantering beside the tracks as the train pulled away into the night. Everybody slept in their clothes.

The miles slipped by. Wu Ying sat imperiously in first class, issuing orders. "Whenever we came into stretches of desolate, isolated country, the officers in charge of security reported to me nonstop, demanding instructions. I handled all of it." But as the train approached the city of Xuzhou, a gritty rail hub nearly 400 miles south of Peking, anxiety levels among those aboard rose rapidly. Xuzhou and the area around it were notorious for banditry.

The bandits of Xuzhou were the product of local poverty, recruited among disaffected soldiery and destitute peasants, and fed off the region's communications arteries. Some were infamous. In 1923 a bandit named Sun Meiyao ambushed the Blue Express, a luxury rail service that ran between Nanjing and Peking. Hundreds of Sun Meiyao's men stripped the train, right down to mattresses and light fixtures.[10] They shot a British man for refusing to hand over his valuables and abducted

for ransom 300 Chinese and 25 foreigners, among them Lucy Aldrich, the sister-in-law of the American oil baron John D. Rockefeller. Journalists documented the bandits' brutality. The hostages, in their nightclothes, were taken from the train at gunpoint and forced to march barefoot for miles. Women were "shoved ahead as they fell behind, beaten when they could travel no faster, and spat upon as they fell alongside the trail, worn out."[11] The bandits released Miss Aldrich and the rest of the women within a few days, but held the men for a miserable, frightening month before concluding ransom negotiations. The sacking of the train became known as the Lincheng Outrage, and it captured headlines the world over as evidence of China's barbarousness.

Now, as Wu Ying and his cargo approached Xuzhou, to his horror he received reports from local officials that bandits were currently active in the area. The reports suggested that a sizable force of perhaps a thousand had assembled on the outskirts of the city and was preparing to attack the train. "It is not often," wrote Wu Ying, "that two thousand and more years' worth of extraordinary treasures emerge from the imperial palace into the world of men. The collection obviously presented an opportunity worth acting on." While the threat of robbery on the railways was very real, in this case Wu Ying's sense of the drama of the moment may have gotten the better of him. Later reports revealed that local troops discovered the bandits, confronted them, and forced them to withdraw. The train continued safely through Xuzhou and on, its guards peering out into the endless landscape. "But it was only when we pulled into Nanjing that everybody heaved a sigh of relief," Wu Ying wrote.[12]

Wu Ying's relief lasted until the train came to a halt at Nanjing's Hsiakwan station. On the station platform stood two officials, clearly agitated, awaiting his arrival. Wu Ying

got off the train, and one of the two ran over and shook his hand. There was clearly a problem.

"We sent you a telegram," stammered the official, "telling you to stop and wait at Xuzhou, but it arrived too late."

"Why?" replied Wu Ying, incredulous. "At Xuzhou bandits were lying in wait to attack us!"

The official explained that the central government in Nanjing had decided, in an abrupt and confusing change of plan, that the shipment should not proceed to Shanghai after all. To store the imperial collections at facilities located in the foreign concessions was, according to arguments presented at the highest levels of government, a "national humiliation." The government had now decreed that the collections should remain under Chinese control and ordered the shipment rerouted west to the cities of Luoyang and Xi'an, deep in China's interior. "I didn't change my expression," wrote Wu Ying. He asked if storage facilities had been prepared in Luoyang and Xi'an. The official replied that the government had sent telegrams "inquiring." Wu Ying's righteous rage was boiling just beneath the surface. Two thousand cases of art—including an ancient library of great fragility—now sat in a Nanjing railway station with no fixed destination, responsibility for its safety resting solely on his shoulders.

He ordered the guards to stay at their posts and took off by car to the offices of the central government. He learned that neither Luoyang nor Xi'an had replied as to whether suitable storage facilities were available. The cases had to stay on the train. Furious, Wu Ying made his way to the Department of Military Affairs and demanded troops to secure the station and protect the train. To his relief, the military assented immediately and ordered 500 soldiers to the station, on condition that the Palace Museum pay the costs of feeding them. Wu Ying agreed, even at the substantial sum of 500 yuan a day.

He hurried back to the station with the soldiers' commanders, introduced them to the museum staff, and left them to work out a plan for the train's security. "Only then," he wrote, "was I overcome by hunger." He went to the Centre Hotel, ate a hurried meal, had a bath, and collapsed in his room. "I was so exhausted I couldn't cope."

Sleep proved elusive. Wu Ying woke at midnight and lay restless in his room, fretting over the absurd change of plan and worrying about the train standing out there in the open. What would happen if it rained? How watertight were the freight cars? How well-wrapped were those fragile, priceless volumes of the Siku Quanshu? Could they withstand a real Nanjing downpour? In his memoir, Wu Ying sounds a note of self-pity. "All the responsibility was mine," he wrote. "If anything were to go wrong, I might as well chop off my own head." At daybreak, anxious, he got out of bed and went to the window to check on the weather. "And yes, of course, there was a fine, hazy drizzle."

He waited until eight, then went to the residence of one of the officials who had told him of the orders for the train's rerouting to remonstrate with him. But the "dull-witted" man had no answers and exuded "pompous self-righteousness." Wu Ying stormed out of the meeting and hurried back to the Department of Military Affairs, where he demanded oilcloth in large quantities. Once again, the military delivered, and Wu Ying went to the station to oversee the covering of all the freight cars with sheets of the waterproof fabric. He made inquiries about a facility in Nanjing where the cases could be stored temporarily, out of the rain and damp and under guard. A hospital, newly built but not yet functioning, might have worked, but he could not get permission. A new sports stadium had some empty dormitory buildings attached, but bureaucrats also vetoed this.

Desperate, Wu Ying got an appointment to see the president of the republic, Lin Sen, who, to his utter fury, chided him for bringing such precious cargo out of Peking without a firm plan for its storage. Wu Ying spluttered that the central government had upended carefully made plans for exactly this. "I spoke excitedly . . . I was very unhappy." The president grudgingly suggested that the cases could be stored in some empty buildings on Purple Mountain behind the imposing Mausoleum of Sun Yat-sen, the Republic of China's revered founding father. The following day Wu Ying struggled up 300 steps to inspect the buildings, only to find them damp and unsuitable. Access was difficult, and what if it rained? "I was in a hopeless position," he wrote. He stood in the mud, looking out over Nanjing. "This was my punishment," he thought, "for being disrespectful to the president."

For two full weeks, the train and its freight cars, swathed in oilcloth, remained in the station, with the museum paying 500 yuan a day to feed the soldiers guarding them. Wu Ying was at his wits' end. It took an intervention by the republic's urbane and powerful finance minister, T. V. Soong, to resolve the situation. Soong decreed that the shipment would go to Shanghai, as originally planned, regardless of whether it was a "national humiliation" to store the cases in the foreign concessions. Chartering a Yangzi River steamer, the *Kiangching*, from the China Merchants Steam Navigation Company, he assigned personnel to help Wu Ying arrange porterage and loading. The cases would go by river to Shanghai. Wu Ying was "elated," not only that his cases of art and the Siku Quanshu would soon be on their way, but at the "vanquishing" of the officials who had made his life so difficult. Nothing seems to have pleased Wu Ying more than a nasty bureaucratic battle and a solid win.

His pleasure was diluted when he set eyes on the *Kiangching*.

The ship, Wu Ying felt, was distinctly shabby. "Although this 'old man of the sea' wasn't entirely satisfactory, there was nothing to be done," he wrote resignedly. It took three days to transfer the cases from the train to the dock and load them aboard. Then, as the steamer was preparing to sail, Wu Ying discovered to his profound irritation that although the *Kiangching* had been chartered for the sole use of the Palace Museum, someone had made a fast buck by selling steerage-class tickets, and the lower decks were suddenly full of passengers and their luggage. Uncharacteristically, Wu Ying realized that trying to kick them off would create an uproar and delay the ship's departure. The passengers would have to come along with them.

The steamer cast off and made its way into the channel. The vast Yangzi River, the central artery of China dividing its south from its north, a mile wide at Nanjing, teemed with traffic and crackled with tension; everybody knew that all-out war with Japan was coming and, when it did, the river would become a battlefield. The *Kiangching* turned east toward Shanghai under the restless gaze of British and American gunboats, and headed downriver. Wu Ying patrolled his ship. The unwanted passengers initially gave him only moderate cause for concern, but as darkness came on, he was incensed to discover that down in steerage they were playing *majiang* by candlelight. Terrified of a shipboard fire engulfing the wooden cases and the tinder-like pages of the Siku Quanshu, Wu Ying insisted the candles be put out. "We got it under control, but there was no way to keep watch there all the time. I was so anxious I barely slept," he recalled. The *Kiangching* forged eastward along the great river. "That ancient ship took three days to get to Shanghai," he groused.

On March 5, 1933, a month after they left Peking, the cases arrived in Shanghai and, for once, things seemed to go

smoothly. Four trucks from a local transportation company and thirty porters were on hand. So was an escort composed of French police and Chinese troops from the Shanghai-Woosung garrison. The cases were to be stored in the French Concession, on the rue Montauban in a seven-story disused hospital that the Palace Museum had rented. A barbed-wire fence had been erected around it, and electricians were busy installing an alarm system. Wu Ying finally began to feel he had managed to do what had been asked of him, and his terror of failure and the blame that would accompany it began to dissipate.

The Palace Museum dispatched four more shipments to Shanghai, and Wu Ying would claim credit for demonstrating how the process could be successfully managed. Yet his experience is an early illustration of a larger truth: the wartime journey of the imperial collections was not smooth, or easy, or even comprehensible at the time to those who had a role in it. Later tellings in Chinese tend to frame the story as charmingly heroic, but in truth it was often a tale of confusion and bureaucratic rivalries, of shaky improvisation and clouded judgment. Fear was widespread—of blame, of failure, of a violent death. In other words, it is a very human story, and one lived out under the exigencies of war. Those are the very qualities that make it remarkable.

5

SHANGHAI

Through the month of February 1933, as Wu Ying supervised the first shipment on its way to Shanghai, the curators back in Peking worked flat out to prepare a second consignment, their sense of urgency deepening with each passing day. The violence at Shanhaiguan, it turned out, was only a precursor. Japanese forces were on the move once again, driving farther into Chinese territory.

On February 23, large formations of Japanese assault troops and tanks left their Manchurian positions and headed west, advancing into Rehe province. Rehe was a poor backwater just to the north of the Great Wall, "full of tumbling mountains, violent rivers, and trouble," as one correspondent described it. But Rehe lay between Manchuria and the Chinese heartland, and was thus in the way of Japan's ambition. The province was controlled by a warlord called Tang, nicknamed "the Flayer" for his ability to strip the people of their wealth as if stripping them of their skin. The Flayer was a bandit with only a veneer of military training. He ran opium and heroin rings, plundered graves and palaces of valuable artifacts, and commanded between 30,000 and 50,000 troops notionally in

the service of the republic.[1] On such men did the defense of north China now depend.

The Japanese moved fast into Rehe, their ground forces advancing over rocky, snow-blanketed terrain, their fighter aircraft roaming, attacking at will. The province fell with little resistance from the Flayer or his men, or from reinforcements when they arrived. As the Japanese Type 89 tanks closed in on the provincial capital, Chengde, the Flayer loaded trucks with opium and valuables and headed south to safety past his despondent, freezing troops. The fall of Rehe was "a disgrace and a humiliation," wrote one furious commentator, and had "dampened the spirits and enthusiasm of the Chinese people, who have hitherto pinned a great hope on the defenders to resist as much as possible."[2] The frontier of Japan's empire now lay only hours by road from Peking, where the sense of looming crisis was palpable. Doctors were "working feverishly" to prepare the city's hospitals for an influx of wounded. The military commandeered foodstuffs, coal, vehicles, and laborers.[3] "The whole north is a powder magazine which is waiting for a spark to fire it," pronounced T. V. Soong after a brief ministerial visit.[4]

Ma Heng and his curators labored through the late-winter weeks packing cases for future shipments as Japanese aircraft flew over Peking almost daily. Rumors rolled through the streets. Might the city—and the palace—be bombed? Might Japanese troops come as occupiers in the name of Pu Yi, Japan's puppet emperor in Manchuria?[5]

The endless packing took its toll on the toiling curators. The decisions were endless. How much cotton wadding, how much rice straw was enough to render a piece immobile? What sort of movement might a piece be subjected to? How much could it take? What sort of variations in temperature and humidity would it encounter? The uncertainty of it all

wore on them. What of their own futures? What were their obligations should all-out war come—to the collections, to their families, to themselves? In the midst of it all, Ma Heng issued an order that to his colleagues appeared to demand the impossible.

Ma Heng's order was directed to the young archaeologist Chuang Yen, who had been among the first to enter the Forbidden City nine years earlier. He was thirty-five now, and married for a little over a year to a gentle, vivacious young woman named Shen Juo-hsia, who wrote poetry, played the bamboo flute, and chided him for spending too much of his tiny salary on books.[6] For almost a decade he had worked with the imperial collections and under Ma Heng at the Palace Museum. He was still a short, slender man. Photographs show him often in a long, dark gown, his hair parted, his posture erect, shoulders thrown back, perhaps to counter the slightness of his physique. In Western clothing he appears dapper, in one picture wearing a sports jacket and an ample bow tie. His expression reads as a little bemused, a little owlish, deeply curious, attentive. Ma Heng trusted him.

Chuang Yen read Ma Heng's order with a sinking heart. "It was," he wrote, "a bolt from the blue."[7] Ma Heng wanted him to proceed to the grounds of what had once been the Imperial Academy, the center of Confucian learning under the Qing and before that the Ming. The academy stood adjacent to the great Confucius Temple in the northeast of the city. There, Ma Heng wanted him to take possession of, and pack for transport, the artifacts known as the Stone Drums of Qin. The Stone Drums are not in fact drums but boulders, chunks of granite standing between two and three feet tall and two feet wide, with "flattened bottoms, convex tops, and sides which range from bulbous to sloping."[8] They are short pillars of rock, their shape faintly reminiscent of traditional Chinese drums, hence the

name. They have, however, no musical function at all. They had stood in their current location, inside the main gate of the Imperial Academy, for 600 years. There are ten of them, and they weigh half a ton each.

Chuang Yen stood in the February chill and stared at them. He had overseen the filling of thousands of cases, but the idea of packing the Stone Drums filled him with "fear and trepidation," he wrote. "I had absolutely no idea how to do it."[9]

The problem, in Chuang Yen's eyes, lay not only with their size and excessive weight, but, oddly, with their fragility, for the value of the Stone Drums lies in the inscriptions that adorn them. On each boulder, carved into the granite, is a poem inscribed in graphs—early versions of Chinese characters. These graph inscriptions are among the oldest known; earlier ancient Chinese inscriptions have been found on bones used in divination. The poems on the Stone Drums describe the pursuits of the nobility during the Bronze Age in all their lavishness. The nobles hunt, driving stags through lush forest and bringing them down with bow and arrow. They ford rivers on horseback, lashing boats together to take their chariots. They observe the natural world closely, its blossoming trees, birds, crashing rain, hares, pheasants, and wild boar. The poems describe a glowing, colorful world of order and abundance, and hint at the social structures and the values of their time. Some of the poems are sensuous in their observations. One describes catching fish in a magnificent river.

In the shallows are small fish
Their swimming is in schools
The white fish shimmer . . . They are tench, they are carp
With what should we wrap them?
Let it be [the branches of] the poplar and willow.[10]

*

The Stone Drums carry China's deepest, most ancient memories. And the graphs in which those memories reside are themselves crucial indicators as to the origins of the written language known as Chinese.

Chuang Yen knew the Drums had been discovered in what is now Shaanxi province early in the Tang empire (618–907 CE), but were much older. Upon examining the graphs, Tang scholars realized immediately that the inscriptions dated from deep antiquity and were of great scholarly and historical importance. They concluded that they were looking at poetry dating from the time known as the Zhou period. The Zhou occupies a monumental position in the imagination of China, and the Stone Drums are among its greatest surviving artifacts. The Zhou was the longest of all of what are often referred to as dynasties, though the word "period" might be more apt, given its length and turbulence. The Zhou commenced in 1045 BCE and lasted for 800 years. It started strong and unified as the Western Zhou, ruled by legendary kings and lords, but grew weaker over the centuries. During what are known as the Spring and Autumn (771–481 BCE) and the Warring States (481–221 BCE) periods, rebellious feudal vassals raised armies, established themselves in independent states, and battled each other for resources and influence. The annals of the time are littered with tales of war, conspiracy, treachery, and bloody revenge.

But amid all the turmoil, the Zhou—particularly in the Warring States period—saw a profuse flowering of culture. Confucius lived and preached his humanist philosophy of ethics and statecraft during the Zhou, as did Mencius. Sunzi wrote his *Art of War*. The great philosophers known as the Legalists, Shang Yang and Han Feizi, produced the strict authoritarian doctrines that shaped the thought of emperors—and of Chairman Mao. The author known as Laozi composed the luminous text of Daoist mysticism, the *Dao De Jing*.

During the Zhou, writing developed from the graphs of the Stone Drums into the characters called Chinese today. As war raged around them, philosophers, thinkers, and statesmen spun dreams of civilization, kingship, and moral order. Rulers undertook vast public works projects. Workers hewed canals and flood defenses from the landscape, requiring the development of complex bureaucracies to manage their labor. Zhou artists and artisans cast bronze into ritual vessels of breathtaking beauty and complexity, their decoration dancing between representation and abstraction. Craftsmen worked the most difficult of all materials, jade, into objects that appear as luminescence lent solid form. The last Zhou king was overthrown in 256 BCE, bringing to an end a fertile age of engineering, metallurgy, design, art, statecraft, and philosophy.

While scholars of ancient Chinese are certain that the Stone Drums' inscriptions were carved during the Zhou, they have struggled to settle on a more precise date. By examining the graphs minutely and comparing their form and usages to other very early texts, some have come to believe the poems were carved into the granite in the fifth century BCE. Others think the inscriptions are later, others earlier. Part of the problem is that centuries of clumsy handling and erosion have meant that many of the graphs are no longer readable. Over a thousand years ago scholars were expressing dismay at the Drums' treatment. In 812 CE the poet Han Yu bemoaned the failure to preserve them better in his "Song on the Stone Drums."

The herd boy strikes fire [on the Drums], and the cows
 rub their horns upon them,
And there is no one to fondle them with caressing
 hands.
The sun burns them, the moon strikes them with its rays,
And they will soon be buried and lost.

For six years have I turned my eyes to the west,
and heaved unavailing sighs.[11]

At some point after this poem was written, one of the Drums went missing. It was found years later, but in the meantime a peasant had hollowed out the top and used it for grinding millet. In 1126 CE marauding Jin horsemen from the far north carried the Drums off. They were rediscovered some time around 1300 CE in Peking, neglected and lying "among mud and sow thistles."[12]

When the Zhou carver laid down his tools two and a half millennia ago, he left an estimated 700 graphs across the ten boulders. By the twelfth century, only 449 were left.[13] And by the time an anxious, harried Chuang Yen stood in the silent, echoing courtyard of the Imperial Academy in early 1933, only 272 legible graphs remained. In his memoir Chuang Yen explained why: "On the Drums are areas of script that, over thousands of years, have been scoured by wind, baked in the sun, lashed by rain, and are much eroded. But the greatest damage has been done by rubbings."

Rubbings were vitally important to *jinshi* scholars. They were the means whereby scholars copied and then transmitted the texts that resided on stone tablets and ancient bronzes. But the method they used to make rubbings of stone inscriptions across the centuries was, for some objects, problematic. First, they moistened a piece of thin paper and laid it on the surface of the stone over the inscription. Next, they laid a piece of felt atop the moistened paper and used a wooden mallet to pound the felt, forcing the moistened paper beneath into the recesses of the carved inscription. They then used a brush with long, soft bristles to work the paper further into every nook and crevice. When the paper dried, they ran an inked pad of silk or cotton gently over it, inking the raised areas, leaving the

recessed areas clean, thus capturing the inscription in exquisite detail, its characters a ghostly white against the dark, inked background. Rubbings of the Drums a thousand years old still exist and can be studied today, but the repeated pounding of the mallets damaged their surface, and the stone began to crack and flake away.

Chuang Yen could see that some graphs lay on fragile stone slivers that had separated from the body of the rock beneath and, elevated and brittle as eggshell, remained only tenuously attached. Any pressure could cause these shards to break off and drop away like flaking skin, taking with them portions of the inscription. How on earth could one even pick the Drums up without damaging them further, let alone wrap them tightly and transport them? Chuang Yen was confounded. If the Drums were damaged in transit, and more of the inscriptions lost, those responsible would be dubbed "cultural criminals." "After a few gloomy days," he wrote, "I thought of a way forward."[14]

Chuang Yen's solution took him to that part of the city that scholars both loved and resented: Liulichang, the home of its voracious antiques dealers. At a renowned antique shop called the Studio of Distinguished Antiquity, he spoke to the proprietor, a man named Huo Baolu, who was in Chuang Yen's mind the foremost collector in Peking. Mr. Huo had overseen the packing of a fantastically important Zhou bronze—an enormous, inscribed, and richly decorated water vessel known as a *jian*—when it left China for a European collection. If anybody would have an idea how to pack the Stone Drums, reasoned Chuang Yen, it would be him.

Mr. Huo did not disappoint. After some reflection, he instructed Chuang Yen in an arcane method that would, he assured the young curator, guarantee the physical integrity of the Stone Drums. Chuang Yen returned to the Imperial

Academy, assembled his team, and got to work. And it was painstaking, excruciatingly detailed work. Mr. Huo's method required the curators to take the most delicate cotton-based paper and soak it. Then, using tweezers, they inserted scraps of the wet paper very gently under and around those fragile, flaking slivers of rock that threatened to fall away. Once the wet paper dried, it would act as a sort of cement to seal in place the vulnerable areas on the stone surface and preserve what remained of the inscriptions. "The work of filling the cracks and fissures was extremely difficult," Chuang Yen wrote, "and progress was extremely slow. We went graph by graph, drum by drum." It took them a month, as with every passing day the threat from Japan grew.

Once the packers had finished the wet-paper process, Chuang Yen directed that they wrap each Drum in a cocoon of fine cotton cloth at least four or five layers thick. Over that they spread a glutinous paste, and then bound the whole from top to bottom with a fine cord made from hemp. When the paste dried, the wrapping became completely immobile. But the process was still far from finished. The packers now secured another layer of thick cotton wadding with a heavier hemp cord, followed by several layers of quilted cotton and yet another layer of cord. The bundled Drum, now twice its original size, went into a specially made wooden case, with the packers filling any spaces with straw and cotton wadding to ensure it remained immobile. The case was nailed shut, and iron slats screwed to its exterior to strengthen it. They repeated the entire process another nine times, and only then did Chuang Yen consider the job done.[15]

The Stone Drums would not be unpacked for twenty-five years.[16] They were, of all the objects packed for transport, the largest, the heaviest, the most unwieldy. They were also, paradoxically, among the most delicate. Chuang Yen spent years

in an agony of concern for their safety and endured a nagging anxiety that he had not done enough to protect the inscriptions. It would be decades until he knew whether the poems, those fragile signals from the distant past, had survived his curatorial attentions. The Stone Drums left their home of six centuries in a shipment that departed Peking on April 21, 1933, and headed south to join the growing number of cases amassed in Shanghai.

The stacks of carefully labeled cases in the old hospital on rue Montauban in Shanghai grew higher. By the end of the spring of 1933, five shipments had made the journey from Peking, totaling nearly 20,000 cases of objects and books. As the piles grew, politics engulfed the Palace Museum leadership; the museum's director, Yi P'ei-chi, was dogged by accusations that he had overseen theft and malpractice during his term in office. So fierce were his detractors that his position became untenable, and in July 1933 he stepped down. In August prosecutors announced that proceedings against Yi P'ei-chi charging him with selling off objects from the Forbidden City without authorization would go ahead.[17]

The Yi P'ei-chi case became a sensational and long-running scandal, and was a terrifying illustration of the dangers and vicissitudes that could await those who ventured into public life. Ma Heng seems to have studiously guarded his own position and sought to avoid involvement, but Yi P'ei-chi's disgrace was a turning point for him, with the board of directors asking him to step into the role of acting director of the Palace Museum. By many accounts, Ma Heng was reluctant to take on the role; perhaps he viewed the position as politically dangerous, perhaps he simply hated the idea of moving from a curatorial role into management. But under political pressure, he relented and accepted the job. By September 1933, the handover was underway.

Ma Heng took over a museum in disarray. The heart of the imperial collections sat in temporary storage in Shanghai, their future uncertain, suspicions of theft and impropriety swirling around them. All-out war with Japan was a real and frightening possibility. However, Ma Heng seems to have moved quickly and intelligently to bolster his position and to guard against the sort of accusations that had brought down his predecessor. To run the Shanghai storage facility, he brought in a colleague from Peking University, a rigorous, exacting character named Ouyang Daoda. A slender man with sharp, unsmiling eyes, Ouyang Daoda came from Anhui province in central China. He had studied at the university and stayed on as a teacher and researcher, working alongside Ma Heng on the inventory in the Forbidden City in 1924.

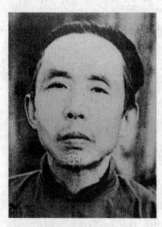

Ouyang Daoda
(1893–1976)

Ouyang Daoda was tough and disciplined. His attention to detail would guide and strengthen Ma Heng's management of the museum. Ouyang Daoda would write the definitive account of the imperial collections in wartime, and what his writing lacks in warmth it makes up for in substance. In Shanghai, in early 1934, Ma Heng ordered Ouyang Daoda to begin all over again the process of inventory and inspection of every case that sat in the repository. Curators opened the thousands of cases in front of officials of the government and courts, checked and rechecked the contents, and drew up a new inventory. Ma Heng was clearly seeking to preempt accusations of theft or mismanagement. Ouyang Daoda brought rigor and credibility to Ma

Heng's leadership, and Ma Heng's faith in him would be repaid many times over.

Ma Heng also suggested that a new set of identifying characters be stamped on the front of each case to aid quick recognition of their contents. Cases from the Palace Museum's Antiquities Department would be labeled with the character *hu* 沪; those from the Library Department with *shang* 上; the Archives Department would use *yu* 寓; and the remaining cases from the museum secretariat would use *gong* 公. Placed together the four characters *hu shang yu gong* translate to something like "the exiled gentlemen of Shanghai." It is an elegant, lyrical little play on words that suggests the objects themselves are worthy characters, cruelly banished from their home. The last two characters, *yu gong*—"gentlemen in exile"—perhaps mirror Ma Heng's feeling of exile from the life of quiet scholarship that he loved.

Ma Heng was confirmed as the director of the Palace Museum in early 1934. If he needed any reminder of the perils his new position held, the fate of his predecessor as director, Yi P'ei-chi, served as a potent example. His arrest ordered, disgraced and terrified for his future, Yi P'ei-chi fled to the foreign concessions in Shanghai, where he lived in failing health, poverty, and isolation until his early death in 1937. But the accusations of theft and mismanagement against Yi P'ei-chi did not die with him; they, and the circumstances in which he was forced out of the museum, would return decades later to haunt Ma Heng.

6

TO LONDON

Even as Ma Heng and the Palace Museum curators sought a permanent safe refuge for the Forbidden City's treasures from a war they feared would soon be upon them, their government assigned them a task of daunting risk and complexity: to contribute some of the most valuable, most extraordinary pieces in their care to an exhibition on the other side of the world. In Britain, planning was underway for the largest exhibition of Chinese art ever mounted to be held in sixteen galleries at London's Burlington House, home of the Royal Academy of Arts.

The International Exhibition of Chinese Art was the dream of a group of London-based collectors, wealthy men whose taste and acquisitiveness had led to their amassing important collections of art from China. Chief among the collectors was Sir Percival David, a prodigiously rich scion of the Sassoon family, whose fortune derived from banking, textiles, and the opium trade in Asia. David had been born in Bombay and fell in love with the art of China while a student at Cambridge University. He was a wily, rigorous collector; he once obtained fifty superb pieces of imperial porcelain from a bank in Peking, where they had been deposited many years earlier as collateral

against loans to the Qing court. Long after the demise of the Qing, the porcelain still sat in the bank's vault, with no hope of the loans it guaranteed ever being repaid. The bank in question may have been linked to, or perhaps even owned by, the larger Sassoon family empire. When David became aware of the porcelain's existence in 1927, he pounced. The pieces left the vault in Peking for his personal collection in London, one of the world's finest, which lives today in the British Museum.[1] David matched his acquisitiveness with the taste of a connoisseur and a serious desire to elevate the world's understanding of China's civilization.

David and his colleagues envisaged their exhibition as being on a grand scale, a national event. The public would line up around the block, the way they did for the Exhibition of Italian Art in 1930. They approached China's republican government via its embassy in London. Might the Palace Museum contribute pieces from the imperial collections for exhibition? Pieces that had never been seen outside China?

In Nanjing, Chiang Kai-shek's government sensed an opportunity. A blockbuster exhibition of China's greatest cultural treasures might serve to raise the republic's international profile, perhaps even elicit sympathy for its plight at the hands of an increasingly militant Japan. Might it not persuade the world that China's civilization was not the cheapened, degraded husk of the West's and Japan's imagination, but one of great value, one worth protecting? Orders were issued for the Palace Museum to cooperate. "Our sole aim," wrote the committee tasked with organizing China's contribution to the exhibition, ". . . is to make the West appreciate the beauty of Chinese art."[2] However, the actual aim of China's participation was to influence the way Western publics perceived China and to cajole their governments into affording the Chinese republic greater status in international affairs. The imperial

collections were to become tools of statecraft, silent ambassadors for the young, brittle republic.

In early 1935 David and other organizers, including the collector George Eumorfopoulos and Oscar Raphael, a great expert on jades, traveled to Shanghai. There, under Director Ma Heng's supervision, curators extracted objects from their cases in the rue Montauban storehouse for consideration. The negotiations over what pieces would be exhibited were tricky. The Palace Museum insisted that no unique, utterly irreplaceable piece could go. An ancient bronze platter known as the San Shi Pan, which bears a unique inscription, for example, was deemed out of bounds. The British were unhappy, but the Chinese view prevailed.[3]

By April the negotiations were over: 1,022 pieces would leave China for exhibition in London. Of those, 735 came from the Palace Museum, including 60 bronzes, 352 pieces of porcelain, and 160 paintings and pieces of calligraphy. The remainder came from other Chinese museums and a private collector.

As news of the plan spread, it was greeted with a chorus of complaints. Suspicion of the British and their acquisitive impulses ran deep in China; it was, after all, only three and a half decades since British troops had murdered and pillaged in Peking in the wake of the Boxer uprising. A group of professors at Peking's prestigious Tsinghua University issued a long declaration opposing the decision to send the objects abroad. They worried that the objects were uninsured and that the exhibition's British organizers included rapacious collectors who, once they had their hands on the treasures, could not be trusted to return them to China. "Once an object of art is acquired by the British Museum," they warned, "it will never be allowed to leave its portals, whatever may be its value."[4] Chuang Yen heard rumors that the objects destined

for the exhibition had been secretly sold to foreign collectors and would never return.[5] Ma Heng needed to calm such fears. His plan: the curators would photograph and catalog every piece before packing; before departure, an exhibition in Shanghai's Bank of China building would allow the public to see exactly what was going abroad; Palace Museum curators would accompany the objects for the entirety of their voyage and exhibition; on return to China, another public exhibition would demonstrate the artifacts' safe return. Ma Heng's position was extraordinarily difficult. He had the enormous responsibility of administering the transport and storage of the collections while facing constant suspicion and mistrust, his professionalism and probity publicly questioned again and again.

Despite the public misgivings, preparations for the exhibition got underway in early 1935. The cases for the London voyage were specially constructed of steel slats and were lined with wood and silk. They were black and resembled steamer trunks, the words HANDLE WITH CARE stenciled prominently in English on their sides. To oversee their packing, Ma Heng once again chose the trustworthy, competent Chuang Yen. Inside the cases, each object occupied its own custom-made box, the interior of firm, quilted cotton "for springiness and elasticity," its exterior covered in colorful satins "to give a look of elegance," wrote Chuang Yen later.[6] Scrolls of painting and calligraphy went in thick sacks of blue cotton cloth. Once packed, the pieces were utterly immobile. There were ninety-three cases in total.

The British, by agreement, would be responsible for transporting the objects from Shanghai to London. Sir Percival David persuaded the British Foreign Office to request a warship for the purpose, and the Royal Navy assigned a cruiser, HMS *Suffolk*, for the task. *Suffolk* was a magnificent ship, a

county class heavy cruiser of nearly 10,000 tons. She had a crew of 700 and could make thirty-one knots. Her speed and her eight-inch guns rendered her a formidable vessel. In 1935 she was the flagship of the China Station, the name commonly given to the Royal Navy's fleet in East Asian waters, and as such she was painted white, her funnels tan. HMS *Suffolk* was a sleek, muscled embodiment of British imperial power.

Chuang Yen, having packed the cases, was also included in the small band of curators assigned to accompany them to London, as was Na Chih-liang. In the early summer of 1935 they prepared themselves for a long sea voyage, a sojourn in a cold, unfamiliar city, and the burdens of safeguarding the art and representing their country. In Chuang Yen's written account of the trip, he seems calm and makes no mention of his own worries or excitement. One can sense in the preparations for the London exhibition the growing discipline of the Palace Museum curators. Between April and June 1935 they prepared, photographed, cataloged, exhibited, and packed more than a thousand objects with remarkable speed and efficiency under close scrutiny. Ma Heng's leadership, his meticulousness, must have been instrumental in their ability to pull it off.

On June 6, 1935, in the heat of the early Shanghai summer, workers from G. E. Marden & Co., Ltd, under the supervision of a Mr. W. J. Hawkings, general manager, moved the ninety-three steel cases out of the vaults of the Bank of China building at the corner of the Bund and Jinkee Road. Mr. Hawkings's men loaded the cases aboard vans that wound through streets lined with police to the China Merchants dock, where HMS *Suffolk* lay alongside. British sailors lifted the cases by crane and, one at a time, lowered them carefully into one of the ship's magazines—the holds used for storing ammunition—that had

been specially cleared for the purpose. In the magazine, sailors clamped the cases together with sacking and wooden planks, and secured them with stout ropes to prevent them from sliding around with the movement of the ship.[7]

Chuang Yen, now in his mid-thirties, said goodbye to his wife, Shen Juo-hsia, and made his way up the gangway onto the cruiser. The China he was leaving behind was in something close to perpetual turmoil. That summer saw devastating floods along the middle reaches of the Yangzi River; one hundred thousand people drowned, fourteen million were affected. The Communist Party and its armies, driven from their sanctuary in east China by Chiang Kai-shek and his republican troops, marched for their lives into the country's far west in search of a defendable base area in a feat of endurance known as the Long March. The young librarian who had worked beside Ma Heng at Peking University, Mao Zedong, was now ascending the ranks of the Communist Party leadership, and his vision would shape its future. And on the day HMS *Suffolk* sailed from Shanghai, a local newspaper ran the headline TOKYO THREATENS RENEWED ACTION IN N. CHINA: INSTRUCTIONS SENT ARMY. Month after month, the Japanese military spewed out accusations and threats calculated to intimidate and undermine the Chinese republic. In occupied Manchuria and beyond, the Japanese military postured and threatened. Vicious small-scale clashes between Japanese and Chinese troops were commonplace. The threat of all-out war was ever present. Life in China in the summer of 1935 was fraught with unpredictability, division, and fear.

On Friday, June 7, at seven in the morning, HMS *Suffolk*'s commander, Captain Errol Manners, ordered her to cast off. The cruiser turned into the channel that led to the mouth of the Yangzi and then out into the East China Sea. The journey to London would take forty-eight days.

British sailors load cases aboard HMS *Suffolk*
for the voyage to London, 1935

Life aboard a vessel of the Royal Navy was deeply strange to the observant Chuang Yen. The day began for the officers of the ship, he noted, with "early tea" at 6 a.m., a cup of tea with milk brought by an orderly and taken in bed. After rising and bathing, the officers retired to the wardroom to smoke and look at the newspapers. They greeted each other with a single word: "Morning." Breakfast was between 8 and 9 a.m., followed by the day's duties. After lunch, Chuang Yen wrote, "If the senior officers had nothing to attend to many of them would relax on deck, or sunbathe, and at this moment the entire ship was still and silent. There was no sound other than that of the sea and the wind and the churning of the engines." At 3 p.m. the ship began to stir, and groups of men would come up on deck for recreation, including games of cricket. "I felt at these times like a tiger in a cage. These were moments of exquisite boredom."

But it was evening in the wardroom that most fascinated and perplexed Chuang Yen. At 7 p.m. the officers would gather, and the customs relating to alcohol consumption seem to have left him faintly disappointed. "The drinks were poured very sparingly," he wrote, "and everyone knew when to stop." The officers would sip their drinks while chatting or reading, and there was no food to accompany them. At 8 p.m. the officers went in to dinner, and "sat silent and stock still, until they heard the sound of a little wooden gavel rapping on the tabletop. Then the padre thanked God, and everybody could start to eat." During dinner all conversation had to be "very prudent." "There was an especial dread of mentioning the word 'woman.' If one had to refer to a woman, one said 'a person, not a man' or some other euphemism." Only after the officers had passed the port bottle around the table three times and toasted the king could the word "woman" be used. Any breach of this rule was taken very seriously. After dinner the officers would play chess, but Chuang Yen and the other curators played furious games of *majiang*. He does not relate how the officers responded to the clack and clatter of the *majiang* tiles in the stuffy wardroom, though he does note, a little mournfully, that "there was no gambling."

As the *Suffolk* sailed south, the mercury rose. Sometimes dinner was taken on deck, the ship's band playing in the background. Every day the curators and a ship's officer inspected the cases in the magazine. The days passed mostly without event, although shortly after leaving the Malacca Strait, off the coast of Malaya, *Suffolk* took part in a naval exercise. Aircraft circled overhead, and the cruiser maneuvered, cutting tight turns through the water. *Suffolk* fired her guns, the shells sending great spouts of seawater skyward. Chuang Yen wrote that "the weather was hazy, and the atmosphere was dreary and desolate. As I stood stiffly on deck, I had an awe-inspiring sense of what a fierce naval battle must be like."

When they docked at Colombo in Ceylon, Chuang Yen went ashore in the company of Lieutenant Commander R. G. Howard, "a man of refinement and education" with whom he had struck up a friendship. Howard had a passion for gemstones and Chinese jade. The two of them went looking for "treasures" in the city markets, and Chuang Yen remembered Howard "treating me with great solicitousness. I have never forgotten it." He was deeply grateful for Howard's kindness. For Chuang Yen the voyage seems to have been a strange interlude, at once alienating and fascinating, at times mind-bendingly dull, often lonely. "The sea and sky were boundless, and I felt small and insignificant," he wrote.[8] Howard's friendship and the endless games of *majiang* appear to have helped him maintain his equilibrium.

As *Suffolk* passed Gibraltar, Chuang Yen noted that the officers exchanged their white hot-weather uniforms for dark blue ones befitting the cooler climate. The cruiser steamed through the western approaches into the English Channel and docked at Portsmouth on July 25, 1935. "Not since Drake's tiny rover, the *Golden Hind*, has any ship come home to England with a richer cargo than that brought safely to berth at Portsmouth by the *Suffolk*," gushed one newspaper.[9] That afternoon, sailors lifted the cases from the magazine under a guard of Royal Marines armed with rifles, bayonets fixed, and loaded the cases aboard four commercial moving vans hired for the purpose: "up-to-date pantechnicons," a British newspaper reported, "their gleaming sides adorned with gay pictures of a house, a ship, a girl at a telephone." At 5 p.m. the garishly decorated vans rolled off the wharf and began the seventy-five-mile journey to London with a police escort. As the convoy moved "very slowly" toward the capital, Chuang Yen had his first glimpse of England, in the summer twilight, as the convoy nosed its way through the lanes of Hampshire and Surrey.

At nearly 11 p.m. they arrived at Burlington House in Piccadilly. A crowd had gathered to watch in the darkness. The gates swung open, and the vans pulled into the courtyard. There was some mirth surrounding the arrival of such sublime art in mundane moving vans. One reporter watched the vans' arrival and noted that "on the face of the van, whose depths contained an untold wealth of beauty, one read, 'The removers of repute. May we quote you?' " All night the vans remained in the courtyard under the guard of four armed policemen—"all crack shots." Chuang Yen finally consented to leave the cases for something to eat. He and the other curators were taken to "lodgings arranged by the Chinese Embassy," though he is silent as to what, or where, these were. The following day the porters moved the cases to the Royal Academy's vaults.[10]

In early September, Chuang Yen and the Chinese curators busied themselves unpacking the cases. More objects arrived at Burlington House from museums and private collections across Europe and the United States. The galleries buzzed with activity, and public anticipation grew. Chuang Yen was by turns impressed and disappointed by his British hosts. He felt their understanding of China's art was "shallow" and that some of the pieces selected for exhibition were "of little consequence." But he admired deeply their professionalism and energy, noting their long hours and rigorous organization. "Their effortlessly persistent spirit is truly admirable; if something cannot be achieved today, then there's always hope for tomorrow." Yet he also detected an underlying danger posed by all these charismatic, efficient London collectors, perceiving perhaps a hint of ruthlessness in them. If China was not careful, he worried, "and if we do not limit the export of our artifacts, in a few decades we will have to travel all the way across the oceans just to see our own heritage." He was perturbed too

when the British, without consulting him or the other Chinese curators, made changes to the English versions of the objects' identifying labels and the catalog.[11] Chuang Yen seems not to have doubted the sincerity of Sir Percival David and the British organizers, but watching collectors from a colonizing nation disregard the Chinese curators' views to impose their own descriptions and definitions upon Chinese objects clearly alerted him to the deeper questions of power and identity in play.

Among the objects that Chuang Yen took from the steel trunks on one of those September London days in 1935 was a painting swathed in a thick cotton sleeve, a gorgeous hanging scroll entitled *Herd of Deer in an Autumn Forest*. Like *Early Snow on the River*, it dates from that period of the tenth and eleventh centuries CE that saw the lands we call China splintered into multiple competing empires and statelets. The painting is thought to originate in a region known as the Liao empire, a great slab of territory that at its height stretched from the Pacific Ocean to the deserts of central Asia, taking in parts of modern-day north and northeast China, Russia, and Mongolia. The inhabitants of the Liao were a largely nomadic people who called themselves the Khitan and spoke the Khitan language, though many Chinese-speaking people fell under the rule of the Liao as the empire expanded. The Khitan were horsemen, skilled in mobile warfare, aggressive, but few in number. They could not but be influenced by the vast Chinese-speaking civilization to their south.

Herd of Deer in an Autumn Forest appears to be one panel in what was originally a set of several, perhaps mounted on a screen. The anonymous artist takes us deep into a thick forest flaring with autumn reds and russets and lush greens. Amid the rich vegetation a magnificent antlered stag stands tall,

tense and muscular, primed for movement and combat. The artist, through exquisite shading, evokes volume and power in the contours of the animal's shoulders and limbs, sleekness in its coat. The stag is surrounded by elegant does, who wander amid the foliage and lie on the forest floor. Some movement, a footfall, a rustle in the leaves, has caught the does' attention, and in quivering, startled stillness they gaze beyond the image into the trees. Their tension is palpable in their posture, in their eyes and pricked ears. In the curve and swoop of their necks the viewer can discern the artist's meticulous observation of anatomy and movement. The painting is profoundly different from *The Stag Hunt* that the emperor Qianlong viewed in the Room of the Three Rarities. In *Herd of Deer in an Autumn Forest*, the artist makes no statement. The deer are motionless in a moment of sublime naturalism, the scene devoid of human presence or intention. A curious feature of the painting is that swathes of the vegetation lack color and appear white. Art historians surmise that when the painting was on a screen a thick textured pigment covered these areas. When the painting was mounted on a scroll the thick pigment was unable to withstand rolling and unrolling and flaked off.[12]

In the early twentieth century, people outside China had very rarely seen paintings like this. Europeans were familiar with Chinese porcelain and silk, but the majority of Chinese objects they encountered—snuff bottles, carvings in ivory and jade, little Buddhist sculptures, and similar things—tended to be described as "curios." This word conveys a sense that the object is uncommon, collectable, perhaps exotic, more than a trinket, bauble, or bric-a-brac, but rarely if ever rising to the level of art.

Herd of Deer in an Autumn Forest, and the thousand other objects that Chuang Yen lifted delicately from their steel cases, unwrapped, checked against his list, compared against their

photographs, and then carefully set out in the galleries at Burlington House, were to change all that.

The exhibition opened to the public on November 28, 1935, and ran until early March 1936. It was an enormous success. Four hundred twenty thousand people attended over its fourteen-week run. Chuang Yen wrote approvingly of the powerful electric lighting in the galleries, the benches for the visitors to sit, the "circulation of warm air" that kept the galleries toasty and welcoming through the dark, cold days of a London winter, and the café "to facilitate visitors' staying the whole day," although he grumbled about the arrangement of some of the displays. People came from all over Europe; five hundred Germans chartered a ship expressly to view the exhibit and used the vessel as a floating hotel on the Thames for the duration of their stay. All of London society came. The king and queen attended on December 1 and professed great interest in the voyage of the *Suffolk* and how the objects had been packed. The poet T. S. Eliot attended on December 5, mentioning his visit in his letters.[13] Eliot's feelings on the exhibition remain unknown, but at this time he was composing his *Four Quartets*. In the first of the four, "Burnt Norton," he explores a philosophy of art, time, and being. Eliot famously chose the image of a Chinese jar to illustrate his intuition that artistic form extends beyond the work of art, across time.

> Only by the form, the pattern,
> Can words or music reach
> The stillness, as a Chinese jar still
> Moves perpetually in its stillness.

Eliot had probably completed "Burnt Norton" by the time he visited the exhibition, but perhaps, in the porcelains and paintings he encountered there, static in their display cases, he

perceived movement through time that transcended temporality, a movement that, like the jar in "Burnt Norton," revealed to the viewer a larger cosmic scheme. Eliot expressed many times a desire to visit China, though he never did. His vision of China's art reflected a gradual, growing recognition among European and American elites of the importance of Asia's material culture beyond a thirst for the exotic and the curio.

The exhibition's reception in the press was exuberant. "A revelation of form and colour," pronounced the *Times*,[14] reinforcing the sense that paintings like *Herd of Deer in an Autumn Forest*, in all its beauty and complexity, were completely new to the viewing public. The left-leaning *New Statesman* instantly grasped the exhibition's political intent, expressing "shocked amazement" at Western assumptions of cultural superiority over the Chinese "tradition as was here set forth."[15] Visitors bought an enormous number of catalogs—more than 100,000—and these, along with a plethora of articles, commentaries, and appreciations, expanded the exhibition's influence well beyond its attendees. The *New York Times* called it "outstandingly successful" and described visitors gaining "new appreciation of the high accomplishments of Chinese civilization."[16] The objects appeared to be doing their job: provoking a reimagining of China, planting seeds of sympathy and admiration for the Chinese republic.

Chuang Yen, as was his habit, viewed all this hoopla with sharp-eyed skepticism. He wondered if the exhibition had really achieved anything at all. "The London exhibition certainly created a stir," he wrote. "It's not wrong to say that it improved China's diplomatic relations and raised China's international status, but it's all something of an illusion. While I was in London, I watched the British conducting research on the art of ancient India, too, discussing it with great earnestness, sparing no effort. Yet India is in the state it is in. It remains under the

control of the British Empire. I did not hear those scholars, even after they swooned over Indian art, show the slightest appreciation of the Indian people's predicament." China, he wrote, must stand strong and independent, and urgently build a republic on pragmatic, scientific principles. "If we do not, others will come and take our place. Our national culture will perish, and the country will be reduced to circumstances too ghastly to contemplate."

Two days after the London exhibition closed, Chuang Yen and his colleagues began to repack the cases, checking every piece against its photograph and description in an elaborate ritual of curatorship, readying the objects for their return to China. The cases would not make the return voyage aboard a ship of the Royal Navy, but on an ocean liner, the SS *Ranpura*. The *Ranpura* was luxurious and expensive, one of four sister ships of 16,600 tons each built for the P&O Steam Navigation Company to carry passengers, mail, and cargo to India and the Far East.

On April 9, 1936, the *Ranpura* pulled away from the King George V Dock in London, the steel cases secured in her hold. The art was not initially unprotected; the British government had assigned an agile little destroyer named HMS *Scout* to escort her from Tilbury to the open sea. After docking briefly at Southampton, where Chuang Yen caught an excited glimpse of the *Queen Mary*, then the most famous liner in the world, the *Ranpura* headed out into the Atlantic. With the open ocean before her, HMS *Scout* bade the liner goodbye and turned for the English coast. The *Ranpura* was now alone, unescorted.

On the morning of April 12 the weather turned nasty. The *Ranpura* plowed through ominous, gray seas. The passengers were miserable with seasickness, and many were unable to leave their cabins. At noon on Tuesday, April 14, the *Ranpura* arrived

at Gibraltar. Conditions were still so poor the liner did not attempt to dock but lay at anchor out in the Bay of Gibraltar, wallowing in the heaving seas. Those passengers who wanted to disembark boarded a tender with their luggage, in high wind and vicious waves. The tender went pitching away in the gloom and roaring wind toward the shore. Just as it departed, the officers of the *Ranpura* realized to their horror that the liner was moving. So strong was the wind that she was dragging her anchor and drifting slowly but inexorably to the northwest in the direction of Punta Mala—"Bad Place." The SS *Ranpura*, one of the most prestigious ocean liners of the day, was in danger of being driven onto the shore and wrecked. Chuang Yen was beside himself. P&O liners were renowned for their safety and reliability, and the situation was, as the ship's navigator told Chuang Yen, "unforeseen, and most unfortunate."

As the liner drifted in the storm, her captain called for assistance. The port authorities at Gibraltar dispatched three Royal Navy tugs to her aid, but by the time they arrived, the ship had run aground and was stuck fast, just off the coast opposite the village of Mayorga, the waves crashing around her. The news spread across the world in moments, a Reuters news story clattering onto teleprinters in newsrooms everywhere and humming through the shortwave frequencies in the dot-dash of Morse code: "Anxiety in art circles is increasing with regard to the safety of the P. and O. liner *Ranpura*, now on the rocks off Mayorga, the northwest extremity of Gibraltar Bay, with a rough sea running and £10,000,000 of Chinese art treasures aboard."[17] The news must have struck terror into Ma Heng, but the Reuters story was wrong in one important regard: the *Ranpura* was not on rocks. Her keel had lodged in soft sand on the sea bottom, and even though she was aground in appalling weather, she was in no immediate danger of being wrecked.

Throughout the day, in the teeth of the gale, the tugs worked to move the liner. They attached steel hawsers and tried to drag her off the sands, their engines churning the gray water, but again and again the hawsers snapped. At night-fall the *Ranpura* was still aground. The weather moderated a little, and tenders were able to take off more passengers in the darkness. Chuang Yen insisted on staying aboard. The tugs returned to port. "That entire night we went nowhere," Chuang Yen wrote.

The following day, April 15, the tugs reappeared at six in the morning and attempted once again to haul the liner off the sands at high tide, but without success. The weather deteriorated once more, the storm rising and sending powerful south-southwesterly winds howling into the Bay of Gibraltar. Such were the conditions that the tenders could no longer get alongside the *Ranpura*. P&O ordered another of its liners, the SS *Barrabool*, en route to Australia, to divert to Gibraltar and to stand by to take on the *Ranpura*'s passengers and mail. It seemed the *Ranpura* was to be entirely evacuated, but what would that mean for the cases containing the artifacts from the imperial collections? Could they be taken off? How and at what risk of a calamity? Were the steel cases sufficiently water-proof to withstand being moved during a gale at sea? What effect might a blast of salt spray have on the thousand-year-old silk of *Herd of Deer in an Autumn Forest*?

Chuang Yen remained aboard "in a state of extreme anxiety, knowing there was absolutely nothing we could do." P&O issued reassuring statements insisting there was no risk to the cases, but officials at the Chinese embassy in London "who confessed that a great weight was off their minds when the treasures had been finally stored in the *Ranpura*, are now . . . awaiting every telegram from Gibraltar."[18] The risk to those sleepless officials in London, to Chuang Yen and the other

curators aboard the *Ranpura*, and to Ma Heng, was extreme. Should the cases be lost, or the objects damaged, they would all face blame, shame, and ruin. Those who had warned against sending the objects to London, those who had opposed the move from Peking in the first place, would all howl with righteous indignation. Heads would roll. Ma Heng, as director of the Palace Museum, was particularly vulnerable. He would have known that his career, his social position, and his reputation could not survive a disaster on the *Ranpura*. He, like his predecessor, would likely be hounded out of his position in disgrace.

The day wore on in gloom, low cloud, and heaving seas. The *Ranpura*'s captain laid out a kedge anchor to prevent the liner grinding its way even farther into the sands. Officers descended deep into the ship to inspect her for damage and found to their intense relief that she was not taking on water. But what damage there might be to the ship's underside and her keel, no one knew. The captain determined that if the *Ranpura* were to be refloated, she needed to be drastically lighter. He ordered that fuel oil and some cargo be taken off as soon as possible—but not the art. The cases stayed put in the hold. The weather remained dismal, and as darkness came on, it became apparent the liner would spend a second night firmly wedged in the sands.

The next morning, April 16, the weather was a little better. A tanker edged alongside the liner and took off a thousand tons of fuel oil and some of the heavier cargo. Five tugs of the Royal Navy set about her once again with hawsers. Still, the liner remained fast in the sand. In the afternoon the wind rose again, hampering the rescue efforts, and Chuang Yen faced the bleak prospect of a third anxious night on the stranded ship. At nearly ten o'clock in the evening the tugs made one last attempt for the day to haul the *Ranpura* out of the sand, and,

suddenly, in the darkness, she yielded, sliding gracefully off the sandbar and into open water.

The next day divers descended into the dark water, feeling their way along the *Ranpura*'s hull, examining her keel for damage. They found none and pronounced the ship seaworthy. Chuang Yen made no mention of his feelings—the relief he must have felt at the refloating of the liner—only noting briskly that "there was no damage to the hull, and we continued on our way." The return journey to China took another month, the liner escorted by destroyers of the Royal Navy for the rest of the voyage. The ship docked in Shanghai on May 17, 1936.

The day of the *Ranpura*'s arrival was a Sunday, cloudy, with temperatures in the mid-seventies. The harbormasters anticipated a busy day. The German freighter *Fulda* was due in port with a heavy cargo. The *Belpareil* was unloading a huge consignment of rolling stock from France: twenty locomotives and twenty-seven carriages intended for the new Canton–Hankow railway, the carriages stacked like logs on the vessel's deck, to be swung ashore on massive cranes. The *Empress of Asia* was to disembark passengers from Canada and Japan beginning at nine in the morning, and P&O was due to deliver a new gunboat to China's customs service for use in patrolling the great rivers and estuaries of China.[19] Shanghai's engines of commerce and modernity continued to turn, but the newspapers that sultry Sunday were full of fear.

The Japanese military had found pretexts to send yet more troops to its garrisons in north China, and the republican government in Nanjing was furious. One newspaper noted that the city of Peking "is rapidly assuming a Japanese aspect. Increasing numbers of Japanese civilians, women as well as men, are to be seen on the streets, and Japanese soldiers appear to be

everywhere. Japanese beer halls, dance halls, and restaurants are being opened in various sections of the city."[20] A Japanese general announced that five million more citizens would leave their homes in Japan and settle in Manchuria over the coming years. It would be "advisable for entire villages and hamlets to emigrate as a unit," he said.[21] Chuang Yen was returning to a country undergoing gradual, inexorable ingestion by a neighboring hostile power. But as long as Chiang Kai-shek persisted in his relentless focus on suppressing the Chinese Communist Party, Japanese expansionism met little military resistance from the republic.

The *Ranpura* docked in the morning. Many of its passengers lingered aboard, gathering at No. 2 hatch to watch the cases of priceless art being lifted from the hold and to take pictures. Chuang Yen oversaw the transfer of the cases from the liner to moving vans, and the drive to the railway station, where laborers loaded them aboard a train under heavy guard. The train left for Nanjing, where an exhibition was scheduled to open in early June to reassure the public, and Ma Heng's critics, that every piece had returned from London in perfect condition.

Ma Heng never went to London. He had remained in China, preoccupied with the complexities of administering the imperial collections and the Forbidden City. In June 1936, just after the *Ranpura* returned to China, the Forbidden City was burgled. A hall was found open, the paper seal across its doors broken. Seventy pieces—all of them objects destined to remain in Peking—were missing, among them a Song-period handscroll. Suspicion fell immediately on the museum's own staff and guards. A watchman and a porter failed to report for work and were found to have disappeared from their homes. Investigators from the Public Safety Bureau found a single fingerprint on the glass that had protected a missing piece of

jade and ordered all staff to provide their fingerprints. Discovery of the theft, reported the newspapers, "aroused a chorus of outcries against the administration of the Palace Museum."[22] Ma Heng rushed to Peking, spoke to the press, promised an investigation, and declared that those found responsible would be "dealt with drastically."[23]

By early July a number of the stolen pieces had been found for sale in the city's antique shops and returned to the museum. The authorities made ten arrests: the watchman, the porter, and eight antique dealers, though other suspects remained at large. Late August saw yet another theft, this time of a sizable piece of jade, and Ma Heng was once again called to account for it.[24] The reluctant museum director lived on a knife edge, but even as he struggled to persuade a fickle public and vengeful bureaucrats that the imperial collections were safe in his charge, he wrestled with a much larger mission: looking ahead and preparing for the possibility of all-out war.

As early as 1933, the Palace Museum's board of directors had considered the possibility of building a permanent, hardened storage facility for all the objects removed from the Forbidden City and stored in Shanghai. In 1934 the government approved the plan, reckoning the cost at less than that of renting buildings in Shanghai long term.[25] Ma Heng favored a site in the capital, Nanjing, in the grounds of a temple complex named the Chao Tian Palace. The palace was an imposing sweep of halls and gates, built and rebuilt through the Ming and Qing eras, facing the Qinhuai River to its front and rising, in accordance with geomantic principles, toward a low hill behind. There, in the rear of the temple complex, in March 1936, just as the London exhibition was wrapping up, construction began. The main facility was a three-story structure of reinforced concrete, housing spacious storage halls. But behind, hollowed out of the hill, was a secure, hidden vault, its

passages plunging deep underground. These featured the latest air-conditioning technology against Nanjing's heat and humidity, and were designed to be secure against aerial bombing. The entrance was through a huge, circular door of solid steel, resembling that of a bank vault. Here, Ma Heng believed, the objects would be safe from war and protected from plunder.

By December 1936, the Nanjing storehouse was ready, and the 20,000 cases of treasures from Peking—the Stone Drums of Qin in their huge, bulky cases weighing more than half a ton each, *Early Snow on the River* in its thick cotton sleeve, and the monk's cap ewer with the copper-red glaze—were all on the move yet again, in four shipments. At the Shanghai storehouse on the rue Montauban it took laborers eleven hours to load the trucks for each shipment. Crowds watched the trucks leave under police guard for the railway station, where special trains awaited them.[26] After three years, the collections were leaving Shanghai behind and moving inland to Nanjing, where the new storage facility at the Chao Tian Palace and Ma Heng awaited them. By December 20, all four shipments had arrived safely. The cases stood in neat stacks, their labels visible, spaced so that curators could easily pass through and inspect them. But Ma Heng's hopes that the collections were now safe would soon be dashed.

Just as the collections arrived in Nanjing, China was transfixed by events unfolding 600 miles to the west, in the city of Xi'an. On December 12, 1936, Generalissimo Chiang Kai-shek, leader of the republic and the KMT, was abducted. His kidnappers were troops under his own command led by Zhang Xueliang, an officer and former warlord known as the Young Marshal. Zhang Xueliang's scheme was ostensibly intended to force Chiang Kai-shek and the KMT to abandon their military campaigns against the communists and to unite with them for the real battle ahead, against Japan.

For two weeks the Young Marshal's men held Chiang Kai-shek prisoner, until frantic negotiations and pressure from Stalin led to his release. Chiang Kai-shek emerged from captivity to a wave of national acclaim and celebration, and within weeks the KMT and the Chinese Communist Party acknowledged a new "united front" against Japan; they had in fact been secretly negotiating such an alliance for a while.[27] And so 1937 dawned in a reinvigorated atmosphere of patriotism and national unity, but it was to prove a terrible, fateful year for China.

War with Japan was coming, an early harbinger of global conflict. And the journey of the imperial collections had only just begun.

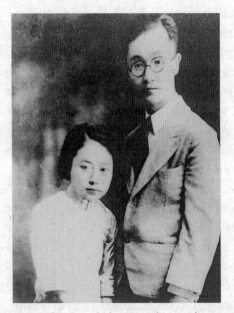

Chuang Yen, who traveled to London with pieces from
the imperial collection, with his wife, Shen Juo-hsia,
in a photograph dating from the early 1930s

7

THE SOUTHERN ROUTE

On the evening of July 7, 1937, a column of Japanese infantry left their barracks in a rural outpost just to the southwest of Peking for night exercises. The troops marched in battle order, carrying rifles, rations and water, and live ammunition. As darkness descended, the temperature barely dropped, and the men sweltered as they marched through fields of wheat and sorghum in the night, the only sounds their own dull footfalls, the muted clank and jangle of their equipment, and the whir and chirp of insects.

The soldiers' commander, Colonel Mutaguchi Renya, was working up his unit's ability to fight in darkness. For months his troops had been practicing moving across the countryside at night. For the local people the exercises were disruptive; the soldiers trampled crops, blundered through irrigation channels, set the dogs barking in sleeping villages. Moreover the troops' very presence on Chinese soil constituted a reminder of China's vulnerability and humiliation in the face of Japanese aggression. Colonel Mutaguchi's troops belonged to the China Garrison Army. Japan had the right to station troops in north China under agreements signed in 1901 after the

Boxer uprising. Supposedly, their role was to protect Japanese interests and to prevent the rise of another anti-foreign popular movement like the Boxers. In 1937 Colonel Mutaguchi's soldiers were among some 7,000 Japanese troops based around Peking and Tianjin, and along the strategically crucial railway that connected the two cities. They conducted maneuvers, swaggered through countryside notionally controlled by the Chinese Twenty-Ninth Army, and ordered local officials around. Flare-ups and skirmishes between the two militaries were common. The atmosphere in the country all around Peking was loaded with tension.

That night, July 7, the Japanese troops marched in the direction of Wanping, a dusty walled town of a few thousand people, and a nearby landmark, the Lugou Bridge, a medieval granite structure spanning the Yongding River, strikingly ornamented with hundreds of lions carved in stone. Nearby, just a little upriver, was a bridge that carried the vital Peking–Hankow line, the only railway line out of Peking not controlled by the Japanese army. It was here, near the bridge and the strategically vital railway, that Colonel Mutaguchi's troops commenced their night maneuvers and set in motion events that would tear China apart.

The exact sequence of events on that night remains unclear, but at some point the sound of rifle fire echoed across the plain outside Wanping. On hearing the firing, a conscientious Japanese officer, Captain Shimizu Setsuro of Eighth Company, First Infantry, ordered his men to fall in for a roll call in the darkness. Captain Shimizu found one of his soldiers unaccounted for. The company began a search for the missing soldier. Failing to find any trace of the man, Shimizu marched his troops to Wanping. He stood before the town's walls and shouted to the Chinese guards to open the city gates and allow his soldiers into the town to search for their missing comrade.

The Chinese officer in charge refused. At four o'clock on the morning of July 8, Captain Shimizu attacked the town, raking it with machine-gun and mortar fire for five hours. The town's defenders—troops of the Twenty-Ninth Army—sustained 200 casualties.[1] In Peking, just ten miles away to the northeast, alarmed officials ordered the city gates closed.

The fighting continued sporadically through July 8 and into the evening, even as Chinese and Japanese officers attempted to negotiate a cease-fire. The following day was calmer, but on July 10 the Japanese launched a renewed assault on Wanping, bringing in four tanks and twenty-seven artillery pieces to pound the town.[2] Over the following days the crisis grew. In Peking the closure of the gates meant fresh food could not enter the city, and the price of vegetables and pork began to rise. Residents could hear gunfire and the roar of tank engines. Japanese aircraft flew overhead. One of China's most famous reporters, Fan Changjiang, noted that if the Twenty-Ninth Army withdrew from Wanping, they would cede control of the nearby railway line, leaving all lines out of Peking in the hands of the Japanese. China's enemy, he wrote, would control the communications of a city that was home to a million and a half people and a thousand years of cultural achievements.[3]

Larger Japanese troop formations now arrived, coming down in railway cars from their bases in Manchuria, while Chinese divisions in the republican-controlled heartland mobilized, heading north by rail toward the scene of the fighting. Within a few days of the Japanese assault on Wanping, decisions were no longer being made at the local level, but by the governments in Nanjing and Tokyo. Generalissimo Chiang Kai-shek pondered whether the time had come to put aside his reluctance to fight Japan. In his diary he wrote, "Is this the time to accept the challenge?"[4]

Even at this moment, with Manchuria and much of north

China in Japanese hands and Peking surrounded, war was not a certainty, but with each day it became more likely. The two sides agreed to a cease-fire on July 11 and another on the nineteenth, but both fell apart. Word reached Peking of a thousand Chinese killed at Langfang, soldiers and civilians, on July 25; eight hundred at Tongxian, just to the east, on the twenty-seventh. Public opinion across China boiled with anger. The fighting escalated. Sixty miles from Peking, Japanese naval aircraft, flying from carriers, bombed Tianjin, a port city of one and a half million people. On Tianjin's crowded northern districts the aircraft dropped incendiaries—bombs containing flammable pellets or slurry that burned at viciously high temperatures for minutes on end. These started raging fires, sending white-hot flames through the alleyways and wooden shop fronts, choking the city with stinking smoke. Those who escaped the fires became some of the first refugees of a war that would displace tens of millions. Chinese troops withdrew from Tianjin, and a stream of Japanese troop trains arrived from the north at the central station. Japanese aircraft bombed the city's revered Nankai University, reducing around half of its buildings to splinters, rubble, and ash. To make sure of the university's complete destruction, a unit of Japanese cavalry entered the smoldering campus on the afternoon of July 30 and set fire to what remained. The flames consumed all the dormitories and laboratories, and the entire library.[5]

By the end of July, Tianjin was in Japanese hands, and all north China teetered. Ma Heng seems to have understood clearly that Peking was about to fall, that the Forbidden City and all of Peking's cultural treasures would soon be under Japanese occupation. From Nanjing, he sent a telegram to the senior curator who had remained behind in Peking, a man named Zhang Tingji. The telegram was brief and matter-of-fact. It ordered Zhang Tingji to comb the Forbidden City for

the remaining important works of art and to crate them up. The museum staff remaining in Peking should get to work on air-raid shelters. No longer should staff take Sundays off. Ma Heng made no reference in the telegram to the anxiety and fear that all Peking's citizens must have been feeling, and offered no words of reassurance even as the Japanese army approached the city.

Peking was defended by soldiers of the Twenty-Ninth "Big Sword" Army, so-called for its sword-wielding infantrymen's brave defense of the Great Wall at Shanhaiguan back in 1933. The Twenty-Ninth was a regional unit, far inferior to the republic's finest, German-trained divisions. On July 26 Japanese troops carried out probing attacks around Peking. Three days later, word spread through the city, by telephone and by whispered conversation, that the Twenty-Ninth had quietly withdrawn from their defensive positions and slipped away. Peking was to fall without a fight.

There followed a strange hiatus. Peking was quiet, its residents stunned at their predicament, many of its busiest districts all but deserted. In some areas businesses hung out improvised Japanese flags, pieces of white sacking with a hand-painted red ball at their center. Rumors spread of imminent poison-gas attacks, the gas to be sprayed from Japanese aircraft at night, and policemen recommended that residents close their doors and windows and prepare a concoction of mud, urine, and green onions as protection. For days, the city waited, its fall an ambiguous, slow-motion catastrophe.

Resolution came on August 8, a cloudy day with light rain. At around noon the clank and rumble of tanks sounded in the streets. Japanese troops entered Peking through three of the city's gates, passing under the great, gray walls. The troops, a brigade 3,000 strong, assembled in front of Tiananmen gate and paraded before the vermilion walls of China's imperial

precincts. The spectacle rammed home the message: Japan was the rightful possessor of China and the steward of her culture and traditions. Some of Peking's residents ventured out to watch, and soon there were crowds, and peddlers selling fruit and sour plum soup.[6]

As the day wore on, the rain cleared, and a breeze developed. The day, according to the traditional Chinese lunar calendar, was the first of autumn. Peking's residents marked it each year by cooking lamb, grilling it over hot coals in the evening, the smoky scent floating down the alleyways. They called this *tie qiu biao*, which means something like "laying on the autumn fat," as if to protect oneself for a long winter to come. On autumn's first day in 1937 it was a subdued celebration. The city once again fell silent as the night drew in, its streets patrolled by Japanese soldiers, its people learning the deep sense of alienation common to those who live under occupation, for whom the familiar spaces and everyday rhythms of life feel irrevocably altered and corrupted.

In the days following the fall of Peking, the Japanese authorities suspended most local Chinese newspapers. News from inside the city all but dried up. Sketchy reports appeared outside China that Japanese soldiers had removed vast quantities of art from the Forbidden City and shipped it away, despite the efforts of foreign diplomats to intervene.[7] A Chinese official named Chien Tung gave a press conference—whether voluntarily or at the insistence of the Japanese authorities is unknown—to deny emphatically the reports of looting. Groups of Japanese soldiers had visited the Forbidden City "for sightseeing purposes," said Mr. Chien, and were "full of praise" for the Chinese treasures on display. The Forbidden City and other cultural institutions were unaffected by the Japanese occupation, he said, although he conceded that the republican government in Nanjing was no longer supplying

its monthly grant of 40,000 yuan, and this had led to serious difficulties for some 600 employees.[8]

In Nanjing, with the heart of the imperial collections safely stored in their brand-new storage facility, Ma Heng might have felt some relief at the foresight he and the museum's board of directors had shown in packing and moving so much out of Peking. But the war was only just beginning.

In August 1937 it became clear to the leaders and the people of the Republic of China that much of north China was lost, and that Japan could be neither contained nor appeased. For some this was a moment of clarity, a moment to celebrate China's newfound unity and resolve in the face of Japanese aggression after so many years of creeping humiliation. Some

Soldiers of the Chinese republic demonstrating the use of a French-made Hotchkiss machine gun against aircraft

newspapers were positively euphoric, one Shanghai-based publication proclaiming, "Children of China! We should congratulate you! You ought to be proud of yourselves! You have been born into this great age! Our ancestors did not see the whole country fighting a war against a foreign enemy! We have seen it and will be a part of it!"[9] The writer was correct in at least one respect: the people of Shanghai would soon see, and be part of, a total, industrialized, urban war.

The spark that ignited Shanghai flashed in the darkness on the night of August 9. The Japanese military presence in the city was assertive and provocative. At the gates of Hongqiao airport a Japanese officer had an altercation with Chinese guards. In the ensuing confrontation two Japanese servicemen and one Chinese guard were reportedly shot dead, though what really took place remains unclear. The political, military, and racial tensions that coursed through Shanghai now grew acute. Japanese marines flooded into the city, marching down gangplanks off naval transports in full view of the population, ostensibly to protect Japanese civilians. The empire's warships lay just offshore, a brooding, threatening presence. Tens of thousands of residents of the Chapei district, mindful of the carnage of 1932, streamed toward the International Settlement and the French Concession, hoping that the presence of so many neutral foreigners might offer some protection from a Japanese onslaught.

On August 13, Chiang Kai-shek ordered the Chinese army to defend Shanghai, signaling that China was now engaged in an all-out war with Japan and that Shanghai was to be the war's first major engagement. No more strategic withdrawals or locally brokered deals. He ordered the Eighty-Seventh and Eighty-Eighth divisions, two of his finest, German-trained units, into the city with orders to drive the Japanese into the sea. The troops advanced into Shanghai and took up positions

but stayed out of the foreign concessions. The two opposing forces taunted each other, and skirmishes broke out.

The following day, a Saturday, Chinese aircraft launched a bold, doomed strike against the cruiser *Izumo*, the Japanese flagship moored just off the dock in Shanghai's Huangpu River, her eight-inch guns menacing the entire city. The weather was poor, and the Chinese pilots in American-built Hawks and Gammas came in low, beneath the clouds, roaring over the crowded streets, hotels, shops, office blocks, factories, and warehouses of Shanghai. The bombs they dropped failed to damage the *Izumo*. Much worse, some went astray, whether because of pilot error or mechanical malfunction is not known, hitting the International Settlement, damaging the Cathay Hotel and the Palace Hotel—killing more than a hundred people—and also the Great World entertainment center, an enormous complex built in faux-Victorian style that housed slot machine arcades, massage joints, ice-cream stands, *majiang* parlors, brothels, medicine shops, and snack stalls.

The Great World had opened its doors to displaced people and was serving as a food distribution point, and it was packed. The bombs caused carnage. Blast and shrapnel tore through the unprotected crowds. A young refugee from Zhejiang province described the aftermath: "It was a ghastly scene. Bodies and heads littered the ground. Bloody wounds looked like mush. Of a modern young woman who now sat atop a yellow car, all that remained were her legs with long stockings and high-heeled shoes: her head and torso were nowhere to be seen."[10] Newspaper reports put the number killed at a little over a thousand. China's first air strike in the war achieved nothing but a massacre of its own people—and a foretaste, for those paying attention in Europe, of the horror that aerial bombing could inflict on a vulnerable civilian population.

Over the following days, the fighting escalated in the streets

The scene after a Chinese aircraft mistakenly bombed
the Great World entertainment center in Shanghai, August 1937

and along the waterways of northern Shanghai. Chinese troops attempted to evict the Japanese from their positions, often hurling themselves in frontal assaults against strongpoints, suffering terrible casualties. Japanese warships fired their guns into the city in support of their land forces, killing Chinese civilians indiscriminately. People cowered in whatever shelter they could find. This was a new kind of urban fighting, fluid, terrifying, street by street, house by house, an environment where every ruin and pile of rubble could conceal a sniper or a machine-gun nest, where the enemy could be in front of you, or behind you, or all around you; where once-familiar streets became an unrecognizable, cratered maze, strung with barbed wire, piled with sandbags. The battle for Shanghai prefigured the great urban battles of the Second World War—Stalingrad, Berlin—and since—Huế, Fallujah. But even as northern Shanghai was destroyed, the foreign concessions remained largely

unscathed. Shanghai's foreign residents watched nervously from the rooftops in the French Concession and the International Settlement, listening to the chatter of machine-gun fire and the *whump* of artillery, watching the smoke rising over Chapei and the flicker and glow of fires in the night.

On August 23 the Japanese launched the largest amphibious landing yet attempted, running troop carriers a short distance up the Yangzi estuary just to the north of Shanghai, the soldiers climbing down into landing barges as naval gunfire sent smoke and flame billowing across the muddy riverbank. By 7 a.m. the initial assault wave of nearly 8,000 troops had landed and established beachheads. Tanks and artillery began rolling ashore. Through late August and into September, fresh Japanese divisions pushed south from those beachheads toward the center of Shanghai. The Chinese army fought ferociously in the semirural, boggy country between the Yangzi and the city, falling back across the fields, establishing new defensive positions at each waterway, making the Japanese fight for every yard.

One Chinese soldier of the Fifty-Eighth Division remembered arriving at the front line near the village of Luodian. He and his comrades began immediately to dig, knowing, as all infantrymen do, that a trench was their only protection from enemy shelling. A few feet down, the trench began to fill with water, and the soldiers found themselves floundering in mud. People from nearby farms tried to help them, bringing timber torn from their own houses to shore up the trench walls before leaving to join the streams of refugees. The soldiers held their positions in the filth and rain for days, soaked and hungry under relentless Japanese artillery fire, waiting for the inevitable ground attack.[11] So intense were the artillery and air strikes that the Chinese forces could move only at night, and resupply of food and ammunition was next to impossible, yet they continued to fight.

In October, the third month of the war, the situation grew bleaker for the forces of the republic. Furious street fighting in Shanghai had failed to dislodge the Japanese from their positions. Japanese aircraft roared across the city daily, hitting railway stations, streetcars, wharves. Their artillery brought buildings crashing down, sending masonry flying, filling the air with smoke and filth, blocking the streets with detritus. Chinese soldiers, exhausted and lice-ridden, huddled in damp, improvised bunkers in the rubble, cooking their rice and a few vegetables over scraps of kindling. Cholera broke out. By the end of the month, the republic had some half a million troops in and around Shanghai, but they were unable to drive the Japanese out.

On November 8 Japanese forces came ashore again—this time to the south of Shanghai, in Hangzhou Bay. The city now faced an enemy closing in from north and south. On the same day, Chiang Kai-shek circulated secret orders to prepare for withdrawal.[12] Over the following weeks, columns of exhausted, half-starved Chinese troops pulled out from Shanghai and made their way west, strafed and bombed by Japanese aircraft as they marched and frantically tried to establish new lines of defense. Shanghai fell—except for the foreign concessions, which would remain neutral, little islands surrounded by Japanese occupation, until much later. Now, for the Japanese, the road to Nanjing, where Ma Heng, his curators, and nearly 20,000 cases of art were based, was open. Japanese divisions readied themselves to drive inland.

China's casualties in the battle for Shanghai were immense. Some 187,000 soldiers were killed or wounded, among them 30,000 officers, many of them from among the irreplaceable elite of the republic's army.[13] Tens of thousands more soldiers died on the retreat inland. It was a terrible defeat, yet one that perhaps contained within it the seed of something else:

an understanding that China was now in a war for its very survival and would fight on no matter how daunting the odds.

The terror and chaos that erupted in Shanghai in the late summer of 1937 sent fear through the republic, whose capital, Nanjing, lay only 200 miles upriver. An awful realization took hold of Ma Heng and the directors of the Palace Museum. For all the precautions they had taken, for all the work and expenditure on the new Nanjing storage facility at the Chao Tian Palace, the imperial collections were no longer safe. Should Shanghai fall, Japanese troops could be at the walls of Nanjing in weeks, possibly days. In the very first days of fighting, in August 1937, a museum directors' meeting decided that a batch of the most significant and irreplaceable objects should move west to safety immediately, far from the shifting front line. Those remaining in the Nanjing storage facility were to be moved into the hidden, bombproof vault dug deep into the mountain, until they too could be transported out of the city. Everyone knew that air raids were coming to Nanjing. Anti-aircraft guns were visible atop government buildings and on the hills all around the city. An exodus of Japanese citizens reinforced fears that the capital would soon be bombed.

Ma Heng set to organizing the cases' departure from the capital. This quiet, introverted scholar of ancient inscriptions was quickly learning to become a wartime logistician. With every move the cases had made since 1933, and every move they were to make in the years to come, there would be funds to appropriate and account for; curators to manage and their families to house and feed; the practicalities of packing to attend to; porters, handcarts, trucks, railcars, and steamships to hire; storage facilities and warehouses to find. It is hard to imagine a life further removed from the one of quiet scholarship that Ma Heng seems to have so desired.

The first batch of cases to leave Nanjing was small, and—by comparison with what was to come—manageable. To oversee it, Ma Heng selected a group from among the curators. He included both the slender, bespectacled packing expert Chuang Yen and the stocky, cheerful problem solver Na Chih-liang. The batch was to consist of the objects that had been shipped to the London exhibition of 1935–6, all of which remained in their decorative boxes and cloth sleeves inside the steel-sided trunks. Ma Heng quickly realized that the luxurious boxes were a waste of space, so with astonishing speed Chuang Yen and a team of helpers unpacked all the trunks and removed the objects from their satin- and brocade-covered containers. They then discarded the boxes and repacked everything using the techniques they had learned in the Forbidden City four years previously, with paper, cotton wadding, rice husks, and straw, gaining extra space. Ma Heng and Chuang Yen added several vitally important pieces to the batch, including some of those deemed too valuable to go to London, producing a total of eighty cases, packed and ready to transport out of Nanjing to safety. "We crammed in as much as we could," remembered Ma Heng.[14]

Ma Heng would remain in Nanjing to arrange more shipments. Chuang Yen, Na Chih-liang, and two other curators would escort the cases on the journey. Their initial destination lay 500 miles away in Changsha, capital of Hunan province in central China, a hot, lush, wealthy, rainy city where Ma Heng had arranged storage in the basement of the university library. A steamship would take them upriver, across the vast Dongting Lake, and south to Changsha. *Early Snow on the River,* the handscroll depicting travelers on a riverbank and fishermen among the reeds, was in this shipment, safe in its thick cotton sleeve, and the journey it and the eighty steel-sided cases took under Chuang Yen's supervision would become known as the

Southern Route. The Stone Drums and the monk's cap ewer, along with more than 19,000 cases, remained in Nanjing for the time being. The day after packing, the eighty cases went by truck to the Nanjing docks, looking out over the choppy, gray-brown waters of the Yangzi River. That evening, a spasm of fear ran through the city after residents heard on their radios reports of an imminent air raid by Japanese bombers, but it was a false alarm, although many in Nanjing spent a nervous, unsettled night wondering when the bombing would begin. On August 14, 1937, porters loaded the cases onto a steamship, the *Chienkuo Lun*, which belonged to the huge conglomerate China Merchants Group. China Merchants steamships had plied the Yangzi River since the late nineteenth century, carrying grain, kerosene, opium, salt, silk and cotton, machinery—all the commodities on which the China trade was built. Now its ships were filled with people fleeing the outbreak of war, the steamers' decks jammed with refugees and their belongings, all heading in one direction: west, upriver, into China's interior, away from the Japanese.

The curators boarded the *Chienkuo Lun*. Chuang Yen had decided to take his wife, Shen Juo-hsia, and their three children with him. The Palace Museum had managed to rent a cargo hold, and the cases were stored there, below decks. Only one cabin was available, however, and the curators agreed that Chuang Yen and his family should take it. Na Chih-liang stretched out in the hold. The ship pulled away from the wharf and turned into the current. The captain agreed to open the cargo hatches in the ship's side; Na Chih-liang was able to sit and watch the scenery slip by and declared himself "very carefree."[15] He seems to have possessed an unusual ability to find pleasure, even in situations others found deeply stressful or exhausting. He was forever looking for small adventures—interesting foods, local varieties of alcohol, a hike in the

hills—and his attitude suggests a startling degree of emotional resilience.

However, this was a pivotal moment. In north China, Peking and Tianjin were falling, and Japanese troops were driving toward the other major cities. Meanwhile, the fighting in Shanghai was escalating. Among China's elites, the realization was taking hold that China faced all-out war on two fronts against Japan, an industrialized, powerful, expansionist enemy. The following day, August 15, the Japanese bombed Nanjing for the first time. At two o'clock in the afternoon, air-raid sirens sounded and, soon after, twenty long-range G3M bombers of the Japanese navy, flying from Ōmura in Japan, roared in low over the city, beneath the cloud cover. Their targets were Chinese air bases on the outskirts.

Antiaircraft batteries opened fire, creating what one reporter called "pandemonium." Police, ambulance personnel, and firemen were all on alert, but the populace of Nanjing was less disciplined, and many, rather than rushing for the shelters, were to be seen talking and laughing in the streets as the raid progressed.[16] The bombing that day was ineffective, the raiders only damaging a few hangars and training aircraft. A motley assortment of fighters—rotund Boeing 281 "Peashooters," Fiat and Hawk II biplanes—took to the air in reply. As the Japanese aircraft turned away from their targets and climbed, weaving through the antiaircraft fire and searching for the shelter of the clouds, the Chinese fighters jumped them, shooting down four bombers that day, sending them spiraling to earth in gouts of flame.[17]

It was a remarkable success for the Chinese air force and a testament to the bravery of its pilots, but the day held an ominous lesson: Japan had developed the capability to carry out long-range bombing missions, flying aircraft from its home islands across ocean and enemy territory to attack targets in

a fearsome display of technology, engineering, navigation, and endurance. Through its bombers, Japan could bring the war deep into China, beyond the front line, directly to the seat of government. Early in the war, when the Chinese could still field a functioning air force, casualties among Japanese bomber crews were high, but that would soon change.

Once again the war in China served as a template for how the wider Second World War would be fought. For China's urban population and for millions of its displaced people, Ma Heng and the curators of the Palace Museum among them, the sound of the air-raid siren, the reek of a stifling bomb shelter, the growl of an approaching bomber formation, the unique acid-sweet stench of a burning street would register among the dominant sensory impressions of the war years, just as they would for many in Britain, Germany, the Soviet Union, and, in the end, Japan.

It took the *Chienkuo Lun* four days to arrive at Wuhan, a vital port city on the Yangzi River's middle reaches. Ma Heng and the museum's directors were worried. Transport by steamer was proving slow, and they were concerned about the safety of the waters between Wuhan and the consignment's planned destination at Changsha. They decided that the remainder of the journey should be by train. Chuang Yen and Na Chih-liang oversaw the cases' unloading onto the wharf at Wuhan and then into barges for a choppy journey three quarters of a mile across the river to the railway station on the far bank. There, porters loaded the cases aboard a train, and on August 18 they traveled 200 miles south, arriving in Changsha in the hot, humid evening. Chuang Yen sped ahead to the library of Hunan University, where the artifacts were to be stored.

The university lay across yet another river, at the base of a stubby, forested mountain speckled with pagodas and temples

that rose some 600 feet to overlook the city. The following day, while Chuang Yen made sure the storage facilities were ready, Na Chih-liang and two other curators saw the cases loaded onto carts, transported to the river, and then ferried across. For Na Chih-liang and Chuang Yen, both natives of China's dry and dusty north, the surroundings must have felt quite alien, the dialect unfamiliar, the spicy cuisine strange, the flora taking on a subtropical character. Na Chih-liang was baffled by the rickshaw pullers and pedicab drivers, who dawdled along the streets at a pace no faster than walking. "Apparently rickshaw pullers in Changsha do not run," he wrote. It took them an entire day to move the cases to the library, which annoyed him. "People here do not seem to be very energetic."[18]

During the next few days, with the cases safely installed in the university library, Na Chih-liang was back in his usual good humor, but he was at a loose end as he waited for orders from Ma Heng and had brought no books with him. To pass the time, he and another curator hiked in the hills around Changsha, pounding along in the heat, leaving the war and the stress and strain of their mission behind them. On one such outing they came across a clear, flowing stream and, like two boys, gleefully began using stones to build dams and canals to change the course of the water. The following day they passed the same way again, only to notice that someone had dismantled their works and returned the stream to its original state. Na Chih-liang and his companion, in a spirit of competition, immediately set about rebuilding their dams. "We'll show them," he said. They returned on the third day to find their constructions once again taken down, and a note stuck to a rock, written in polite but firm terms: "This stream supplies drinking water for everyone who lives at the foot of the mountain, so, dear passers-by, please stop making things difficult." "We ran away," remembered a chastened Na Chih-liang.

The episode, while trivial, suggests how distant the worlds of the urban intellectual and the rural dweller were. The young nation of China, even as it began to solidify in the face of invasion, could still feel deeply divided by class and region. To someone away from home, away from their familiar food and dialect, family and landscape, this vast country could feel deeply foreign. As Chuang Yen oversaw the cases' storage in Changsha's university library, Na Chih-liang now confined himself, restless and bored, to his rented rooms, waiting for Ma Heng, back in Nanjing, to tell him where to go next.

The telegram, when it came, ordered Na Chih-liang back to Nanjing, and back to the war, so he made his way across the river to Changsha's main railway station. The station was heaving with people, "mountains and seas of people," he wrote, all seeking a route to safety in a melee of confusion, rumor, and indecision. Some sought tickets on trains heading west, to put as much distance between themselves and the Japanese advance as possible. Others wanted to head east or south to the coastal ports in the hope of securing passage on a ship out of China. Na Chih-liang found it impossible even to get near the ticket office because of the crowds. The idea of obtaining an actual seat on a train looked wildly optimistic, so he and his traveling companion left the station and wandered the streets outside, unsure what to do next. At some point that day they spoke to the captain of a cargo ship, who offered them passage down the Yangzi River as far as Wuhan, roughly a third of the way back to Nanjing. They accepted eagerly and were doubly gratified when the captain showed them to a cabin. Once again, Na Chih-liang delighted in his luck, and the two of them passed several enjoyable days on board watching the beautiful lake and river scenery slip by.

On disembarking in Wuhan, the situation was dire. The river port was swamped with refugees from the fighting around

Shanghai. Na Chih-liang could find no berth for an onward journey anywhere and was reduced to striking an illicit bargain with some deckhands. In return for a fee, the deckhands smuggled them onto a cargo vessel bound for Nanjing, showed them to two tiny bunks, pulled a curtain down, and ordered them not to show themselves under any circumstances. Such stowaways were known as *huangyu*, or "croakers," a reference to a small fish. Na Chih-liang spent a miserable twenty-four hours below decks. When customs inspectors came aboard, all the croakers were rousted from their berths and forced to move silently about the ship to avoid discovery. It was a frightening, demeaning journey.

When the ship reached Nanjing, the situation worsened. To Na Chih-liang's horror, the captain refused to take the ship alongside the dock but remained in the middle of the channel. Any passengers wishing to disembark, he ordered, had half an hour to do so, and must make their own arrangements to reach shore. The Yangzi River is up to a mile wide at Nanjing; it is choppy and treacherous and fast-moving. The croakers, which included Na Chih-liang, stood on deck in the late summer heat, peering over the side at the muddy water, wondering how on earth they would get off.

Their answer arrived in the form of a number of little wooden skiffs that came pitching over the waves toward the ship, the boatmen shouting up demands for payment. Deckhands threw ladders of coarse rope over the ship's side. The skiffs waited beneath, lurching violently on the water. The climb down was a horrible prospect, the jump from a rope ladder into a bobbing skiff terrifying. Na Chih-liang wondered what would happen if a passenger lost their footing and went into the water; would anyone even attempt a rescue? But he and his companion knew they had no choice. They clambered

down the precarious ladder, hurled themselves into a pitching skiff, and set off on the hair-raising journey to shore, the little craft beating itself against the waves and the wind. When they stepped shakily onto land, the boatman demanded an exorbitant fee. Na Chih-liang remonstrated with him, but the boatman argued that he had risked his life. Na Chih-liang reflected to himself that the boatman was not the only one.[19]

Na Chih-liang was beginning to experience the sense of dislocation and powerlessness that overtake the displaced civilian in war. As a member of Peking's intellectual class, a respected curator in the country's foremost museum, he was a man accustomed to some privilege and deference, yet he had been suddenly no more able to obtain a train ticket than any other dispossessed refugee in the frightened, heaving crowds at Changsha's railway station. He found himself dependent on the petty subterfuges of deckhands and vulnerable to the extortions of boatmen.

The transformation from rooted, stable citizen to powerless drifter can occur astonishingly quickly in war and disaster. Home vanishes; supportive friends and relatives scatter; income disappears; personal dreams, ambitions, and purposes evaporate. The days blur into nothing more than a quest for shelter, safety, food, clean water. The refugee makes life-and-death decisions—where to flee, whom to trust—based on rumor and half-informed speculation, leaving them racked with doubt and guilt. The memory of a previous self fades, identity fragments. Becoming a refugee was central to the war experience of many tens of millions of Chinese people. Ma Heng, Na Chih-liang, and Chuang Yen must sometimes have felt like refugees, but their experience was moderated by their circumstances: they all retained their jobs, a mission of vital importance, and sometimes their salaries. For all the privation and fear that they

endured, they never lost their sense of who they were. In saving the works of art, perhaps the works of art also saved them.

Chuang Yen and his family remained in Changsha with the eighty cases in his charge, including that containing *Early Snow on the River*. He was, however, worried that the university library's basement was inadequate as a storage facility, and the museum put a new plan into effect, commissioning workmen to dig tunnels into the side of the mountain immediately behind the university and hollow out chambers in the rock. The chambers would be sufficiently dry to store the cases and would offer protection from bombing. The work got underway and was completed by December 10, 1937, but these facilities were never used. After the fall of Shanghai in November and the Japanese advance to Nanjing, Ma Heng and the directors changed their plans once more. Even Changsha, they decided, was no longer safe.

The museum's board of directors' order came to Chuang Yen. The cases, he learned, had to go on. This time the destination was Guizhou, a province in China's southwest; poor, rocky, and stippled with mountains so that roads were few and railways all but an impossibility. A local saying had it that Guizhou saw "a sky never three days clear, land never three feet level, and people never three coins wealthy." The journey was to be made by road, the cases loaded on trucks. The route was horribly roundabout, arcing south through Guangxi province, and then up to the northwest into Guizhou. It meant some 600 miles on unreliable roads, through rough, desolate terrain, through small towns and flyspeck villages, where the local languages were unintelligible and supplies of gasoline, food, and water patchy. Chuang Yen's first problem, however, was even more fundamental: Where on earth was he to find the trucks?

For an entire month, through December and into January

1938, Chuang Yen sought transport, badgering and cajoling government departments and private companies. The museum had the funds to hire trucks, but the vehicles were often not available, and when they were, their owners could find other, more profitable, uses for them. Moving food, or opium, or war supplies between major cities was more lucrative than transporting cases of art to the middle of nowhere. After weeks of negotiation, Chuang Yen secured three buses from the Jiangnan Automotive Company, a truck from the post office, and five commercial vehicles from the Guangxi Provincial Roads Administration, all of which could manage different legs of the journey. A ragged little convoy of vehicles carrying thirty-six cases left Changsha in the chill morning of January 12, 1938. It took more than two weeks to arrive at its destination, the capital of Guizhou province, Guiyang. A second convoy, carrying the remaining forty-four cases, arrived there in early February.

Guiyang was an impoverished place, a world away from Shanghai or Peking, a backwater with gray city walls and a dank moat filled with stagnant water and garbage. At its center, newly built banks and office blocks stood on a wide boulevard, lit at night with electric streetlights. Elsewhere, the city reverted to an older self, the streets dark and narrow, the houses low and pitch-roofed. Yet by early 1938 Guiyang's population had swollen with the arrival of refugees from Shanghai and the coastal cities, and the streets echoed with the accents and dialects of China's eastern seaboard. Restaurants had started to cater to eastern, urban tastes with delicate rice noodles and wontons alongside Guizhou's own roaring hot, chili-laced cooking. Newly arrived hairdressers and tailors had set up shop. Refugees often stood out in their Western suits and high heels against the dowdier dress of the city's natives and the embroidered clothes and straw sandals of the Miao people from the mountainous regions outside the city.[20] The war was

forcing people who were utterly dissimilar in experience, dialect, and taste to encounter each other, and to consider what it meant to share a nationality. This wartime movement of people was strengthening the idea of a single Chinese nation, of a national identity that transcended regional differences.

The trucks deposited the cases at the headquarters of the local military authorities, but the plan was to find permanent storage in one of the many caves that dotted the mountains on the outskirts of the city. Local officials identified two sites, and Ma Heng arrived from Nanjing in November to inspect them. He was not happy. One was small, narrow, and difficult to access. Water dripped down the walls all year round, making it far too damp. High levels of humidity posed a serious threat to *Early Snow on the River* and to all the paintings and calligraphy in the shipment. For paper and silk, damp means mold and rot, and irreparable damage. The second cave sat at the top of a mountain, and the steep climb, with porters carrying the cases on their backs or slung between shoulder poles, was too hair-raising to contemplate.[21]

Ma Heng set off on a hunt for a suitable cave. He took Chuang Yen and Ouyang Daoda, the strict, disciplined curator from Peking University, with him. They left Guiyang and went out into the surrounding country, clattering over the rocky roads, searching among the villages in Guizhou's gray-brown mountainscape. It would have been chilly, the temperature dropping toward freezing at night, the high altitude wreathing the mountains in cloud. They spent a week clambering in and out of a dozen caves, and Ma's brief account of the time makes clear the dilemmas he faced during this period. Having removed the art objects from their home in the Forbidden City for safety's sake, he now faced a serious problem of conservation. "The safest place was likely a cave, but all things have their upsides and their downsides. There's no such thing as

a dry cave, and if the objects turned moldy and rotten, we would have destroyed them through an excess of care."[22] After visiting a number of caves, he concluded that one with a wide mouth was less likely to hold the damp. Just outside a town called Anshun, some fifty miles to the southwest of Guiyang, he found what he was looking for.

It was known as the Huayan cave, named for the Garland Sutra of Buddhism. At its mouth stood a small temple, home to a monk who burned incense, chanted from Buddhism's sacred texts, and made an impious living slaughtering pigs for the locals. Chuang Yen remembered that he appeared to have a wife as well.[23] Dubious religious credentials aside, the monk was custodian of a cave that, Ma Heng felt, was "almost ideal." It had a sizable entrance and opened out inside to become a spacious cavern with a high, domed roof. It was damp, of course, but not disastrously so, and it was accessible by a track, making transport of the cases much easier.

With the objects stored temporarily at the provincial capital, Ma Heng arranged for workmen to build two shelters of wooden planking inside the Huayan cave. The shelters would be raised from the cave floor, to allow air to circulate and prevent the cases from becoming damp, and their roofs would be sloped and tiled to protect against drips from the cave's ceiling. Starting on January 18, 1938, Chuang Yen oversaw the shipment of eighty cases containing some of the Palace Museum's most revered objects—*Early Snow on the River* among them, and *Herd of Deer in an Autumn Forest*, alongside the pieces that had traveled to the London exhibition—from Guiyang to the Huayan cave. By January 23, the cases were safely installed, enclosed, and protected by the wooden shelters inside the dim, echoing cave. An accord was reached with the monk, and guards, who used the temple as a makeshift barracks, were posted at the cave's mouth.

Chuang Yen rented a cramped and dingy wooden house in the nearby town of Anshun, and moved in with Shen Juo-hsia and the children. The house had just two rooms and a study where Chuang Yen could work and keep his books. Shen Juo-hsia found a job teaching literature at a school forty minutes' walk away. She received her salary not in cash, but in rice, which came in a sack that she would carry home across her shoulders. Over the years, as the war dragged on, Ma Heng would visit from time to time. He treated Chuang Yen as an equal now, though Chuang Yen continued to regard him as his teacher. In the evening the two of them would sit at the table over a bottle of fiery *gaoliang*, drinking from little cups. They held earnest discussions about different varieties of wine, and which regions produced the finest sorghum spirits, Ma Heng probably smoking a cigar as they talked. Sometimes they would sing *kunqu*, the dreamlike opera of the watery, lush eastern regions of China. Shen Juo-hsia would play the flute. Chuang Yen and his family would stay in Anshun for six years, guarding and conserving the artworks that had taken the Southern Route to safety, until the war finally caught up with them.

On April 10, 1938, some ten weeks after the cases had left Changsha, at two in the afternoon, Japanese aircraft attacked the city. They appeared to target the university, hitting it with forty to fifty bombs. The library, where the eighty cases containing the rarest pieces of the imperial collections had been stored, burned to the ground, its entire collection lost in the flames. Had Ma Heng and Chuang Yen not made the decision to move those cases to the Huayan cave, their contents, including *Early Snow on the River*, surely would have been destroyed.

But even as those cases found a measure of sanctuary, 19,500 more, including those containing the Stone Drums of Qin and the red monk's cap ewer, remained in Nanjing.

8

FLEEING NANJING

As the summer of 1937 turned to autumn, China descended into a complex, shapeless war. The great cities of the north—Tianjin, Peking, Taiyuan, Datong, Jinan—fell one after another to the Japanese. In the east the shattered divisions of the republic retreated from Shanghai, and the war burned inland along the course of the Yangzi, toward the river cities of central China and toward Nanjing.

The soldiers of Japan had not expected resistance from the Chinese; the fighting was fiercer than they had anticipated, their casualties higher. The Japanese infantryman, fighting his way out of the urban maelstrom of Shanghai, now found himself in flat, open country, the fields wet and muddy, the villages empty or hostile. He marched heavily loaded, hungry, on rutted roads that turned to mud in the rain; and the rain, when it came, was cold, chilling him to his miserable, sodden core. Much of the advance to Nanjing was through that hard autumn rain, mud sucking at boots, getting in rifles and the food. The soldiers spent hours hauling trucks and field guns out of the mud.

The advance, while implacable, came at a wrenching cost.

At times Chinese troops offered ferocious resistance, raking Japanese units with machine-gun fire from concrete pillboxes, fighting to the end so retreating units might gain time to reorganize. On November 18, a little over four months since the incident at the Lugou Bridge outside Peking, a Japanese spokesman astonished journalists by announcing that, to date, 80,000 Japanese soldiers had become casualties in battle across China.[1] Nobody, least of all the Japanese, had expected their casualties to be so high.

The death of a Japanese soldier was couched in ritual. The soldier's comrades recovered the corpse and laid it in a pit alongside other soldiers, heads pointing to the north. They cut switches of the dead man's hair and wrapped them in white paper as mementos. Where they could, they piled brushwood atop the corpses and cremated them as an army priest chanted sutras.[2] Soldiers carried the ashes of their comrades—often mixed with those of other dead—in wooden boxes wrapped in white cloth and hung about their necks. Eventually, the army shipped the boxes home to bereaved families.

If the infantryman's will to fight faltered in the grueling conditions, the army had its remedies. The Japanese armed services maintained a brutal discipline relentlessly enforced by noncommissioned officers. The infantryman could expect any infraction to bring physical punishment, often a powerful openhanded slap to the side of the head, sometimes a punch or a beating with a bamboo cane. Such punishments could be inflicted multiple times a day, day after day, leaving the soldier stunned and brutalized, perhaps even cognitively impaired. The military ethos was one of absolute obedience and loyalty to the emperor of Japan, who was, according to Shinto's blend of religion and ideology, a direct descendant of the gods, and whose authority was rooted in the divine.

The army required that the infantryman commit to memory a text known as the *Imperial Rescript to Soldiers and Sailors*. This was written in 1882 and had become an ideological mainstay of Japanese imperialism; it defined the relationship between emperor and military, and demanded five qualities in the soldier: loyalty, respect, valor, faithfulness, and plain living. "Duty is heavy as a mountain" went the text. "Death is light as a feather." Ideology was a significant driver of Japanese militarism, yet the common postwar portrayal of the Japanese soldier as a mindless fanatic obscures a much more complicated reality. In Shanghai and the Yangzi River region, entire Japanese divisions were manned by reservists, older men, many of them husbands and fathers plucked unexpectedly from their civilian lives to fight in China.[3] Stubborn Chinese resistance, high casualty rates, disease outbreaks, and squalid conditions shook morale in Japanese units, but savage discipline and imperial ideology ensured that they continued to fight.

As they left Shanghai and made their way out into the Chinese hinterland, the Japanese savaged the towns and villages they passed through. In the middle of November 1937, at Jiading, a walled town of some 30,000 people surrounded by waterways, aerial bombing destroyed about a third of the buildings. Troops of the Japanese 101st Division, all reservists, patrolled into Jiading's smoking ruins at nine in the morning on November 13, the weather cold and wet. They had occupied the town by one in the afternoon. They then set about a slow-motion slaughter of the town's inhabitants. In the six weeks that followed, 8,000 Chinese civilians from Jiading and its environs died at the hands of Japanese troops, their bodies strewn across the cold, sodden fields, left in ditches.[4] After Jiading, the next town in the path of the Japanese advance

was Taicang. There Japanese troops burned half the town. The population fled, and the troops looted everywhere, cleaning out the town granary and the salt depot and burning the library. Farther on, at Danyang, only fifty miles from Nanjing, aerial bombing set the entire town ablaze. It burned for three days. Nothing was left.[5] The Japanese advance up the Yangzi delta was ruinous, the bombing, burning, and slaughter intended to terrorize China into capitulation. The fate of these towns was merely a foretaste of what was to come.

Chiang Kai-shek swore to defend his capital. Nanjing mustered a defense out of its own garrison and the battered units that had survived Shanghai—those whose soldiers had not deserted and were still capable of lifting a rifle. On November 25 Chiang declared that the city would be defended "to the last inch and to the last man."[6] By the end of the month, the Japanese were at Lake Tai, less than a hundred miles away, and still, 19,500 cases of art remained in the Nanjing storage facility.

Nanjing was the pride of republican China, a capital city of trees and boulevards reflective of the new state's dreams of modernity. By November 1937, it was a terrified husk of its former self. Even as the republic's troops prepared a desperate defense of the city, its government began to evacuate. Government departments laid off their workers except for those deemed essential, packed their files, and left by train or steamer for the far west of China, leaving behind skeleton staffs. Most foreign diplomats burned their sensitive files and fled as well; at the war ministry a bonfire of secret papers lasted all day on November 9. Nanjing University's faculty and student body evacuated. The Geological Institute removed all its instruments and maps. Businessmen, merchants, and all those who could afford to travel sought a way out. Many shops and businesses

were closed and locked up, the windows boarded in a forlorn attempt to protect against the inevitable looting by fleeing, ravenous Chinese troops or the advancing Japanese.

As the evacuation became an exodus, the city's population of more than a million halved. Residents and refugees seeking passage west jammed the wharves on the Yangzi, and Nanjing's wide traffic arteries were packed with every kind of vehicle: trucks, cars, rickshaws, and handcarts piled with bedding, pots and pans, and wailing children.[7] Outside the city's walls, the streams of automobiles and carts quickly turned the roads to mud in the rain. The cold, gray drizzle that persisted through much of November added to the gloom. As Nanjing's population fled west, refugees from the Japanese advance arrived from the east, exhausted families from rural areas trudging into the city on foot, sometimes leading a water buffalo or an ox and cart. Thousands upon thousands of wounded Chinese soldiers came in on trains, evacuated from the fighting at the front, just hours away. The city had neither the facilities nor medical staff to treat them. Trainloads of terribly injured men were simply unloaded onto the station platforms and left there. A remarkable sight of the time, noted by journalists, was that of the city's sing-song girls—women who worked as entertainers and hostesses, companions and courtesans—out in the crowds raising money for the wounded.[8]

At this moment, as the Republic of China's capital began to reckon with its fate, a small group of foreigners decided not to flee but to remain in the city. They gave themselves the task of organizing the International Safety Zone, an area of the city that, with the agreement of the Chinese and Japanese armies, would take on neutral status. Soldiers would not be permitted to enter, and Chinese civilians inside the zone would be afforded protection from air raid, bombardment, and slaughter. It was an ambitious, principled, brave undertaking. Among

the leaders of the effort was a German named John Rabe, a businessman who worked for Siemens and was a member of the Nazi Party; George Fitch was the American head of the local YMCA; Minnie Vautrin, also American, was a missionary and dean of a local women's college, the Ginling College for Girls, where she had worked for many years. Fifty-one years old, devoutly Christian, dark-haired, bespectacled, and given to sensible flowery dresses, Vautrin was a well-known figure in Nanjing and deeply loved by her students at Ginling. Alongside the foreigners worked several well-connected locals: Han Lih-wu was an urbane academic and bureaucrat. He was a handsome, charismatic man, well tailored, with a severe parting to his hair and a square jaw. A fluent English speaker who had studied in London and the United States, Han Lih-wu headed the board of trustees of the Sino-British Cultural Association, which administered the British share of an enormous fund known as the Boxer Indemnity. The fund's origins were complex. For many years, China had paid compensation to several foreign powers for losses of life and property during the Boxer uprising of 1900. The British government, in an act of enlightened self-interest, directed its compensation payments back to China to fund infrastructure and education. At thirty-five years old, Han Lih-wu wielded considerable influence and financial clout in Nanjing.

Through November, with the Japanese army coming closer by the day, Rabe, Vautrin, Fitch, Han Lih-wu, and many others worked to set up the boundaries and the structure of the International Safety Zone. They sought the agreement of the warring armies, hoping that John Rabe's Nazi credentials might stand him in good stead with Germany's newfound ally, Japan. As the work progressed, Han Lih-wu received a telephone call from the mayor of Nanjing asking if the zone might include the Palace Museum storage facility at the Chao Tian

Palace and the 19,500 cases of art within it. The mayor's office believed the zone might afford the cases and their contents protection should the city fall to the Japanese. Han Lih-wu saw the suggestion as unworkable. He replied that extending the zone beyond its planned boundaries was impossible, and in any case he had no idea if Japanese troops would even respect its neutrality. Han Lih-wu felt he could offer no guarantee of safety for the cases. They should be moved immediately, he said, out of Nanjing. To his surprise, the central government agreed and ordered Han Lih-wu himself to step aside from his work with the International Safety Zone and to take responsibility for transporting the cases out of the city.

Apparently undaunted by such an enormous undertaking, Han Lih-wu contacted Ma Heng and the Palace Museum staff, and together they began to plan. The cases would have to leave by steamship within days if they were to escape the advancing Japanese. The effort would require porters, hundreds of them, and they would need vehicles to transport the cases more than four miles from the storage facility to the wharves. They would also need to find cargo space, at a time when the docks were swamped with refugees, the military was struggling to move troops and war matériel toward the front, and the transport system was under terrible strain. Above all, they would need money to pay for it all: wages, cargo fees, tickets, food, bribes. With extraordinary bureaucratic deftness, Han Lih-wu went straight to the other trustees at the Sino-British Cultural Association and asked for—and got—permission to use money from the Boxer Indemnity fund.

Suddenly, the entire shipment was in principle financed, but there was a problem. The fund could only write checks. And nobody, as war descended, was interested in being paid by check, least of all the porters and deckhands whose labor was essential to the shipment. Even the steamship companies

wanted cash. Han Lih-wu needed to find large sums of ready cash quickly, but where? He approached the China Maritime Customs Service, the sprawling government body responsible for regulating trade in China's rivers and ports.[9] The service was uniquely staffed in part by expatriate, often British, bureaucrats. The customs commissioner in Nanjing, Hubert Duthy Hilliard, had remained in the capital to maintain a skeleton organization amid the chaos on the Yangzi. Hilliard took it upon himself to lend $4,000 in cash to Han Lih-wu, with the assurance that the money would be repaid into a bank account in a safe city farther upriver.[10] Han Lih-wu agreed, and started hiring porters and booking passage.

A small army of porters began moving cases out of the storage facility. Han Lih-wu assembled a motley collection of trucks, among them one belonging to John Rabe, the German businessman helping to administer the safety zone. Rabe noted disconsolately in his diary that his truck, which was bringing aid to wounded soldiers, had "been placed at the disposal of Dr. Han Liwu who has assembled a whole parking lot full of trucks in order to take to the harbor, would you believe, 15,000 crates of curios . . ."[11] Rabe clearly believed that the trucks would have been more usefully employed carrying the wounded. Han Lih-wu's fleet, loaded with the imperial collections, lumbered for days through the city, under the towering walls to the wharves at Hsiakwan, where a steamer, the *Kiangan Lun*, owned by China Merchants Group, was berthed.

The docks were overrun. Crowds of refugees thronged the wharves, shouting, arguing, bargaining for berths on a steamer or a junk or a sampan. Some just sat and waited in the cold, surrounded by piles of their possessions. The porters had to fight their way to the ship. Mounds of war supplies were piled on the concrete: uniforms, blankets, rifles, stoves, stacks of ammunition, field guns, zinc piping, rolls of telephone

cable, furniture, countless bales and bundles. Troopships disgorged columns of soldiers destined for Nanjing's defense. They came ashore in blue padded uniforms carrying their equipment, mugs and flashlights dangling from their belts, poles across their shoulders laden with bedding, cooking pans, and entrenching tools. Sometimes, a sharper, German-trained unit would disembark in their coal-scuttle helmets, marching smartly, rifles shouldered.[12]

Han Lih-wu's porters pushed and shoved their way through, bellowing at the crowds to move aside, the wooden cases on carts or suspended from shoulder poles. Over several chill, damp days and nights, they moved 4,081 cases of art to the dock, took them up the gangway, and loaded them aboard the *Kiangan Lun*. On November 19, 1937, the steamer edged away from the wharf and set sail for Wuhan, 400 miles distant, with the cases aboard. This long, treacherous journey up the Yangzi would become known as the Central Route.

Ma Heng was already upriver in Wuhan anxiously awaiting the arrival of the *Kiangan Lun*, but the desperate shortage of river transport made it impossible to move all 19,500 cases out of Nanjing by river. As the situation became desperate, the Palace Museum directors ordered Han Lih-wu to arrange additional transport by rail. The orders were vague: load as many cases as possible aboard freight trains and take them nearly 200 miles north to the rail hub of Xuzhou. Then transfer them to another line and head west, 500 miles into the poor, semidesert province of Shaanxi. The directors told Han Lih-wu that the city of Xi'an was their destination, but he had no idea where the cases would be stored when they got there.

Despite the uncertainty, Han Lih-wu developed a complicated plan to move thousands of cases out of Nanjing by train. The military sent telegrams to all railway bureaus ordering

them to make freight cars and locomotives available to the Palace Museum. The hundreds of porters Han Lih-wu had hired to move cases to the docks began a parallel effort, hauling thousands more to Hsiakwan station, shoving their way through the crowds, the museum staff struggling to keep control. At the station, porters and curators worked in shifts around the clock to load the cases aboard waiting freight cars, snatching sleep in empty carriages. When an air-raid warning sounded, they threw themselves beneath the freight cars, lying amid the garbage, filth, and human waste on the tracks. When the Japanese bombers left, they crawled out from beneath the cars and resumed loading. Among the crates hauled to Hsiakwan station were the massive, inordinately heavy cases containing the Stone Drums of Qin, the chunks of granite inscribed in the Zhou period with their beautiful, mysterious poetry. After loading, the freight cars were shunted aboard a ferry to take them across the Yangzi, and on to China's northwest.

One chilly late-November evening, a line of freight cars waited at Hsiakwan station, loaded to capacity and ready to leave, but without a locomotive to haul them, thousands of cases beside a platform amid the barely contained chaos of the station. Han Lih-wu learned that a locomotive would arrive the following morning at the earliest, which meant the freight cars would have to wait all night, so he requested armed guards from the local military authorities. A contingent of ten men arrived to stand watch from eight in the evening until four in the morning, and Han Lih-wu left the station to get some rest, but an hour later, at 9 p.m., he received a panicked telephone call. One of the guards, "a particularly diligent person" noted Han Lih-wu dryly in his account, had taken it upon himself to inspect the contents of the freight cars and discovered to his horror that the cases did not have external locks. The guard reported his discovery to his commanding officer,

who telephoned Han Lih-wu. The officer said he intended to stand down all the guards and return them to their barracks, as he could not risk assuming responsibility for unlocked cases. If pieces were found to be missing, he and his men could face allegations of impropriety. The guards would be gone by 10 p.m.

Han Lih-wu hurried back to the station. The cases were indeed without locks, but their paper seals were all intact, showing that none had been opened. The officer insisted that he could not continue guarding the cases, however, and Han Lih-wu, having failed to persuade him, tried graciously to accept his logic. The guards departed, leaving the shipment without security. Han Lih-wu rushed to a telephone and rounded up a few colleagues, and this tiny crew, exhausted, unarmed, and untrained, patrolled the freight cars through the night, standing watch over a cargo of incalculable monetary, cultural, and historical worth until 4 a.m. Han Lih-wu confessed that he worried about the cases' lack of locks too and raised it with the Palace Museum, but in the rush to get the shipments out of Nanjing, nothing could be done.

On November 25, as the loading continued under the eyes of the museum curators, Han Lih-wu took time away to attend a small Thanksgiving dinner at the house of an American resident of Nanjing who had not yet fled. It had been a clear day, ideal for flying, and the Japanese bombers had been busy. Minnie Vautrin, the missionary and college dean from Illinois, was among the guests. She was shaken and worried, but had found some consolation earlier in the day in prayer at a Thanksgiving service. The little gathering ate roast goose, and Vautrin discussed with Han Lih-wu the last-minute evacuation of the Palace Museum art treasures from Nanjing. "Strange that they should have been left here so long," she wrote in her diary.

Over those fearful days, three shipments of cases left Nanjing by rail, rattling north in early December 1937, then turning west into Shaanxi, in a journey of nearly a thousand miles. One of Ma Heng's sons, Ma Yanxiang, went with them as an escort, wondering where the shipments would end up. The freight cars carried a total of 7,287 cases on what was only the first leg of the frightening, exhausting voyage that became known as the Northern Route.

As Japanese advance units approached the capital, Han Lih-wu searched for every possible way of evacuating the remaining cases from the city. About ten days after the departure of the *Kiangan Lun*, a second ship berthed at the crowded Nanjing wharves to load another shipment for transport upriver to Wuhan, the second shipment that would travel the Central Route. Han Lih-wu had been to the British embassy to beg for help. A British diplomat noted tersely that "Generalissimo's Headquarters have appealed to us through Han Lih-wu for assistance in evacuating . . . cases of Palace Museum treasures." The embassy staff were instructed to "mention request" to the British company Butterfield and Swire.[13] B&S assigned to the task the steamer *Whangpu*, 338 feet in length and a little over 3,000 tons, built in Hong Kong in 1920, a sturdy, spacious, unremarkable beast of maritime burden. She flew the red ensign, the flag of British civilian shipping. Now she and her sister ships in the B&S fleet were among those evacuating the administrative heart of republican China from Nanjing to the west. B&S steamers carried the central administration of the post office, the central bank and its records, the ministry of health, even shiploads of banknotes upriver to safety. The republic was on the move, by any means possible.[14]

On the bridge of the *Whangpu* was a watchful, forty-two-year-old Scot from Inverness named William McKenzie,

the ship's captain. McKenzie had seventeen years of service with B&S and knew the Yangzi River and the China coast intimately. But this job—transporting a priceless, fragile cargo in wartime conditions and in the context of delicate British neutrality, air raids, trigger-happy Japanese units along the riverbank, and a frightened crew—was unlike any he had ever known. Nevertheless, by December 1 his ship was ready to begin loading.

Nanjing's situation was becoming more perilous by the day, with Japanese units reported only forty miles away. The gates in the city walls were fortified with sandbags and barbed wire, while outside the walls thousands of laborers dug entrenchments. Some 300,000 Chinese troops established lines of defense in concentric rings around the city, shivering in the mud and cold as they awaited the Japanese advance, the onslaught of artillery it would bring, and the tanks and infantry that would follow. The soldiers of the republic had almost no armored vehicles and limited air cover. Japanese aircraft now operated freely over Nanjing, and formations of bombers roared in to attack multiple times a day. Parts of the city were soon burning. Bewildered, hungry refugees poured into the International Safety Zone, where John Rabe, George Fitch, Minnie Vautrin, and their staffs struggled to maintain order and stockpile food.

Amid all this, for fifty hours straight, through December 1 and 2, porters loaded the *Whangpu*, the ship's British officers standing watch over the process. Han Lih-wu himself stood at the end of the gangway at the cargo hatch, taking the tally sticks from the porters as they manhandled case after case into the hold. During daylight, every time an air-raid warning sounded, the loading paused, and Captain McKenzie pulled the *Whangpu* hastily away from the dockside, quickly steaming upriver to shelter next to British navy vessels moored in the

channel. Under the cover of the Royal Navy's guns, McKenzie watched the Japanese G3Ms skim in on their bombing runs, the smoke rising over the rooftops and drifting across the city. When the bombers disappeared into the haze, he ordered the ship back to the wharf to resume loading, preferring the darkness when the Japanese could not fly.

The first mate of the *Whangpu*, Graham Torrible, a thirty-three-year-old from Lancashire, watched over the nighttime loading. The crowds of refugees on the wharves stretched far into the darkness. Torrible stood at the cargo hatch as the porters fought their way to the ship. He remembered seeing the telltale ripple in the multitude, then two chanting porters emerge from the crowd and into the light, carrying between them a packing case slung on a bamboo pole. They would come across the gangway, hand over their tally stick, and disappear into the ship. Another ripple on the surface of the crowd, and another pair of porters toting a case between them emerged from the mass of refugees, one after another.[15] Captain McKenzie watched the loading too, hour after hour. The porters, he thought contemptuously, did not know or understand what was contained in the wooden cases they carried. They spat on the cases, sometimes slept on them, and ate their meals sitting atop them.[16]

Over two and a half wintry, frightening days and nights, the porters loaded 5,250 cases aboard the *Whangpu*. By the morning of December 3, she was ready to sail. So great was the crush of refugees on the dockside that Captain McKenzie worried his ship might be swamped, and he stood the *Whangpu* off the dock at a distance of seven or eight feet so that desperate refugees could not jump aboard. At the last minute, McKenzie insisted Han Lih-wu accompany the shipment. It is not entirely clear why; it is possible the captain worried that his taking sole responsibility for Chinese government cargo would violate the

rules governing British neutrality and potentially lead to the Japanese boarding or attacking his ship. If Han Lih-wu were aboard the *Whangpu*, the captain could argue the cases were in the charge of a Chinese national.

Han Lih-wu had not anticipated this; he needed to get back to his refugee work at the International Safety Zone. Standing on the dock amid the crowds, he was flummoxed. He had no time to return home to pack. He ran to a dockside office and telephoned George Fitch at the zone to explain what was happening. Han Lih-wu seems to have feared that Fitch might feel he was running away, abandoning the refugee work. He promised Fitch that he would do all he could to return to Nanjing.

Back at the quayside, the *Whangpu* was still standing off the dock, and the crowds were immense. Han Lih-wu had no way to board, but Captain McKenzie would not sail without him. In the end, deckhands threw him a rope; Han Lih-wu clung to it, jumped, and the deckhands unceremoniously hauled him up the ship's side.[17] First Mate Torrible remembered the *Whangpu* leaving Nanjing on the morning of December 3, 1937, "packed with refugees, many hanging on outside the main deck rails, until gradually they could find a foothold on the inside."[18] The steamer plowed upriver, and Han Lih-wu watched Nanjing recede, the throb of the ship's engines beneath his feet, the stench of the bombed, burning city in his nostrils.

By the time Han Lih-wu had seen the cases unloaded and on their way to storage in Wuhan some days later, the journey back downriver had become too dangerous to undertake. John Rabe was sorry to see Han Lih-wu leave. He was, wrote Rabe, "an extraordinarily competent man."[19]

As the Japanese closed in on the capital, Ma Heng was safe upriver, watching the Central Route steamships churning up the Yangzi to the docks in Wuhan and the porters doggedly

unloading case after case from the cargo hatches. But in December his arduous duties as director of the Palace Museum were suddenly overtaken by harrowing personal concerns, or, in his son's words, by love.

Ma Heng's fourth son was a soldier in the army of the Republic of China. Just a few months earlier, in September 1937, Ma Wenchong had graduated from a military academy and received orders to report to the Shanghai area of operations. The raw young officer was to be thrown immediately into combat. Given the scale of the casualties that the republican forces were suffering, especially among officers, he must have believed, and so must Ma Heng, that his chances of survival were bleak. On the way to the front to take up his duties, Ma Wenchong traveled to see his father, quite possibly to say his farewells. Ma Heng spoke quietly to him, telling him that the defense of China "required great bravery."

By the end of November, as Han Lih-wu was organizing the frantic loading of the last shipments out of Nanjing, Ma Wenchong was among the hundreds of thousands of troops deployed in the city's hopeless defense. How or where is not clear, but he was gravely wounded. Somehow, he escaped the awful fate of so many wounded soldiers and was evacuated upriver to a hospital in Wuhan.

The lot of a Chinese soldier who became a casualty was, in general, hopeless. Most died of blood loss or shock where they fell, in a trench or a ditch or in the rubble of China's eastern cities. Battlefield medicine barely existed in the army of the republic. Wounded men evacuated from battle could face days or weeks of lying in their own blood and filth before arriving at a casualty clearing station or a hospital after an agonizing journey, bumping and swaying on a stretcher or a truck, without painkillers. Wounds festered, and infection killed untold numbers. Medical reports of the time note that wounded

soldiers who did reach a medical facility were often weakened by malnutrition. Months of eating a diet of old white rice and little else left them without strength, body fat, or resistance. They arrived at hospitals with infectious diseases as well as wounds; men with dysentery and malaria filled the wards. Outbreaks of typhoid, cholera, and plague erupted with regularity. The soldiers were riddled with lice, so lice-borne diseases like typhus were widespread, as were parasitic infections. Wounds from shrapnel or gunshot that ruptured the stomach or intestine, remembered one doctor, could lead to infestations of roundworm escaping the gut and spreading into the abdominal cavity, an outcome that invariably proved fatal.[20] Ma Wenchong was exceptionally fortunate to find himself in a hospital receiving treatment; perhaps his father's prominent position as director of the Palace Museum was a factor.

Ma Heng, on hearing of his son's injury, made his way to the hospital in Wuhan. When he arrived, Ma Wenchong was unconscious; he had been in surgery under general anesthetic and had not yet come round. Other soldiers on the ward watched as Ma Heng approached his son's bed. Ma Wenchong lay unresponsive, eyes closed, skin pallid. His father sat by the bed and waited for a long time. At one point Ma Heng took a handkerchief from his pocket and wiped away tears. Throughout, he said nothing.

Later, on hearing of his father's visit from other soldiers in the ward, Ma Wenchong marveled at this public demonstration of parental love. Such an emotional display seemed to him deeply out of character for Ma Heng. The son knew his father as someone who suppressed his feelings and placed great value on self-control. "It surely grew out of the way he was educated," Ma Wenchong wrote. "He never wanted any romantic notion of forsaking duty for love to seep into his children's thinking."[21] It might seem strange that a father

leaving his work to rush to the bedside of a wounded son could spark such surprise, yet a nineteenth-century Confucian education could impose powerful psychological constraints on the individual. For the Confucian intellectual, to act in an unrestrained, spontaneous, and emotional way was beyond undesirable; it was unbalanced, even unethical, a signal that one's baser instincts had triumphed over self-cultivation. It is not hard to imagine that his son's life-threatening wounds, added to the onerous nature of his work at the museum and its accompanying political hazards, and the awful responsibility of ensuring the safety of the imperial collections, combined to place Ma Heng under great emotional strain. One might imagine too that he was not best equipped to manage or to express his own anguish.

Han Lih-wu's effort to evacuate the imperial collections from Nanjing was not a complete success. Nearly 3,000 cases never made it aboard a steamer, and on December 3, the ferry service taking the loaded freight cars across the Yangzi River stopped running, so no more cases could leave Nanjing by rail. At least one more steamer, the *Wenchow*, was due to dock at Hsiak-wan to take on more cases, but air raids and the crowds of refugees had rendered the situation at the waterfront so peril-ous that the ship's captain "did not dare to risk stopping and loading." Porters hauled the remaining cases back to the Chao Tian Palace storage facility. A few curators locked them away and remained with them as custodians. Over the following days, the supply of porters and trucks entirely dried up, and all movement ceased. On December 7 military police sealed off the Chao Tian Palace complex, and stationed troops and an army hospital in the museum's storage buildings and work-shops. As a result, 2,954 cases never made it out of the capital. Ma Heng castigated himself for the failure. In a report to the

museum's board of directors he wrote, "I have examined my conscience in this matter, and I am filled with remorse that our work at the Nanjing storage facility was not completed . . . I must shoulder the entirety of the blame."[22]

Generalissimo Chiang Kai-shek flew out of Nanjing on December 7. He was "broken-hearted" at abandoning the city, according to his diary.[23] In the ensuing days the republic's troops followed orders and fought hard to keep the capital out of Japanese hands. Some 70,000 died trying to hold the city.[24]

On Sunday, December 12, 1937, the weather was unusually mild and clear. Japanese artillery pounded Nanjing's great gray walls, and tanks and infantry probed. Inside the city, Chinese troops withdrew from their positions, setting buildings on fire to deny the enemy use of them. Discipline started to break down: soldiers looted and abandoned their weapons and uniforms. Thousands of soldiers fled to the docks at Hsiakwan, hoping for a boat or some means of escaping to the far bank of the Yangzi, nearly a mile away. To reach the docks, streams of frightened, leaderless men had to pass through the city wall at the narrow Yijiang Gate. Soldiers and refugees in their thousands jammed the gate, and panic set in. Untold numbers died there, crushed or asphyxiated in the melee, or shot, as furious, terrified soldiers randomly opened fire. Beyond the gate, on the docks, hordes of soldiers and refugees swamped the boats that came to take them across the river. Hastily rigged rafts sank in the brown Yangzi waters, their occupants swept away. Throughout the day, civilians streamed into the International Safety Zone, where Rabe, Fitch, Vautrin, and the other foreign organizers readied themselves for what was to come. By 5 p.m., Japanese infantry were clambering up ladders and piles of rubble to raise their flags on the city walls. In the evening the Chinese general charged with defending the city ordered the remnants of his divisions to break out through a gate in

the northern wall, and to launch a fighting retreat. It was over. Nanjing had fallen. "Few people will sleep in the city tonight," Minnie Vautrin wrote in her diary.

Japanese troops, exhausted, hungry, and vengeful, advanced into the city on the morning of December 13, 1937.

Our knowledge of what followed the fall of Nanjing derives from varied sources: the testimony of Chinese civilians and Japanese soldiers, war crimes investigations, journalists, the dogged work of historians and archivists, and, very significantly, from the diaries and recollections of Minnie Vautrin, John Rabe, and the other foreign organizers of the International Safety Zone. A missionary, John Magee, shot 16-millimeter film that was later smuggled out by George Fitch. Together, the evidence shows that, in the weeks immediately following their occupation of Nanjing, Japanese troops committed mass murder throughout the city, slaughtering Chinese soldiers and enormous numbers of civilians with rifle, bayonet, machine gun, and sword. They committed atrocious acts of sexual violence on women and girls. They acted with apparent impunity, their own officers and military police reluctant to intervene. Collectively, the Japanese soldiery perpetrated a colossal act of terror and violence, and inflicted profound, lasting trauma.

The killing started within hours of the Japanese entering the city. The streets were soon strewn with the bodies of executed Chinese prisoners of war. Late in the day on December 13, Japanese soldiers entered the International Safety Zone and dragged out 200 men they deemed to be Chinese soldiers sheltering there and killed them, setting a pattern that would continue for days. John Rabe found himself patrolling the zone brandishing his Nazi Party badge and a swastika armband to deter marauding Japanese troops. On the night of December 17 Rabe wrote in his diary, "You hear of nothing

but rape. If husbands or brothers intervene, they're shot. What you hear and see on all sides is the brutality and bestiality of the Japanese soldiery."[25]

Minnie Vautrin's beloved Ginling College, where she had worked and taught, now sheltered some 10,000 refugees, most of them women and girls. At night Japanese soldiers would prowl the college grounds, dragging out women for rape. Vautrin confronted them time and again, placing her body between terrified refugees and the predatory troops, cajoling and imploring the troops to leave. On December 17 she recounted in her diary how after dark the Japanese came to the college supposedly searching for Chinese soldiers in hiding. They marched out male members of the college staff, janitors, gardeners, and cooks, and made them kneel by the side of the road.

Vautrin, certain the men would be killed, remonstrated with the Japanese. The soldiers forced them all to remain there by the roadside in the freezing darkness for hours. After a while, Vautrin heard screams and realized it was a ruse. She and her staff were held at the front gate while soldiers entered the college through a side entrance and abducted women for rape. They took twelve. "Never shall I forget that scene—the kneeling at [the] side of road, Mary, Mrs. Tsen and I standing, the dried leaves rattling, the moaning of the wind, the cry of women being led out."[26] To read Minnie Vautrin's diary is to witness this cheerful, devout, punctilious woman's journey through fear into incomprehension, and on to psychological exhaustion and breakdown.

It remains uncertain how many people fell victim to Japanese atrocities in Nanjing. The government of the People's Republic of China maintains that 300,000 died. Some historians estimate a lower number, but in the many tens of thousands.[27] The true figure is unknowable, as is the experience

of every individual who lived through that time, or who died during it. The question of how or why the atrocities took place draws unstable, shifting answers; historians have pointed to the brutalization of Japanese soldiers and army-wide fury at Chinese resistance, a failure of military discipline and logistics, and racial chauvinism. The Japanese commanders, it seems, did not order the massacre.[28] Yet the manner in which some of the killings were carried out—the roping together and systematic execution of large numbers of Chinese prisoners of war, for example—suggests a premeditated, planned aspect to them. Our knowledge of these events has to it a quality of the glimpsed, the half-seen and half-understood.

The courageous foreigners who set up and ran the International Safety Zone found their lives defined and blighted by their experiences in Nanjing. George Fitch, the YMCA director, worked tirelessly in the United States to draw attention to Japanese war crimes. John Rabe, on his return to Germany, was arrested and interrogated by the Gestapo, who then forbade him to speak of what he had seen so as not to undermine Germany's relations with Japan. Minnie Vautrin returned to America in May 1940 shattered by her experiences. She underwent long, difficult treatment for depression. She seemed to recover for a while but wrestled with a profound sense of failure. In May 1941 she was staying at the home of a missionary colleague in Indianapolis. Alone in the apartment one day, she went into the kitchen, turned on the gas stove, and took her own life.

9

THE CENTRAL ROUTE

In the terrifying weeks that preceded the fall of Nanjing, Palace Museum staff managed to evacuate some 16,000 cases of artifacts. Eighty of them, those containing the very rarest pieces, were sent into China's far southwest on the Southern Route. On the Northern Route, 7,000 or so cases rattled across the railways of northwest China. But the largest shipment, some 9,000 cases, was to take the Central Route, by steamship up the Yangzi River.

The Yangzi River was dangerous. Mines floated unmoored all along the lower reaches. The Chinese army had removed aids to navigation along the banks, making it hard for captains to judge their position in relation to its hazardous sandbanks and shoals.[1] And as they withdrew, the Chinese laid booms across the channel to prevent the passage of Japanese warships upstream. In December 1937 the river's banks were deserted where the Japanese army had passed, the villages empty, cold, and bleak but for an occasional fisherman and small boats moving silently in the reeds. Seen from passing vessels, Nanjing and the occupied river towns were still, smoking ruins, their landings littered with sunken shipping.[2] Japanese

bombers droned overhead, using the river to navigate to their targets.

Early in December the two steamships *Kiangan Lun* and *Whangpu*, carrying the Central Route consignment, had navigated the 400 miles upriver from the beleaguered capital to the port of Wuhan and some small measure of safety. Somewhere in a case aboard one of the two steamers, carefully wrapped in cotton wadding, was the Ming monk's cap ewer with the copper-red glaze. Ma Heng's staff had porters ready at the docks. They unloaded 9,331 cases, pushing their way through the crowds of soldiers and refugees who filled the city. Temporary storage had been arranged in the warehouses of Liddell Brothers, a British company that had traded up and down the Yangzi for decades in everything from animal hides and carpets to cotton. The company owned fire-resistant warehouses with sprinkler systems that the Palace Museum staff no doubt found reassuring, though the cases would not be there long.

For now, Wuhan acted as the hub of the republic's war effort. The headquarters of the military was here, and from the east came the officers, bureaucrats, diplomats, and journalists, as well as refugees who had fled Nanjing and Shanghai. The city was alive with discussion and debate as to the future of the war and of China. If Wuhan could hold, perhaps central China might not be lost to the Japanese, but it seemed an unlikely hope. The government planned to leave Wuhan and withdraw even farther to the west, following the Yangzi through a broad swathe of rocky, mountainous territory and into the lush lowlands and isolation of Sichuan province. The republic's leadership believed that the Japanese tanks, infantry, and lines of supply would find it all but impossible to reach that far, even if the bombers could. Sanctuary, of a sort, lay in Sichuan.

Ma Heng and the Palace Museum's board of directors followed the government's lead. Less than three weeks after

the Central Route cases had arrived in Wuhan, porters began manhandling them out of the warehouses and back to the docks. The Palace Museum had gone once more to British trading companies, B&S again and Jardine Matheson, hiring two steamers and an enormous iron flat-bottomed barge. On Christmas Eve 1937 the vessels, loaded with the cases, got underway, plowing ever farther upriver, 350 miles to the port of Yichang.

Yichang was overwhelmed. Refugees poured in by boat and by road, most of them desperate for passage farther west. The town had become a bottleneck, overflowing with exhausted, destitute families, their expensive clothes from the fashionable cities of eastern China now dirty and threadbare. Many had sold their belongings to survive and were now stuck, unable to afford tickets even if they could find a berth on a boat. Diarrheal disease and typhoid were rife. On the city wall that ran along the waterfront, scrawled in chalk, were thousands of messages left by families and traveling companions who had become lost or separated, in the hope that a scribbled name and destination might somehow find a lost husband or parent or child. The docks teemed with river traffic. Occasionally, a Commodore flying boat would skim in and land before the waterfront, bringing in dignitaries or senior officers.[3]

The steamers and the barge chartered by the Palace Museum had all arrived at Yichang by January 6, 1938. The directors had no intention of leaving them there for long, however. The town was a target for Japanese air raids, which were reaching ever farther west. Ma Heng gave orders for the cases to continue upriver into Sichuan province as soon as possible.

Difficulties in securing river transport were now compounded by geography. For 110 miles upriver of Yichang the Yangzi was extremely difficult to navigate. The river's rolling floodplain gave way to mountain ranges, its waters surging

through boulder-strewn gorges hundreds of feet deep, its level rising and falling precipitously. The current was fast; the water was shallow and boiled white around lethally sharp rocks. Whirlpools sucked and clawed at passing vessels. Strange hydrological phenomena arose apparently from nowhere, noted one famed river pilot: "The water rises in a dome-shaped mass, then suddenly caves in, forming momentarily a deep hole down which the surrounding water rushes with a great commotion and roar. It would hopelessly engulf any small craft and probably break up a junk if caught in the vortex."[4]

The workhorse Yangzi steamships and barges that the Palace Museum had chartered up to this point were no longer any use; they were too large and underpowered, too clumsy, their keels far too deep. On the upper Yangzi, ships had been hauled upriver for centuries by men known as trackers. Squads of trackers, sometimes hundreds strong, tramped the banks of the river dragging boats through the vicious currents on ropes of woven bamboo. It was terrible, dangerous work, the men bent double, chanting to keep time as they drove forward inch by inch along riverbank paths worn into the rock, the ropes at breaking point. But by the 1930s the shipping corporations had designed steamships specially to handle this arduous stretch of river. The new upper Yangzi steamers were light, stubby in appearance, with shallow draft and powerful engines. They could maneuver quickly and deftly, driving hard against the current on the upstream journey, bobbing and careening at high speed on their way downstream. It was these vessels the Palace Museum needed to transport the cases onward from Yichang, but because the steamers were small, the curators needed many more of them.

Ouyang Daoda, the sharp-eyed disciplinarian who oversaw much of the logistical organization on the Central Route, remembered the early months of 1938 as an exhausting search

for cargo space on upper Yangzi steamers and a desperate race to stay ahead of the Japanese bombers. Local businessmen were profiteering, charging exorbitant rates for passage upriver, and, even when the Palace Museum's curators explained their patriotic mission, were unmoved, Ouyang Daoda noted with contempt. The negotiations left the curators "parched with exhaustion," but they succeeded in securing cargo space on steamers belonging to Jardine Matheson, B&S, and the Min-sheng Industrial Company.[5] The first consignment upriver to Sichuan left Yichang on January 9, just three days after the last cases had arrived. The shipments continued sporadically in the following days and weeks, 500 or so cases at a time, but the first Japanese bombers arrived over Yichang well before all the cases were evacuated. Eight aircraft targeted the local air-field. Bombs went astray and landed on the waterfront, tear-ing into crowds of refugees, causing carnage.[6] As the air raids continued, Ouyang Daoda implored, cajoled, and harried the steamship companies. At times like this, the imperial collec-tions seemed only days ahead of disaster.

It took nineteen shipments to move the 9,000 cases out of Yichang. The little steamers pulled away from Yichang's water-front and churned against the current, heading west, upriver, into the deep, shadowed gorges, dodging the shoals and reefs, fighting their way through the whirlpools, hugging the banks to avoid ships scudding downstream before the current, pilots wrestling the wheels. The steamers passed chanting trackers, the rotting skeletons of wrecked junks scattered upon the rap-ids, and villages, their houses of straw matting perched on sunless cliffs. All along the Yangzi River flowed the spoil and detritus of war: displacement and disease, corruption, dead-ening loss, and fear. Amid it all, under the shaky, improvis-ing hands of Ma Heng, Ouyang Daoda, and a few exhausted art historians, the monk's cap ewer and a vital portion of the

imperial collections continued on the Central Route, invisible within their stifling layers of paper, cotton wadding, and straw. Only after four agonizing months, in May 1938, had all the shipments arrived at their destination, Sichuan province, and the river city that would serve as China's wartime capital, Chongqing.

Chongqing was a city suspended between river and rock, a great promontory thrusting out into the confluence of the Yangzi and a tributary. The center of the city clung to cliffs, its streets a steep, angled maze of stairways and switchbacks, its passages peopled by sweating, bellowing porters toting shoulder poles, baskets, bundles, and sedan chairs. The arrival of the republican government swept in hundreds of thousands of new residents: legions of bureaucrats, diplomats, military officers, the KMT's party functionaries, factory managers, engineers, journalists and writers, students, and teachers. With them streamed in near-destitute refugees forced westward by the Japanese advance. The distinctive dialect of Sichuan province mixed in the city's speech with those of Shanghai, Nanjing, Wuhan, Guangzhou, and every point between, in a great emulsion of language and regional culture. The population had swollen from a quarter of a million to three times that. Food was scarce. So desperate was the shortage of accommodation that shops did their normal business during the day and rented out their counters as bed space at night.[7] Hasty new construction bloomed along the riverbanks. Transplanted factories geared up to begin production of weapons, cotton cloth, silk, wire, and nails, and vegetable oils to substitute for gas and kerosene. Universities evacuated from their eastern campuses began classes in improvised lecture halls. As the battered republic struggled to reestablish itself, bewildered government officials unpacked their files in unfamiliar, cramped offices and

tried to get to work. Chongqing was a city transformed, experiencing crisis and boom all at once. And the Japanese bombers had not yet arrived.

The Palace Museum's cases trickled into Chongqing by steamer between January and May 1938. The first 3,000 went to a warehouse owned by a local bank for temporary storage, but the available space was soon filled. In February hundreds of cases went to a warehouse once used to store confiscated opium, owned by the city and located in the center of town. Whoever was responsible for inspecting the place—whether Ouyang Daoda or Ma Heng or another curator—failed to notice a problem: a joist holding up one section of the warehouse's wooden floor was rotten. Porters carried in the cases and started to stack them. As the weight increased, the joist cracked, and part of the floor gave way. To the curators' horror, a stack of cases plummeted into the space below and crashed to the ground. Staff clambered down to assess the situation. Seven cases looked like they had sustained damage. Case number 4272 was in the worst shape. The catalog told them that 4272 contained eight fine white porcelain wine vessels, their form modeled on a style of ancient ritual bronze known as a *jue*. The *jue* stood on three delicate legs, its spout elongated and elegant. It had little loop handles for pouring. The original bronze *jue* were used in deep antiquity for ritual libations. The porcelains, probably dating from the Ming or Qing, were a remaking of this ancient, mystical form.

In the old opium warehouse the curators broke the paper seal on the case, pried off the lid, and peered inside. Of the eight vessels, two had shattered into pieces. A third had lost a leg. The other five owed their survival to the packing, to the concentrated efforts of Chuang Yen and his staff back in the Forbidden City five years earlier. Six other cases were damaged, but in all of them the contents were unharmed. Ouyang Daoda, the

starchy disciplinarian, was unimpressed. "We made a special note of this event," he wrote, "in order that it might encourage vigilance."[8] The warehouse was abandoned as unsafe.

The cases ended up scattered in seven warehouses across the city of Chongqing, some owned by the venerable French perfumery company Antoine Chiris, others by a Swedish company, Anderson, that dealt in hides and cured meats. Ma Heng fretted over the warehouses. They were "exceptionally simple and crude," he reported to the board of directors, and "practically incapable of providing any protection from fire or air raid." This had to be temporary. Everyone knew the Japanese bombers were on their way.

In March, before all the cases arrived in Chongqing, the board ordered Ma Heng to find safe, permanent space. Ma Heng set off in person through the crowded, churning city to look for a solution, and he thought he had found one. In July 1938 he went to the directors with a bold plan. Work should begin immediately, he wrote in a report, drilling tunnels deep into a rocky hillside at a spot named Caiyuanba, on the edge of Chongqing. The tunnels should be deep enough to constitute an underground shelter that could hold 18,000 cases. Ma Heng's chosen location was suitable, he argued, because it abutted a road, so transportation would be simple; it was high enough above the river to be clear of the water, yet still well protected by deep layers of rock. He drew up plans for outbuildings and suggested hiring a railway engineering company for their expertise in tunneling. He acknowledged that damp might still pose a problem, and argued that paintings, calligraphy, and books vulnerable to humidity should go farther to the southwest, even as far as the high, dry city of Kunming, more than 400 miles away. The plan in its entirety constituted an enormous, very costly undertaking. The cost of drilling the tunnels alone Ma Heng estimated at 230,000 yuan.[9]

The Palace Museum's directors circulated the report to the government and the military. The proposal was emphatically rejected. The site was too near the airfield, which would certainly be a target for Japanese bombing, and the digging would take a year at least, and that was far too long. Ma Heng was sent away with a recommendation that he search outside Chongqing in more remote areas, where the threat of Japanese bombing was less.[10] So he and Ouyang Daoda set out into the villages and tiny towns that speckled Sichuan's countryside to the west of Chongqing in a search for the right place—a place not too far from a river, perhaps, so the cases could be floated or barged if need be, and the muddy, rutted roads avoided. The two of them traveled for weeks during that uncertain spring, clambering in and out of caves; inspecting a university campus; poking around in Buddhist, Taoist, and Confucian shrines whose walled courtyards enclosed spacious, airy temple buildings; and evaluating clan and ancestral halls in quiet villages of red earth and shining rice fields.

The early months of 1938, as those 9,000 cases made their watery way to Chongqing on the Central Route, were a crucible for the republic. In January Tokyo announced it would no longer negotiate with the government. Its aim was to destroy the Chinese state. In March a former Japanese foreign minister stood in Japan's parliament and said, "The Chinese must be made to realise that they are inferior to the Japanese in culture and aims and they must follow in the footsteps of the Japanese."[11] Japanese armies thrust into central China. From the north came the divisions that had stormed out of Manchuria, crossed the Great Wall, and taken Peking. From the east came those that had fought in Shanghai and ground their way along the Yangzi, leaving Nanjing abominably violated in their wake.

In March 1938, in a town called Taierzhuang 200 miles to the north of Nanjing, Chinese troops fought with breathtaking tenacity to hold back the Japanese advance and keep control of vital railways. They dug holes in canal banks to shelter from artillery bombardment, emerging to fight hand to hand. In the cramped town, Japan's advantage in artillery and tanks counted for less. This was street fighting, infantrymen mauling each other in the rubble with machine gun, bayonet, and hand grenade. Japanese forces were accused of using chemical weapons at Taierzhuang, perhaps a harassing agent like diphenylcyanarsine, sometimes known as sneezing gas, a powerful irritant that causes tears, sneezing, and vomiting.[12] The Japanese carried it in red canisters they called *aka-to*—"red candles."[13] (The Japanese army would use chemical and biological agents repeatedly in China during the Second World War.)

At Taierzhuang the Chinese showed suicidal bravery. Infantrymen strapped grenades to their chest and leaped under Japanese armored vehicles in the hope of blowing them up. And for once, the Chinese lines of supply held. Ammunition and fuel arrived, although exhausted troops were reported to be subsisting mostly on sweet potatoes. After a week of desperate combat, the Japanese had had enough. They broke and ran. It was the first Chinese victory of the war, albeit a lonely one, and cause for great celebration. For a moment the Japanese army appeared less than invincible. Taierzhuang stiffened China's brittle resolve and fostered a tentative, growing sense of national resistance among people of disparate regions, dialects, and class. The elation was real, but the advantage temporary. The Japanese regrouped, counterattacked, and pushed on into central China, the crucial city of Wuhan in their sights. The republic's position was desperate.

Generalissimo Chiang Kai-shek searched for a way to slow the Japanese down, to buy time for his armies and his

government in their withdrawal to what he now called Free China, in the west. In June 1938 he approved a plan so extreme and so callous as to blight his legacy and reputation forever.

The Yellow River runs through north China. It flows down from the semidesert regions of the northwest, carrying a heavy load of silt. The silt builds up, choking the river, which bursts its banks with regularity and causes terrible flooding. For 2,500 years China's rulers have sought to control the Yellow River. For centuries, imperial officials raised armies of laborers to maintain hundreds of miles of flood defenses, building vast embankments of earth to contain the river, some of them sixty feet high. In the 1930s the river remained dangerous, its course determined by gigantic dikes. The physical integrity of the dikes was crucial; a breach would be catastrophic for the surrounding population.

On the night of June 6, 1938, army engineers of the republic's Eighth Division stood atop a Yellow River dike at the village of Huayuankou, looking out at the moving water, feeling the warm early-summer wind on their skin, walking by torchlight, surveying the structure beneath their feet. Japanese advance units were just a few miles away to the north, on the far side of the river.

Two days later, on June 8, at that same spot, the engineers oversaw 2,000 soldiers begin to hack away at the dike with picks and shovels. Singers and musicians performed to encourage them, and officers promised the soldiers extra pay if they worked fast. Within hours the soldiers had breached the dike. River water began to flow through the breach into the surrounding countryside. The breach grew. By 10 a.m. the following day it was hundreds of feet wide, and the water was a torrent. Some three quarters of the Yellow River's volume poured out onto the fields, villages, and towns of Henan province.

No warning was given to the people in the path of the flood. The water surged across the landscape, washing away houses, inundating fields, polluting wells, turning everything to mud. Villagers drowned or fled, taking only what they could carry, clambering to higher ground, sloshing through the water to the point of exhaustion. People whose lives were already precarious became destitute in an instant. In the summer heat the filthy water bred disease. Starvation for those displaced was not far behind. The scale of this deliberate, man-made disaster staggers the imagination: the flood inundated some 21,000 square miles of central China. It is impossible to know how many died. There was no one to keep count. The republic's own estimate, after the war, was that nearly 850,000 people died across three provinces, and nearly five million became refugees. Some researchers have concluded the number of dead was lower, perhaps around half a million.[14] No one knows their names or who they were.

Initially, the government of the republic tried to blame Japan, saying that its bombers were responsible for the breach in the dike. Japan denied this emphatically, and it was soon widely accepted that the Chinese government was itself responsible, that it had made the deliberate decision to kill hundreds of thousands of its own people and ruin millions more. Chiang Kai-shek's plan, of course, was to use the floodwaters to slow the Japanese advance. A modern army could not cross inundated land; its tanks and trucks and guns would simply bog down. A pause in the advance would buy the republic time it desperately needed. Historians seem unsure as to how far the flood achieved that objective. Perhaps it bought a little time. Wuhan would still fall to the Japanese later in the year; they just advanced from a different direction, avoiding the water and the mud.

The effects of this man-made flood lasted for years. While

the breach remained open, the flood returned annually, creating new refugees year after year. They wandered a desolate, defiled landscape, the fields and roads in some places covered in three feet of mud and silt. The silt rendered great tracts of fertile land unusable. Terrible famine years were coming, and they flowed in part from the breach in the dike at Huayuankou. The government of the republic did not abandon the flood victims; it made sincere attempts to help. Refugees were resettled and mobilized to recover damaged land. But those efforts were not enough to compensate for the terrible damage done. Exhaustion and disillusion spread across the inundated areas of central China, an early foretaste of the wider disillusionment the republic would face as the war dragged on.[15]

The curators of the Palace Museum had had time to adjust to their wartime role as emergency conservators, and in the Chongqing warehouses, where the cases on the Central Route now waited, there was work to be done. Storage required active conservation, and in the spring and summer of 1938, under the unflinching eye of Ouyang Daoda, the curators busied themselves with the elaborate rituals of caring for fragile, perishable art. Ma Heng commissioned the construction of hundreds of feet of shelving. The shelves stood about a foot off the floor, were made from cypress wood, and were sturdy enough to support stacks of several cases. Lifting the cases off the warehouse floor enabled air to circulate around them and lessened the danger of damp. The curators slathered tar on the supports of the shelving to keep the wood from rotting, and underneath spread coal to battle ants, termites, and moths, the first skirmish in what was to become an anxious, demanding, yearslong campaign against the voracious pests of west China. They arranged the shelves in orderly rows with space between them so that cases could be identified by the codes on

their paper seals and brought out for examination, and they compiled lists of where exactly every case was. They could cross-check the list with the catalog to pinpoint the location of any given piece, from a volume of poetry to a Tang funerary object to a bronze bell used in ancient rituals whose form and significance remained a mystery.

The curators inspected all the cases; they replaced any that were damaged and repacked them, altering the catalogs and coding systems accordingly. During the inspection they found damp inside several cases. Ouyang Daoda tried to work out how the water had gotten in. Probably, he wrote, spray from the river during loading on and off steamships had seeped in through cracks in the wood. It had taken six months to transport the cases all the way from Nanjing to Chongqing, and at no time had the curators been able to take out paintings or books to air them and dry them in the sun. That summer Ouyang Daoda oversaw the opening of 112 damp cases and the careful inspection of their contents for the tiny black specks that signified mold. In case 162, which contained books, they found that water had accumulated inside the case. Pages had stuck together. The curators opened the books to dry them out and unrolled and hung paintings so the air could get at them. On sunny days, not so common in Chongqing, they took the damp wooden cases outside, wiping them down and turning them over to dry in the sunshine. Chongqing is a humid, cloudy city, often wrapped in mist, and the curators worried that the climate was all wrong for long-term storage. For a porcelain object such as the monk's cap ewer, damp posed no problem, but to paper and silk it was a pernicious threat.

Toward the end of the year a request came from a museum located in the province of Anhui. Could the Palace Museum take into its care twelve cases of evacuated Anhui objects? Ouyang Daoda agreed. The objects were ancient bronzes and

The Meridian Gate, southern entrance to the Forbidden City, in the late 1930s.

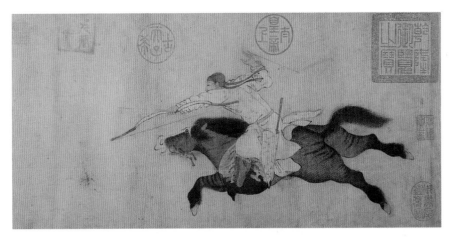

Detail from *The Stag Hunt*, attributed to Huang Zongdao, active ca. 1120. The prominent seals at the top of the image are those of the Qing emperor Qianlong.

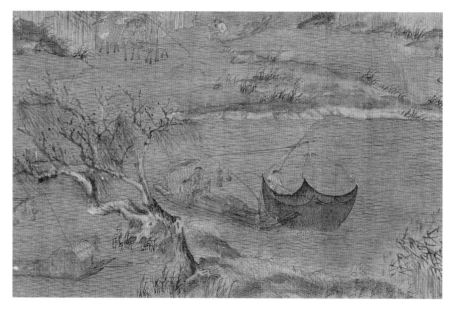

Detail from *Early Snow on the River*, handscroll, ink and color on silk, by Zhao Gan, active in the late 10th century. Note the careful depiction of the fishing apparatus.

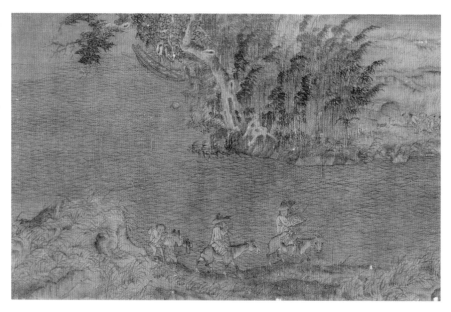

Another detail from *Early Snow on the River*. The figures in the foreground are concubines on donkeys, and servant boys.

Unknown artist, *Jadeite Cabbage with Insects*, Qing period.

Palace Museum staff pack objects in wooden cases prior
to evacuation from the Forbidden City, 1932.

A soldier of the Republic of China, Shanghai, 1937. He wears
a German-style helmet, and has grenades strapped to his chest.

Damage wrought by Japanese aerial bombing in Chongqing, the wartime capital of the Republic of China, 1940.

Communist troops on patrol amid fields of sorghum in a communist-held area of north China, 1939.

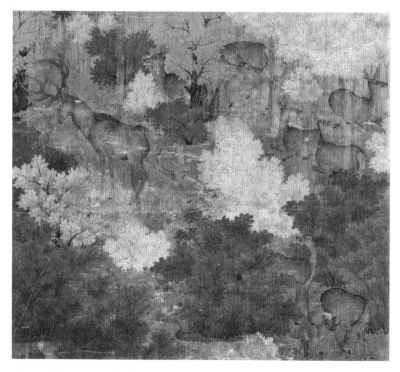

Detail from *Herd of Deer in an Autumn Forest*, hanging scroll, ink and color on silk, by an unknown artist in the 10th century.

Monk's cap ewer with red glaze, Ming period,
Xuande reign (1426–35).

One of the ten Stone Drums of Qin on display
in the Palace Museum, Beijing. Note the damaged surface.

Detail from *Inscriptions on the Stone Drums (Eastern Zhou dynasty,
5th century B.C.)*, by an unknown artist, 17th century.
This long handscroll consists of a series of rubbings taken
of inscriptions on the Stone Drums of Qin.

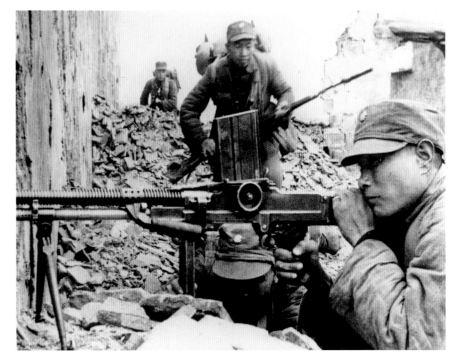

Infantry of the Republic of China in action amid the rubble
of a Chinese city, 1940s.

artifacts of stone and jade from the state of Chu, a rich, myste-
rious kingdom renowned for its art, poetry, and shamans that
expanded across central China over hundreds of years during
the Zhou period, only to be crushed by the Qin in 223 BCE.
When the cases of Chu objects arrived, Ouyang Daoda was
horrified. They were huge, and far too heavy to be easily car-
ried or loaded. They had also been left out in the rain, so
the wood was rotting. Inside, he found horribly inadequate
packing. Hard, heavy objects of stone lay next to light, frag-
ile bronzes with only rice husks and straw to separate them.
Some pieces had broken. The curators extracted every object
and fragment they could find, compiled a new inventory, and
repacked everything in new, much smaller cases.

At every stage of their journey Ma Heng and his curators
learned anew the crucial importance of packing. The objects in
their care faced assorted dangers—bombing, plunder by Japa-
nese troops or by bandits, weather, damp, pests, poor roads,
turbulent rivers, rotted joists, and accidents of all kinds—but
poor packing posed the greatest danger of them all. If the
objects were not immobile and dry in their cases, little else the
curators did to protect them had any point. The irony did not
escape Ma Heng or Ouyang Daoda, both of whom noted in
their accounts of these years that removing the objects from
the Forbidden City to save them from Japanese air raids and
plunder served to expose them to other, more banal but no less
formidable risks.

In late 1938, however, it was the threat of Japanese
bombs falling on Chongqing that consumed Ma Heng and
the museum's directors. Ma Heng and Ouyang Daoda spent
weeks exploring rural Sichuan, searching for a storage site
that offered safety, accessibility, and anonymity for the years
to come. Near the city of Leshan, they found one. Leshan lay
100 miles west of Chongqing, but by river the distance was

closer to 300, a long weaving journey, first on the Yangzi and then up its tributary, the Min River.

The traveler who arrives in Leshan on the Min is greeted by an enormous seated Buddha, 230 feet tall, carved 1,200 years ago into red sandstone cliffs flanking the water. At the Buddha's feet, the river splits again, and the Dadu winds away to the west. Some eight miles upstream along the Dadu lies a small town called Angu. The town was dotted with ancestral halls, templelike complexes owned by local clans and used for rituals, weddings, and gatherings. Ma Heng liked the way these structures all stood somewhat alone, with open space around them, making them less vulnerable to the spread of fire. He chose the Dingyi temple and six ancestral halls belonging to various local clans to act as warehouses, and started the delicate, careful negotiations with local elders necessary to secure help and cooperation. The museum would pay rent for the buildings, and could employ villagers as porters, as craftsmen to work on the fitting out and upkeep of the warehouses, and as guards and laborers. Renovation work at Angu got underway by early 1939, and Ma Heng and Ouyang Daoda began urgent preparations to ship the Central Route cases out of Chongqing to what they hoped would be safety for the duration of the war, however long that would be. But the war was catching up.

The first Japanese air raids came to Chongqing in early January 1939, and not a single case had yet left for Angu. Over 9,000 remained there, stacked in flimsy, temporary warehouses. Initially, the Japanese bombers targeted military facilities outside the city limits, but on January 15 bombs fell for the first time on the center of the crowded, claustrophobic city. Spotters reported thirty Japanese aircraft flying west along the course of the Yangzi at 1:30 p.m., and they were over Chongqing shortly afterward. The city's antiaircraft guns

roared into action, but to little apparent effect. Bombs fell on waterfront warehouses, where "many wharf coolies were killed or wounded." A packed teahouse near the east gate took a direct hit. A reporter counted fourteen bodies laid out in the street, though many more "were still entombed" in the ruins. Police and firemen dug in the smoldering rubble and pulled out victims, living and dead. Many of the wounded, wrote the reporter, "had their hands, arms or legs blown off by the fragments of exploding bombs." Chinese aircraft scrambled and intercepted the bombers, their engines screaming as they dived. The air force claimed to have shot down at least one bomber, though the Japanese denied it.

Japanese aircraft raided up and down the Yangzi River that day. While the cities of Sichuan were safe from occupation by Japanese troops, it was painfully clear that they lay within the deadly reach of the empire's air force, and that civilians would not be spared. The reporter who witnessed the bombing at the teahouse noted somberly that "an intensive aerial bombardment of [Chongqing] city would result in an appalling catastrophe, as the city is densely populated, without any open spaces for refugees in case of fire."[16] The city set workers to building air-raid shelters, tunneling hundreds of feet into the rocky slopes, and strengthened its early-warning systems.

As the first bombs fell on Chongqing, something akin to panic seems to have taken hold among the directors and staff of the Palace Museum. The directors ordered Ma Heng to get all the cases, now totaling 9,361, out of Chongqing by the middle of April, no matter what. As his staff scrambled once again to hire porters and find cargo space aboard steamships, Ma Heng found himself facing a larger and apparently intractable problem. To arrive at his chosen destination in the temple and ancestral halls of Angu, the cases first had to travel along the

Min River to the feet of the great sandstone Buddha of Leshan. In spring, however, water levels along the Min fell so low as to render the river unnavigable. Ma Heng and his staff might get the cases out of Chongqing, but reaching safe, permanent storage in Angu was impossible until the water rose, months later in the summer. They would have to take the cases to a staging point, a facility where they could wait until later in the season. It was an unsatisfactory solution; temporary storage meant yet more unpredictability and risk, damp and creaky warehouses, and difficulty conserving the most fragile objects. Ma Heng settled on four warehouses owned by a variety of companies and banks in the river city of Yibin, where the Min meets the Yangzi, signing a contract with a commercial transportation company called Lianyun, a decision everyone would come to regret.

Loading began on March 28, 1939, and on March 30 a steamer, the *Changhong*, left the wharf at Chongqing and plowed upriver, carrying the first shipment of 680 cases to the staging point at Yibin, a journey of two days. Work at the wharves in Chongqing went on at a frenzied pace; in only fifteen days twenty shipments left Chongqing for Yibin on an assortment of small steamers. Loading continued around the clock in what the usually taciturn Ouyang Daoda called a "surge of panic and haste." The events of April 10 perhaps explain his anxiety.

In the early morning of that day, the steamer *Minte* was taking on 160 cases from a warehouse on the south bank of the Yangzi. It was just before dawn. Thirty-two-year-old Zhu Xuekan, a Palace Museum curator of archives and documents, rose early and boarded the ship in darkness. He planned to inspect the cargo hold and to oversee loading. The *Minte* was due to leave Chongqing the same day, so it was imperative the cases went aboard quickly and efficiently. Zhu strode along

the deck of the steamer in the predawn gloom. He did not see the open hatch beneath his feet. "He stepped onto emptiness," wrote Ouyang Daoda.[17]

The crew found him at the bottom of the cargo hold. He had suffered a terrible head injury and was unconscious. He was rushed to the Canadian mission hospital, but nothing could be done for him, and he died hours later. They buried Zhu Xuekan the following day at a place called Lion's Peak on the south bank of the Yangzi, and erected a tombstone. He was an only son from Anhui province. Six years were to pass before the museum staff were able to locate his mother, and to provide her with some financial support from donations.

The shock of Zhu Xuekan's death did not slow the relentless pace of the shipments. Steamers including the *Tienfu*, the *Hwatung*, and the *Minfu* left daily for Yibin, but by April 11 more than 1,300 cases still remained in Chongqing. The mid-April deadline for their departure was fast approaching. Ma Heng and Ouyang Daoda resorted to desperate, dangerous measures. For two days they haggled with boat captains down on the waterfront, finally settling on the hire of eleven wooden junks. The junks came alongside the wharf and loaded all through the night, each taking more than a hundred cases. On April 15 the junks slowly made their way upriver. They moored some ten miles or so beyond Chongqing, far enough, Ma Heng hoped, to be safe from air raids. There they waited by the bank for steamers to become available and take on the cases. But by April 18 all 9,361 cases were on their way to Yibin, where they would have to wait until the waters of the Min rose.

At the beginning of May 1939 the bombing of Chongqing began in earnest. On May 3 fine weather brought more than twenty Japanese aircraft over the wartime capital. They

unloaded high-explosive and incendiary bombs onto the densely populated city center and along the waterfront, circling back in for a second run. Fire quickly took hold on streets dense with wood structures. Buildings of stone and concrete came crashing down, burying hundreds under the rubble. The power supply was cut, and communications with the rest of China severed. Thousands of people fled to the riverbanks to escape the flames.

The following day, at dusk, the bombers were back, twenty-seven of them this time, cutting a swathe of destruction through business and residential areas a mile and a half long. Thousands died, eviscerated by shrapnel, burned, or buried. Rescue crews worked frantically to contain the fires and to dig out "civilians who were screaming, moaning, and crying beneath collapsed walls and masonry." At the Canadian mission hospital, where Chinese and foreign doctors worked on the crowds of injured, the floors "literally dripped with blood."

As night fell, the city was dark but for the glow of fires. Along the riverbank thousands of families slept in the open, and on the road that led west out of the city thousands more trudged on foot toward safety.[18] The bombing of Chongqing was to last for five years. The city was hit hundreds of times. Until the German and Allied air campaigns got underway in Europe, China's wartime capital was the most bombed city in the world.

The bombers that pounded the cities of China in the 1930s were manufactured in the great factories of Japan, owned by corporations like Mitsubishi and Nakajima. For the most part, the aircraft belonged to the Imperial Japanese Navy. Their range was remarkable for the time; the twin-engined Mitsubishi G3M could fly more than 1,000 miles to its target. To achieve such distances, the aircraft needed to be light. To lessen the weight of the airframe, the bomber had

Japanese bombing in the region of Chongqing, 1940

little armor, leaving its crew and fuel tanks unprotected and vulnerable. A single hit from an antiaircraft weapon or from one of the Chinese republic's obsolete fighters could puncture a fuel tank, and if the leaking fuel caught fire, the G3M became a flying inferno. For the crew of seven, conditions aboard were cold and primitive. Communications were poor or nonexistent.

Japanese bomber crews, according to memoirs from the time, often elected not to carry parachutes. They knew that if they bailed out of a stricken bomber, rescue was out of the question and an awful fate awaited them at the hands of the Chinese if they were captured, so they chose to go down with their burning aircraft. A Japanese pilot on a bombing mission described watching his comrades' aircraft get hit, and the inevitable flames beginning to lick along the fuselage. As the aircraft was consumed, its burned and bleeding crew crawled

through smoke and searing heat to join their comrades in the cockpit. The desperate pilot flung open the hatch above him, and the crewmen pushed their heads and shoulders out into the cold air, embracing each other a last time as the flames engulfed them, the wings tore off, and the doomed bomber arced toward the earth.[19]

As Chongqing burned under Japanese bombs, the cases sat in temporary storage in Yibin, guarded by a company of soldiers, the precious artworks swathed in heat and humidity, the warehouses vulnerable to air raid and fire. It was an awful time for the museum staff. Between the bombing of Chongqing, the vulnerability of the Yibin warehouses, the Japanese advance, the death of Zhu Xuekan, and the general financial uncertainty, the pressure on Ma Heng and Ouyang Daoda was crushing. Nearly three months passed before seasonal rains rendered the Min navigable, and the cases on the Central Route could once again get moving toward their destination in the quiet halls of Angu.

In early July 1939 the shoals and rapids of the Min River finally disappeared beneath the swollen water, and the Lianyun Transportation Company announced itself ready to commence shipping. The steamers had only a narrow seasonal window to work the Min. In the middle of September the river would once again fall, and the rocks reappear. On July 9, 350 cases left Yibin and headed upriver aboard the *Futung*, but the plans laid by Ma Heng and Ouyang Daoda were about to go seriously awry.

The second shipment left on July 11 aboard a small, agile steamer. Only thirty miles out, in a stretch of the river speckled with islets and sandbars, the ship's keel ground against an underwater shoal, "due to the negligence of the river pilot," fumed Ouyang Daoda. An engine was damaged, and water started to enter the cargo hold. The pilot turned the vessel

around and quickly headed back downriver toward Yibin. On the way, he encountered the steamer carrying the following shipment. The pilots conferred and decided to head back to Yibin together. On arrival, they returned their cargoes to the warehouses. The pilots of all the contracted steamships then announced that they would not attempt any more shipments up the Min. Everything ground to a halt. The Ming monk's cap ewer with the copper-red glaze and tens of thousands of other objects were stuck, stacked in temporary warehouses, with only eight weeks to go before the river once again became impassable.

It transpired that the reason for the holdup was far more complicated than a shoal in the Min River. Upon investigation, Ouyang Daoda found out that the Lianyun Transportation Company possessed no steamships of its own, and had subcontracted the job out to other companies while retaining a handsome profit for itself. When the subcontractors found out how much money they were missing out on, they sabotaged the operation, using any excuse to interrupt the shipments. The museum staff in charge of the Yibin operation, headed by a Mr. Liu, were overwhelmed. To make matters worse, support staff assigned to the museum from the central government were clamoring to return to their families in Chongqing and refused to work. Mr. Liu was reduced to bribing the support staff with expensive dinners at restaurants to get them to stay at their posts. Meanwhile, from his base in a hostel upriver, Ouyang Daoda sent frantic telegrams every day, demanding to know when shipments could resume.[20]

The subcontractors wrangled with Lianyun for two weeks before coming to an agreement; the steamers recommenced loading and heading upriver only on July 23. Precious time had been lost. In early August Ma Heng instructed the hapless Mr. Liu to leave Yibin. To rescue the situation, he turned to the

ever-reliable Na Chih-liang, ordering him by telegram to get to Yibin and take over the stalled shipping effort.

Na Chih-liang received his orders with trepidation but traveled to Yibin as instructed. He was disheartened by what he found: by the time he arrived in mid-August, only 3,000 cases had been shipped. Six thousand remained in the Yibin temporary warehouses, and only four weeks remained to ship them before the river once again became unnavigable. The shipping companies were "irresponsible." The support staff "moaned every day about wanting to return to Chongqing." Air-raid sirens sounded continually, sending people running for shelter. Na Chih-liang wondered what effect incendiary bombs might have on Yibin, and concluded that if the city burned, saving the cases would be impossible.

Na Chih-liang decided on drastic measures. He ordered the unhappy support staff to pack their bags and leave. He also demanded the shipping companies speed up operations, but without any result. He pondered the fact that the company of soldiers guarding the warehouses were, in effect, under his command. Why not use them? he thought. To the Lianyun Transportation Company and its subcontractors, Na Chih-liang issued an extraordinary threat: if the cases did not start moving immediately, his soldiers would commandeer their steamships. Panicking, the companies agreed to allocate the Palace Museum two out of every three of their steamers that docked at Yibin. Na Chih-liang was careful not to push his luck; the situation was volatile, the docks crowded with desperate, sometimes angry people, and in the Yangzi shipping business he was up against powerful local interests who cared for profit over the war, and certainly over art. Na Chih-liang seems to have felt threatened, worried that the steamship companies might stir up trouble among the refugees on the docks, and that he might find himself "on the end of a beating." The

episode illustrates the fragmented, lawless situation in China at the time, the country's violent undertow. The new spirit of nation, and of a national struggle, clearly did not extend to certain venal steamship owners on the Yangzi.

Nevertheless, Na Chih-liang's threat seems to have worked. The shipments moved fast after that, steamers pushing one after another up the Min River. By September 16, 1939, the warehouses were empty. Na Chih-liang sent a telegram to Ma Heng to tell him that all the cases had shipped, and the Yibin office was shutting down. The letter he received in return from Ma Heng was "suffused with happiness."[21]

When the steamers reached the feet of the great red sandstone Buddha at Leshan, they moored at transfer points along the river, where low-sided, shallow-draft wooden boats and barges awaited them. For Ouyang Daoda, this last leg of the journey, just nine miles of shallow water, was a logistical nightmare: the Dadu River, which would take the cases the last brief leg to the little town of Angu, was filled with sandbars and other hazards. He hired engineers to dynamite rocks and awkward promontories that might obstruct the boats' voyage upriver. He ordered channels and unloading points to be dredged and cleared. He hired porters to carry out the tricky, nerve-jangling transfers from the steamers' holds to the decks of the boats. The boats would have to move upstream against the Dadu's strong current, so Ouyang Daoda hired trackers and great coils of bamboo rope to haul them.

On arrival at Angu, the plan envisaged the boats mooring at different points along the riverbank, each as close as possible to the storage facility designated for its cargo. Laborers would unload the boats and carry the cases, one at a time, slung beneath shoulder poles, up to half a mile across fields and along muddy paths. It was a gargantuan, backbreaking

task, and manpower was hard to find. September was harvest season, and most men were busy in the fields. A road was under construction too, and road building paid more than portering. Ouyang Daoda scoured the area for boats and labor. He went to the local government, to the boatmen's union, to salt producers and coal mines. To load the boats safely, he needed skilled professional porters. For those whose job would be to carry the cases across the fields, he recruited among local farmers and itinerant laborers. He negotiated rates of pay through complex formulas relating to the number of cases carried, the distance carried, the size and weight. By the time the first steamers arrived, in July 1939, he was ready.

It was awkward, slow work in the humidity and heat of the Sichuan summer. The sweating porters loaded fifty or sixty cases aboard each boat. The trackers fixed their ropes of braided bamboo to the prow of the boat and hauled, driving their feet into the sandy riverbank, chanting to keep time. The boats rode deep in the water, the steersmen working the tillers hard to keep them off the shoals. Ouyang Daoda could only watch from the bank. The cases and their invaluable, esoteric contents had traveled two thousand miles and more since leaving the Forbidden City six years earlier. Now imperial treasures of porcelain and jade, of fine silk and brittle paper, lay in flimsy wooden boats, their fate utterly reliant on the dexterity of the steersmen and the knotted musculature of the trackers, men paid in copper coin and rice, illiterate, who dwelled in huts of mud and straw by the river.

Ouyang Daoda was watching when a loaded boat left a jetty at Dujiachang, close to the great stone Buddha. The trackers hauled it through the turn into the rushing Dadu River and drove upstream, yard by yard, foot by pounding foot, the bamboo ropes whip taut. Aboard the boat, alongside the steersman and crew, was a curator, Liang Tingwei, whose

forebears had worked in the Forbidden City for generations. There was nothing Liang Tingwei could do when the trackers' ropes attached to the prow of his boat began to unravel and then snapped. Those ashore could hear his screams for help as the boat drifted back downstream, helpless on the current, picking up speed as it went. Pitching and spinning on the brown, angry water, it careered back toward the junction with the faster, wider Min, where surely it would be swept away, or capsize, or have its hull ripped open on the rocks, the crew drowned, the cases lost.

The boat barreled into a bend just short of the Min, Liang Tingwei and the boatmen bawling for help. The steersman, pale with fright, took a chance and rammed the tiller hard to the right, as far as it would go. The boat lurched and heeled, but the prow came round, the boat inching its way out of the channel toward the bank. Moments later Liang Tingwei felt the keel grind into the sandy bottom. They were aground, stationary, and safe. Afterward, Liang Tingwei shakily recounted the story to his fellow curators.[22] It was a brush with utter disaster just a mile or two short of their destination.

On August 19, thirty-seven Japanese bombers hit Leshan with incendiaries, destroying nearly a third of the town in roaring fires. An estimated 1,000 people died out of a population of 60,000.[23] All operations on the river ceased, only resuming a week later. By now it was clear that nowhere was safe from Japanese bombing. Ma Heng and Ouyang Daoda had to hope that Angu, with its dispersed buildings and rural setting, would not be considered a worthwhile target by the Japanese.

The wooden boats, the boatmen, and the trackers made 180 trips up the Dadu River to Angu. The porters staggered across the fields, the cases suspended from shoulder poles between them, far too slowly for the censorious Ouyang Daoda's liking.

"Many of them were not used to this kind of work, and felt it was very difficult. They kept stopping, and did not want to finish the job, so progress was sluggish," he wrote.[24] By September 19, 1939, the Ming monk's cap ewer was in one of the 9,361 cases stacked in the cool, dry, dark halls of Angu. They would remain here, under Ouyang Daoda's stern eye, for seven more years.

10

THE NORTHERN ROUTE

The trains rattled across the gray winter flatlands of north China in the early days of December 1937, the freight cars carrying over 7,000 cases of objects from the Forbidden City, the cases Han Lih-wu and his weary, frightened staff had loaded at the railway station in the capital, Nanjing, days before the city fell. Among them were the ten massive cases containing the Stone Drums of Qin. This perilous, frightening journey would become known as the Northern Route.

On leaving Nanjing, the trains headed north, taking the cases back the way they had come nearly five years before, but at the town of Xuzhou they turned abruptly west and headed toward the Loess Plateau, a rugged, yellow-brown, semiarid landscape sown with mountains, pitted by gulches, ravaged by dust-laden wind. The curators aboard the trains, one of whom was a son of Ma Heng named Ma Yanxiang, had little idea of their destination, nor where the cases were to be stored. They pushed on, the freight cars creeping west into Shaanxi province through the frigid, winter days as Nanjing fell, and the republic began its desperate, doomed defense of central China.

Ma Heng, flitting between towns on the Yangzi River,

juggling demands for cargo space, warehouses, trucks, supplies, funds, personnel, had struggled to form a plan for the cases on the Northern Route. He sent telegrams to the military headquarters in Shaanxi, begging for assistance, apparently without result, and once again turned to the hardheaded, reliable Na Chih-liang. He summoned Na Chih-liang to Wuhan, gave him letters of introduction, and ordered him to Xi'an, the capital of Shaanxi. There, Na Chih-liang was to arrange storage for the 7,000 cases, and to be ready to meet the trains when they arrived from Nanjing.

Na Chih-liang hurried to Xi'an. When he arrived, he went immediately to military headquarters. To his surprise, he found that the first train loaded with cases had beaten him there, and with it Ma Heng's son. Ma Yanxiang had also thought to approach the military, and when he did, he encountered officers from his home province, Zhejiang. Their shared dialect, background, and acquaintance brought immediate cooperation. The military assigned officers, and they quickly identified what they believed were suitable storage facilities. The facilities lay not in Xi'an, but farther to the west at the terminus of the railway, in a town called Baoji: two large temple complexes, one currently in use as a munitions dump, the other as a depot for the Roads Bureau.

Gratified and relieved to know that the cases now apparently had a destination, Na Chih-liang took the train the very next day for Baoji. It was late when he arrived. In the freezing dark he made his way through muddy streets to the Dajintai Hotel, near the city's east gate. Baoji was surrounded by wretched rural poverty, yet the city itself had the air of a new if ramshackle prosperity. The railway that the cases had just traveled was only recently completed, and there were plans to extend it farther. The influx of railway staff, engineers, and businessmen had created a small pocket of affluence. When Na

Chih-liang, tired, cold, and grubby from his journey, entered the hotel lobby, he was struck by the number of prostitutes. He ignored them and went straight to his room and slept. "It was only the next day I found out that the town's hotels and its brothels were one and the same," he wrote.

Over the following days, 7,286 cases arrived in Baoji by three trains. As usual, the Palace Museum curators had hired porters and trucks to wait at the station. The museum staff were anxious. Japanese air raids were reaching deep into China, and railway infrastructure was an obvious target for bombing. The staff wanted the cases out of the freight cars, onto the trucks, and off to storage as rapidly as possible, but haste, the curators were learning, was dangerous. On December 7 a loaded truck pulled away from a train and drove toward a railway crossing. The driver apparently did not check to make sure the line was clear before he entered the crossing. As the truck lumbered over the tracks, a locomotive smashed into it. The curators ran to the wreckage. Two cases were severely damaged. In case 653 a number of imperial yellow porcelain bowls were shattered. In case 2540 the damage was less severe: a number of domed glass covers used to protect clocks were broken. Ouyang Daoda was predictably incensed when he found out. "The root cause was lack of care," he wrote, "to such a degree that our relocating and dispersing the objects lost all meaning."[1]

Na Chih-liang stayed in Baoji just long enough to oversee the cases' installation in the two temple complexes that would serve as temporary storage. Leaving a small team of curators in the bleak railway town to look after them, Na Chih-liang and Ma Yanxiang, pleased to be making their escape, booked train tickets for the long trip back to Wuhan, where they were to report to Ma Heng at a temporary Palace Museum office. The two bought a bottle of fine *fen* liquor, a local sorghum spirit of blazing strength, to drink on the train. They polished

off the bottle before reaching even halfway on their journey and regretted buying only the one.

When Na Chih-liang arrived back in Wuhan, Ma Heng surprised and dismayed him by telling him to turn round and go straight back to Baoji to take charge. Na Chih-liang fretted about his luggage, which was distributed between various different points, and his books, and his albums of drawings of jades and bronzes, the work of years of systematic study. What would become of them? To his further annoyance, Ma Heng instructed him to escort to Baoji the families of the curators assigned there, eight people in all, three women and five children. Sounding uncharacteristically glum, he complied. "They caused me so much trouble," he wrote.

Na Chih-liang collected his charges and took them to the railway station in Wuhan. They boarded a train relatively easily, but changing for the second leg of the journey was a nightmare. At Zhengzhou he bought tickets for the group, and they waited on a platform amid heaving, agitated crowds as he tried to keep the little band together. When a train bound for Baoji finally pulled in, it was packed. The crowd surged toward it and began to board. Na Chih-liang and the three women picked up the children, jammed them through the carriage doors, and tried to follow. Somehow, they all got aboard, but inside the carriage the crush was intolerable. The children began crying, and Na Chih-liang was flustered. He accosted travelers who were seated, demanding to see their tickets. It quickly became clear that most had boarded without tickets, and he furiously demanded they give up their seats. Through bluster and argument, he managed to shame eight passengers into standing and to get his whole party seated for the 300-mile journey ahead of them. As the train clattered west into the arid, dusty dark, Na Chih-liang sat stewing in anger and guilt at his own high-handedness, trying to justify his behavior

to himself and wondering how he had become someone who bullied penniless refugees out of a seat on a train.[2]

Ma Heng had ordered Na Chih-liang back to Baoji to over-see a task of vital importance. Such was the panic when the cases were shipped out of Nanjing at the end of 1937 that no one had made a detailed note of which cases went where. The system in place that used tally sticks had accounted for how many cases were loaded aboard each steamship or train, but not specifically which ones. The museum lacked a complete list of where each case was stored, and drawing one up was an urgent necessity.

Na Chih-liang arrived back in Baoji, reunited the curators with their families and children, and got to work. It was, he wrote, "an extremely troublesome task." Space was short in the two temples, and the cases were stacked close together. Porters had to take down each stack, wrestle the cases out into the courtyard, and lay them out in a row for the label to be read and noted, then take all of them back into the temple and restack them. Na Chih-liang knew how difficult conservation would be with the cases piled so high and so close, and concluded that the temples were utterly inadequate as storage facilities. He wrote to Ma Heng to tell him so. Ma Heng replied that the central government had set in motion a plan to dig caves at a location outside Baoji, and Na Chih-liang found himself traveling by train regularly to the provincial capital, Xi'an, for meetings with military officers about the project. Before each meeting, he went to a Muslim district in Xi'an city to buy beef. Beef was hard to come by in northwest China, as government edicts strictly limited the slaughtering of cattle to a few licensed, Muslim-run businesses. Oxen were critically important in farm work and could not be spared.[3] Na Chih-liang bought beef from a Muslim butcher and took it with him

as a gift for his military interlocutors, in the hope of smoothing relations.

It seems to have worked. With remarkable speed, in the opening weeks of 1938 the military began excavating and rapidly completed two large caves, but Na Chih-liang was worried. The caves were damp, with levels of humidity high enough to endanger paper and silk and put all books, paintings, and calligraphy at risk. An elderly local farmer warned him too that the caves would be unstable, and might collapse. That was enough for Na Chih-liang, and he rejected the caves. The military was displeased. At a tempestuous meeting, an officer demanded angrily that Na Chih-liang assume all responsibility should a Japanese air raid against Baoji damage the imperial collections. He assured them he would. In the end, they compromised: Na Chih-liang would report to Ma Heng before a decision was made. "Everyone parted on bad terms," he wrote.

Ma Heng had more serious concerns. The Japanese army was preparing an offensive whose route of advance followed the very railway line that the cases on the Northern Route had just traveled. If the offensive was successful, Japanese advance units could be within 200 miles of Baoji in a matter of weeks. Ma Heng frantically formulated an alternative plan. The cases would once again have to move, but there was no more railway; the cases stored in Baoji were quite literally at the end of the line. Any onward movement would have to be by road, but in northwestern China, in winter, the options were limited and grim.

Na Chih-liang waited in Baoji for Ma Heng's instructions. He wandered the town and its markets. He watched the winter dust storms roll across the yellow-brown landscape. He noted how in villages the houses had undersized windows to keep out the pervasive loess dust. He ate the local food, buying *guokui*, a large wheaten flatbread, and eating it with fresh

persimmon, the bread in one hand, the fruit in the other, a mouthful of each. It seemed odd, a clumsy way of eating to this urban sophisticate. But then, he thought, it was not so different from eating bread and jam. He went to the market to buy *doufu*, bean curd, and found none. On inquiring, a seller of vegetables pointed him to a neighboring stall selling a hard, gray-black substance utterly unlike the pale, delicate, silky bean curd he was used to. The vendor hacked a piece off for him and, to Na Chih-liang's amusement, weighed it by jamming it on a hook and suspending it from a balance. Na Chih-liang took the alien bean curd to his lodgings and cooked it in a soup. "It did, in fact, taste like bean curd," he decided. He was surprised at the market's low prices. Just one yuan bought a hundred walnuts, a few coppers bought a chicken.[4] Such plenty was not to last.

When the Palace Museum's decision came, it did not surprise him. The cases were immediately to move south to the city of Hanzhong, only ninety miles on the map but a daunting journey to undertake at any time, and especially in winter. Because no railway linked Baoji and Hanzhong, the cases would go by truck, and they would be forced to negotiate one of China's most formidable natural obstacles: the Qinling mountain range.

The Qinling is a ragged spine of mountains, running west to east for 400 miles, rising to 12,000 feet. The lower and middle slopes are forested with birch, cypress, and pine, and are home to bears and clouded leopards. They give way at altitude to rocky peaks wrapped in cloud much of the year, blanketed in snow through the winter. To get to Hanzhong, hundreds of trucks loaded with cases, including the Stone Drums of Qin, would have to climb right over the top of the Qinling range. The road corkscrewed up toward high, cold mountain passes, littered with hairpin bends above precipitous drops. Much of

the way, a boulder-strewn, tumbling river snaked below, its roar echoing up the mountainsides. The route was sparsely populated, and icy in winter. The road was vulnerable to landslides, great piles of rock and earth rendering it impassable until work crews removed the debris by hand.

Na Chih-liang pondered the risks. More than 7,000 cases, loaded 20 or so to a truck, would require well over 300 journeys. It was hard to see how every single one of those journeys would be completed without incident or accident, yet there was no alternative. For once, though, he did not have to worry about finding vehicles, competent drivers, and fuel. The military agreed to provide everything, which was a weight off his mind given his recent dispute with them. He spent hours talking it over with the officers, no doubt with beef and the strong *fen* liquor making for a more congenial atmosphere. Together, they settled on a series of rules for how the operation would proceed: all trucks to be loaded and serviced the day before driving; trucks to travel in groups with no overtaking, no falling behind; in each truck a driver/mechanic and an armed soldier, extra passengers forbidden; on downhill stretches no turning off the engine to coast and save fuel. On February 22, 1938, they began loading. The following day the first convoy rumbled out of Baoji into the gray cold, toward the mountain range rising in the south.

The first three shipments went reasonably smoothly, convoys of a dozen or so trucks nosing slowly up the switchbacks, through the forests, through tiny villages of mud-walled houses, the river curling beside the road. The weather held, and the passes were clear. On the fourth shipment, however, things started to go awry. By the time the trucks pulled out of Baoji in the early morning, snow had started to fall. As they reached higher altitudes, the snow grew heavier. In the late morning the trucks pulled in at an isolated village so the drivers and guards

could eat. Locals told them that on the pass ahead a landslide had left the road all but impassable. Smaller vehicles were just squeezing through; for a truck laden with fragile, irreplaceable objects like the Stone Drums of Qin to attempt it was unthinkable. The soldiers made the decision to stay put. The snow fell heavily as the day wore on, covering the road until first the tire tracks and then the road itself disappeared. By the next day the snow was several feet deep and the trucks were stranded. For the cold, tired drivers and guards their first problem was food. None had brought provisions with them, thinking the drive would take a single day. The only place in the village to buy a meal was a little noodle shop, and it quickly ran out. The soldiers faced the prospect of being stuck for days in freezing temperatures, at altitude, with nothing to eat, snow falling on the trucks and their cargo.

A commercial vehicle forced its way past the landslide. As it headed slowly through the village in the snow, the soldiers flagged it down. Its occupants agreed to take a message back to Na Chih-liang in Baoji. On receiving the message, Na Chih-liang dispatched staff to buy provisions and readied himself to make the journey up to the stranded trucks. His colleagues objected. The trip was absurdly dangerous, they argued, the chances too high of skidding off the narrow road and tumbling hundreds of feet into the river, or into a rocky valley, to die there from injury or exposure. Besides, as the senior museum official present, Na Chih-liang had a duty to stay with the collections. Na Chih-liang insisted that he could not allow another curator to take such a risk in his stead. In the end, a curator named Wu Yuzhang and an army officer volunteered to go and insisted that Na Chih-liang stay in Baoji. He was deeply affected by their selflessness.

The other drivers, however, were not so high-minded. Not one volunteered to drive the supplies up to their stranded

colleagues, even when offered a large cash bonus. Na Chih-liang harangued and cajoled them, and eventually a young man stepped forward and consented to go. He was the driver of a red truck, serial number 1407, although his name is not recorded. Na Chih-liang was "immensely grateful." The driver, the officer, and the curator loaded the provisions, bundled themselves in padded jackets and scarves against the mountain cold, and started out.

The road was completely invisible under the snow, so they searched for tire tracks to follow. They inched up into the mountains in something approaching a whiteout, the truck skidding and slewing on the gradient, its occupants "shivering with fear." The driver stared at the featureless blanket of snow before him, struggling to keep the truck from spinning off the road. The officer leaned from the window to spot obstacles and potholes in their way that might send them crashing down into the river. On the more precipitous stretches they had to guess where the edge of the road fell away into white nothingness. It was an awful journey. They pulled into the village to meet the snowbound trucks late in the day, and staggered from the driver's cabin, stiff and exhausted, their thick winter clothing damp with sweat.

Laborers eventually cleared the landslide, and the weather eased. The shipments continued, though from this point all trucks were equipped with snow chains for their tires. After the mountains, the trucks headed down toward a broad valley, with a river, the Hanshui, at its heart. The gray, icy slopes gave way once again to cypress forest, and then to fields terraced into the hillsides and blossoming fruit trees. It took forty-eight days, until April 11, 1938, to move the nearly 7,300 cases over the Qinling mountains to Hanzhong.

Hanzhong was a large town, prosperous despite its isolated location between two mountain ranges. The valley was fertile,

a center for the manufacture of and trade in tung oil, pressed from the seeds of the tung tree and used to finish and protect wood. The storage facility was in a Confucian temple and some ancestral halls, but once again Ma Heng and the museum directors were uneasy. The extraordinary range of Japan's G3M naval bombers rendered everywhere a target. The temple in which thousands of cases were stacked was roofed with yellow tiles, making it highly visible from the air; the bomb aimer in a G3M might easily pick it out and use it as a reference point. In mid-March, as the trucks were still fighting their way through the snowy passes, Japanese bombers twice raided the airfield at Hanzhong, hitting a fuel dump. The explosions sent gouts of flame hundreds of feet into the sky.[5] Ma Heng began to plan another move.

In Hanzhong the cases waited, stacked and silent, in the great, echoing temple halls, guarded by a company of soldiers. Spring eased into early summer, bringing warmth and humidity to the valley. On June 26 a careless guard on duty in one of the ancestral halls let a hand grenade fall from his grasp. The grenade hit the floor and exploded. Grenades are designed so that when the explosive inside them detonates, their metal casings fragment and are blasted outward as hot metal shards. This shrapnel tears through anything short of brick or concrete for yards in all directions. On this occasion the grenade killed the hapless guard and wounded two of his comrades, and shrapnel ripped into four of the stacked cases. A porcelain bowl of blue and white dating from the eighteenth century reign of Qianlong was smashed. A porcelain jar decorated with a design of flowers had its neck lopped off. The contents of the other two cases were undamaged. Why the guard was handling a primed grenade is unclear. No account tells us who the poor man was. Ouyang Daoda sourly deemed the incident "unfortunate."[6]

By the time of the incident with the grenade, trucks had already begun moving the cases on a new leg of their journey, farther south, deep into Sichuan province. The artworks had been in Hanzhong only six weeks, but Ma Heng was adamant that the threat of air raid was too great for them to stay. This time the destination was Chengdu, the province's ancient capital, 350 miles away along poor roads that twisted through another mountain range, the Daba, before dropping into the Sichuan basin.

The operation was fiendishly complicated. Ma Heng, Ouyang Daoda, and Na Chih-liang found themselves trying to piece together hundreds of truck journeys, using vehicles from the military, the Public Roads Administration, and commercial companies. They had to divide the journey into stages using transit points and unsuitable temporary storage. Pitifully few trucks were available; most were occupied transporting cotton seed for planting, or salt. Na Chih-liang found himself wrangling with companies whose trucks held licenses to operate

A truck loaded with cases is pushed up a hill,
Northern Route, late 1930s

only in their home province and could not cross from Shaanxi province into Sichuan or vice versa. Drivers were paid by the day rather than the job, so they found any reason to slow down the work, pleading mechanical problems in the middle of a journey and halting for days, the cases stuck by the side of the road, exposed to the elements.

At one point Ma Heng sent Na Chih-liang a telegram ordering him to a tiny town that lay along the route named Guangyuan, where a military officer was offering a solution to all their problems. The officer "spoke very politely" and offered Na Chih-liang an under-the-table deal. He was in charge of military vehicles on the road between Hanzhong and Chengdu. When the trucks were idle, their drivers and guards used them to moonlight, shifting goods on the side for personal profit. Why not use these vehicles to move the cases, and quietly distribute the museum's travel budget to everyone concerned, half for the military, half for the museum staff? Na Chih-liang did not like the idea, even as he realized it would be the easiest, quickest way to get the job done. He told the officer he would think about it and reported the proffered deal to Ma Heng. But to Na Chih-liang's dismay, at a dinner one night Ma Heng "had too much to drink" and gave an account of the offer to a senior commander, identifying the corrupt officer who had made it. The officer was dismissed from his post and punished. Na Chih-liang wrote that he "felt really guilty." He himself was accused of corruption at around this time; someone alleged he had been selling off the museum's gasoline coupons. Ma Heng, after a cursory investigation, dismissed the allegations.[7]

Small convoys of trucks rolled out of Hanzhong sporadically through the summer of 1938 and into the autumn and winter, nosing their way to the southwest on the road that twisted through the Daba mountains. Na Chih-liang went with them twice, bumping along in the driver's cabin in the shadow

of the peaks. The Daba posed less of a challenge than the Qin-ling, but the road was long, and the complicated arrangements at the transit points in the towns along the way were cause for gnawing anxiety. Nonetheless, Na Chih-liang, in his curious and upbeat way, found excitement and purpose in the journey. At Five Peak Pass he traveled in the very last truck in the convoy. He watched as those ahead spiraled up on the mountain road, their gears grinding through the switchbacks, and as he did he experienced a powerful thrill. "It seemed as if the whole mountain were filled with vehicles," he remembered. "It was spectacular."[8]

In places the road followed the ancient Shu Road, pathways hewn out of the mountains 2,500 years earlier, their walkways of wooden planking still clinging to the sides of the gorges. Na Chih-liang marveled. He stopped briefly to view the Thousand-Buddha Cliff at Guangyuan—or what was left of it after road builders had dynamited it a few years earlier—a cliff face forty feet high, incised with thousands of tiny chambers, inside each a Buddhist deity carved in stone. He remarked that he never had enough time to properly visit the historical sites he passed. He and Ma Heng and the other curators seem to have experienced the feeling that in the landscapes through which they traveled lay places of deep fascination, sites that gave clues to the nature of China's antiquity—desolate, faraway places that the curators would likely never visit again. One can sense in Na Chih-liang's writing his regret at the opportunities lost to the mundane business of trucks and shipments and schedules. "Such a pity," he wrote.[9]

Ma Heng came this way too and mused about antiquity and memory. He left a poem about the Buddhist carvings and another, entitled "On the Old Jiange Road," that references the winding mountain roads on this stage of the journey.

This tortuous old road on either side is thick with
 cypress forest.
The darkened forms on silvered trunks rise to eighty
 feet.
I think back to old Peking, its altars, temples, trees.
The year's turned cold, and now they bear encroaching
 frost and snow.

Ma Heng did not write a detailed memoir of his wartime
experiences, so it is through his poetry that we glimpse his
state of mind. Around this time the poems are filled with a
sense of movement, transience, and uncertainty. Permanence,
stability, and culture reside in Peking, the city he left behind,
which now must bear the "encroaching" winter of Japanese
occupation. They are the poems of a fifty-seven-year-old man
whose desired life of scholarship and reflection has given way
to crushing responsibility and arduous, unforgiving travel in
dangerous times.

These themes—duty, travel, exile, the yearning for home—
recur in classical Chinese poetry, and Ma Heng would cer-
tainly have been aware of how his predicament echoed those
of the scholar-officials who had toiled to manage the far-flung
imperial bureaucracy of earlier ages. The poems often sink into
melancholy, yet sounding through them, like the deep tolling
of a bell, is Ma Heng's sense of duty. The preservation of the
imperial collections had come to him as an unwanted burden,
but this quiet, fastidious scholar never seems to have consid-
ered forsaking it. The disciplined Confucian in him always
seemed to win out. Yet in his long, detailed reports to the Pal-
ace Museum's board of directors, written during these years,
a sense of Ma Heng's deep anxiety occasionally obtrudes on
the careful, bureaucratic language. Transport on the Northern

Route, he wrote in 1938, was "especially worrisome," the museum's finances "increasingly difficult," its future needs "impossible to calculate." His words give an impression of resignation, duty borne not out of honor but because his character and circumstances rendered the burden inevitable.

Ma Heng could not yet know the full cost that duty would exact.

If the mountains were not frightening enough, the Northern Route to Chengdu had further horrors in store. As it dropped into Sichuan, the route crossed several rivers where the bridges were out. Vehicles had to cross by means of antiquated, precarious ferries. At each river Na Chih-liang's loaded trucks drove to the bank then onto the ferry, which was always little more than a large flat-bottomed raft of wooden planks. The ferry had no means of propulsion other than the muscles of the boatmen, who propelled it through the water using long bamboo poles. With the trucks aboard, the boatmen would pole the ferry upstream for a distance, then allow it to drift back down on the current while they steered it toward the opposite bank. Aside from the obvious danger of the ferry sinking or capsizing, Na Chih-liang's chief concern was simply that the

Boatmen pole trucks loaded with cases across a river,
Northern Route, late 1930s

process was terribly slow; it took hours of labor to get a small convoy of trucks across each river. The stage from Hanzhong to Chengdu went at a snail's pace.

In Chengdu Ma Heng had once again settled on storage in the grounds of a temple, the Buddhist Da Ci complex in the heart of the city. The temple grounds were expansive, and the enormous, red-pillared pavilions and halls had plenty of space. Ma Heng reached an agreement with the local military authorities that they would hand over two of the largest halls in the complex to the Palace Museum. The Hall of Scripture Repository was a little damp, so cases containing porcelain and jade, which were unaffected by humidity, were to be stacked there. The drier Hall of the Sakyamuni Buddha was set aside for those containing books, paintings, and calligraphy. The military authorities sent a police officer to the temple to inform the resident monks of the arrangement.

The monks were not happy at the imposition. The temple's abbot convened a meeting at which the monks discussed how to respond. The result was a long, carefully worded letter to the military authorities. The temple, it argued, was private property, and appropriating its halls ran contrary to the republican government's property laws. It was also a sacred place, with its own important relics and religious life, that should not be disturbed by secular considerations. In addition, they said, the temple monks had already done a great deal in support of the war effort by housing displaced people, praying for Japan's defeat, and serving in the ambulance corps. Surely no more could be asked of them?

The military authorities were unconvinced by the abbot's arguments, and the halls were duly allocated for the use of the Palace Museum. Thousands of cases then began to arrive after their long, dangerous journey from Hanzhong and were unloaded from the trucks and stacked in neat, accessible rows

in the two halls. The monks seem to have accepted the decision with ill grace, even rebelliousness. Their kitchen, where the monks cooked over naked flames, lay near the halls. When Ma Heng entreated the monks to move the kitchen, they refused and carried on cooking their meals there in what appears to have been a calculated act of defiance. Ma Heng was consumed with concern that the cases might be incinerated in a fire and wrote to the military asking for help, which was not forthcoming. In the end, he compromised with the monks, gaining their permission to replace some flammable plaster walls with brick at the museum's expense, thus reducing the danger of a kitchen fire spreading. Such were the endless, aggravating tasks Ma Heng was called on to deal with.

It is notable that the monks, who one might assume would have set great store by the Buddhist scriptures and art contained in the cases, seemed unconcerned by their fate. Not everybody recognized the imperial collections as embodying a Chinese tradition or China's national essence, or even saw their preservation as a priority.[10]

Na Chih-liang had his own opinions about the monks, and they were not flattering. One night the abbot invited him to a dinner in honor of a visiting, politically well-connected monk. Na Chih-liang sensed that his presence was intended to help entertain and impress the influential visitor. He attended, only to find the event deeply dreary. "All there was to eat was some bean curd and some cabbage," he told his colleagues. Scornful of what he thought of as the monks' plain living and vegetarianism, he swore he would not attend any more dinners with the abbot. In due course another invitation arrived. Na Chih-liang declined, but his colleagues urged him to attend, saying it would be rude and impolitic not to. He gave in, and made his way to the abbot's dining room. To his astonishment, the table was laden with a variety of dishes of meat and fish. Na

Chih-liang could only conclude that the simplicity and bland-
ness of the earlier meal had been calculated to impress the
visiting monk and bore no relation to the abbot's customary
eating habits. Astounded at the hypocrisy, Na Chih-liang's
view of the Buddhist clergy dropped even further. "Being a
monk is clearly a profession," he wrote. "How many really
practice the faith?"

The Japanese launched their first air raids against Chengdu,
where the cases on the Northern Route were slowly accumu-
lating, in November 1938. The city would be bombed regu-
larly after that. Nonetheless, Na Chih-liang loved being there.
He wandered the teeming streets clad in his long robe and
fedora, and inhaled the city's heady wartime atmosphere, the
flourishing of culture and writing and scholarship as teach-
ers and students fleeing the war flooded in from the east. He
spent hours at the busy book market, and to his delight found
a copy of *Jade Illustrations from the Yizai Hall*, a rare collec-
tion compiled in the Qing period of finely executed drawings
depicting jade artifacts. He had hankered after the book for
years, once trying to copy it by hand from an edition in a
library, and here it was, for sale at a bookstall in the far west of
China. His delight runs through his recollection. The extraor-
dinary, luminescent jade carvings of antiquity were to become
his area of deepest expertise after the war. Na Chih-liang loved
Chengdu's food as well, the raucous, chili-strewn cooking of
Sichuan—chicken, duck, eel, carp, rabbit, bean curd, eggplant,
all fried in smoking, peppery oil and lustrous sauces over spit-
ting blue flame, or steeped in broths of ginger and scallions. He
remarked on the names of the restaurants he frequented: Fat
Duck Wang's, Don't Come If You're Busy, and the No Going
Home Unless Drunk Café.

The process of shipping the cases down from Hanzhong
to Chengdu seemed endless. Between the river crossings, the

need for staging points, and the scarcity of trucks and fuel, more than a year was to pass before all 7,286 cases arrived in Chengdu in the summer of 1939. There were some narrow escapes along the way. Twice Na Chih-liang was traveling in trucks that overturned. One time the truck, luckily empty at the time, slid off the road near Ningqiang, ending up on its side in a muddy field, Na Chih-liang sandwiched between the driver and the guard, all of them unhurt but covered in mud and laughing with relief. Another time his truck, once again empty of cases, came down a hill at high speed, swerved to avoid hitting an elderly woman in the road, and careered into a field. No one was hurt, but the old lady was furious and demanded compensation. It took hours to haul the truck out. When a truck loaded with cases toppled off a bridge and crashed some distance down onto a muddy riverbank, Na Chih-liang remembered turning "white with fear." Once again, his luck held: the cases were full of documents, and no damage was done.

Even luckier perhaps was Liang Tingwei, the same curator who had narrowly avoided drowning in 1938 when a raft laden with cases on the Dadu River had gone adrift. In the middle of 1939 Liang Tingwei was still in Hanzhong, overseeing the dispatch of cases on the mountain journey down to Chengdu. Days after the last cases left the storage facilities, he was busy closing the museum's temporary office in Hanzhong and wrapping up its affairs. He was going over bills with an accountant from a transportation company when air-raid sirens sounded over the city. He and the accountant took to their heels, running for the safety of open fields on the edge of town. They were not quick enough; the aircraft were nearly overhead. The two of them looked desperately for somewhere to shelter. Terrified, they slid down the dusty bank of a dried-up stream and hid under a bridge. They survived the raid, only to

find out later that the Japanese aircraft had strafed the fields where they had intended to take shelter. Many civilians died under their machine guns.

Some days later the bombers were back, and the yellow-tiled roof of the Confucian temple in Hanzhong where the cases had been stored attracted exactly the attention Ma Heng had feared. A Japanese bomber dropped its payload on the temple, reducing the now empty storage facility to smoking splinters and rubble. The Palace Museum curators were stunned, and Na Chih-liang wrote later that some began to wonder if the objects from the Forbidden City were possessed of some sort of spirit or soul protecting them. "They were bombed without being hit and dropped without being shattered. How was this real?"[11]

During the awkward transfer from Hanzhong to Chengdu, the Palace Museum's board of directors decided it was time for an inspection of progress on the Northern Route. They instructed Ma Heng to arrange for another director to inspect the cases and their storage in Chengdu and report back to the board. The director selected to carry out the inspection was none other than the renowned anthropologist and archaeologist Li Chi, who had been selected over Ma Heng to head the infant archaeology department at China's central research institution, the Academia Sinica, in 1928.

Li Chi had studied anthropology at Harvard, earning his PhD in 1923. He was an academic in the American mold, one of that wave of scholars who brought foreign training and thinking to China in the early republican period. Since 1928 Li Chi had overseen nine years of excavations at Anyang, in east-central China's Henan province, where, deep in the earth, he discovered the remains of the ancient and mysterious city of Yin. He found tombs and temples, chariots and bronzes, and

vast numbers of inscribed oracle bones. Li's finds at Anyang proved that a state known as Shang had preceded the Zhou period. Shang spanned the centuries from around 1600 BCE until 1046 BCE. Until the Anyang discoveries, Shang had occupied a semi-mythical place in Chinese historiography, but Li Chi's use of modern archaeological techniques is credited with demonstrating its existence beyond doubt. The outbreak of war in 1937 brought his work at the excavations to a halt, but Li Chi's reputation was made.

When the Palace Museum's director, Ma Heng, and the famous anthropologist Li Chi arrived in Chengdu in the summer of 1938, they went straight to the Da Ci complex, where, under the eyes of the resentful monks, Li Chi set about his inspection. He took a copy of the inventory and at random chose two cases of objects, circling their numbers on the page. Curators headed into the stacks and returned within minutes bearing the cases. Li Chi was pleasantly surprised at the curators' efficiency, and Na Chih-liang explained the system whereby the cases were arranged, with the location of every case noted in an index. The curators pried open the two cases and removed their contents, and Li Chi checked off every object against the inventory, to everyone's satisfaction.

The following day Ma Heng and Li Chi were to take to the road. They meant to drive the route to Hanzhong, watching the trucks making their way down through the mountains. Na Chih-liang, with some trepidation, was to accompany them. The weather was warm and the route was free of ice, but anticipating that the two great men might be surprised by conditions on the road, Na Chih-liang purchased bedding and canned food for the journey. They left Chengdu in a hired car—Na Chih-liang, the two distinguished scholars, and a driver—and made their way northeast through the country toward the mountains. As they set out, the party was jolly. The

two scholars began reciting "The Song of Everlasting Regret," the great Tang period poem by Bai Juyi, published in the year 806 CE. Ma Heng and Li Chi bumped along in the hired car through the villages and fields of northern Sichuan, chanting the rhythmic quatrains of the tragic poem, and all was well.

After passing the town of Mianyang, however, the road began to deteriorate. "There was mud everywhere," Na Chih-liang remembered. The two great men allowed their recitation to trail off and began to worry about their safety and whether on such an uneven and slippery surface the car might even turn over. A few miles farther on, the driver pulled over and refused to continue, saying he had not realized the state of the road. However, by a happy coincidence, some trucks rented by the Palace Museum and heading in the same direction were stopped nearby, and the three travelers took their baggage and transferred to the drivers' cabs. But there were further complications. When they stopped for the night at a small roadside inn, the wooden beds had no mattresses, and most windows no glass. "Not only were there no bathrooms," wrote Na Chih-liang wryly, "there were no lavatories." To relieve themselves, the scholars had to leave the inn and make their way across a courtyard to a manure pit next to a pigpen, there to manage the best they could. They felt it was "all very inconvenient," wrote Na Chih-liang, though he reflected that the two great men would now at least appreciate the curators' difficult lot as they escorted the cases through west China.

Food was another problem. Everywhere they ate, the tables and dishes were covered in flies. Worried about infection, Na Chih-liang dared order only steamed eggs, steamed rice, and radish soup, because these dishes came hot and covered. His providential purchase of tinned food and bedding alleviated some of the discomfort, and they pushed on toward the mountains, reaching Hanzhong without further incident, to his

relief. On arrival, Ma Heng and Li Chi inspected the remaining cases there, riding between the storage locations in sedan chairs. Their stay was cut short by a telegram informing Ma Heng that Chongqing was being bombed, and he must return immediately. The return journey to Chengdu by truck took another three days. Ma Heng and Li Chi then took the train back to Chongqing and the endless bombing.

It was early 1939 before Ma Heng finally settled on a destination for the cases on the Northern Route, which were piling up in the temple in Chengdu to the displeasure of the monks. He found what he believed to be suitable storage in Emei, a small, ramshackle town without electricity or running water at the foot of a mountain sacred to Buddhism. Mount Emei rises 10,000 feet out of the Sichuan basin, its peak crowned with temples, its steep slopes peopled with Buddhist pilgrims seeking the blessing of the bodhisattva Pu Xian, who rides an elephant and protects the faithful. The town was replete with temples, their pavilions offering acres of cool, dry storage. The town's small size and simplicity made it an unlikely target for Japanese bombers. Ma Heng selected the Temple of the Great Buddha and the Temple of the War God, and appointed Na Chih-liang director of the Emei branch office of the Palace Museum.

Trucks shipped the cases the eighty or so miles from Chengdu to Emei in small batches through the spring and summer of 1939. Porters shouldered 7,286 cases into the temple complexes, stacking them in the required neat rows on low shelving for air circulation, labels facing the right way, with plenty of space for the curators to move between the stacks. Na Chih-liang mapped the location of every case and compiled an index. He ensured that balls of camphor were placed in cases containing paper and silk to ward off moths.

He established routines to check for termites. He oversaw the drilling of ventilation holes in the temple walls and the provision of sand buckets, hoses, and fire extinguishers. Here, in the temples of Emei, at the foot of a sacred mountain, the cases that had traveled the Northern Route came to rest.

Na Chih-liang had to return to Chengdu briefly to close down the operation there, no doubt to the relief of the Da Ci monks. He went in a hired car, bumping and rattling through the rich farmland of Sichuan. As he entered the city by the south gate, the air-raid sirens were sounding, but he decided it was a false alarm and told the driver to continue to the Palace Museum office at the Da Ci complex. Arriving, he got out of the car and greeted some of the monks. They stood in the temple courtyard chatting, until one of the monks looked up and pointed. Silhouetted against the sky were the black shadows of Japanese bombers. Na Chih-liang and the monks ran for the shelters, little more than trenches dug in the earth, covered with branches. He crouched in the trench waiting for the raid to pass, antiaircraft guns sounding all over the city.

Emerging when the noise of the raid had died away, he looked out over Chengdu. Just to the west of the temple, the streets were ablaze. He walked out of the grounds and watched the wounded being carried to the hospital. He remembered the sounds the wounded made. The following morning, early, he made his way to Chun Xi Street, which had been hit, and watched people digging in the rubble for their valuables, or sitting in the dust and sobbing, or standing looking blank, not knowing what to do.[12]

As the summer of 1939 came to an end, and news came from Europe of the war there, Na Chih-liang found a place to live in Emei and wondered how he might bring his family from occupied Peking, or if he could, or should. He would remain in Emei, guarding the imperial collections, for nearly seven years.

11

A SORT OF SANCTUARY

By late 1939, 16,727 cases of art had made it to storage in China's far west, storage as permanent as it was possible to imagine at the time. The eighty steel cases of the finest, most irreplaceable objects that had traveled by the Southern Route lay stacked in their wooden shelters in the cave at Anshun, in Guizhou province, *Early Snow on the River* among them, under Chuang Yen's conscientous care. At Angu, in Sichuan province, not far from the great, red sandstone Buddha, were the 9,361 cases that had come up the Yangzi river on the Central Route. The Ming porcelain ewer with the copper-red glaze was here, nestled deep inside a case in a cool, airy ancestral hall, under the stern eye of Ouyang Daoda. At the foot of Buddhism's sacred mountain at Emei were the 7,286 cases that had traveled by rail and by truck over the Qinling mountains on the Northern Route. The Stone Drums of Qin, in their enormous cases, sat silent here, where Na Chih-liang was in charge. The curators, under Ma Heng's quietly anxious leadership from the wartime capital, Chongqing, now tried to settle into their new, precarious, impoverished lives.

The situation was dire. North China, and much of the east

and center, had fallen to the Japanese, whose forces had established footholds along the southern coast as well. Retreating Chinese troops often used scorched-earth tactics. They burned entire cities, plunging millions of their own countrymen into destitution and despair. Chinese troops put Changsha, where Chuang Yen had temporarily stored his eighty cases in the university library, to the torch in late 1938. The city burned for five days. Its defenders, fighting from the ruins, went on to repulse Japanese attacks with astonishing resolve.

But to the surprise of Japan and much of the world, the Chinese republic, cornered in its ramshackle, overcrowded

Japanese troops fighting in Changsha, 1939

wartime capital of Chongqing, managed to endure. The Chinese Communist Party, headquartered now in the isolated, dusty northwestern town of Yan'an, survived too. The party held inkblots of territory across north China, with tens of millions of people under its control, and also launched military operations against the Japanese, although its wartime alliance with the republic grew irritable and eroded over time.

During 1939 the forces of the republic attempted counterattacks, in places pushing hard against the Japanese front, testing the resolve and the supply lines of the invaders. The Chinese had neither the equipment nor the air power to push the Japanese back, nor the allies to help them do so. Any hope of an outright victory, on either side, was gone. By the end of the year, the war seemed to have settled into a conflict of attrition, each side slashing at the other without decisive result. Japanese bombers ranged more or less freely across the country, their raids relentless and bloody. In the occupied areas, Japan controlled the towns, roads, and railways, but in the vast rural hinterland its hold was less certain, and guerrillas of both the republic and the Communist Party harassed its forces. The Japanese tolerated a collaborationist government under the leadership of Wang Jingwei, a former rival of Chiang Kai-shek for the leadership of the republic, based in Nanjing. Elsewhere they installed other collaborators and struck bargains with the local authorities. The sheer size of China meant that the boundary between the Japanese-occupied areas and those controlled by the republic was often imprecise. It was possible to move between the two zones throughout the war, and people did so. The great tides of refugees began to ebb, and people tried to adapt to a future of protracted war.

Ma Heng spent the war years based in Chongqing. On its rocky promontory above the Yangzi River, the city heaved

with exiles from the eastern cities: government officials and military men, journalists, diplomats, writers, teachers, society ladies from Shanghai and Nanjing, businessmen and bankers, traders, tipsters, spies, charlatans, and hucksters. At the apogee of the republic was the generalissimo himself, Chiang Kai-shek, a terse, ascetic Christian soldier whose grip on the ruling party, the KMT, and thus on the machinery of government and army, was secure. At his side stood his dazzling American-educated wife, Soong May-ling, whose gifts as hostess, diplomat, and political facilitator were celebrated. In the early war years, the Chiangs' supporters at home and abroad saw the couple as the glamorous embodiment of China's struggle against enormous odds: steely, modern, suffused with patriotic purpose, tinged with tragedy.

Around the Chiangs orbited a constellation of relatives and retainers who assured their place in power. Soong May-ling's brother, T. V. Soong, served variously as finance minister, foreign minister, and the Chiangs' personal representative in Washington. Her older sister's husband, H. H. Kung, was governor of the Bank of China. The generalissimo's extended family amassed stupendous wealth. Chiang looked to two brothers, Chen Li-fu and Chen Kuo-fu, to maintain his control over the KMT, while Tai Li ran the KMT's predatory, vicious intelligence agency, which suppressed any dissent threatening Chiang's position and spied on communist and Japanese targets. The generalissimo's image, either photographed or in paint, usually in ornate military garb, adorned walls all over Chongqing.

The city's wartime expansion produced a concatenation of styles. Its ancient crooked stone staircases and alleyways opened onto a newly constructed city center where bank buildings of stone and concrete in art deco style stood next to cinemas layered with chrome and neon. Much new construction,

though, was of flimsy wood and plaster, which lent the city the feel, one visitor remembered, "of exposition buildings, or a theatre set."[1] Elsewhere, the city reverted to its earlier self, each alley a parade of wooden shop fronts that opened onto the street, cluttered with signage advertizing tea, medicine, shoes, soapstone, ironwares, groceries, silks. So steep and cluttered were these older thoroughfares that even rickshaws had difficulty passing. Those with means hired porters to carry them in a sedan chair or litter. In winter the city shivered in rain and mist. Come spring the mist burned away, and damp, stifling, subtropical heat rolled off the river, carrying with it the odors of mud and putrefaction. The sky turned crystalline blue, and Chongqing was visible from the air.

The city authorities tried to prepare for what they knew was coming. They ordered hundreds of air-raid shelters dug. They purchased five motorized fire engines from Hong Kong,

A street scene in Chongqing following a Japanese air raid, 1940

although much of the city proved inaccessible to them, so to tackle blazes in its steep, narrow alleyways, the city recruited a force of firemen equipped with hooks and buckets. Surveyors mapped the stone cisterns that were the only water supply in many districts.[2] An early-warning system alerted the city's inhabitants to incoming air raids through colored balls hoisted on towers, and sirens. By the end of 1940, the Japanese were flying the lethal, long-range fighter known as the Zero over China. Zeroes could escort Japanese bombers all the way from their bases in eastern and central China to Chongqing and beyond. The remnants of the republic's air force were no match. In the month of June 1941 alone, Japanese aircraft bombed Chongqing fifteen times in raids employing dozens of bombers at a time.[3]

Ma Heng, along with the rest of Chongqing's inhabitants, passed entire days in stifling, reeking air-raid shelters blasted out of the city's rocky slopes, an awful, claustrophobic experience that tried patience and endurance to the very limit. When the red ball was hoisted, everyone filled flasks with water, packed baskets with cookies and steamed buns, and, carrying stools or some cushions, made their way to the shelters, where they sat hour after hour beneath flickering oil lamps. When the bombing started, they leaned forward, hugged their stomachs, and opened their mouths to protect themselves from the concussion of the explosions. They prayed for cloud, rain, and bad weather.[4]

Among the most notorious of the shelters was one known as the Great Tunnel, in the densely populated Shibati district. The tunnel was immense, one and a half miles long and big enough for 6,500 people. It was entered via over thirty feet of steep steps and lacked seating, lamps, lavatories, and, crucially, adequate ventilation.

On the evening of June 5, 1941, at about 7 p.m., the alarms

sounded, and thousands of people headed to the shelter. Some estimates placed the number of people trying to enter at 10,000, a number far above the shelter's capacity. Inside, people jostled for space in the semidarkness and waited for the raid to get underway. By 9 p.m., its occupants were listening to the crump and whine of the bombing above them, and the temperature in the tunnel was rising. People fanned themselves. Children began to cry. Hot and breathless, people noticed that their kerosene lamps were starting to dim, sputter, and die—a sign that oxygen inside the shelter was running low. Panic spread, and thousands surged toward the exit, desperate to get out into the fresh air. Hundreds clambered up the steep steps and out into the night, but behind them the crush grew. Some stumbled and fell to be trampled underfoot, obstructing the exit. Others were asphyxiated by the sheer pressure of the crowds desperate to force their way out.

The result was catastrophe. No rescue came until the next morning, and then the rescuers' task was simply to clear thousands of bodies from the tunnel and transport them to a mass grave.[5] The incident at the Great Tunnel traumatized the city deeply. A furious public blamed the government, and Chiang Kai-shek's republic saw a little more of its authority leach away.

In late 1941 Japanese aircraft attacked Pearl Harbor. The United States and Britain declared war, and finally the Republic of China had allies in its war with Japan. Chinese hopes rose, but fell again as Britain's military and colonial presence in East Asia collapsed before the Japanese onslaught. Nevertheless, American military aid began to flow, sporadically, to the republic, and American bombers operated from Chinese airfields against Japanese targets. However, the aid the republic received was never sufficient to tip the balance of the war in its favor, and the regular bombing of Chongqing continued throughout the years of the Second World War. Yet the

Republic of China did not capitulate. Chongqing stood all but alone in East Asia, a lonely, brittle, troubled outpost of resistance against Japan.

Ma Heng spoke rarely of his own experiences of Chongqing in wartime; we glimpse him only in stories narrated by others, in the workings of the museum, an occasional surviving letter, and in his poetry. He was entering his sixties, living alone, as afflicted by fear as any other citizen in war. In September 1939 he wrote to Na Chih-liang with a frank confession of his own dread: "Last night, enemy aircraft bombed south of Chongqing, causing one to shake with fear . . . Today we had more air-raid warnings. They come like arrows piercing the heart . . . "[6] Yet he remained utterly committed to his work, though the privations and unpredictability of his life seem to have taken their toll. He writes in one poem of a weakness in his legs and of having no will to climb the stairs, in another of his boredom and of how he missed Peking.

Yeh Wei-ch'ing, his wife, remained in Shanghai under Japanese occupation. The war was bad for the Yeh family businesses, and she seems to have lived in circumstances much reduced from those of the family's wealthiest years at the turn of the century. Shanghai was a shell of itself, much of its suburbs still in ruins from the fighting of 1937. It is not clear how, or how often, Ma Heng communicated with her, or what their marriage had become. Perhaps attachment to her life in Shanghai precluded her leaving and joining him in unoccupied China, or perhaps she was just frightened of the war. Whatever the reasons for their separation, they were never to meet again. She died on September 18, 1940, of what cause is not clear. On learning of her death Ma Heng wrote a poem entitled "Autumn Rain." In it he recounts the sleepless night he spent after receiving the news.

That very night the autumn rain was utterly relentless.
I'd burned out the wick in the only lamp; dreams
 would not come.
I lay on my pillow listening to the city slow and
 quieten,
And the sound of moving water murmuring till dawn.

The poem is suffused with sadness and a sense of the deadening of possibility. As the lamp in the poem burns out, so a light leaves Ma Heng's life, and his imagination fails. The sound of water "murmuring till dawn" suggests perhaps the relentless workings of conscience, as he lies in the darkness considering the course, and fate, of his marriage.

In 1941 Ma Heng moved to a house in the Haitangxi—Crabapple Brook—area of Chongqing, an outlying district on the southern bank of the Yangzi, poised between city and village. The house gave him some relief from the congestion and chaos of the city center, and to some degree from the bombing. Ma Heng wrote in the preface to one of his poems that if he climbed a nearby hill he could look out and see the city across the river, and if he turned around he had a view of mountains and of streams winding into the distance. In the body of the poem he described damp, rainy mist rising over fields and hearing the calls of farmers as they herded their animals by the water. He seems to have found some stability in the new house, and perhaps some relief from the intense worry that his work brought him.

The administration of the storage sites presented Ma Heng with a tangle of problems. Finance was a constant source of anxiety. The transportation costs associated with shipping the cases, the curators' and guards' salaries and food allowances, rental payments on storage facilities and offices, fire prevention, and the equipment and materials used in conservation

all added up to huge sums. Funding came from the central government, and Ma Heng found himself struggling to cover costs. In 1940 he reported to the board of directors that the cost of transporting the collections to west China came to 775,450 yuan, but the museum had received from the central government only 330,000 yuan—less than half of what was needed. The remainder would have to be made up, he wrote, by advances from the Boxer Indemnity fund. Once all the cases were settled into permanent storage at the three sites in Emei, Angu, and Anshun, Ma Heng was under pressure to economize, and he, along with the entire Republic of China, was confronted by a new enemy: inflation.

In 1942 Ma Heng reported that prices were rising "abnormally" and that financing the three storage sites had become "extremely challenging." Oil for the lamps that lit the warehouses, he wrote, in 1938 cost 20 cents for about half a quart. By 1942 the price had risen forty-fold. The cost of the tung oil, coal, and lime used to prevent insect infestation had risen by a similar amount. "Stationery items, telecommunications, renovations, work materials, and other business costs have all increased tenfold." Ma Heng estimated that only about a quarter of his annual expenses were now met by government funding. Low salaries and inadequate food allowances were taking their toll on the museum staff. At Angu nine staff resigned in 1941–2. Only seven remained, and four were new to their posts. Ma Heng worried about their lack of experience.[7]

Inflation continued to eat into the museum's ability to operate for the rest of the war. By mid-1943 the cost of lamp oil had risen to 130 times its cost five years earlier. Ma Heng was coming to understand a force that would prove deeply corrosive to the republic. Inflation prompted the wealthy to convert their capital into foreign currency and to send it out of China; it eroded the savings of the middle class; it plunged the

poor into ever deeper impoverishment. For those on salaries—officials, soldiers, teachers, museum curators—inflation made it impossible to afford even the fundamentals of life. Stories abounded of government officials and military officers working as laborers and water carriers on the side to earn enough to feed their families.[8] Inflation as much as war ended the republican dream of a modern state, one with health care and highways and a prosperous, stable economy. It undermined what respect the ruling KMT retained in the eyes of the republic's citizens. It stimulated the search for alternative ideas, new policies, new ideologies. Inflation, and the humiliation and misery it wrought, led people to look north, to the communist base areas, and to wonder about the future.

Two hundred and fifty miles south of Chongqing, the cases containing the collections' most precious pieces that had come by the Southern Route lay stacked in the Huayan cave. Nearby, in their dingy, wooden house in Anshun, the archaeologist Chuang Yen; his wife, Shen Juo-hsia; and their children passed the war years. Anshun was a small city, a regional hub for the trade in tea, and in opium. It lay 4,500 feet above sea level, its elevation lending it a crisp, cool atmosphere, free of oppressive summer heat. Around it, low, tree-covered mountains rippled across the landscape.

In the early war years Anshun and the rest of the rocky, isolated province of Guizhou seemed far from the front, but life there nevertheless felt precarious. Some months after Chuang Yen and his family arrived in early 1938, cholera struck, claiming lives throughout the city. Rumors spread that female agents of Japan were poisoning food supplies. In the markets shoppers fretted over whether their purchases were safe to eat.[9] The arrival in Anshun of four antiaircraft guns drove home to the city's residents that they too were within range of

Japanese bombers. The authorities organized the building of
air-raid shelters. Streams of troops passed through the city on
their way to the front.[10]

Shen Juo-hsia walked the forty minutes every day to Qian-
jiang School, where she taught literature. On payday she
would walk the forty minutes home carrying her salary, the
sack of unhulled rice that helped keep the family fed. Some of
the rice she put aside and sold. Chuang Yen's Palace Museum
salary was unreliable; Ma Heng sent it from Chongqing, but it
was often late. The family's diet was basic but adequate. They
ate rice porridge early in the day, the children sitting about the
single wooden table. In the evening they had steamed rice and
vegetables, sometimes enlivened by herbs they had foraged
for in the hills—shepherd's purse and wild garlic, anything
to give the food some savor. Shen Juo-hsia cooked noodles
and *laobing*, an oily, chewy flatbread. She pickled radishes and
cabbage with chilies and garlic. Only occasionally did the fam-
ily eat fish or meat. When they did have pork, Shen Juo-hsia
would let the fat brown and crisp in the hot oil at the bottom
of the pan. The next day she reheated it and poured it over
noodles, which the children loved.

In the evenings Chuang Yen retired to his study, and the
rest of the family would sit at the kitchen table by the light
of a lamp that burned vegetable oil, the children doing home-
work or reading flimsy books printed on cheap wartime paper
that cracked and crumbled. When the children brought a book
home from school, Chuang Yen insisted that to protect it they
cover it in a jacket fashioned out of old newspaper. He was
particular on the question of how the jacket should be made,
and the children became deft at this simple act of conserva-
tion. The habit stayed with them in later life.

The family slept on beds of wooden planking, softened
with quilts, plagued by bedbugs that lived in the cracks and

crevices of the bed frames. The children would wake scratching at themselves, the bites raising itchy, red welts. The family dragged the beds outside and poured boiling water over the frames in the hope of killing the bugs and their eggs. This brought relief, but never for long. The children had head lice too. Disease was a constant worry. Measles was common, and outbreaks frightened the family. All their clothes deteriorated, and there was little money to spare for scarce cloth. Everything was worn and frayed, patched and darned, the colors faded.[11] The Chuang family was hardly alone in its penury; everybody looked thinner, older, shabbier, the children spindlier and more ragged. Peking, its restaurants and teahouses and libraries, the bookshops and antique dealers of Liulichang, the opera, the gracious architecture, the lakes and the willow trees and the palaces of the Forbidden City, lived in an imagined past and a barely hoped-for future.

The Huayan cave was a brisk half-hour walk from the Chuang family home. Chuang Yen would walk there most days. At the mouth of the cave soldiers stood guard. The strange Buddhist monk with whom Ma Heng had bargained for use of the cave chanted sutras and burned incense, as well as running his sacrilegious side business slaughtering pigs. Ma Heng and Chuang Yen decided that the interior of the cave became too humid in the wetter late summer and autumn, and ordered that the cases of paintings and calligraphy be brought out and stacked at the cave's mouth. If it began to rain or an air-raid warning sounded, curators and soldiers moved the cases back into the cave in a matter of minutes. Locals helped with labor and guard duties. Thus, wrote Ma Heng to the museum's board of directors in 1940, "we can contend with the danger posed by air raid, thieves, and moisture damage simultaneously, and can be sure that nothing is being overlooked."[12]

Moisture was a threat to the integrity of the imperial

collections as great as any Japanese bomb or band of pillagers. A painting like *Early Snow on the River*, ink on silk a thousand years old, carefully mounted on a paper scroll, was immensely fragile, and vulnerable to humidity. Organic fibers such as those in paper or silk absorb moisture easily and shed it only with difficulty. Moisture causes paper to expand and contract. Different papers, when damp, expand at different rates. The scroll on which a painting is mounted may be constructed of several different kinds of paper, so expansion can stress the painting, causing ripples and cracks. Moisture can degrade the adhesives used to attach the painting to the scroll. And moisture invites mold, tiny invasive colonies of bacteria growing in the fibers, showing as black specks that disfigure the painting and draw the eye to the single plane of its surface, so destroying the artist's portrayal of depth and distance, a quality central to landscape painting. Keeping a painting dry—but not too dry—is the central task of the conservator.

At the Huayan cave Chuang Yen was permanently alert to the possibility of damp infiltrating what the museum deemed the most irreplaceable pieces. His precaution against it was simple in principle, complicated and dangerous in practice. After each year's wet season, when the autumn weather was still sunny and warm, he brought the cases out from the cave into the fresh air. Soldiers set up a perimeter inside which only authorized personnel were allowed. He and the curators opened the cases and unpacked the paintings and calligraphic works, checking them carefully against the inventory and noting the date and time. Chuang Yen unrolled the paintings and hung them up or laid them out. The breeze and the sunlight played on the paintings' surfaces, drying the paper and silk fibers, dispelling the spores that cause mold. *Early Snow on the River* would lie in the warm sunshine, the autumn light

playing across the river, the reeds, the fishermen in their wooden skiffs, the travelers on the riverbank. Curious villagers walked over to the Huayan cave to watch the proceedings, the soldiers ensuring they did not come too close.

Chuang Yen took his children up to see the airing of the paintings. He impressed on them the names of the artists, the period from which each painting dated, the importance of what was before them, that these masterpieces were nothing less than *guobao*—the treasures of a nation, markers of a civilization. At home in the evenings, as they ate around the table, Chuang Yen would play a game with the children, quizzing them on the names of the painters and the periods in which they had lived and worked, the children yelling the answers— *Song dynasty! Yuan dynasty! Ma Yuan! Wang Meng!*

The children loved visiting the cave. With their father they would take torches made of reeds and explore deep inside, clambering along narrow passages in the flickering torchlight, the rock damp and cool, listening to the roar of water from some deep, subterranean stream running far below. They watched the soldiers assigned to guard the cave run through training exercises and admired their uniforms and rifles, the bayonets dangling from their belts. They sang along with the soldiers' martial songs. "The Great Sword March," a favorite of the troops, called for the beheading of the Japanese invaders. The song was written in 1937 to commemorate the moment at the battle for Shanhaiguan in 1933 when soldiers of the Twenty-Ninth Division had fought in the breach of the Great Wall with their long curved swords.

Our swords hang above the head of the devils,
 ready to slice them off!
For the soldierly brothers of our nation
The day of resistance has come.

The song culminated in the soldiers bellowing, *"Sha! Sha! Sha!"* "Kill! Kill! Kill!" The children joined in with gusto, running in the wake of the marching troops, yelling, "Kill! Kill!"[13]

The Chuang family survived the dangers and uncertainty of the war years. Chuang Yen and Shen Juo-hsia had a strong marriage and a sense of purpose in the work of conserving the part of the imperial collections in their care. They probably enjoyed some social status locally. Their income was meager and unreliable and would erode later in the war years, but they at least had one. Theirs was, by comparison with the lot of many Chinese people, a good war.

In the early stages of his sojourn at Anshun, Chuang Yen received a directive from Ma Heng that was to set in motion one of the most extraordinary episodes of the imperial collections' extended voyage. In the spring of 1939, Ma Heng ordered Chuang Yen to pack two of his special steel-sided cases with a variety of pieces. They would of course be pieces of the highest quality, but none would be entirely irreplaceable. The journey these two cases were to take was full of risk, though just how much risk was not apparent at the time.

Chuang Yen did as he was told, overseeing the careful packing of forty-eight paintings, forty jades, ten bronzes, and two tapestries, according to all the rules of spacing and immobility in which he was now expert. In July 1939 the cases, in company with eleven others from various institutions, arrived in Chongqing and were loaded onto a train for Lanzhou, in China's northwest. In Lanzhou they were placed aboard a plane for Urumqi, in the distant desert region of Xinjiang. After a six-week wait there, an aircraft from the Soviet Union touched down on the dusty airstrip and taxied to the hangar. Once loaded, the Soviet aircraft took off and set a course for Almaty, and then on to Moscow, where it arrived on September 24.

Early in January 1940, at the Museum of Eastern Culture in Moscow, the Chinese Art Exhibition opened. Nineteen hundred pieces were on display, and the exhibition ranged far beyond antiquity and tradition. On entering, the first thing the visitor saw was a display of war photographs depicting China's resistance to the Japanese invasion. The next room took the visitor deep into ancient China with a display of bronzes and inscribed oracle bones. The following rooms moved chronologically through the great sweep of Chinese civilization. Among the highlights was a magnificent narrative painting dating from the mid-sixteenth century and attributed to the Ming period artist Qiu Ying. The painting, *Ode on Shanglin Park*, is a monumental, vivid handscroll of ink and pigment on silk nearly forty feet in length. Based on a poem, it depicts a Bronze Age emperor in lush, beautiful hunting grounds, his vast entourage wending its way through a mountainscape of brilliant blues and incandescent greens. Cloud and water drift through the painting, their swirls and ripples supple and moving. The artist creates a vast field of vision, from mountains receding into the deep distance down to the folds of a gown, the pull and jangle of a horse's bridle, a windblown tussock of grass.

On the second floor of the exhibition were rooms filled with an eclectic collection of pieces. Folk and religious art hung next to contemporary works depicting wartime scenes. An earnest commentary in *Pravda*, the Soviet Communist Party newspaper, noted that earlier works "served the dominant classes," but the recent beginnings of capitalism in China meant that the "lives of the middle classes and toilers began to intrude into the pictures."[14]

In its first month 25,000 people visited the exhibition. "I am enraptured," said the famous Soviet writer Aleksey Tolstoy after his visit.[15] Such was its success that the exhibition was

extended for months, even though its Chinese curators had to return home for lack of funds. The Soviet authorities then requested that the pieces be allowed to transfer to Leningrad for a further, unscheduled exhibition. The Chinese government seems to have felt unable to refuse, but Ma Heng was alarmed.

Paintings on paper and silk should never hang in the light for long periods. Ultraviolet and infrared light can cause cumulative, irreversible changes, the photochemical damage bringing on darkening and discoloration. Three months' exposure to light was all Ma Heng was comfortable with, and by May 1940 he was already concerned that the paintings in Moscow had hung for too long. "It makes the heart uneasy," he wrote in his report to the Palace Museum's board. One solution might have been to display the paintings behind special glass that filtered out harmful light, but the Soviets regretfully informed the museum that such glass was unavailable. Ma Heng requested that certain paintings be rotated in and out of the exhibition so they would spend time in darkness, even though that meant more handling and the attendant risks.[16] It is not clear if his scheme was implemented. The Moscow exhibition, originally slated to last only a few months, went on for a year. The objects moved to the Hermitage in Leningrad only in March 1941, and the exhibition continued, but the artworks now faced far greater risks than light.

On June 22, 1941, while the pieces were still on display in the Hermitage, 150 German divisions attacked the Soviet Union. They advanced in three great thrusts: in the south into Ukraine, in the center toward Moscow, and in the north toward Leningrad. Over the following days German armored units penetrated deep into Soviet territory. On June 30, eight days into the invasion, the republican government sent a panicked note to the Soviet government via the Chinese embassy in Moscow. The note pleaded for the objects to be secured and

returned to China as soon as possible. The Soviets responded, assuring the Chinese side that their artifacts would be kept safe but insisting that transport back to China was impossible. The pieces, said the Soviets somewhat cryptically, were to be stored in a safe location.

Through July, Soviet forces buckled before the German advance. Hundreds of thousands of Soviet soldiers were taken prisoner. Amid the chaos, the Chinese ambassador to Moscow persisted in demanding that the objects be returned to China. Only at the end of August, as German forces closed in on Leningrad, was the Chinese ambassador assured that the pieces had been packed and removed from the city. However, the Chinese were not told where they were. On September 8 German troops cut the last road connecting Leningrad to the rest of the Soviet Union. The city was surrounded, and now began the longest, cruelest siege in modern history. But the Soviets had been true to their word; the paintings, bronzes, and jades of the Palace Museum were safe, a thousand miles to the east, beyond the Urals in Sverdlovsk.

It took another year for the cases to find their way home. After long and detailed negotiations and many false starts, they were taken by train to Almaty in Soviet central Asia, and from there by aircraft to Urumqi, Lanzhou, and Chongqing. On September 23, 1942, the steel-sided cases, the stenciled words HANDLE WITH CARE still clearly visible on the sides from their journey to London in 1935, arrived at the Palace Museum's offices in Chongqing. Ma Heng himself oversaw their opening and the extraction of each piece, the checking against the lists and catalogs, the careful inspection for damage or deterioration.[17] In later reports to the directors Ma Heng was silent on the question of whether the ancient, fragile paintings had suffered during their three long years in the Soviet Union.

*

In Angu, not far from the great sandstone Buddha of Leshan, the cases that had come by the Central Route along the Yangzi River were in the care of Ouyang Daoda, the strict, precise professional who wrote the most authoritative account of the imperial collections' journey. The Ming monk's cap ewer was here. Ouyang Daoda's task at Angu was greater and more complex than that at the Huayan cave by an order of magnitude, simply because of the far greater number of objects in his charge. The cases were spread out among a temple and six ancestral halls dotted around the little township. Under Ouyang Daoda's system, admission to the storage facilities was strictly controlled. Every door was locked, and a paper seal applied. Entry required permission and was noted in a register. Inside, the cases were neatly stacked in their accessible rows, the labels visible, the location of every one pinpointed. Ouyang Daoda ordered the production of a register that listed which cases were in which warehouse, another that listed all cases by the objects contained therein, a sketch map of every location where cases were held, and a register of all the cases that had been left behind in Nanjing. He invited in experts from the University of Wuhan, which had relocated to Sichuan, and the ministry of education to carry out spot checks on cases, their location, and their contents, to ensure that his system functioned.

The conservation work was constant at Angu. Airing the enormous number of books and paintings stored there was a huge labor in itself, the curators working their way methodically through thousands of cases, opening them, checking the contents against the register, inspecting them for damage from damp or, heaven forbid, moths and termites. They used thick, heavy paper as wrapping to further protect against damp. They took out the most fragile paper and silk pieces to dry in the sun. On completion, each case was repacked, nailed shut,

and returned to its designated spot, all details and times care-
fully noted. Ouyang Daoda's approach was remarkable in its
meticulousness and attention to detail.

Termites were a plague at Angu. Ouyang Daoda and his
team devoted countless hours to combating them. Termites
are tiny, pale, eyeless insects a few millimeters in length that
live in enormous colonies, usually underground. They feed on
all kinds of dead plant matter and possess the ability to digest
cellulose, the compound found in the fibers of cotton, wood,
and paper. Termites venture out from their nests to forage
in great columns, guiding each other in their blindness with
antennae and pheromones. Once above ground, the termites
build long, winding tubes from soil and their own feces. These
brownish tubes are a few millimeters wide and afford the col-
umn some protection. The tubes are easily visible, winding
up walls and along joists. Ouyang Daoda and his curators
were always on the lookout for these signs of termite attack.
They inspected the wooden pillars and walls of the temples
and halls endlessly, crawling between the great stacks of cases,
peering into the gloomy recesses under the floorboards, wor-
rying. A termite infestation that made it undetected to a case
containing books or paintings would cause havoc, the insects
munching their way through the wooden container and its
priceless contents.

In 1942 three of the storage halls at Angu were found to
have termite infestations. Curators spotted the telltale tubes
winding around the feet of the low wooden shelving on which
the cases were stacked, but caught the infestations before there
was any damage to the cases and wiped them out, slather-
ing the shelving in tung oil and spreading charcoal and lime
through the halls. The curators came up with an ingenious idea
to make checking for termites simpler. They collected stones of
similar shape and size, then placed the stones between the floor

and the feet of the shelving, so every shelf rested on stones rather than directly on the wooden floor. To make it as far as the wooden shelving and onto a case, the termites now had to build their tubes up and over the stones. Thus, a curator had simply to run his hand over each stone feeling for the tubes, rather than crawl the entire length and breadth of the shelving, inspecting inside and out in the gloom. It made the search easier and more precise. Regularly painting each stone with tung oil further dissuaded the creatures.[18] Such were the daily imperatives of conservation in Angu, termites becoming an all-consuming preoccupation for the museum's staff during those years.

Ouyang Daoda carefully cultivated relationships in the township to ensure the security of the cases. He employed the village elder, a man named Liu Zhao, to hire and oversee laborers, and by doing so gave the residents of Angu a stake in the Palace Museum's operation. He detailed soldiers from the guard detachment to work on projects like road maintenance that made a tangible difference to the local economy. A trusting relationship developed, and Angu's people knew never to discuss with outsiders where the cases were stored. The facilities' security became a point of local pride.[19]

Ouyang Daoda had rented a spacious farmhouse not far from the ancestral hall of the Song clan, where he had his offices. The farmhouse had half-timbered white walls and a tiled roof. Beyond its gate were poplar trees, a thicket of bamboo, and fields. To begin with, he was alone, having left his wife, Hu Shuhua, and their children behind in Nanjing. Hu Shuhua was pregnant with their fifth child. Before the city fell to the Japanese in late 1937, she took the two youngest children, one and three years old, and joined the great flood of refugees. She headed for her hometown in Anhui province. Somewhere along the way, sheltering in a ruined

temple, Hu gave birth to a son. After a long and convoluted journey, she managed to join Ouyang Daoda in Angu, and settled there for the war years. In all she gave birth to ten children. Six survived. Three were born during the war years in Angu, Ouyang Daoda himself overseeing one of the births at home in the farmhouse, cutting the umbilical cord with a pair of sanitized scissors. The entire family depended on Ouyang Daoda's salary from the Palace Museum, and life was spartan. Ouyang Daoda was characteristically strict with the children. He ensured they received an education, but he refused to allow any of them to apply for scholarships to attend school, believing that the country's distressed circumstances made it unpatriotic to do so.[20]

Ouyang Daoda's written account of the war years is limited to the work of the Palace Museum. He told the story in a manuscript of 80,000 characters, written with brush and ink in a hand of great clarity and precision, as one might expect. He gave away little about himself, and his children said later that, for the sake of the family's safety, he never passed on any personal papers, an act of some foresight given what was to come.[21] A beautiful photograph of the Ouyang family, taken in Leshan in the mid-1940s, shows Ouyang Daoda, Hu Shuhua, and five of the children. They stand a little stiffly amid scrubby grass and weeds before a grand, ornamented gate. They wear long gowns of faded, rumpled cotton. Hu Shuhua and her daughter smile. Ouyang Daoda looks straight at the camera, unsmiling, his expression unreadable, his hair brushed back severely from his forehead, chin raised a little almost as if meeting a challenge.

Just twenty miles to the east of Angu lay the town of Emei, where the Palace Museum operation was run by the irrepressible Na Chih-liang. The cases that had come via the Northern

Ouyang Daoda and family,
pictured in Leshan in the 1940s

Route were stored in the Great Buddha Temple outside Emei's east gate, and at the Temple of the War God, near the west gate. The Stone Drums of Qin, in their huge cases, spent the war years here. Na Chih-liang's simple living quarters were in the Temple of the War God, and each day he walked the short distance between the two temples, through the town's muddy streets. He oversaw a system of stacking and registering the cases every bit as precise as Ouyang Daoda's, ensuring the rebuilding of the floors and partitions inside the Great Buddha Temple's halls was to the museum's specifications. He appears to have assuaged the concerns of the resident monks by liberally dispensing cash and having them sign agreements to the work. He began opening and checking the contents of the cases and airing those pieces vulnerable to the depredations

of humidity, just as at the other locations. He also laid down pesticides and searched for any sign of rats, mice, or insect infestations.

A company of troops from the republican army's Fifth Special Services Division guarded the Emei facilities initially. Their commander was a spit-and-polish officer, whose uniform was always correct no matter how hot the weather. His approach impressed Na Chih-liang, though when two soldiers went absent without leave, a different and frightening side of the army emerged. The two men, both in uniform, took to the road on foot, but were found, arrested, and returned to Emei. The officer assembled the Emei company and forced the two men to kneel in front of them. After a brief speech, he took his sidearm from its holster, walked to the man he considered the instigator, and shot him dead. Na Chih-liang recounted the episode without comment, except to note dryly that word spread locally of the Palace Museum's policy of executing people. The event suggests something of the capricious, random discipline often meted out to soldiers in the army of the Chinese republic, a factor that contributed to the army's gradual decline in morale and effectiveness. Na Chih-liang's lack of reaction to the incident perhaps reflects the pervasive violence and casual cruelty of the times.

Later, troops of the Twenty-Ninth Division replaced those of the Fifth, and Na Chih-liang noted a serious deterioration in discipline. To his disgust, the new company commander began hiring his troops out as laborers, taking them away from their duties guarding the storage facilities to work on roads or in fields, and then paying the troops only a fraction of what they earned. Unsurprisingly, the soldiers began to desert. The company commander's solution, according to Na Chih-liang, was simply to press locals into service in order to maintain a full complement of soldiers. These impoverished, forcibly

conscripted men were locked in their barracks and allowed out only for drills. In their turn, the troops from the Twenty-Ninth were replaced. In 1941 a detachment of soldiers from another special services unit, controlled directly by the military's high command, arrived. They wore a blue shoulder patch with the character *te*—"special"—in white.[22] Na Chih-liang found them smart and efficient, but hopelessly underfunded. They were unable even to provision themselves adequately. On one occasion the men became so hungry they took their rifles and went hunting dogs for food, shooting at anything they saw in the fields. The expedition went terribly wrong. A stray round struck a villager in the head, killing them. Na Chih-liang had to visit the bereaved family to pay compensation. The relatives of the deceased emerged from their houses and knelt in the road, weeping. "No one ate any dinner at all," he remarked morosely, "it was all so sad."[23]

As seen by the curators and their families, the troops that accompanied them through the war years were by turns heroic, conscientious, corrupt, shabby, and brutal. Different units behaved in wildly different ways, and the impression is of an army that was chaotic and poorly served by its leaders. For all their sacrifice in the name of a young, fragile, invaded nation, the public viewed army units with suspicion, and KMT politicians and officials frequently treated their own soldiers with callousness, even contempt. The conscription system was a confused, contradictory mess. Laws and regulations changed constantly. Local officials ran rackets, extorting huge sums from families in return for exemptions from the draft. Poor, illiterate families, whose understanding of war, law, or government was limited, were easy prey. Families regularly paid substitutes to take the place of their conscripted sons. The substitutes would later desert and repeat the process to earn more money. Press gangs compelled young men of fighting age into

service, dragging them from villages and factories.[24] Forced and corrupt conscription became more widespread as the war progressed, eroding trust in the KMT and the republic.

As Na Chih-liang tried to settle down in Emei, his wife, Na Hu-hwei, and their children remained in Peking, living with his father under Japanese occupation. Na Chih-liang was unable to remit any of his salary to them, and they were forced to fend for themselves. Initially, they relied on savings to survive, but after a few months began to run perilously short of money. Na Chih-liang wanted them all to come to Emei, but his father refused to leave Peking, so he formulated a plan to cross into occupied China to fetch them. When he wrote asking permission, Ma Heng refused and ordered him to stay in Emei and to focus on his work, but offered to sell objects from his own Peking house on Yabao Lane and give the money to the family to help them get by. It was a generous offer but came to nothing; the museum staff in Peking thought it improper to sell off their boss's possessions. Na Chih-liang grew increasingly worried for his father, wife, and children, and his worst fears were realized. Na Hu-hwei wrote in late 1939 to tell him his father had suffered a series of heart attacks and passed away. Na Chih-liang was racked with guilt for having left his family.

After her father-in-law's death, Na Hu-hwei made the decision to take the children, leave Peking, join the great tide of refugees, and somehow make her way to Sichuan to find her husband—a plan fraught with risk, made perhaps out of desperation. It was early 1940, and there was snow on the ground. The journey meant taking three children through the great swathe of north, east, and central China occupied by Japan and finding a place to cross to the unoccupied zone in the west.

Gathering what little money she had, Na Hu-hwei and the children set out by train. She carried packets of cigarettes to give to Japanese soldiers who demanded to see her papers or to know where she was going. Traveling on overcrowded trains, staying in filthy hostels, the little band made their way south to Xuzhou and then Jieshou, where they made the crossing into unoccupied China. They traveled by cart, had their food stolen, and fought for tickets in packed, frightening railway terminals. At one chaotic station Na Hu-hwei trusted a stranger to buy their tickets for her. He shoved his way into the crowd and disappeared, never to be seen again. She sold her jewelry and her wristwatch to keep going. After weeks of travel, keeping her husband informed of her progress by telegram, she and the children neared Emei in a pedicab. Na Chih-liang walked out of town to meet her. "Suddenly there were four more people in the house, and my finances deteriorated badly," Na Chih-liang wrote, "but it was such fun." His wife's happiness was short-lived; she contracted malaria, sickening to the point where she could neither stand nor speak. Na Chih-liang went as far as making funeral arrangements, until a local doctor assured him that malarial attacks were not always as serious as they seemed. After several days in a clinic, she recovered. Na Hu-hwei's extraordinary experience—like that of most women of the time—comes to us only in fragments, remembered and relayed by men. Her voice remains unheard.

The Na family spent the war years in the same sort of poverty as the Chuangs and the Ouyangs, their lives leavened by the sense of identity and purpose that the work of conserving the collections brought them. To supplement his salary, for several years Na Chih-liang took a job teaching English and history at a local school. He became a well-known figure among the schoolchildren of Emei, who, according to custom, would greet and salute him respectfully when they saw him on

the street. On one occasion Ma Heng came to Emei on Palace Museum business. As the two men left the storage facilities, the soldiers on guard duty snapped to attention and saluted. As Na Chih-liang escorted his eminent guest through town, a stream of schoolchildren offered him salutes. Everywhere Na Chih-liang went, he was saluted. Ma Heng turned to him and remarked, somewhat archly, that he had become "quite the local personage," a moment that Na Chih-liang seems to have thoroughly enjoyed.

The Na family explored the famous Buddhist mountain that towered over their town, climbing its twisting pathways to the temples, feeding the monkeys, looking for rainbows in the mountain mists, which were said to be the halo of the Buddha. Na Chih-liang noted approvingly that while devout Buddhist pilgrims climbing to the peak were offered only vegetarian food in the temples, sightseers like him could buy smoked meats and rice wine. His skepticism of Buddhism does not seem to have diminished with familiarity.[25] For Na Chih-liang, the war years were trying, but his resilience—perhaps even, at times, insensitivity—seems to have served him well. His writings suggest that his circumstances and his responsibilities never got the better of his urge to explore and to find pleasure in the moment.

As the war moved into its fourth, fifth, and sixth years, the imperial collections remained secreted in west China, the cases stacked in their quiet halls, suspended between sanctuary and chaos. The curators eked out a living and attended to the endless tasks of conservation, holding back the forces of age and decay as if keeping a patient alive. The curators' children grew up on their parents' stories of the majesty and beauty of old Peking as they lived on peasant food and played in the forests and muddy fields of Sichuan and the rocky hills of Guizhou.

But even as the curators dreamed of a return to the Forbidden City, the possibility of recapturing the life they had once known was receding.

Na Chih-liang came perilously close to disaster in Emei. One day in 1943 he was working at the Temple of the War God, in the western part of the small town, where a portion of the cases in his charge were stored, when he heard a fire alarm. The blaze had begun at an opium den in town, where someone had dropped smoldering ash onto a straw mattress. Those present made no attempt to put out the fire, instead running for their lives. The neighboring shop sold vegetable oil, which ignited and fueled the flames. Na Chih-liang ran to the troops guarding the storage halls and ordered them to take their firefighting equipment to the scene. The platoon commander pointed out that Emei had no running water; their hoses would be useless.

The situation was fast becoming serious. The blaze was spreading toward the town's west gate, beyond which lay an area of shacks, huts, and stalls built of highly flammable wood, bamboo, dried grass, and straw, the homes of poor families and traders. Just beyond that lay the Temple of the War God and its cases of irreplaceable art. The shacks would go up like tinder. Na Chih-liang realized that to prevent the flames reaching the temple he needed to cut a fire break. He ordered the troops to knock down all the structures outside the gate "no matter whether it was a house or a pig pen or a store." The troops, ignoring the desperate pleas of those who lived there, tore into the flimsy houses, smashing them to the ground. Na Chih-liang made hasty promises that everyone who had lost a hut would receive compensation.

The fire that day consumed a large part of Emei; the town's government building, the post office, and the bank were all damaged. The flames did spread beyond the west gate in the

direction of the Temple of the War God, but the destruction of the shacks worked, and the fire progressed no farther. No cases were damaged, probably due to Na Chih-liang's decisive, hardheaded action, but at enormous cost to the marginalized people whose homes and livelihoods his decision destroyed that day. Na Chih-liang did not record how much compensation he paid, or who got it, or how.[26]

In the later war years, even after the United States and Britain entered the war against Japan as China's allies, the suffering of China's people only became more acute. The KMT arrested and tortured its opponents. The space for free expression shrank. Food became scarcer, and the days when Na Chih-liang could wander a rural market and wonder at its plenty were gone. The burden of feeding the army of the republic and the millions of refugees fell on poor farmers in the territory still controlled by Chongqing. In the summer of 1941 the KMT made the fateful decision to collect land taxes not in cash, but in grain.

Farming families, already weakened by the conscription of young males, began to see their food siphoned away to the war effort. In central China the dry spring and summer of 1942 combined with the devastation wrought by the destruction of the Yellow River dikes wrecked the harvests. In Henan province the shortage of grain became acute. Less affected, neighboring provinces refused to send aid. The famine, when it came, was devastating. Official corruption and ineptitude exacerbated it; grain stores that should have provided relief were empty. Farmers and their families starved to death in their villages or took to the roads, wandering in desperation through the ravaged landscape. The dead numbered in the many millions.[27] The republic was exhausted and on the verge of collapse.

In November 1943 Chiang Kai-shek attended the Cairo Conference, meeting Britain's prime minister, Winston Churchill, and the US president, Franklin D. Roosevelt. The Allied leaders discussed the war with Japan. Stalin was not present. Chiang Kai-shek, for a fleeting moment, was a leader on the global stage. In reality, the leaders of the racially segregated United States and imperial Britain did not see China as an equal partner and had little faith in the republic's ability to contribute significantly to Japan's defeat. Chiang Kai-shek left Cairo unsure of Britain's and America's commitment to China's cause. The Western powers' lack of engagement with China's position at Cairo presaged a wider postwar forgetting of China's role in the Second World War. Today, beyond East Asia and outside academia, China's war is rarely glimpsed in literature, in museums, or in any popular representation. That such a cataclysmic series of events should be so stubbornly absent from our understanding of the war and so little examined asks hard questions of us. How is history made? By whom? Whose interests are served by the privileging of certain stories over others? Whose history matters?

In 1944, even as tide of the wider war turned irrevocably against them, Japan's military leaders launched one last, bold offensive in an attempt to knock China out of the war and regain the initiative in Asia. It was code-named Operation Ichigo, carefully planned, and generously resourced. That spring half a million Japanese troops in central China thrust south. Operation Ichigo's objectives were to destroy the American air bases in China threatening the Japanese home islands and to take control of railway lines, thereby linking Japan's armies in north, east, and central China to those in the south. If successful, Operation Ichigo would strangle the republic strategically and economically.

Japanese infantry attack in Henan province
during Operation Ichigo in 1944

The republic's military response to the Japanese onslaught was pitifully weak. Some of China's finest troops were far away, fighting the Japanese to the south alongside the American- and British-led forces in Burma. Those armies that remained to face the renewed Japanese advance had decayed into ineffectiveness. Corruption festered. Inflation had eroded soldiers' pay to a pittance. Poorly led, malnourished conscripts were no match for the reinvigorated Japanese forces, nor for their artillery and aircraft. Operation Ichigo began in Henan province, where much of the Chinese population still starved in the wake of the famine. Exhausted and furious farmers turned on the republic's troops, denying them food, taking their weapons. Resistance collapsed. Over the summer of 1944, as the

world watched Allied forces storm ashore in Normandy and Soviet armies drive the Germans out of Russia, the Republic of China flailed. The city of Luoyang fell, then Changsha, then Hengyang. The rivers of refugees flowed again.

By November 1944 Japanese divisions had thrust far into southwest China, and into Guizhou province. They took the town of Dushan, only 110 miles from the Huayan cave where Chuang Yen and his family guarded the eighty steel-sided cases containing the most valuable items of the imperial collections. Ma Heng reported to the board of directors that the cases were in "a dire situation" and should be moved immediately. Transportation could only be by truck, which of course led Ma Heng to worry inordinately. The prospect of worn-out trucks, poorly maintained and short of fuel, rattling down blasted roads as they fled before Japanese troops, overturning, spilling their contents into the mud, was terrifying. The trucks, he wrote "must travel slower than their usual speed" and should be "lightly loaded." The drivers must all be "excellent," and no truck should carry any weapons or ammunition. He requested three million yuan to pay for the moving, the enormous figure a sign of out-of-control inflation.[28]

Ma Heng's initial plan was to take the cases from the Huayan cave to join those nearly 300 miles away at Angu and Emei. With the Ichigo offensive, however, came waves of bombing reaching far into Sichuan. Japanese aircraft were "rampant," noted Ouyang Daoda. Ma Heng then appears to have decided that dispersing the cases, rather than concentrating them in two locations, was wiser. He settled on some abandoned warehouses belonging to an oil exploration agency about thirty miles south of Chongqing, near a town called Yipinchang. The warehouses were a few miles out of town, off the road, out of the way, inconspicuous in rolling country of forest and terraced fields.

Chuang Yen and his family, who had been in Anshun for six years, prepared to leave. The war was frighteningly close. Retreating Chinese soldiers in filthy, ragged uniforms straggled through the town and lay exhausted in the streets and court-yards. The Chuang children gazed at them, never afraid but very aware of the soldiers' plight. Many of the men had poorly bandaged bullet and shrapnel wounds. When the soldiers ate, the children inched closer to see what was in their mess tins and were shocked to see only a few vegetable sprouts and nothing more. It was time to go. The family packed its belong-ings and sold what they could not take with them. To their astonishment, even their old, worn, patched clothing fetched a few pennies.[29]

On December 5, 1944, guards and laborers carried the eighty steel-sided cases, including case number 43, in which lay *Early Snow on the River*, out of the Huayan cave and loaded them aboard fifteen waiting trucks. Perhaps Chuang Yen, in his long robe of padded cotton against the winter morning chill, walked with Shen Juo-hsia and the children from their little wooden house to see the trucks off.

The roads were in a terrible state, jammed with traffic head-ing north to Chongqing, clogged with refugees on foot pulling carts and leading oxen. Japanese aircraft came screaming down to strafe the civilians on the road, their machine guns wreak-ing terror and carnage. The trucks of the Palace Museum soon became separated in the melee, although the drivers followed their orders to rendezvous at particular towns before setting out again together. The little convoy and its irreplaceable load straggled north through the endless, unremitting war. It took them thirteen days to cover 250 miles. Outside the town of Zunyi, vehicle number 24129, loaded with cases full of porce-lain, was struggling up a steep hill. Halfway up, the engine cut out. The truck began to slide backward down the hill, picking

up speed, the driver struggling to maintain control. When it reached the base of the hill, the truck smashed into another truck. The packing, even after the passage of so many years, proved its worth once again. Nothing in the cases broke.[30]

The convoy pulled in to Yipinchang on December 18, 1944, and from there took back roads to the warehouses. The eighty steel-sided cases, and *Early Snow on the River*, remained here for the rest of the war.

12

THE UNFORGETTABLE DAY

On a cool autumn morning in late 1945 a jeep drove out of the Republic of China's wartime capital, Chongqing, and took the road south. The jeep passed through the town of Yipinchang and at the Valley of the Flying Angels turned onto a rocky, uneven side road. As it twisted up into the hills, the road followed a stream that tumbled over rocks, thickets of bamboo on its banks. The jeep passed roadside shrines and women working the terraced fields of broad-leafed beans, bearers carrying loads swaying at the ends of shoulder poles, and thatched farmsteads loud with the clucking and grunting of chickens and ducks, pigs and water buffalo.

Aboard the jeep was an extraordinary group of people. Ma Heng, sixty-four years old now and still director of the Palace Museum, his brush cut frosted with gray, occupied one of the seats. Next to him sat Horace H. F. Jayne, a jovial American historian and curator of Asian art from Philadelphia. Jayne had spent the war years working for the US government on the protection of valuable art and architecture in combat zones, an effort that gave rise to the Monuments Men program to locate and protect the art treasures of Europe

looted by the Nazis. At the end of the war the State Department sent Jayne to China to report on the damage to its culturally important structures and artifacts. With Horace Jayne and Ma Heng in the jeep was Wilma Fairbank, cultural attaché at the embassy of the United States in Chongqing and authority on early bronzes and pottery. Wilma was married to John King Fairbank, a famous Harvard scholar of Chinese history. Liang Ssu-ch'eng, an influential architect and teacher, and Wang Shixiang, an authority on traditional Chinese painting, completed the party. Between them, the group possessed a profound knowledge of China's material culture, its palaces and paintings, its cities and ceramics, jades, bronzes, and tombs. The place of that culture in the fragile, changing postwar country, and the security of its material artifacts, was of deep concern to all of them.

For a while the track narrowed to almost nothing, just a pair of wheel ruts amid the bamboo groves, before turning into a narrow lane that led to a stone bridge, a sentry box, and a guard at attention. The jeep pulled up amid half a dozen neat, well-kept warehouses. Horace Jayne dismounted and looked around at this "forgotten pocket in the hills," at the twisted pines and gnarled rocks, and felt himself enter a Song landscape painting a thousand years old. The Palace Museum staff at the Yipinchang storage facility had gathered. The visitors sat briefly and drank tea with them, their mood full of anticipation. Jayne felt that the staff were "a fine group— young men all, with sensitive faces and cordial manners." After tea and formalities, Ma Heng led Jayne, Fairbank, Liang Ssu-ch'eng, and Wang Shixiang into a long, narrow warehouse with a gabled roof and wide eaves. Jayne noticed everything: the warehouse's whitewash and cross-timbering stained black, its cool interior, the atmosphere lifted by a row of windows high up in the walls. He registered the neatness of the black,

steel-sided cases piled three high in long rows, the stacks rest-
ing on wooden beams a foot square to keep them off the floor
and away from damp.

The curators opened cases and extracted pieces—paintings
and jades—for Jayne to examine. He noted how the interior of
each case was lined with tin, and each jade resided in a padded
box of green silk damask, each painting in its own sleeve of
blue cotton. The museum staff unfurled the scrolls and hung
them for Jayne and the others to view. The group saw Tang
and Song period landscapes, figure paintings, portrayals of
birds and flowers. Jayne was awestruck and especially moved
by *Herd of Deer in an Autumn Grove*, a hanging scroll "of
haunting beauty," and "surely one of the greatest paintings of
any epoch or culture." Jayne had seen the scroll at the Lon-
don Exhibition a decade before, and to see it again after years
of war seems to have almost overwhelmed him. To his aston-
ishment, Ma Heng then presented a second, almost identical,
painting, *Herd of Deer in a Maple Grove*, a companion to the
first, the maples "every conceivable shade of crimson and rus-
set through golden yellow to pearly grey." Only the composi-
tion of the deer herd differed. Jayne and Ma Heng discussed
the relationship between the two paintings, hypothesizing that
they had, long ago, been a part of a screen depicting the life
cycle of a stag.

The viewings were interrupted by "a sumptuous lunch,
somehow conjured up by the staff out of the wilderness,"
and in the afternoon they resumed. Jayne's fulsome, joyous
account of the day is suffused with wonder and relief at the
wartime survival of the imperial collections. "It now seems
clear," he wrote, "that the entire collection is intact, having
been kept most meticulously throughout this long period of
travail."

Evening drew in, and the paintings and jades went back

into their black cases. The group took their leave "amid a profusion of thanks and farewells," boarded their vehicle, and set out on the drive back to Chongqing through the dusk. On the road the jeep suffered mechanical problems. Jayne was unperturbed, even after it "threatened to shed its muffler, and absolutely refused to permit any of its alleged brakes to work at all. But what were these mechanical difficulties after such an unforgettable day?"[1]

Horace Jayne's written account captures the colossal achievement of Ma Heng and the Palace Museum staff, and the optimism of the moment. If he understood the precariousness, the danger, that underlay that moment, he gives no sign.

The Second World War was officially over. American Superfortress bombers had dropped their atomic payloads on Hiroshima and Nagasaki on August 6 and 9, 1945. Japanese forces surrendered to the Allied powers aboard the battleship USS *Missouri*, moored in Tokyo Bay, on September 2.

The formal surrender of Japanese forces in China came a week later. At the Central Military Academy in Nanjing, the commander in chief of the Japanese armies in China, General Okamura Yasuji, gave up his sword. He was allowed to do so in private, both to save him public humiliation and to prevent him committing ritual suicide in public. The ceremony of surrender was held at 9 a.m. on the ninth day of the ninth month. The Chinese side chose the time and date carefully. The number 9 in Chinese, *jiu*, is said the same way as the word for "long-lasting." The numerical symbolism suggested a long, durable peace.[2] General Okamura signed the instruments of surrender and handed them to his Chinese counterpart, General He Yingqin. A million Japanese troops across China stood down in relatively good order. KMT leaders flew into Nanjing on a warm Sunday to be greeted by rapturous crowds waving

the flag of the republic amid piles of rubble and bombed-out buildings.

The victory was sudden and unexpected. Chiang Kai-shek, the republic's leader, found himself next to Churchill, Stalin, and Truman as one of the "Big Four," the Allied leaders who would shape the postwar world. Chiang Kai-shek's vision of a unified, sovereign China was closer than it had been in a century. Taiwan and Manchuria were no longer Japanese colonies. The foreign concessions in Shanghai and elsewhere, forced on China by the imperial powers in the nineteenth century, were gone, even though Hong Kong and Macao remained foreign colonies. Chiang Kai-shek, in a speech on September 3, 1945, promised China a future of constitutional democracy and an end to censorship; he promised land to war veterans and better livelihoods for farmers and laborers. China's future as a modern state depended, he argued, on an end to the armies that roamed China; military forces other than those of the state were "relics of the days of the warlords," and would not be tolerated. The streets of the battered wartime capital, Chongqing, were alive with celebration and decked in the flags of the republic, the United States, and the Soviet Union. Thousands of cheering citizens converged on government headquarters, others filled the restaurants and tea shops in celebration.[3] The euphoria obscured complicated truths.

The war had left the Republic of China shattered. Casualties, corruption, the brutality of the KMT, famine, displacement, and trauma all came together in a demoralizing, enervating stew. The monetary system was degraded. Inflation was out of control. Infrastructure was wrecked. The great tides of refugees that had made their way west at the beginning of the war now surged and stumbled in the opposite direction homeward. Millions found their towns and homes destroyed, their families scattered. Sons, fathers, and brothers who had

fought for the republic had disappeared without a trace, their deaths in action or as prisoners in Japanese labor camps unrecorded, unremembered. Such unresolved losses were deeply traumatic for families. Food was scarce, hoarding and profiteering were rife. Famines scoured great swathes of territory.

When republican troops and KMT officials returned to areas previously occupied by the Japanese, they undertook brutal searches for collaborators. The confiscation of collaborators' property turned to expropriation and outright looting. In China's north, east, and central regions liberation from Japanese occupation brought fear and humiliation as often as it brought relief. In many places the respect and loyalty that Chiang Kai-shek and the KMT had earned through their dogged resistance to Japan drained away.

In sharp and consequential contrast, the war years had given the Chinese Communist Party the space, the time, and the opportunity to build and strengthen itself. At his headquarters in Yanan in China's northwest, Mao Zedong refined his ideology of revolutionary socialism calibrated to the particular needs of impoverished rural China and imposed it upon the party. Communist troops had fought the Japanese, but Mao never allowed the war against Japan to erode or undermine the party's strength; he was content for republican troops to do most of the fighting and dying. The republic's growing fatigue and dysfunction gave the communists an opportunity.

By 1945 the Communist Party claimed a million members, an effective, well-fed regular army 900,000 strong, and many more militiamen and guerrillas. It controlled significant tracts of territory. The party was at its heart increasingly totalitarian, even as it maintained an outward show of moderation. But communist operatives and soldiers were disciplined and well-behaved. Their stated vision of a socialist future free of economic exploitation and class inequality stood in stark contrast

to the corruption of the KMT. "Do not take a single needle or piece of thread from the masses," the party ordered of its troops. Such behavior was unheard of in a Chinese army.

Mao was unshakable in his belief that communism was poised to triumph in China. After hearing news of the explosion of the atomic bomb over Hiroshima, he is recorded to have said, "It is obvious that the fruits of victory belong to us."[4] As the faltering, exhausted republic celebrated Japan's defeat, the Communist Party moved to secure control of China. For Ma Heng, the Palace Museum curators, and all those who had served the republic, the future remained frighteningly uncertain, the prospect of a renewed civil war alarmingly real.

Ma Heng devoted himself to realizing his dream of returning the imperial collections to Peking, of laying the cases on the cold, stone flags in the halls of the Forbidden City and prying them open, of taking the objects from their wrappings of cotton and cord, the paintings from their sleeves of indigo cotton, of replacing the collections in their rightful context. The nearly 17,000 cases at Emei, Angu, and Yipinchang would, once more, have to be loaded and shipped. Peking lay more than 1,500 miles away, across a country devastated by war. Uncertainty lay everywhere. What route should the cases take? Did any kind of transportation infrastructure even remain in north, east, and central China? In what state was the Forbidden City itself? The end of the war meant an end to the threat of aerial bombing, artillery bombardment, and plunder by Japanese troops, but all the other dangers remained: moisture, vibration, and insects posed as great a threat as ever. Trucks still rattled and shook and overturned. The security of temporary storage was as tenuous as ever. The perils of manhandling cases on and off junks, ferries, and steamships induced just as much of a churn in a curator's gut as they ever had in the war years.

The long journey back began on January 21, 1946. The eighty steel-sided cases at Yipinchang were loaded on trucks belonging to the Sichuan Oil Exploration Agency. Their initial destination lay only fifteen miles away, just south of Chongqing. Ma Heng's plan was to gather all the cases in Chongqing and use the river to transport them back to east China. He settled on a suite of government offices and dormitories on the south bank of the Yangzi at Xiangjiapo as the collection point, and he appointed Na Chih-liang to lead the operation.

In May the 7,000 cases at Emei began their move, also by truck, more than 200 miles east to the Chongqing collection point. Na Chih-liang found himself in another awkward, tedious subcontracting dispute with the transportation companies that slowed the process badly. It took 256 trips to move all the Emei cases, an endeavor that took five months through the sweltering summer of 1946.

As that summer ended, and the weather began to cool and turn rainy, Ouyang Daoda's staff at Angu threw themselves into the herculean effort of getting their part of the collections back to Chongqing, first by river and then truck. Porters carried the 9,000-plus cases stored there back across the fields to the Dadu River, where a small fleet of wooden boats and bamboo rafts awaited them. It was a treacherous stretch of river, but Ouyang Daoda trusted that the boatmen knew their work, and would skirt the spits and sandbars to arrive safely at the bank of the Min near the great sandstone Buddha and the wooden pier that would facilitate unloading. A grain storage barn on the shore was dry and secure, and would provide temporary storage while the cases awaited convoys of trucks to drive them to Chongqing.

The very first day of barging, September 10, 1946, was something close to a disaster. Seven stout bamboo rafts left the jetties on the Dadu River. They carried 620 cases between them.

The boatmen navigated them safely into the Min and across its channel to the far bank, but unloading fell far behind schedule. As the sun went down, 540 cases remained on the river, lashed to the rafts. The museum staff decided that unloading in the darkness was courting danger. They covered the cases with oil-cloth and bamboo matting and left them aboard the moored rafts overnight.

At midnight, however, the weather turned nasty. A stiff wind arose, churning the river water. Rain began to fall in tor-rents. Woken by the storm, the museum staff roused the labor-ers, and they ran to the riverbank, where the laborers dragged more oilcloth over the rafts in a desperate attempt to keep the cases dry. The storm lifted at dawn, and the anxious museum staff went to investigate. Water had pooled on the oilcloth and had seeped through. The curators had all the wet cases offloaded immediately and set about opening them.

Sixty-three cases had taken on water, and in twelve of them the contents had sustained water damage. More than a dozen volumes from the Siku Quanshu, that vast library of canonical works assembled by the emperor Qianlong in the eighteenth century, were soaked to varying degrees. One was a volume of essays and poetry composed in the tenth and eleventh centuries during the Song period, another a complex glossary of literary expressions and usages published in 1711 to aid scholars and poets, known as the *Peiwen Yunfu*. Over the next seven days museum staff dried out these fragile materials in an impro-vised conservation operation conducted in the grain storage barn by the side of the river. In dozens more cases the packing materials—rice straw and cotton wadding—were wet, but the objects themselves were unaffected.

It was late in the year by the time all the cases made it to the eastern bank of the Min River. Over the closing months of 1946 and into 1947, the cases from Angu traveled 200 miles,

to Chongqing by truck. The weather was poor, and so were the roads. Ouyang Daoda, in his account, recites in agonizing detail every incidence of damage from water and vibration on this leg of the journey. He makes no comment, though the reader senses that every incident was purgatory for him. The battered, potholed roads did some awful damage. Case number 1681: Qianlong-period large porcelain bowls in yellow glaze; six shattered, three cracked. Case number 5: a bronze vessel with a hunting pattern, damaged; a *ding* bronze vessel of the Zhou period, one leg broken off. Case number 212: Kangxi-period blue-and-white porcelain bowls, four shattered. The list extends to dozens of cracked and shattered pieces and books attacked by damp and mildew, although only a tiny fraction of the total shipped suffered damage.

By March 10, 1947, all of the nearly 17,000 cases from Angu, Anshun, and Emei were gathered in Chongqing in the warehouses at Xiangjiapo. For the curators it was a miserable period. Their dormitories were infested with bedbugs, and every night during that spring Na Chih-liang found himself devoured. Whenever the sun shone, he dragged his bed outside, overturned it, and whacked the wooden frame to see hundreds of the little creatures tumble to the ground. He poured boiling water on the frame, but to no avail. The bugs survived in cracks in the dormitories' walls and floor and were back within days. "They reproduce three generations in one night," he wrote despairingly.

The collections' onward journey would be to Nanjing, once again capital of the republic. They would go by river, specifically by enormous naval landing craft plying the Yangzi, great steel beasts with flat bottoms and powerful engines, easy to load and unload, but with the cases relatively unprotected from the elements. The operation got underway at the end of May 1947, the landing craft plowing eastward down the

Yangzi more than 900 miles. It took six months for all the cases to arrive in Nanjing.

The landing craft were unloaded at the docks at Hsiakwan, exactly where, a whole ten years earlier, they had been rushed aboard the British steamships as Japanese bombers flew overhead. The arrival of the collections back at Nanjing should have been a cause for relief and reflection for the museum staff but instead became one of acute anxiety. To the curators' horror, the dockers' method of unloading cargo was simply to lay a sheet of burlap sacking at the base of each stack of cases, clamber to the top of the stack, and shove the topmost case from its place, allowing it to fall with a crash to the deck, to be gathered up in the burlap and carried away.

When he saw what was happening, Liang Tingwei, who had nearly lost his life on the Dadu River when his craft loaded with cases went adrift, rushed over and ordered the dockers to stop. The men did not like his tone and encircled him. Na Chih-liang and others intervened to forestall a beating. Apologies and negotiations followed, but the dockers would not change their methods. Their only concession was to lay more burlap on the deck so the cases at least had a softer landing.

Na Chih-liang overheard another curator mutter, "That's democracy for you. Everyone just does what they want." It was clearly painful for Na Chih-liang to see the cases on which they had lavished so much care treated in such a brutal fashion. He remembered the outward journey of ten years before, the care and precision of loading even in the wartime chaos of the Nanjing docks. The cases had been slung from shoulder poles back then, two laborers to each, foremen scolding any who did not take sufficient care. As he stood and watched case after case land with a thump on the piled burlap, he seems to have sensed that something in the order of things had changed,

that the war had left the republic mean, bitter, and fragile, that the prewar world was never to return.

One small group of cases took a different route back to Nanjing: the ten containing the Stone Drums of Qin. These, Ma Heng decided, were too heavy and unwieldy to go by river, and would make the entire journey—a thousand miles—by truck. To escort them, he turned to the ever-reliable Na Chih-liang, who was understandably unenthusiastic about a weeks-long trip by truck through war-ravaged central China. He grudgingly consented to go, but only in an advisory capacity, insisting that other curators take responsibility for the shipment.

The little convoy carrying the Stone Drums in their huge cases pulled out of Chongqing on May 31, 1947, with Na Chih-liang sitting in the driver's cab of the lead truck. They were barely out of the city when a truck went missing. The convoy halted and waited for the missing vehicle to catch up, but it never came. Na Chih-liang decided to go back and search for it, but the other drivers refused to turn round. Furious, he hitchhiked back in the direction from which they had come. He found the truck overturned by the side of the road, the enormous, weighty case containing the Stone Drum lying in a field. The entire convoy had to wait for a replacement truck, then find laborers to lift the case aboard.

The convoy pushed on to the east over the following days, into rural, mountainous country, and Na Chih-liang began to recover his spirits. At White Horse Pass the trucks crawled up a steep tangle of switchbacks in drifting mist, Na Chih-liang once again marveling at the beauty of his country as the vehicles "moved in and out of a sea of clouds." Gazing at the mountain peaks around him, he imagined building a retreat among them to follow a life of Buddhist contemplation. Given

the skepticism with which he regarded every monk he encountered, it seems an unlikely dream. He was surely more fulfilled digging around in an antique market or putting away fine *fen* liquor with his friends than he would have been retreating to a mountaintop to contemplate metaphysics. Nonetheless, his feelings as his truck clattered along the deserted roads, the vast chasms between the mountains brimming with cloud, seem to have amounted to a blissful moment of transcendence, articulated as the scholar's particular yearning for an arcadian quiet—a dream that courses through China's art and literature.

Na Chih-liang was dragged firmly back to reality a short while later. Winding through wild, lush mountains, the roads empty, the trucks lumbered over a high point at a tiny village named Gaokanzi. Before them the road twisted steeply downward into a valley. One of the drivers, who knew the route well, turned off his engine to save fuel and let his truck coast. As he rounded a sharp bend, he was surprised by an oncoming vehicle. He panicked and wrenched the wheel over to the right. The truck careered toward the mountainside. Compensating, the driver hauled the truck to the left. The truck lurched across the road and came to a standstill, teetering on the edge of a precipitous drop to the valley below. The three occupants—the driver, his assistant, and a police escort—all bailed out, jumping for their lives as the loose soil beneath the wheels gave way, and the truck toppled off the road, overturning as it went.

The case containing the Stone Drum was so heavy that the driver had thought it unnecessary to lash down, so as the truck turned over the case fell out onto the mountainside, where it lodged. The truck tumbled away, turning over and over until it crashed into the river far below; the case remained precariously stuck among the rocks, intact. Na Chih-liang, typically, reflected on his luck: no injuries, and if the case had followed

the truck down the mountain into the river it would surely have broken open, and the Stone Drum's fragile surface been damaged beyond imagining. Laborers dragged the case back up the slope with ropes, manhandled it back onto a truck, and the convoy pushed on to the east.

The drive seemed endless, but Na Chih-liang found opportunities for pleasure. He stopped in the market at Longtan to buy cinnabar, a mineral that gives a deep, rich, red pigment. He wanted it to make seal paste, and perhaps with this trivial purchase he was envisioning the future, the moment he would return to his study, to write, perhaps to paint, to leave his scarlet mark imprinted on a poem or a piece of calligraphy. At Yiyang he bought cloth for summer clothes, bamboo mats, and pillows. But when the little convoy wound through Changsha, the city so catastrophically bombed, fought over, and burned, he did not recognize it. All the old streets were gone.

The trucks crept on in the summer heat into east-central China, into those areas most ravaged by the war. The two years since its end had done little to heal this part of the country. The roads were terrible, potholed, washed away, so rutted that the trucks' chassis scraped the ground. Bridges were down, and the Stone Drums wobbled across rivers on flimsy, leaking ferries. The little convoy drove through ghostly, silent towns where the inhabitants had been massacred. People on the roads warned of armed gangs at night. The seventy miles between Shanggao and Nanchang were "the most bleak and desolate stretch of the entire journey." From the cab of his truck Na Chih-liang looked out over fields untended and over-run with wild grasses. There was barely any sign of human life; occasionally he glimpsed a lone figure wandering in the neglected fields, sallow and emaciated, their clothes ragged, "in the depths of misery."

Farther east, the roads became even worse. Driving the

entire route back to Nanjing was clearly impossible. They turned north, headed to the Yangzi River port of Jiujiang, and waited in the stewing heat and humidity for cargo space aboard a ship. Na Chih-liang whiled away the time reading novels rented from a bookshop. Only after three weeks did he finally secure space aboard a steamer. The Stone Drums of Qin made the final stretch of the journey back to Nanjing by water. Ma Heng awaited them, and, Na Chih-liang desperately hoped, so did a return to the life he had missed, that of scholar and curator charting the vast, sweeping river of China's material culture.[5]

It fell to Ma Heng to make sense of the Palace Museum's situation in the months immediately following the end of the war. As soon as was possible, he hurried to Nanjing to see what had become of the nearly 3,000 cases of objects that were never taken off the docks in 1937 and left behind in the Chao Tian Palace storage facility. Ma Heng and his staff found the palace in disrepair. The Japanese military had taken over the entire complex and used it for the storage of weapons and munitions. Parts of it had been used as a military hospital, and the Palace Museum staff found Japanese characters scrawled in blood on the walls. In 1939 the Japanese had used explosives to blow their way into the underground vault, and flooding had left it unusable.[6] The sophisticated steel doors to the vault, with their elaborate locking systems, had been ripped out and taken away. All the air-conditioning units had vanished as well, to Ma Heng's fury.

The story of the Nanjing cases during the war years is confused. They appear to have been taken from the storage facility and distributed among several locations around Nanjing. Some were opened, and objects and materials may have

gone missing, though apparently not those belonging to the Palace Museum. Most of these seem to have been recovered. The collaborationist government of Wang Jingwei attempted to centralize the management of cultural relics and art under its authority, with the aid of Japanese "advisers." The moving and opening of the cases at Chao Tian Palace appears to have been a part of that effort.[7]

Ma Heng had moved back to Peking in early 1946, living in his old house on Yabao Lane.[8] Peking had been spared the devastation that engulfed Shanghai, Nanjing, and Changsha. The Forbidden City still stood, its courtyards once again over-run with weeds and drifts of windblown sand. Within its walls the Palace Museum had continued to function through the war years as a shadow of its former self. A skeleton staff did its best to conserve the remnants of the imperial collections, those pieces that Ma Heng and the curators had not packed and taken to the west.

The Japanese had interfered with the management of the museum and tried to install administrators drawn from among local Chinese collaborators. They demanded maps from the Forbidden City's collections, which they copied and eventually returned.[9] Japanese officers had confiscated library catalogs and destroyed thousands of journals and magazines they considered sensitive or subversive, such as those detailing the situation in Manchuria, the affairs of the Chinese Communist Party, and events in the Soviet Union.[10] In 1944 Japanese troops stormed into the courtyards and began confiscating objects made from copper and iron for the war effort. The museum staff protested and succeeded in protecting some valuable bronzes and fittings, but the soldiers removed bronze cannons and more than 250 large copper vessels.[11] Many were later recovered.

The curator who remained in charge through those years, Zhang Tingji, seems to have taken considerable risks negotiating with the Japanese for the protection of the Forbidden City and fending off the predations of collaborators. The public records of his experiences are sketchy, but his was a deeply isolated, frightening position, separated from the museum's leadership, menaced on all sides, struggling for financing, resources, even food. Ma Heng, in his reports to the museum's directors, made a point of repeatedly praising Zhang Tingji's lonely courage.

For museums and libraries across occupied China, the war years were disastrous. The library of Peking's Tsinghua University, one of China's greatest institutions of higher learning, lost hundreds of thousands of volumes after it was turned into a Japanese military hospital. In Tianjin, Nankai University and the Institute of Technology saw their libraries destroyed by bombing, as were those of multiple colleges and universities in Shanghai, Baoding, and Changsha. A sizable part of Nanjing University's library collections disappeared after 1939, along with its card catalog, and was probably transferred to Japan. The Japanese even established the Central China Committee for the Taking Over of Books and Documents in Occupied Areas to transport and catalog looted materials. The committee employed 367 Japanese soldiers and nearly 4,000 Chinese manual workers.[12] The Royal Asiatic Society in Shanghai and universities in Shanghai and Suzhou saw all or part of their collections and catalogs taken to Japan.[13] All this, of course, was in addition to the thousands of rare books, documents, and antiquities destroyed when Japanese aircraft bombed Shanghai's Commercial Press building in 1932. Before the Japanese invasion, China had boasted 4,747 libraries across the country. By 1945 there were just 940.[14] Many more treasures were lost as private homes were bombed, burned, and

looted. Against such a backdrop, the true scale of Ma Heng's achievement in preserving the heart of the imperial collections becomes clear.

Ma Heng set about returning the Palace Museum to a semblance of normality as best he could. He seems to have understood, however, that the peace would not last. With him in the house on Yabao Lane was his son, Ma Yanxiang. The younger Ma was in close contact with the Communist Party, and entertained senior party officials, including the eminent general Ye Jianying, who visited in February 1946. Ma Heng was aware of the visitors but did not meet them, but neither did he object.[15] The awareness seems to have been growing in him that a decisive battle for China was coming, and that he was going to have to make a terrible choice: Would his loyalties remain with the republic that he had served, tainted and degraded as it was? Or would he side with the Communist Party, whose youth and vigor made it a serious contender for power in a still-to-be-imagined postwar nation, but whose ideology and true nature was still a mystery?

In a poem dating from this time Ma Heng wrote of hearing the mournful cries of birds year after year, and of looking in a mirror to find that the graying in his hair had deepened to white. Any postwar optimism has vanished; the poem teeters on the edge of despair. Ma Heng is anguished at the prospect of China falling back into civil war between the republic and the communists. To what purpose, he wonders, was the country's youth set against itself? He writes that he could "lean on alcohol" but "when I fix my gaze upon the desolation of war, I have no taste for it."[16]

China did not resume its civil war right away; the leader of the communists, Mao Zedong, went to Chongqing in 1945 for talks with Chiang Kai-shek. However, they achieved little, and

even as Mao negotiated, the Communist Party was working on a strategy to take power.

The communists' plan called for their forces to seize control in Manchuria—the icy northeastern provinces that the Japanese had occupied in 1931, with their railways, factories, coal mines, and steel mills. Manchuria had been occupied by the Soviet Union. Stalin only declared war on Japan in August 1945, but on doing so, had launched eighty-nine Soviet divisions in a crushing attack on what remained of the Japanese army. More than a million Red Army troops ground through Manchuria and down into the Korean peninsula. When the Soviets withdrew, they took with them half a million Japanese prisoners as slave laborers, enormous quantities of industrial machinery, and another copy of the Siku Quanshu. The Soviets also captured the hapless last emperor, Pu Yi, and handed him over to the Chinese communists. Pu Yi's palace, from where he had reigned over Manchuria as Japan's puppet, was looted "down to the lightbulbs."[17]

As the Soviets pulled out, the Chinese communists moved in. Chiang Kai-shek watched with alarm as anticipated control of China's richest industrial region slipped away from him. The first battles between republican and communist forces took place in early 1946. Many of the republic's troops were from the south and had never seen snow. The conditions were appalling, their equipment inadequate. Tens of thousands were maimed by frostbite.

The shape and progress of China's civil war is hard to visualize. Like the war against Japan, it was not fought on a single front. Violence bloomed in many different regions simultaneously, separate conflict zones bleeding across the map. In the summer of 1946 the republic launched a nationwide offensive against areas controlled by the communists. More than four million republican troops went on the attack. Mao Zedong

and his generals met the offensive with "mobile warfare," ducking and weaving, pulling communist troops back from major cities, skittering away from dangerous confrontations, clawing at the republicans' flanks and then disappearing, wearing them down. By the summer of 1947, the republican armies had shrunk by half a million. They were low on ammunition, and their strategy of holding territory and garrisoning cities had stretched them thin and tied them down. The offensive stalled, and Mao saw his moment.

In the second half of 1947 Mao ordered the People's Liberation Army (PLA) into the attack. Offensives got underway across the country, disrupting the economy and hammering morale in the republic. In the vital battleground of Manchuria, communist forces surrounded the cities and cut them off. The PLA used a devastatingly simple tactic to disrupt republican communications: they set on fire the tar-soaked sleepers of railway lines.[18] Nothing could move by rail; no food or ammunition or reinforcements reached the besieged, isolated republican garrisons. As winter hit, the temperatures plummeted, and the cities froze.

At Changchun, the city Japan had made the capital of its colony, the communists cut the railways, blockaded the roads, and tightened their cordon around the city. Half a million civilians were trapped in Changchun alongside a large republican garrison. Temperatures dropped to minus twenty Fahrenheit. The residents burned trees, furniture, anything flammable to survive. Chiang Kai-shek ordered Changchun to hold out. As winter turned to spring, food arrived by air, but the military took it, handing nothing over to the locals. By May 1948 the communist troops had requisitioned all grain within a twenty-mile radius and laid swathes of barbed wire on the city's outskirts. By August the combination of blockade and inflation led to a pound of sorghum selling for one hundred million

Chinese dollars, a pound of dog meat for twenty-four million.[19] Changchun's populace was reduced to eating animal feed, corncobs, and weeds.

The communists enforced the blockade with iron discipline and allowed no one to leave the city. Official reports speak of women and children making their way two miles out of town to the communists' barbed-wire barricades and begging to be allowed through, only to be turned back. Some committed suicide within sight of PLA troops. Others wandered the no-man's-land between the siege lines and the defenses, starving to death. The city finally fell in October 1948. Deaths among its population are thought to number somewhere between 120,000 and 330,000.[20] Other Manchurian cities suffered similar fates.

By the end of November 1948 Manchuria was under communist control. People's Liberation Army offensives were underway across China, and Mao was on his way to Peking.

13

EXILE?

Ma Heng was sixty-seven years old when, from his house on Yabao Lane in Peking, he watched the Republic of China disintegrate. Communist armies had secured the party's grip on Manchuria and were launching offensives against Tianjin and Peking. Farther south, half a million PLA troops were prying open a route to the republic's capital, Nanjing. In many of these confrontations republican forces enjoyed superiority in armor and artillery—supplied by the United States—but their exhausted commanders were unable to match the aggression, discipline, and mobility of the communists; the republican soldiers too often surrendered, deserted, or defected. Desperate attempts at peace negotiations achieved nothing.

Chiang Kai-shek ordered his armies to fight on even as they fell apart. Administration broke down. Republican generals no longer knew how many troops they had to deploy, or how much ammunition and fuel they could rely on. Entire divisions barely functioned. Casualties went uncounted; only the walking wounded ever made it to a dressing station. The rest died where they fell that autumn, unrecorded and unknown.[1] Chiang Kai-shek's dream of a new Chinese republic, modern

yet steeped in tradition, free of colonialism but oriented toward the Western powers, was dying with his forsaken troops.

Ma Heng was still in Peking when, on a Sunday in early November 1948, a small group of intellectuals, museum curators, and directors met very discreetly in Nanjing to discuss the fate of the imperial collections in the nearly 20,000 wooden cases still stored at Nanjing's Chao Tian Palace. They gathered at the residence of a senior republican politician. It was an informal meeting, the subject too sensitive for official discussion. They talked about the likelihood that Nanjing would fall to the communists in a matter of weeks. They assumed that the government of the republic would relocate, just as it had during the Second World War, but to where? Would it go west to Chongqing once again? Or east, to the island of Taiwan, ninety miles from the coast? The signs, they seem to have concluded, favored the latter. Those at the meeting agreed unanimously that the Palace Museum and other vital cultural institutions should be ready, once again, to evacuate the thousands of cases of objects and documents to prevent them falling into the hands of the communists.[2] Their destination would be Taiwan.

For the Palace Museum staff, even though they had spent nearly sixteen years packing, loading, and shipping the flower of the imperial collections, the moment was profoundly strange. This time the museum's leaders meant to evacuate the imperial collections to preserve them not from a foreign invader but to keep them from those they saw as the enemy within.

One of the voices calling forcefully for the evacuation at that Sunday meeting belonged to Han Lih-wu, the suave English-speaking bureaucrat who had been instrumental in shipping the cases out of Nanjing in 1937. He was vice minister of education now and a member of the Palace Museum's board of directors. He had quietly argued for months that China's

most important artifacts needed to be kept from the communists, but his reasoning is hard to fathom. PLA troops, ruthless though they were in action, were known to be disciplined. It is unlikely that Han Lih-wu or the others at the meeting believed that the communists would steal or destroy the Forbidden City's treasures. A hastily planned evacuation to Taiwan, on the other hand, was full of risk.

The cases would again travel over water, vulnerable to poor handling, damp, and spray. They would be moving through a chaotic combat zone, at risk from aircraft and artillery. The potential for damage or loss was alarmingly high, yet Han Lih-wu seems to have harbored no doubts as to the wisdom of the voyage. His account of the time takes it as self-evident that the artifacts should be kept out of the hands of the communists, no matter the risk. Han Lih-wu ordered Chuang Yen to start the process of selecting the pieces that would leave for Taiwan.[3] The painting *Early Snow on the River*, the Ming monk's cap ewer with the copper-red glaze, and the Stone Drums of Qin were all among the pieces chosen for evacuation.

As the planning for an evacuation to Taiwan got underway in Nanjing, Ma Heng, in Peking, carried on as normal in his role as director of the Palace Museum. On November 9, 1948, he chaired a meeting that dealt with routine concerns: efforts to clear the years of accumulated rubbish, dirt, and sand that still littered the Forbidden City's grounds; the museum's opening times; and restoration projects in the jade and porcelain exhibition halls. The following day he received a telegram from Zhang Tingji, the curator who had stayed in the Forbidden City throughout the war and who was now in Nanjing. Zhang Tingji's shocking message informed him that Han Lih-wu was planning to remove part of the collections from Nanjing to Taiwan, and asked what the staff of the museum should do in response.

Ma Heng sent a telegram the next day with his reply. "If the board of directors has authorized a move to Taiwan, then comply. Use the staff who were at Anshun to organize the objects."[4] It was a fateful message, and to send it must have caused Ma Heng great pain. He was in effect sanctioning the division of the imperial collections into separate parts, perhaps permanently. He was confirming that Chuang Yen, among his most trusted curators, the man who had packed the Stone Drums of Qin in 1933, who had traveled with the eighty cases to London, who had spent the war years at the Huayan cave, should be the man to divide them. Soon after sending the message, Ma Heng fell seriously ill with what seems to have been a cardiac event. He spent two weeks in the hospital, on bed rest.

For the museum staff in Nanjing the question of whether to leave for Taiwan was crushingly difficult. How long would they be gone? Would they be welcome in Taiwan? Lush and subtropical, the island was politically, culturally, and linguistically distinct from the Chinese mainland and since 1895 had been a Japanese colony. On Taiwan's return to the Republic of China after Japan's defeat in 1945, the KMT had asserted its control with violent repression. What were the implications of retreating there with the defeated Chiang Kai-shek and a battered, shrunken republic? Would they ever be allowed to come home? Would this mean permanent exile?

By the beginning of December 1948, Nanjing's situation appeared ominous. Trains leaving the city were jammed with thousands fleeing the communists, many clinging to the carriage exteriors and sitting on the roofs. FEELING OF IMPENDING DOOM blared the headline in the *South China Morning Post* on December 1. "Informed opinion," reported the paper, was that "Nanjing will not remain safe for long." Government agencies, the article continued, had received secret

orders to pack their documents ready for evacuation.[5] That same day, after dark, a customs vessel, the *Haihsing*, docked at Shanghai near the Bank of China. A stream of laborers emerged from the shadows carrying boxes slung from shoulder poles. They boarded the ship and stacked the boxes in the hold. As soon as loading was complete, the *Haihsing* sailed for Taiwan with a substantial part of China's gold reserves aboard. The ship berthed at the port of Keelung, in Taiwan, two days later.[6]

Chiang Kai-shek intended to retreat to the island not in chaos, but with the trappings of his republic: two million ounces of gold, elements of the military, government files, and a selection of the finest pieces of imperial art intended to validate his stubborn claim—even in defeat—to be the true leader of China, the bearer of China's intellectual inheritance in the face of communist philistinism. The objects of the imperial collections—*Early Snow on the River*, the Ming ewer, the Stone Drums of Qin—were to be enlisted once more to serve as silent witnesses of a ruler's right to power, as embodiments, in the minds of those who possessed them, of an essential, eternal Chinese-ness that could not be undone by war, time, or revolution.

In the chill days of early December 1948 events moved at a dizzying pace. The communist offensive to take Peking got underway in earnest, with People's Liberation Army units driving captured American trucks and Japanese tanks rolling toward Peking from the west. By December 7 they were only forty miles from the city walls. Far to the south, on December 8 PLA artillery pounded the town of Jiangyan, just seventy miles from Nanjing. Tens of thousands of communist troops took Jiangyan in a bayonet charge.[7]

Han Lih-wu worked furiously, chivying the Palace

Museum's board of directors to make plans for the cases' move to Taiwan. Chuang Yen received orders to accompany the first shipment, and the republican government approved the plans on December 9, 1948. At the storage facility at Chao Tian Palace in Nanjing curators unpacked cases, rearranged and repacked them, and updated the inventory. The eighty steel-sided cases containing the rarest, finest pieces would be among the first to leave for Taiwan.

The course of events seems to have bewildered the three curators in whom Ma Heng had placed so much trust, the tough-minded Ouyang Daoda, the resilient Na Chih-Liang, and the studious, careful Chuang Yen. Worried that they might lose contact with Ma Heng as the communists closed in on Peking, all three of them sent messages to him seeking guidance. Ma Heng was just out of the hospital. His responses offered reassurances that the curators were acting correctly in obeying the board of directors' instructions, but he ordered that no piece should be packed for evacuation unless specifically authorized by the central government. Chuang Yen reported to him on December 14 that in addition to the steel-sided containers, another 120 cases of paintings and ceramics were packed and ready for shipment. The tone of his telegram is poignant. "Managing this process in the absence of your leadership," he wrote, "it's hard to avoid confusion. People are extremely anxious, and morale is suffering."[8]

Ma Heng could have left Peking, boarded an aircraft, flown south, and joined his curators, the people with whom he had been through so much during the war years. The republic was urging China's leading intellectuals to flee to Taiwan. The great archaeologist Li Chi was going, packing artifacts that he had excavated at the site of the Shang capital at Anyang and taking them with him. Ma Heng's friend the writer and statesman Hu Shih was preparing to evacuate. In a telegram Han

Lih-wu urged Ma Heng to leave Peking and the Forbidden City to their fate and fly south. The choices facing the aging Ma Heng were extreme, both offering nothing but disruption, uncertainty, and loss.

In that anxious winter, as the communists closed in on Peking, Ma Heng suddenly started to keep a diary. For the first time in his long, varied life we hear his private voice. He wrote the diary's first entry on December 13. It reads:

December 13 (Monday). Cloudy.

Arrived at the Museum at 9:30 in the morning. This is my second week back at work following my illness. Although we can hear the sound of explosions, no one in the museum pays them any attention. Such activity now has become the norm and causes no concern. I heard more after coming home in the afternoon, and I asked [my servant] Yuxiang about it. Yuxiang said, "It's just the neighbours unloading coal." I went to get a haircut and to have my photograph taken and returned home around four. My nephew Yi telephoned to say that his family had all moved into the city. Only then did I understand that the noise really was that of an artillery bombardment. I asked him if it was near or far away, and he replied, "Very near."

The next day, December 14, Ma Heng recorded that the Palace Museum had closed its doors. He saw light aircraft trying to land in a Peking square because, he thought, the airport had been damaged. He wanted to telephone his friend Hu Shih, but decided to visit him instead, only for the gatekeeper at his residence to tell him that Mr. Hu was "not at home." Later, a mutual friend at Peking University took Ma Heng aside and

told him quietly that Hu Shih had already fled Peking for the south. Ma Heng expressed relief. His diary entries, written in the dense, literary Chinese of the scholar, dwell on who among his colleagues is leaving and who is staying.

On December 17 he heard that artillery rounds had landed near the airport, and "chaos broke out among the passengers. Some made it aboard their flights but left their luggage behind, some could not board, some got injured while boarding. The planes took off in a hurry; more than half of the passengers did not make it." As the days passed, and the communist forces drew nearer, Ma Heng said his farewells to friends and associates as they scrambled for seats on the last few aircraft leaving Peking. He escorted his grandson to school, held meetings, argued with the military about the number of troops deployed around the Forbidden City, and complained about inflation. "Over the past three days, prices have soared like a bolting horse. Pork is now 340 yuan a kilo; flour 1,200 yuan a sack. Common folk will be starving to death." The steady rumble of artillery was always in the background. Troops were "everywhere." Ma Heng's tone veers between matter-of-fact and deeply melancholic. The entry for New Year's Eve reads: "Friday. A light snow last night. Heavy fog this morning. The branches of the trees are all white with icicles because of the fog. After ten it cleared . . . The evening I spent drinking to mark New Year, feeling particularly desolate."

In his diary Ma Heng does not seem to anticipate the arrival of the communists with optimism; he gives no hint that he feels his country to be on the verge of "liberation." Yet neither does he pack his bags and battle for a seat on an aircraft heading south. The idea of retreating to Taiwan seems alien to him, even as he encourages Na Chih-liang and Chuang Yen to obey orders and prepare for their, and the cases', departure. As

the weeks go by, it becomes clear that Ma Heng has decided to stay, and to wait for the communist takeover.

The *Chungting* was a "landing ship, tank"—LST—an ungainly gray vessel some 350 feet long. She had been built in Evansville, Indiana, in 1943, and served with the United States Navy at the Normandy landings. Her bottom was flat, and with a maximum speed of only twelve knots she lumbered and wallowed through the swell, condemning crew and passengers to violent seasickness. Her bow was blunt; one sailor called it "a horrible snow-shovel snout that cannot cut the water." In action an LST nosed right up to a beach, where her bow doors would grind open, and hundreds of troops and a dozen tanks would flood down the ramp straight into the assault. Crammed with troops and armor, the ships, recalled veterans, "stank of diesel oil, backed-up toilets, and vomit." More than a thousand LSTs were built. The crews joked that the acronym stood for "large slow target."[9] After the war the Americans made a gift of dozens of LSTs to the navy of the Republic of China. The *Chungting* was one of them.

On December 20, 1948, the *Chungting* lay alongside the wharves on the Yangzi River in Nanjing. Some 772 cases of art and documents sat on the dock, awaiting loading. Of those, 320 belonged to the Palace Museum; the others came from the Central Museum and the Central Library, the great research institution the Academia Sinica, and the foreign ministry, whose boxes contained vital diplomatic documents, copies of treaties, and international agreements. Disconsolate crowds of people seeking passage out of Nanjing milled around the docks, many of them officials and military personnel and their families fearful of the communists' intentions and desperate to get to Taiwan.

Chuang Yen and three other curators were to oversee the

loading of the *Chungting*, but on boarding found the LST already half-filled with boxes of government documents. Worse, hundreds of naval officers and their families, on hearing of the ship's destination, had swarmed aboard with their possessions. The ship was packed with people and cargo, and the curators had no idea what to do until Han Lih-wu demanded an admiral come to the *Chungting* and take control of the situation. Admiral Kwei Yung-ching arrived and boarded the ship to remonstrate with the officers and their families, reassuring them that other ships would become available and that they would not be abandoned to the communists. Eventually, he ordered them to disembark. One by one the officers hauled their luggage sullenly back down the gangway and onto the crowded dock.

The loading of the cases then proceeded, but the work was badly done; the cases lay scattered and unsecured in the ship's cavernous hold when the *Chungting* got underway on December 22. Chuang Yen, Shen Juo-hsia, and their children were aboard, along with several other curators. In one of the steel-sided cases in the dank hold was *Early Snow on the River*, in its sleeve of thick blue cotton. The ship turned east and pulled away from Nanjing, the once-again doomed capital of the Chinese republic, to make her sluggish way along the greasy brown river. She passed Zhenjiang, Jiangyin, Nantong, river towns still bearing the scars of Japanese occupation, now awaiting the arrival of civil war. On December 24, 1948, she slipped past Shanghai, through the mouth of the Yangzi River, and out into the East China Sea.[10]

The going was harder now. A depression set in, the weather worsened, and as daylight faded the seas turned rough. The *Chungting* suffered engine trouble. She lurched and pitched, her snub nose rising high on the swell, her flat bottom crashing down onto the water's surface in a ghastly juddering motion. In the close, reeking spaces below decks the passengers were

soon prostrate with seasickness. In the hold the unsecured cases containing the Forbidden City's rarest objects began to slide around on the oily deck. With every roll of the ship, they slid from one side of the hold to the other, crashing into each other and into the bulkheads in the darkness. The violent seas breaking over the bow sent torrents of seawater cascading down the decks, dripping into the hold and onto the cases. The curators could barely stand; they could do nothing to protect their charges. The captain had a dog, and the frightened beast howled unceasingly through the night. Between the roaring of the wind and sea, the sickening motion of the ship, the crashing of the cases, and the eerie howling, Chuang Yen and the curators felt "as if it were the end of the world."[11]

The *Chungting* limped into the port of Keelung on the northern tip of the island of Taiwan on December 26, 1948. No berth was available, so the ship lay at anchor, and the exhausted curators had a day to collect themselves before docking and unloading. By 5 p.m. on December 28 the cases were aboard a train and on their way to a shipping company warehouse. Heavy rain fell en route, and Chuang Yen worried about their exposure to moisture. At the storage facility a hurried inspection found that twenty-six cases were wet. But they, and the curators, were in Taiwan and safe.

Back in Nanjing, Han Lih-wu prepared a second shipment. This time Na Chih-liang would act as escort. Na Chih-liang knew himself prone to seasickness and dreaded the trip even though the shipment was to go aboard a steamer, the *Haihu*, belonging to China Merchants Group, rather than an LST. Loading got underway and the *Haihu* set sail from Nanjing on January 6, 1949, with 3,500 cases aboard, nearly half of them belonging to the Palace Museum. The *Haihu* docked in Keelung three days later after an efficient, uneventful passage, Na Chih-liang's violent seasickness notwithstanding.

The situation Na Chih-liang found in Taiwan was chaotic. A permanent storage facility was yet to be determined. The soldiers sent to guard the cases were poorly behaved and expensive, so the museum sent them away and the curators took turns on guard, sleeping on the floor or atop the cases in the warehouse. Accommodation was scarce, with multiple families crowded into single rooms, eking out an existence with what little money they had brought with them. Shen Juo-hsia had to sell some of her jewelry to feed the family. No one knew where the imperial treasures or their guardians would end up, or what the future held.

As Han Lih-wu worked on a third shipment, Ma Heng, in Peking, came under ever greater pressure to fly south and join the republic and the intelligentsia to which he belonged in the partial exile that life on Taiwan represented. On January 14, 1949, Ma Heng finally let his decision be known, though he did so in a characteristically oblique way. In a letter to Han Lih-wu he blamed his health: "I suffer from coronary artery disease, and in November was laid up for a fortnight . . . and although the central government has sent aircraft to collect us, the doctors have told me that I should not fly. On their advice, I will not be leaving Peking." He sent his regards to Hu Shih and the others who had left for Taiwan. Perhaps he knew that he would never see them again. Ever attentive to detail, he expressed his concern about the water damage to the cases that had already reached Taiwan and urged that their contents be properly dried out. Ma Heng had declared, in effect, that he intended to remain in Peking, at the Forbidden City, to wait for the inevitable takeover by the communists.

Why did he decide to stay? His age and recent illness were surely factors in his decision, but perhaps there were other reasons. In his diary he expressed skepticism about those who were leaving. "All this scheming," he wrote, "why bother?"

It is possible that the Communist Party, in advance of taking Peking, had sent him assurances that the Forbidden City and its artifacts would be safe. His son, Ma Yanxiang, had strong connections in the party, and it is likely he influenced his father. In the end, though, perhaps it was the implacable sense of duty that had governed Ma Heng's behavior through the preceding decades, expressed in his loyalty to the Palace Museum and the Forbidden City, that drove his decision to stay.

In Nanjing Han Lih-wu worked furiously to evacuate a third shipment of cases to Taiwan. By late January 1949 reports had reached Nanjing that PLA troops were massing on the far bank of the Yangzi just forty miles to the east. The city's residents expected communist artillery to begin shelling the city any day, yet the panic of the previous weeks had dissipated, to be replaced by a strange, unnerving calm. The frosty streets were half-deserted. Slovenly, disheartened troops manned the defenses. A few remaining government officials huddled in their chilly offices. According to one reporter, the capital seemed "like a frozen country village awaiting a blizzard."[12]

On January 28, 1949, the republican navy steamship *Kunlun* docked in Nanjing. She was an aging, decrepit vessel, her hold already half-full of cargo, and she was on a tight schedule. She needed to be underway in twenty-four hours. On the dock stood 2,000 more cases destined for Taiwan; 1,700 of them belonged to the Palace Museum. Han Lih-wu and the curators were anxious to get the consignment aboard and on its way. The ship lay gray and silent at the dockside, the vast, brown river stretching away into the winter gloom. It was the day before the Lunar New Year. In normal times everyone would be heading home to spend the holiday with their families. They would be cooking dumplings in steamy kitchens, drinking, playing *majiang*, fussing over the children, going

out for walks in the cold, calling on the neighbors, exchanging gifts. Even now, as the republic fell, the embers of a holiday spirit glowed faintly, and the dockworkers wanted to be off duty and in their homes. They did not want to spend the night working and refused to begin loading. As daylight faded, the cases remained on the wharves.

Palace Museum staff negotiated with the workers, offering big bonuses. Grudgingly, the dockers came around, and loading commenced as night fell, but the curators' problems were not over. Word spread that the *Kunlun* was bound for Taiwan, and the situation faced by the *Chungting* repeated itself as hundreds of naval personnel and their families converged on the ship, rushed up the gangway, and boarded, forcing their way into every cabin and compartment. Once again the admiral was roused and came aboard, but this time his orders and entreaties were ignored. The arguments became heated and tearful as the refugees begged the ship's captain to take pity on them. All the admiral could do was order the captain to clear space to allow as many cases as possible aboard. In the end, they were stowed everywhere around the ship—in the medical quarters and the wardroom, in companionways, wherever cabin space could be cleared. Still, only a little over half of the Palace Museum's consignment made it aboard. Seven hundred and fifty-six cases remained on the dockside.[13] Among those left behind were the huge cases containing the Stone Drums of Qin.

The *Kunlun* got underway on January 30, 1949. She followed the Yangzi River to its mouth and made for the open sea. The atmosphere aboard was tense. Rumors swirled around the ship. One curator from the Central Museum named Suo Yuming, who was thirty years old, remembered realizing something was seriously amiss when, as the *Kunlun* pulled away from the mouth of the river, the ship turned not to the

south in the direction of Taiwan, but to the north. Suo Yuming was under orders to see more than 1,200 cases of invaluable objects and documents directly to Taiwan, and now he wondered where on earth the captain was taking them. The ship heaved to a little way out to sea, and arguments began. The captain, Suo Yuming heard, had family on the mainland and did not want to leave. Others on the ship wanted to be put ashore at various ports.

The crew, naval personnel, were under orders to sail to Taiwan, and were bewildered by the captain's actions and confused by the arguments among the passengers. The ship was soon in need of supplies and put in at ports along the coast, but its final destination remained unclear to those aboard. A voyage that should have taken a matter of days turned into a week, then two. Suo Yuming, however, forged a plan. He had in his possession a large amount of money given to him by the head of the Central Museum and intended for the museum's expenses on arrival in Taiwan. He decided that the cash would be better spent on the ship's crew and distributed wads of it in return for assurances that the *Kunlun* would make for Taiwan. The crew held to their end of the bargain. The captain was overruled. After a stop-start journey of three weeks, the ship finally docked at its intended destination in Taiwan on February 22, 1949. The captain, Suo Yuming was later told, was arrested for disobeying orders and shot.[14]

In all, Han Lih-wu oversaw the evacuation to Taiwan of 2,972 cases. These contained the pieces the curators deemed the most essential, the most irreplaceable, of all the imperial collections. The monk's cap ewer with the copper-red glaze was one of more than 20,000 pieces of porcelain that made the journey. *Early Snow on the River* was one of hundreds of painted masterpieces. Fan Kuan's monumental,

mysterious Song-period landscape *Travelers Among Mountains and Streams* was another, as were *Herd of Deer in an Autumn Forest*, the hanging scroll that went to London and so delighted Horace Jayne, and Xia Gui's *A Pure and Remote View of Mountains and Streams*. Masterpieces of calligraphy, perhaps the most highly valued works in all of China's material culture, crossed the sea on those rust-streaked, heaving ships. One hundred fifty thousand volumes of rare and valuable books went to Taiwan, including Qianlong's huge compendium, the Siku Quanshu, and a significant part of the Qing dynasty's imperial archives. Thousands of carvings in jade and ivory, funerary statues, bronzes, and tapestries left the Chinese mainland with no certainty of return. Sixteen thousand of the cases that had made the wartime journey to west China and back did not leave for Taiwan but remained in Nanjing, the Stone Drums of Qin among them. The collections that had graced the great palaces of the Qing empire and its predecessors were now torn apart, scattered between Taiwan, Nanjing, and Peking.

The curators—many of whom had been among the inventory teams that probed the dark, silent recesses of the Forbidden City in the freezing winter of 1924–5, who had designed and launched the Palace Museum, who had packed the thousands of cases in 1933, who had shepherded the cases into hiding and guarded them through war—were also torn apart. Ouyang Daoda joined Ma Heng in his decision to stay on the Chinese mainland and wait for the communists. Chuang Yen and Na Chih-liang, having escorted the cases to Taiwan, spent the rest of their lives there. The four men who had played such a pivotal role in the collections' survival would never again talk over a drink of *fen* liquor, play a game of *majiang* and smoke, pore over a jade, or take a rubbing from a bronze.

*

In Taiwan, Na Chih-liang and Chuang Yen oversaw the art-works' journey into the island's central highlands and storage in warehouses belonging to the Taichung Sugar Corporation. The curators fell back into their conservation routines, inspecting the cases, unpacking books and paintings for airing. The government built new stores and in 1953 a modest museum facility at Peikou, just outside the city of Taichung. Over the years, curators, conservators, and art historians gradually and carefully unpacked the cases, discarded the paper and cotton wadding and rice straw, and after decades in darkness the pieces reemerged into the light.

In 1960 funding was announced for a new National Palace Museum, to be built on the northern outskirts of Taipei, where it stands today. The pieces from the Forbidden City form the heart of the museum's collection, although *Early Snow on the River* stays hidden in the vaults for fear of photochemical damage. But the porcelain galleries are filled with pieces that made that extraordinary sixteen-year journey from the Forbidden City, through the wars, west to Sichuan and Guizhou, and east again, and on to Taiwan. The Ming monk's cap ewer, with its glaze of impossibly deep, intricate red, is often on display.

The early years were hard for Chuang Yen and his wife, who struggled to make ends meet. He had to sell his seal collection, and Shen Juo-hsia continued to chide him gently for his excessive book buying. Instability and repression followed the KMT's arrival on Taiwan, but the couple found some stability and raised their children over the course of a long, happy marriage. Chuang Yen's days of packing art for shipment were not over. He oversaw the transport of the objects from the imperial collections around Taiwan to their new home in Taipei, where he became assistant director. He took a long trip to the United States in 1961–2, accompanying hundreds of pieces for exhibition in Washington, DC, New York, Boston,

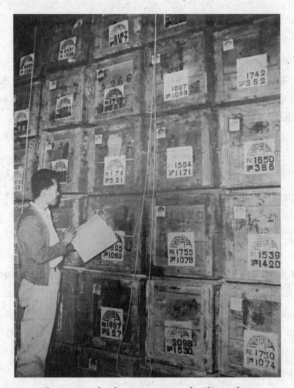

Cases stacked at a storage facility after
arriving in Taiwan, with the labels visible

Chicago, and San Francisco. This careful, good-natured, studi-
ous man retired from the museum in 1969. He died in 1980,
remembered as a great authority on the imperial collections,
a connoisseur, a fine calligrapher, and a mentor to a younger
generation of art historians. His sense of himself, though, was
inextricably bound to the handling of porcelain, bronze, and
jade, paper and silk, and to the fraught processes of packing—
the swathing of fragility in paper and cotton and rice straw,
the gauging of proximity and immobility.

For Chuang Yen, handling and packing were operations on
which conservators were forced to stake everything. Packing

was a bulwark against time and an act of resistance to the kinetic forces that could shatter civilization itself, whether through vibration or by bomb and bullet. Late in his life he wrote movingly of the correct way to lift a delicate teacup, and how to hold a fragile bronze under its belly, in one's palms, so as not to strain the legs or handles. He wrote of "packing and moving, packing and moving, endlessly, without rest." He remembered how, all those years before, his colleagues had joked about his surname and how it rhymed perfectly with the word for "pack." "Sometimes I think of that little joke, how it captured the work of half my life. And when I do, the feeling of time present and time past is so hard to bear."[15]

Na Chih-liang also spent the rest of his professional life at the National Palace Museum in Taipei. He published extensively on his specialty: ancient carvings in jade and texts relating to them. He accompanied Chuang Yen on the long trip to the United States for the exhibitions of 1961–2 and became an important interlocutor for Western art historians seeking to establish the study of China's art in Europe and America. He retired in 1979 but remained his vigorous, resilient self, and taught graduate students long after that. As he grew more infirm, students trekked to the suburbs of north Taipei for lectures in his apartment near the museum. He seemed a figure from an earlier age, appearing to care little for the contemporary theories of art that fascinated them. To distract him, the students would ply him with questions about the war years and the Forbidden City, particularly about the dark, silent winter of 1924–5, when that teenage boy shuffled and shivered in its frigid halls and wrote in the inventory the name of each piece among the boundless, unknown treasures of the imperial collections. Na Chih-liang died in 1998 at the age of ninety-one.

*

Ouyang Daoda refused to leave for Taiwan; he and his family stayed in Nanjing. He oversaw the Chao Tian Palace warehouses, where the thousands of cases that did not leave for Taiwan, including those containing the Stone Drums of Qin, remained stored. As the communist forces approached, he sealed all entrances to the warehouses and cooperated with the new authorities when they arrived in the spring of 1949. His written account makes no mention of these events, and we know little or nothing of his motives, thoughts, and feelings during these crucial, frightening months. He spoke little to his children about any of it, and as far as is known passed on to them no diary or correspondence. He did not even tell them that he had been awarded a medal by the government of the republic for his wartime work; his children only found this out many years later. His personality—frugal to the point of ascetic, disciplinarian, self-critical, retiring—surely made him a difficult man to read, but Ouyang Daoda was shrewd, and it is possible that he understood what was coming, that the new regime would scrutinize the records of those who had worked for the republic in any capacity, even as a museum curator. Perhaps Ouyang Daoda did not confide in his children to shield them from knowledge that might one day have become politically dangerous.

He seems to have fared relatively well under the new regime. He stayed on at the Palace Museum, returning to Peking—now Beijing—in 1954 to become head of its archives. He does not appear to have fallen foul of the political campaigns and the terrible purges that racked Chairman Mao's China. Ouyang Daoda retired from the museum in 1959. He died in Beijing in 1976, an apparently unknowable figure, yet one whose rigor and discipline had certainly been vital to the imperial collections' survival through the war years.

Ma Heng's story is clearer and more painful to relate.

14

HUNTING TIGERS

The closing months of 1948 and January 1949 saw Chiang Kai-shek's exhausted army suffer shattering defeats. In what became known as the Huaihai campaign, the People's Liberation Army rampaged toward Nanjing. Over a matter of weeks, 150,000 republican soldiers were killed, and another 350,000 were wounded, captured, or deserted. On January 10, Xuzhou, the railway hub that republican troops had defended so bravely against the Japanese, fell to the PLA. Against miserable republican units, freezing in static defenses, the communists launched agile, mobile operations and fought with the conviction of soldiers who scented victory. Communist logistics depended on an army of laborers bringing up food, fuel, and ammunition to the front in wheelbarrows, and evacuating casualties to the rear by the same means. It was simple, cheap, and devastatingly effective.[1]

In the north, communist units assaulted the coastal city of Tianjin, crossing its frozen moat and penetrating deep into the city's heart. After a punishing artillery bombardment, the city and its population of two million fell on January 15, 1949. Peking, sixty miles to the northwest, was to be next.

As the PLA surrounded Peking, Ma Heng wrote in his diary of the rumors and confusion spreading through the city. Emissaries were shuttling between the communists and the general in charge of Peking's defenses. Ma Heng noted that the contents of their talks were being kept secret, "so we have no idea what medicine they're selling." Among the negotiators was the former mayor of Peking, a colorful and dedicated man named He Siyuan. He argued for the peaceful surrender of the city, so that its palaces and temples, its lakes, and its beautiful slate-gray alleyways of courtyard homes filled with books and antiquities might be spared the artillery barrage that had pulverized Tianjin, or the siege that had decimated the population of Changchun. Infuriated by his defeatism, republican agents bombed He Siyuan's home and killed his young daughter. But the momentum was with those who wanted to see Peking fall, once again, without a fight.

As its fate was decided, the city remained relatively calm. Shops were open, though supplies of electricity and water were unreliable. Each time a rumor of peace spread, the price of flour, rice, and vegetables in the city's markets dropped dramatically. Each time a rumor of imminent fighting took hold, prices shot up again. Each morning gangs of laborers marched out of the gates to hack trenches out of the frozen ground. With them went the stinking "honey carts" that carried out the contents of the city's toilets to fertilize fields now held by communist troops.[2]

Across China, the republican forces crumbled. Chiang Kai-shek wrote in his diary that "reports of lost battles swirl in like falling snow."[3] In mid-January 1949, Mao Zedong issued a statement that in effect demanded the republic's unconditional surrender. On January 21, 1949, Chiang Kai-shek, at a government meeting in Nanjing, officially stepped down as president

of the Republic of China, though he had no intention of giving up control over his battered political party, the KMT.

The following day Ma Heng made his way through the wintry Peking streets to the house of his friend the artist Xu Beihong, who had drawn his portrait many years before. They sat and talked, chewing over the situation. While Ma Heng was there, the telephone rang. The general in command of Peking's defense, Fu Zuoyi, had announced a 3 p.m. meeting at which he would appear in person and make a statement. The two men, the scholar and the artist, wondered what it might mean. Perhaps peace was near.

That afternoon, General Fu Zuoyi reported the results of his negotiations with the communists. Thirteen articles specified the terms under which Peking would surrender to the People's Liberation Army. Ma Heng noted all thirteen in his diary. Hostilities around the city were to cease. Republican troops were to march out of the city for "reorganization." All government institutions were to continue as before until contacted by the communist authorities. Mail and telegraphs were to continue uninterrupted. Newspapers were ordered to publish, but also to register for censorship. People's livelihoods would be unaffected. Article number twelve would have caught Ma Heng's eye. "All cultural objects and historical sites to be preserved."[4] And with that, Peking surrendered to the PLA.

After Fu Zuoyi's announcement, Peking once again entered a kind of limbo, the ancient city suspended between rulers. The ubiquitous portraits of a flinty Chiang Kai-shek wearing his generalissimo's uniform began to disappear, leaving their outlines on walls, blank vestiges of his vanished authority. It is perhaps a measure of the communists' reputation at the time that there was no panic; Ma Heng seems not to have doubted their commitment to taking the city peacefully and to ensuring

that the Forbidden City sustained no damage. Among those professors, writers, and intellectuals who, like Ma Heng, had refused to fly south and leave for Taiwan, confidence began to grow.[5] Perhaps their positions would be respected. Perhaps, as custodians of Peking and its material and intellectual treasures, they would be allowed to contribute to the new regime. Perhaps, just perhaps, everything was going to be all right.

On January 31, 1949, troops of the People's Liberation Army entered Peking. Some 20,000 of them, a brass band the only concession to triumphalism, marched in through the city's gates. The communist troops were serious and silent. They seemed tired. They wore padded jackets and bandoliers of ammunition. Their rubber-soled shoes made no sound on the city's streets. Some of Peking's university students who had communist sympathies did their best to promote a festive spirit of liberation, plastering the streets with posters bearing the characters for "Long Live Mao Zedong" and "Long Live the People's Liberation Army." But the people of Peking who lined the streets to watch the PLA arrive were quiet and curious, perhaps a little overawed at what they were seeing. Ma Heng, in his diary, said only that "in the afternoon, part of the People's Liberation Army came into the city."

Communists led by Ye Jianying, the officer who had surreptitiously visited Ma Heng's son at the house on Yabao Lane, took over the Peking Hotel and the top two floors of the Hotel Wagon Lits, paying cash in advance for their rooms. Everyone employed in those establishments, from managers to chambermaids, suddenly found themselves earning an identical wage.[6] From these temporary headquarters, the Communist Party set about building a new administration in the city that, in time, would be renamed Beijing and become the capital of the People's Republic of China.

*

The day after the People's Liberation Army entered Peking, Ma Heng took himself to work as usual at the Palace Museum inside the Forbidden City. He was perturbed to find that two members of the museum staff had proclaimed themselves members of the communist underground and were asserting their authority, demanding that all staff attend impromptu meetings and register, though few did. Ma Heng was dubious of their credentials and wondered if they were simply being opportunistic. The day was full of confusion over who would take over the administration of the museum. In the following days Ma Heng began holding meetings with party officials.

Ma Heng adjusted quickly to the new reality. A man named Luo Ge was to be the liaison between the museum and the party and military authorities. Luo Ge arrived at the museum on February 10 and went to Ma Heng's office to introduce himself. Ma Heng rose from his chair to greet the newcomer— a show of great respect. Embarrassed by the older man's deference, Luo Ge pointed out that he had been a mere student at Peking University when Ma Heng had been a renowned professor. Ma Heng responded gravely, "This is the Palace Museum, not Peking University. This is an office, not a lecture hall. And you are not a student but a representative of the Communist Party. This is the way it must be." Luo remarked that from then on, whenever he passed instructions, Ma Heng solemnly noted them down using brush and ink in his fine, elegant calligraphy, and never questioned them. Ma Heng urged all the museum staff to follow the leadership of the party.[7] Ma Heng's behavior toward Luo Ge was marked by total obedience to the new regime. He was to learn, like all of China's intellectual class, that such demonstrations of subservience were no guarantee of the party's trust.

In the early months of 1949 Ma Heng quickly found himself immersed in complex bureaucratic tasks. The party decided

that soldiers of the People's Liberation Army were to be given guided tours of the Forbidden City. It fell to Ma Heng to organize these—a monumental job. Starting on February 12, 1,200 soldiers per day would take the tour, 600 in the morning and 600 in the afternoon. Ma Heng opened three routes through the maze of palaces, halls, and courtyards, and stationed museum staff along the way to act as guides and monitors. Over the weeks, more than 10,000 battle-hardened Communist troops wandered the imperial precincts and wondered at evidence of their country's past. Tours for the troops were followed by more tours for intellectuals, student associations, trade unions, model workers, and Soviet officials. The strain seems to have taken a toll on Ma Heng. Unwell, he took to his bed for two days in March 1949, and passed the time reading Chairman Mao's *Selected Works*. In April the commander of the People's Liberation Army, Zhu De, and the great general Lin Biao came for a tour. Chairman Mao himself was expected on May 14, but his visit was canceled. The chairman "was too tired."

Even though Peking had fallen to the communists, Nanjing still held out. Ma Heng waited for news from Ouyang Daoda, who remained in charge of the Chao Tian Palace storage facility. Toward the end of April 1949, troops of the People's Liberation Army swept across the Yangzi River and advanced on the republic's capital. Those government personnel who remained in the city fled, and republican troops blew up their ammunition and fuel dumps along the river, the huge explosions shaking the entire city. They wrecked their airfields and vehicles, and set fire to Hsiakwan station, from where the trains bearing the cases on the Northern Route had departed in 1937. The station—a monument to the modernizing dreams of the republic—collapsed in flames. After destroying what they could, the troops withdrew. Nanjing's policemen took off their uniforms and went home.

Looting broke out. Crowds rampaged into empty govern-
ment buildings, military facilities, and official residences, rip-
ping out whatever they could carry.[8] The Chao Tian Palace
storage facility sheltered all the imperial pieces that had not
been taken to Taiwan—some 16,000 cases—but under Ouyang
Daoda's steely protection, the facility remained untouched.
The looting came to an abrupt halt when communist troops
entered Nanjing early in the morning of April 24, 1949, and
the capital of the republic fell.

Chiang Kai-shek lingered for a while on the Chinese main-
land during those closing moments of his republic, as if unable
to bring himself to leave. He visited his ancestral home in the
little river town of Xikou, just south of Shanghai, and spent
days in a cabin on a hillside above his mother's grave, dressed
in a long, black robe. Only in May did he finally board the ship
that would take him to Taiwan. Over the next few months
communist forces would push on to take the rest of China to

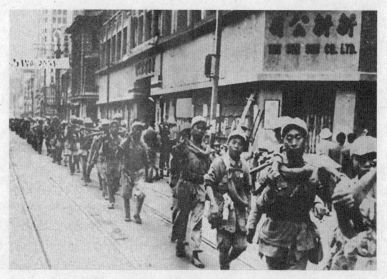

Communist troops enter Shanghai, 1949

the south and west, wiping out shrinking pockets of republican resistance as they went.

As the early months of communist rule in Peking went by, Ma Heng continued his work as director of the Palace Museum as best he could, but he came to understand that his authority was greatly reduced. The texture of his life began to change. He found himself attending lectures and study sessions to learn about communism. Gone were his tailored Western suits. He took to wearing the *zhongshanzhuang*, the simple buttoned tunic and trousers often referred to as a Mao suit. By late spring his situation was becoming complicated. The authorities instructed the Palace Museum to reduce staff numbers, and ordered Ma Heng to conduct staff evaluations. The ensuing weeks were painful, as veteran curators and historians came to his office and to his home to plead for their jobs. Ma Heng did as he was told and wrote the evaluations.

For those forced out of their positions in the new China, the consequences could be dire. Ma Heng's own nephew was reassigned from his job at an institute, and sent with his wife to a farm to work on land reclamation. When they objected, party officials accused them of "agitating." Ma Heng noted their "quandary" in his diary, and his words contain a rare sputter of anger at the Communist Party official he deemed responsible. "Director Chen joined the Communist Party more than twenty years ago. To do things in such a bureaucratic way, he must have something psychologically wrong with him."

As 1949 passed, new expressions and vocabulary started to appear in Ma Heng's diary. He began to use the term *qunzhong*—"the masses." He referred to "vestiges of feudalism." He was learning the vocabulary of the new regime. In July he remarked upon a speech given by a senior party official at the Forbidden City, noting how the official "used

extremely colloquial language to explain Marxism-Leninism and Mao Zedong Thought. It will be immensely popular with the masses." At sixty-eight years old, Ma Heng appeared to be working to transform himself in line with party ideology. It is impossible to know to what degree his efforts were sincere or derived from fear and a desire for self-preservation. His diary entries suggest a genuine attempt to understand and implement the Communist Party's program, though he was surely writing in the knowledge that the diary might one day be read by party officials. It paid to be careful.

Some diary entries make it clear that the habits and practices of his old life had not entirely left him. He continued his study of the books, bronzes, and seals in his own collection. On September 18, 1949, he commemorated the ninth anniversary of Yeh Wei-ch'ing's death with a traditional offering of scented flowers to his wife in the afterlife. He had also hoped to travel to his ancestral home, Ningbo, for the anniversary of his mother's death. The plan had been to visit a famous Buddhist temple, the Temple of Seven Pagodas, to make offerings and read from the sutras. But Ma Heng sensed that the plan was risky; the party frowned on such "feudal" practices. He abandoned the idea, writing in his diary, "The rules of public behavior are changing drastically, and I cannot anticipate how." Thus did this elderly, cautious man once more adjust his behavior to survive in the midst of protean political forces. The psychological distance that Ma Heng traversed over the course of his life was immense. From his youth as a subject of the Qing empire, to life as a wealthy businessman in industrial Shanghai, to his position as a Peking University scholar at the heart of China's intellectual upheaval, to his wartime work as conservator and logistician safeguarding the imperial collections, to, right at the end of his life, a student of communist ideology, Ma Heng's transformations reflect those of his

country. Change and uncertainty were the defining features of his life right until the end.

In the late summer of 1949 Ma Heng started to notice disappearances and suicides. He wrote about them in his diary. In August Public Security detained an employee from the Palace Museum's Archives Department. The employee's wife came to Ma Heng's house to beg for help, but on learning that the man had been classified as a "reactionary," Ma Heng recommended his dismissal from the museum. The same month he noted that a museum worker had been found dead inside the Forbidden City, in the Hall of Gracious Learning. He had hanged himself. His diary dwells somewhat on these stories, suggesting Ma Heng was deeply troubled by them or perhaps recognized them as early signs of a drift toward political terror.

In October 1949 Chairman Mao announced the establishment of the People's Republic of China. He chose to make his speech standing atop Tiananmen, the Gate of Heavenly Peace, whose enormous vermilion walls marked the entrance to the old imperial city. Even in revolutionary China, those walls retained their mesmerizing cultural authority. The Communist Party made full use of the imperial precincts, installing its headquarters in the gorgeous halls and pavilions of Zhongnanhai, the old Lake Palaces to the west of the Forbidden City. Chairman Mao had his residence there. The supreme party organ of the time, the Central People's Government, met in the Hall of Diligent Statesmanship. The party's leaders lived—and still live—secretively behind those walls, among the pleasure gardens and lakes built for the emperors of the Ming and Qing, their seclusion a strange echo of imperial behavior.

During 1950 and 1951, the cleaning up of the Forbidden City and its outlying precincts was an enormous undertaking. Grasses and weeds festooned the courtyards. Piles of cinders and slag lay about. Drifts of fine loess dust, blown in on the

desert winds, had settled in every nook. Many trees were in a terrible state. The halls and palaces themselves were sorely in need of refurbishment.[9] The leadership of the Communist Party, hardened disciples of Marxism-Leninism though they were, recognized the powerful symbolism of nationhood and cultural greatness that lingered in those great halls, and the party oversaw a repair program that lasted years. The rest of Beijing, meanwhile, suffered. The magnificent gray city walls were torn down, courtyard neighborhoods and streets of wooden shop fronts were bulldozed, but the party ensured that the Forbidden City, and the imperial precincts that surrounded it, were preserved intact.

On January 26, 1950, a special train clattered toward Beijing's west station on its way from Nanjing. It carried the first returning shipment of the thousands of cases stored at the Chao Tian Palace facility. After nearly seventeen years away, the imperial collections—minus their finest pieces—were returning to the Forbidden City. Ma Heng went to the station with a gaggle of curators to greet the train. "Everyone is so excited," he wrote in his diary. The train was delayed outside Beijing, so Ma Heng and the curators trooped off to the station canteen to have lunch and wait. What was an extra hour or two after so many years? At 1:30 p.m. the train finally pulled into the platform and porters started hauling the cases from the freight cars in a quiet culmination to their extraordinary journey. The following day a second train arrived, bearing the Stone Drums of Qin in their huge cases. Ma Heng was there to greet them but fretted over the porters' clumsiness. "I told them to improve. Their moving and stacking of the cases was most inept." For all Ma Heng's excitement and his fussing, it was an incomplete homecoming. The rarest pieces of the imperial collections were now in Taiwan. Many important pieces were slated to remain in Nanjing for exhibition there.

The original disposition of the imperial collections inside the Forbidden City—the emperor Qianlong's vision for them—could not be re-created.

Nonetheless, the Communist Party had bold plans for the Palace Museum. The Ministry of Culture envisaged a museum that would memorialize not a palace, nor the empires of the Ming and Qing, but the broad sweep of what the party deemed Chinese culture. Under the slogan *tuichen chuxin*—"Cull the old to bring forth the new"—the Party reconciled its disdain for the "feudal" past with its desire to promote a grand narrative of China's cultural greatness. The ministry set up a purchasing office to acquire art for the museum, buying up pieces that had made their way on to the open market. Private collectors read which way the wind was blowing, and many donated their collections.[10] The Palace Museum staff embarked on an ambitious new round of authentication and cataloging. Ma Heng's relations with the Ministry of Culture were stable, and his position as museum director appeared secure, if diminished. His dream of a return to scholarly life seemed to have been in part realized. But unease runs through the pages of his diary.

One source of unease was an old and dangerous controversy that had flickered back into life in 1949. A letter arrived on the desk of a senior Communist Party official that contained a vicious denunciation of Ma Heng. The letter alleged that back in the 1930s he had plotted against the Palace Museum's first director, Yi P'ei-chi. Ma Heng had, according to the letter, falsely accused his predecessor of theft and corruption in order to unseat him and take the directorship of the museum for himself. The letter's author was none other than Wu Ying, the cantankerous curator who had overseen the very first, difficult shipment of cases from Peking to Shanghai in 1933. Wu Ying, it appeared, believed that the Palace Museum's first director

had been unjustly hounded from his position, and it was Ma Heng's fault.

Ma Heng was horrified. "It is a total attack on me . . . utterly astounding," he wrote. He was further stunned to learn that the accusation against him had gone all the way to Chairman Mao. He wrote a rebuttal and gathered articles and materials from his past that he believed would clear his name, but the affair dragged on through 1950, apparently without a clear resolution. For the time being, Ma Heng's position was unaffected, but this would have been a very frightening development for him. The Communist Party was turning its attention to the political reliability of those in positions of authority across China, and the atmosphere was turning fraught and suspicious.

On August 1, 1950, Ma Heng heard that a museum worker had hanged himself inside the Forbidden City, in the Imperial Garden, once the emperor's private retreat, "because of family matters." On August 18 he wrote that another corpse had been found, this time on the small hill that overlooks the Forbidden City from the north. It was another hanging, the face so badly decomposed no one could identify the body. With it was a suicide note addressed to Chairman Mao. Ma Heng recorded the contents of the note in his diary. "It read something like 'I followed you for many years but absolutely no good came of it. I could not say this to you directly, hence this note. Name withheld.'" Just days later, quick-witted museum staff prevented a suicide in the the Hall of Martial Valor, cutting down a guard who was attempting to hang himself. Ma Heng speculated about whether the incidents were connected, one perhaps inspiring the others.

In the late summer of 1950 the political tensions of the time made themselves felt within Ma Heng's family. His son Ma Wenchong, who had been seriously wounded while serving

in the republican army in 1937, came under investigation. The younger Ma had fled to Taiwan, but Ma Heng persuaded him to return to the mainland and to come to Beijing with his wife and son. On their way the little family passed through the city of Dezhou, in Shandong province, where a military movement was underway, and roads were closed. Ma Wenchong appears to have casually inquired of local security personnel what was going on. His questions aroused suspicion. A check of his papers found he was missing a residence pass for the "liberated" areas, while a search of his baggage turned up a certificate of service in the republican army and a marriage certificate bearing the name, as witness, of a well-known figure in the republic's military. The security personnel arrested Ma Wenchong and ordered his wife and son not to leave the city.

In Beijing Ma Heng leaped into action. He fired off letters to friends and colleagues in the Ministry of Culture, asking them to use their influence. Ma Heng's other son, Ma Yanxiang, who had strong party contacts and held a post in the ministry, ordered a functionary to Dezhou to see what could be done. After a lot of back-and-forth, Ma Wenchong was released, but his identity and his past as a republican army officer were now known to the communist authorities. He was a marked man, and he and his family were denied the much-sought-after residence permit for Beijing. The authorities assigned Ma Wenchong to teach in a school in Shandong province, some 400 miles from his father.

Ma Yanxiang's behavior also vexed his father, but for different reasons. To Ma Heng's fury, his son planned to get married for a third time, to an actress. Ma Yanxiang's connections to the party and his official position had, his father felt, made him imperious and arrogant. "The admirable thing about Communist Party members is their courage and frankness in admitting mistakes. Yanxiang is the exact opposite of

this," Ma Heng fulminated in his diary. At an awkward dinner with his son's fiancée, the actress, Ma Heng informed the young woman at length of his son's faults. He also informed her that her profession made her an unsuitable match. It seems to have been an ugly scene, with Ma Heng demonstrating uncharacteristic harshness and snobbery. Perhaps Ma Heng's behavior was prompted by anxiety; his diary entries suggest he was concerned that her profession might render her politically suspect. "I don't know if investigation has turned up any problems with her or not," he wrote. Ma Yanxiang's relationship with his father deteriorated further when he took to lecturing the rest of the family on ideology, much to their irritation. The politics of the new was forcing its way into the home, encroaching on intimate relationships, eroding Ma Heng's old sense of self, clouding his notions of propriety.

In late 1951, despite Wu Ying's accusations against him, Ma Heng still seems to have enjoyed the trust of the Communist Party. A high point of his later life came in December of that year. The Ministry of Culture sent him on a mission to Hong Kong to buy and return to China two exceptional pieces of calligraphy, *Mid-Autumn*, traditionally attributed to Wang Xianzhi, who was active in the fourth century, and *A Letter to Boyuan* by Wang Xun, which dates from around the same time. Both pieces were beloved of the emperor Qianlong, whose seals are clearly visible on them, and were kept in the Room of the Three Rarities, the little study where Qianlong viewed works of the imperial collections in the afternoons. Both had disappeared from the Forbidden City in the 1920s; an elderly imperial consort is said to have smuggled them out. They reappeared in a bank vault in Hong Kong in 1951.

Ma Heng did not make it to Hong Kong, then a British colony, but he did go to Macao, the Portuguese colony next door, where he and members of his delegation stayed at the

International Hotel. While one of their number went on to Hong Kong to retrieve the two pieces of calligraphy, Ma Heng went sightseeing in Macao and ate rather well. He explored some of the colony's famous casinos, though he did not gamble—he disapproved. The bright lights of Macao, a Western suit, the good restaurants, perhaps a cigar, must have taken Ma Heng back to prewar days. It would have required some self-discipline to return to the austerity and political uncertainty of revolutionary China. But return he did, first to Guangzhou, where the two pieces of calligraphy arrived safely on November 28. After a dinner with the mayor of Guangzhou, who served a snake soup that Ma Heng considered extravagant, he made his way to the station for a night train north. It seems to have been a stimulating trip for the seventy-year-old Ma Heng. It was also the last time that the things he so valued—art, a certain kind of restrained, scholarly friendship, official respect, a little luxury— would be available to him in the way they once had been.

Upon his return to cold, dusty Beijing, news of yet another suicide dampened Ma Heng's spirits. He noted the story in some detail in his diary. The dead man's name was He Kongcai. Over the generations his family had amassed an impressive library. In 1949, after the Communist victory, He Kongcai donated his collection to public libraries and museums in Beijing, winning acclaim for his generosity and selflessness, but in December 1951 he drowned himself in Beihai, the beautiful lake adjacent to the Forbidden City. Ma Heng, nonplussed, attempted to find out why he had taken his own life. It transpired that the party had investigated He Kongcai's background, and he had not cooperated fully, perhaps trying to cover up some aspect of his past, though Ma Heng did not know what. The case was one more indicator of the political pressure building on China's old elites.

Until this point Ma Heng had managed relatively well

under the new regime. The accusation that he had corruptly unseated his predecessor as director of the Palace Museum lingered, but Ma Heng had kept his position at the museum and his social standing. The following year, 1952, would be different.

For Chairman Mao, victory in the civil war and the establishment of the People's Republic of China was only the beginning of the revolution. He was intent on transforming Chinese society. In rural China the party sent teams into villages to confiscate and redistribute land, dragging landlords before terrifying "speak bitterness" meetings, where villagers would harangue and humiliate them in public. The landlord's execution sometimes followed.

In urban areas the party launched fierce campaigns to take control of the economy and remake it according to a socialist model. The state urgently needed revenue; China was at war again. On the Korean peninsula, badly equipped, poorly supplied Chinese "volunteers" were engaged in combat with American-led forces fighting under the United Nations flag, and were taking terrible casualties. Chairman Mao was convinced that corruption saturated China's economy, that the bourgeoisie were sucking the economic life out of his revolution. He ordered mass mobilization and called for "major war between the proletariat and the bourgeoisie."[11]

In late 1951 the Communist Party unleashed its *San Fan*—"Three Anti"—campaign. All over China zealous work teams marched into party units, government and public institutions, and businesses to expose and punish those deemed guilty of three evils defined by Chairman Mao: corruption, waste, and "bureaucratism." Anybody who held an official post or managed public resources in any way, from functionaries in ministries to factory managers, was a potential target, any perceived

misuse of public resources a potential crime. Chairman Mao sanctioned extreme measures. "Nationwide," he said, "we may have to execute anywhere from 10,000 people to a multiple of that figure, otherwise the problem cannot be solved." In November 1951, as the campaign got underway, investigators in the city of Tianjin found two officials, both revolutionaries with a history of service to the Communist Party, guilty of engaging in embezzlement and corruption. In a clear signal to the party and the people, Chairman Mao ordered the two men shot.[12]

In December 1951 the Three Anti campaign came to the Palace Museum. Ma Heng noted in his diary that he had been appointed chairman of a "Thrift Inspection Committee" at the government's Bureau of Cultural Relics, and that the Palace Museum had set up its own committee, with three subcommittees, charged with pursuing the campaign. The sterile, bureaucratic language disguises the true nature of these events. The campaign was relentless and frightening. Nearly all routine work in the Forbidden City ground to a halt. Ma Heng came under serious pressure to demonstrate that he was rooting out corruption, waste, and bureaucratism at the Palace Museum. He held long meetings to "mobilize" the museum staff and dragged himself home at nine or ten at night. As with all Maoist campaigns, the party emphasized the need for confessions and self-criticism—the cataloging and analysis of one's own mistakes, practical, political, and ideological—to be made in public.

Ma Heng prepared his own self-criticism. He then read it out in front of his assembled staff and party operatives, who deliberated on its accuracy and sincerity. His diary entry for Sunday, January 6, 1952, reads, "No rest today. I called a meeting for all staff at the Shenwu Gate for eight o'clock. I delivered my self-criticism first. Zhu Jialian, Chang Xueshi, Zhu

Jiajin, and Li Liantang delivered theirs in succession. Strong wind, bitter cold." It did not go well. The next day "every group agreed that my self-criticism is not deep enough, nor comprehensive."

The Three Anti campaign was grueling. On January 21, 1952, Ma Heng listened to the self-criticisms of two museum staff—"neither was thorough," he wrote—and then sat for six hours as "the masses raised many complaints." His days dissolved into a blur of confession, criticism, and suspicion. Following the party's template, he set up "shock teams" to investigate specific areas of the museum's activity and to hunt for the corruption, waste, and bureaucratism that Chairman Mao insisted were there. For a man like Ma Heng, for whom traditional propriety in relationships had always been a virtue, the task of running investigations against veteran museum staff—some of them curators with whom he had worked throughout the war years—must have been deeply distasteful. Failure to comply with the orders of the party, however, could lead to frightening consequences, and he must have felt that he had no option but to persevere.

By the middle of February 1952, it was becoming clear that the party was not happy with Ma Heng's progress. Four officials from the Institute of Marxism-Leninism, hard-core ideologues, arrived to take up positions on the museum's committees. They were joined by fourteen party operatives who had worked on land reform campaigns. The focus of the campaign turned to senior museum staff. After one long, exhausting February day Ma Heng informed his son, Ma Wenchong, the former soldier, that the campaign had intensified and that Ma Heng himself was now a target of investigation. His family was terrified.[13]

On February 15, 1952, Ma Heng "confessed." His diary entry for that day reads, "Clear. Cold. I confessed to using

museum staff to perform tasks at my home. Today is the last day [for confessions], so everybody is confessing problems with great eagerness. At 8 p.m. I began listening to reports and did not finish until midnight. My slack implementation of regulations resulted in loss and damage to cultural artifacts, even as I enjoyed all the privileges of high office without really applying myself. I have such regrets, but it's too late." The self-blame is shocking. Perhaps it is testament to the power of the party's program of "thought reform" that Ma Heng, after everything he had done to conserve the imperial collections, could have arrived at such a perception of himself. Or perhaps he was writing carefully, self-protectively, in the knowledge that his words could be used against him. Either way, the diary entries are those of a frightened, disoriented man.

On February 28, 1952, another clear winter day, Ma Heng's situation turned truly dangerous. He was summoned to a meeting at the Lake Palaces. Waiting for him were senior officials of the Ministry of Culture. They told him that the situation inside the Palace Museum was "complicated." Apparently they had secret reports indicating that "reactionaries" were planning to commit arson inside the museum; enemies of the revolution, they alleged, intended to set the Forbidden City on fire. The museum was to close. The Forbidden City's gates would be shut and locked to guarantee the safety of the palaces. All museum staff were to move out. Party operatives would divide the staff into two groups, each of which would go to hastily established Public Security Cadre Schools located in the grounds of two of Beijing's larger temples. The term "cadre school" today sends a shudder through a generation of Chinese people. They performed different functions, from professional training through to ideological indoctrination, detention, and incarceration. To Ma Heng, the term would probably have been new and unfamiliar, its implications unclear. He was

permitted to return home to Yabao Lane to pack a bag before reporting to the Palace Museum for transport.

Later that day, at the Forbidden City's northern gate, trucks waited in the chilly dusk. The staff milled about, wondering what was to become of them. A Ministry of Culture official, the famous wartime journalist Fan Changjiang, gave a "mobilization speech," and then the staff climbed aboard the trucks. It would have been a cold journey, bumping through Beijing's familiar gray streets, the evening air threaded with the smells of cooking, coal smoke, and dust, the twilight reflected in the lakes. Ma Heng's truck would have gone some distance south, passing the giant red walls of the imperial city, and then turned west, some five miles in all. The truck stopped at the Temple of the White Cloud, a Daoist complex lately closed by the Communist Party, its monks evicted. Ma Heng clambered out. The cadre school now occupied the temple grounds and consisted of quickly built single-story brick dormitories filled with bunk beds. This would be the site of Ma Heng's detention and interrogation.

The entries in Ma Heng's diary now become much shorter and even more matter-of-fact. He spent the following days receiving instruction regarding the aims of the Three Anti campaign and what work and study he was to perform. A young woman named Wang Bishu accompanied him at all times, perhaps because of his age or perhaps because he was seen as a suicide risk. He and the other museum staff learned from the party operatives overseeing them that the campaign had turned its energies to seeking out *da hu*—"big tigers"— a euphemism for the corrupt "bourgeois" elements alleged to infest senior levels of government and public institutions. There were tigers lurking somewhere in the Palace Museum, and it was the job of the party's *da hu dui*—"tiger-beating teams"—to root them out and extract their confessions. The

language reads strangely and, in its original Chinese, is loaded with threat and dehumanization. Who were these big tigers? Was Ma Heng one? That, the museum staff were informed, is what the coming weeks, and relentless self-examination, self-criticism, and interrogation, would ascertain.

Ma Heng set about putting on paper long accounts of himself, his past, and his thoughts. On March 3 he confided to his diary that "there are people among the masses who are demanding I confess." A few days later he began writing an account of his "social relationships," a document in which he would have listed and explained his friendships, contacts, and professional associations over the course of his life. Of probable interest to the *da hu dui* would have been his connections to the republic and the KMT and to his colleagues who had left for Taiwan, and his relationships with capitalists, such as his wife's family, businessmen, and art dealers. Ma Heng's life and tastes—his early wealth, his car, his Western suits and cigars, his connoisseurship—would have rendered him immediately suspect in the eyes of the Communist Party's more radical operatives. His experiences and values were anathema to people who had spent a quarter of a century making revolution amid the poverty and desolation of wartime China's fields and villages, its mountains and deserts, people who revered a proletarian way of life.

It seems likely too that the curator Wu Ying's accusations made more than two years previously—that Ma Heng had corruptly plotted the downfall of his predecessor as director of the museum—figured in the investigation. Ma Heng did not detail in his diary the substance of any accusations against him, nor did he describe the sessions at which he was questioned. It is possible his age shielded him from the worst excesses of the campaign. Certainly, by the standards of the time his treatment was not extreme. His investigators allowed him a certain

amount of freedom to wander, accompanied by his minder, and even to return home some weekends. He does not seem to have been physically harmed. Yet the deliberate disorientation, the accusations, the humiliations were to prove psychologically devastating for him. For other Palace Museum staff, the outcomes were even worse.

Those staff who the investigators felt could implicate Ma Heng in corruption underwent grueling interrogation. The curator Wang Shixiang, who headed the museum's Antiquities Department after the war and who had traveled in the jeep to Yipinchang to view the collections on that joyful day back in 1945, found himself sequestered in a cadre school located at the Dongyue Temple. There he braced himself for interrogation. Wang Shixiang was in trouble from the start: he had held government positions in the republic, had studied in the United States, and had visited Japan, all of which made him suspect.

According to his own written account, he was held in solitary confinement, and the tiger-beating team were relentless. They questioned him at all hours, dragging him from his bed in the middle of the night without explanation, working on him to the point of utter exhaustion. The questioning was crude. The interrogators demanded to know everything about his relationship with Ma Heng. They wanted evidence that Ma Heng was guilty of stealing antiquities from the Forbidden City. Had Wang Shixiang stolen antiquities at Ma Heng's command and smuggled them out of the Forbidden City? Had Ma Heng ever demanded that Wang Shixiang bring him valuable objects? By his own account, Wang Shixiang refused to implicate Ma Heng. Enraged by his "stubbornness," the interrogators screamed at him and threatened him with execution. The sessions lasted weeks.

Such techniques were hallmarks of China's political campaigns during the Mao years. The psychological pressure wore

down the victims' sense of identity and agency, leaving them deeply confused and emotionally shattered, often to the point of mental breakdown. Wang Shixiang's silence earned him ten months shackled in a stinking jail, fed corn bread and pickles twice a day. He was put to work making matchboxes. While incarcerated, he contracted tuberculosis. He survived the ordeal and the disease, though he wrote many years later that he had contemplated suicide as a way out.[14]

Through March and into April 1952, Ma Heng remained in the brick dormitory on the grounds of the Temple of the White Cloud. The questioning and the self-criticisms continued. On April 1 he collapsed a few hours after receiving inoculations against typhoid and cholera. He was found and put to bed, where he ran a high fever and fell into a deep sleep. Over the following days, exhausted, he wrote an "ideological self-criticism." As he worked, he noted that the peach trees in the temple grounds had burst into blossom.

On April 12 the investigators announced that twenty-seven people whose ideological progress was deemed adequate could leave the cadre school. Ma Heng was not among them. He spent the rest of the month continuing work on his self-criticism. When he was not working, he read novels and books on ancient inscriptions. Spring turned to early summer, and still his case was not "resolved." In June he was ordered to write everything he knew about the case of Yi P'ei-chi, his predecessor as director of the Palace Museum, a clear indication that Wu Ying's accusations were a part of the case against him. He also had to answer specific questions about the packing and unpacking of a certain case containing jewelry in 1933. Some of it had allegedly gone missing. What had happened to it? Ma Heng wrote that he had no memory of any such episode.

In the summer of 1952 the Three Anti campaign began to

wind down. On June 16, despite the lack of a resolution to his case, Ma Heng was allowed to return home. It was a warm, overcast day. A car was brought for him, and he rode through the dusty Beijing streets to the house on Yabao Lane. It was his birthday, and he ate traditional birthday noodles for his lunch. He was seventy-one.[15]

Ma Heng did not return to work at the Palace Museum, though he continued to receive his salary. He stayed at home. The house was quiet. Where once he had enjoyed a steady stream of visitors, lively dinners, and hours spent with friends poring over paintings, seals, and inscriptions, few came now. Ma Heng did not speak about what he had gone through at the cadre school. Even his family did not learn from him the true nature of his experiences there. His demeanor changed. He became withdrawn and anxious, even quieter than before. His bedroom was bare but for two photographs hanging on the wall. One was of his wife, Yeh Wei-ch'ing, dead twelve years by this time. The other was of the racecourse at Jiang-wan in Shanghai, where forty years before he had exercised racehorses, cantering around the track with his wealthy brothers-in-law in the morning light.

The family worried about him. His state of mind was not helped by financial pressures. His wealth was long gone, and the household's circumstances were much reduced. Ma Heng's own collection of antiquities was extensive, all of the pieces purchased during his years of affluence, but he refused to sell any of them. Instead, he busied himself that summer reorganizing the collection. His son Ma Wenchong remembered that the house on Yabao Lane had four rooms filled to bursting with books, objects, rubbings, and seals. Ma Wenchong loved looking at the fans, delicate calligraphy by some notable artist on one side, an exquisite painting on the other, "so many of

them you could view a new one each day and still not be done by summer's end." He remembered his father's collection of seals, the gorgeous calligraphy worked into the stone, word transmuted into form, rendered in the magnificent scarlet paste that Ma Heng had ground himself.[16] Ma Heng insisted the collection could not be sold for profit, even to ease the family's situation. He told his sons that he wanted his library and his collection donated to the state. While sorting through the cluttered rooms, he found his wife's old opium pipe, symbol of the habit that he had so detested in her. The pipe was now illegal drug paraphernalia, and he turned it in to the police.

Ma Heng's case dragged on. Ma Yanxiang, the party man, continued to lecture his father on his "thought work," which annoyed the rest of the family intensely. They called Ma Yanxiang *jiaoxun laozi* behind his back, which translates as something like "old scold."[17] It was only in the autumn that Ma Heng's situation began to clarify. The tiger-beating team cleared him of corruption and waste, but he was found guilty of bureaucratism, a vague term that could indicate poor leadership distanced from the masses and socialist reality, but could also imply wastefulness and inefficiency.[18] Ma Heng's punishment was dismissal from his job as director of the Palace Museum. He was to report to work at the Beijing Commission for the Preservation of Cultural Relics in a minor bureaucratic post entailing little meaningful work and less responsibility. It was a humiliation.

Ma Heng went back to work in November 1952 and seems to have sunk further into depression; Ma Wenchong remembered his "silence and dejection." His friendships fell away, blighted by suspicion on both sides. When Wang Shixiang, who had steadfastly refused to denounce him, returned from detention, he saw his old friend on the street, but the two dropped their eyes and passed each other by as though

they were strangers. Friendships between two persons accused by the state were impossible. Wang Shixiang consoled himself with the thought that each had a clear conscience, and even though they could not speak, knew the same of the other.[19]

Due to his supposed bureaucratism, the party required Ma Heng to continue work on his ideological transformation, so he was ordered to attend study sessions "among the masses." Each day he walked to a rear gate of the Forbidden City to join rickshaw pullers for a class in ideology. As he made his way through the maze of gray streets, he carried with him a small wooden stool so that he could sit for the duration of the session. Only when a famous writer, Guo Moruo, heard of Ma Heng's treatment and was appalled did the sessions stop.[20]

On the last day of 1952 Ma Heng wrote in his diary that "the lessons of the last year lie in the knowledge that, in the past, I preserved my integrity by standing above and apart. This is no longer appropriate in today's world. It is imperative to connect with the masses; only through mutual help can we truly serve the people." The entry reads as if Ma Heng is cutting out his own personality, that the *jinshi* scholar of old—restrained, dispassionate, a psychological step removed from the sordid everyday—was being excised. The party, however, does not seem to have valued Ma Heng's efforts at self-transformation. The diary makes it clear that he was being discarded, even as he desperately tried to adapt to the new regime.

During 1953 and 1954, Ma Heng continued to work at the Beijing Commission for the Preservation of Cultural Relics. Much of his work seems to have concerned the repair and refurbishment of old buildings. He administered contracts. He wrote memos on construction workers' meal and transportation allowances, and negotiated schedules and costs— all work that would have been familiar to him from the war

years. Occasionally the Palace Museum sought his advice on an exhibition. He tried tactfully to dissuade the Communist Party from tearing down important imperial buildings among what had once been the Lake Palaces but was now the Zhongnanhai leadership compound. He continued to read, and to study inscriptions. He worked particularly on inscriptions in stone dating from the Han period, foundational texts of Confucianism engraved into stone tablets 2,000 years old. He read essays by Chairman Mao, and Stalin's *History of the Communist Party of the Soviet Union*. He attended meetings, lectures, and study sessions, and conducted his "thought work."

In early 1953 Ma Heng's health started to deteriorate. He had fevers. On February 5 he wrote, "I felt under the weather when I came home last night. I thought a little drink would cure me, but this morning I was still running a fever . . ." He developed stomach problems and took more time off work. He wrote about anxiety-laden dreams in which he was back in the Palace Museum. His health problems persisted but did not incapacitate him. It was not until the following year that he started receiving regular sessions of a treatment that he refers to as "electrotherapy." Ma Heng seems unclear about his diagnosis; his doctors referred to cardiovascular problems, telling him to work less and rest more. They suggested he find someone to buy nutritional supplements in Hong Kong and have them sent up to him in Beijing. Antibiotics did not bring down his fevers, and in August 1954 an X-ray was taken of his chest.

At the follow-up consultation a doctor told him that continued electrotherapy was the only treatment for him and wrote out a prescription. Sitting across the table, Ma Heng looked down at the prescription form to see that under diagnosis was written "lung cancer." "It was enough to fill one with utter dread. I pressed Dr. Tang about it, and he changed the diagnosis to read pneumonia. How casually he did so." Reluctance to

inform a patient of their true condition, while surprising, was not uncommon, but Ma Heng now knew the truth.

He had daily electrotherapy until October 1954. The doctor told him that an X-ray showed some shrinkage in the tumor, and that he should return for monthly checkups. His fevers continued, and there was blood in his sputum. Throughout, he continued his research into the stone inscriptions of the Han period, and wrote about it regularly in the diary.

Ma Heng's final diary entry came on March 24, 1955. He describes the weather as clear. He had been taking traditional Chinese herbal remedies, and he notes some discussion in the family as to whether he should continue. He complains of exhaustion, and the entry stops abruptly.

As his grandson later told it, Ma Heng felt weaker and sicker the next day. That morning, his grandson assisted him to the bathroom, helped him wash, and remarked on the lifeless look in his eyes. The family decided that Ma Heng should go to the hospital, and the Ministry of Culture sent a car to take him there, a final courtesy and perhaps an indication that the name of this elderly scholar, despite all that he had been through at the hands of the Communist Party, still inspired a modicum of respect. He was admitted to Beijing University Hospital, but nothing could be done for him. Ma Heng died, from cancer, the following day.[21] He was seventy-four.

At the time of Ma Heng's death, his son Ma Wenchong was 400 miles away, still teaching at the school in Shandong. Immediately, Ma Wenchong's past—his military service as a republican officer, his brief time in Taiwan—caught up with him. Public security personnel confronted him and informed him that he was under arrest on suspicion of acting as a secret agent for Taiwan. He was taken away, a court sentenced him to "reform through labor," and, like so many of his generation, he

disappeared into the vast penal system of the People's Republic of China. The soldier who had been gravely wounded fighting the Japanese spent the next twenty years in a Shandong labor camp. By the time of his release in 1975, his wife had divorced him, his son had left, and he was alone.

In 1976 Ma Wenchong returned to Beijing to visit his father's grave. When he arrived at the cemetery in the west of the city where Ma Heng was buried, he found a scene of devastation. During the Cultural Revolution—the decade from 1966–1976 that marked the height of Maoist fervor—Red Guards had rampaged through the cemetery and smashed the headstones. Ma Wenchong searched for his father's grave but never found it.[22]

Ma Heng's entire life was entwined with the material and written culture of the civilization we have come to call Chinese. This reserved, introspective man encountered time in object and word, in porcelain cool and tensile between his fingers, in the strong, sinuous economy of brush and ink on silk, and the strange, unanchored dance of ancient ideographs on the surface of a stone. The past continually called to him in his tumultuous present. He cultivated himself in the Confucian tradition and excavated meaning from ancient texts, even as he and his generation engaged in a passionate reimagining of nation and culture.

He conceived of himself as a scholar first, and his scholarship survives him. Yet perhaps the greatest work of Ma Heng's life was practical in nature: the work of inventory in the cold halls of the Forbidden City in 1924; the creation of the Palace Museum; the packing and evacuation from Peking of 20,000 wooden cases containing—as he saw it—the embodiment of a civilization; the flight across a landscape of total war, from the bloody chaos of Nanjing along the Yangzi River to China's

deep interior, and all the way back again. From Ma Heng's life, his association with the imperial collections and that great journey spools out the larger story of modern China, its traumatic passage from imperial to modern, through world war to revolution.

The end of Ma Heng's life was laden with ironies. The bitterest of them was surely the way the Communist Party took his devotion to the collections and turned it against him, hounding and humiliating him in his final days. But perhaps a larger, sadder irony resides in the fact that Ma Heng was not present for the reopening of the cases that contained the rarest works of the imperial collections, those that made the journey to Taiwan. He never saw the final act of his own vast feat of conservation.

In Taiwan curators broke the paper seals, pried the wooden cases open—the sound of splintering wood, the smell of straw and mothballs, flecks of cotton rising in the still air—and extracted the pieces from their dark cocoons to bring them back into the light. Chuang Yen was there, in his spectacles and scholar's robe, and so was stocky, jovial Na Chih-liang, the two of them no doubt peering in, scrutinizing the lifting and unwrapping, alert for any slip or clumsiness, impatient for each breathtaking piece to emerge and declare the fact of its own survival.

The art awaited them, as it awaits us. Every work—the blood-red glaze on porcelain, the poem worked in stone, the ink on silk of *Early Snow on the River*—invites our approach, asks us to hold it in our gaze and incarnate it anew. When we do, the pieces live and voyage again in their stillness, akin to those travelers on the chill riverbank, picking their way past rocks and knotted pine trees, past reeds and moving water and distant, laughing fishermen, astride time, as flakes of early snow swirl and scatter on the wind.

Acknowledgments

Many people assisted and advised me during the years it took to research and write *Fragile Cargo*. Without the help of all those acknowledged here, the book might never have seen the light of day. Any errors in the finished work are mine alone.

I owe a deep debt of gratitude to Ben Zong. Ben threw himself into the search for Chinese-language source material for me. He read volumes on my behalf, and steered me away from fanciful accounts and toward the reliable. He translated sources and helped me interpret them. He read the manuscript and saved me from embarrassing blunders, and much more besides. The manuscript greatly benefited from his calm demeanor, clear eye, and professionalism.

My profound thanks go to Professor Robert Bickers of the University of Bristol, who gave vital support and succor throughout. As one of the foremost historians of the period, he pointed me toward important sources, helped me locate the story in its broader historical context, read the manuscript, and gave me fundamental editorial advice. My warmest thanks go to Cindy Hao, who guided me through Ma Heng's diary and his poetry, patiently untangling complicated references and historical allusions and helping me to understand more of this complex, reticent man. I am also grateful to Sean Ye and Bradley Seegert for their translations.

The staff of the National Palace Museum, Taipei, gave me a warm welcome and were generous with their time. Lisette Lou

(Lou Chung-yen) pointed me in the right direction early on. She arranged the introductions and interviews that set my research in motion. Dr. Daniel Sung (Sung Chao-lin) patiently shared his vast curatorial expertise and knowledge of the National Palace Museum's archives, helped me understand important aspects of the story, and read and commented on the manuscript. Museum librarian Lü Yü-nü found me important source material. The museum's former director, Ming-chu Fung, and curators Liao Pao-hsiu and Jo-Hsin Chi filled gaps in my understanding and drew my attention to vital elements of the story. I am deeply grateful for all their expertise, kindness, and friendship.

I was privileged to interview two surviving eyewitnesses to the imperial collections' journeys. Chuang Ling, son of the curator Chuang Yen, shared memories of his childhood that brought the whole story powerfully to life. Suo Yuming, who as a young curator helped escort the imperial collections to Taiwan, invited me into his home and shared his experiences in moving terms. I am deeply grateful for their time and generosity. My thanks go to the Chuang family, especially Ch'en Hsia-shen, and to the Suo family. Elsewhere in Taipei, old friends Kin Moy and Kathy Chen made introductions and attended to the care and feeding of the author. Art historians Lai Yu-chih and Shih Ching-fei offered valuable context and shared memories of their teacher Na Chih-liang. James Spencer shared his vast knowledge of Chinese porcelain; walking with him through the porcelain galleries at the National Palace Museum was a revelation. Taiwan's former minister of culture and celebrated author Lung Ying-t'ai helped demystify the story for me over tea. My thanks also to Arthur Na and his family, US-based descendants of Na Chih-liang.

In the UK the wisdom of art historian Professor Stacey Pierson of the School of Oriental and African Studies, University of London, was invaluable. Her boundless knowledge of China's

ceramics and art history helped me orient the entire narrative. She saved me from basic mistakes early on, and she read and commented on key parts of the manuscript. My thanks also to the great China scholar Frances Wood, formerly of the British Library, and to Nicole T. C. Jiang, one of the world's top experts on the imperial collections, for their time and guidance. Paul Forty and Amanda Brookes gave practical and editorial advice based on their decades of experience in the worlds of publishing and design. I am also grateful to Paul for the book's title.

In Washington, DC, Jan Stuart, Melvin R. Seiden Curator of Chinese Art at the Smithsonian's National Museum of Asian Art, gave early encouragement and answered my naïve questions with generosity, humor, and understanding. Under her stewardship, the National Museum of Asian Art's Freer Gallery of Art offers one of the world's most powerful and beautiful encounters with the art of China. Georgetown University's Professor James A. Millward and George Washington University's Professor David Shambaugh lent help, encouragement, and support, as did Penny and David Yao. The journalist Nadia Tsao made a crucial early introduction. Paul French, Mei Fong, and Andrew Lih, Kim Ghattas and Yudhijit Bhattacharjee have all been excellent writing companions over the years. The Maryland-based artist and calligrapher John Shun-Chieh Wang cut a beautiful seal for me depicting the character *shou*, meaning to guard or defend.

As I wrote, I held an affiliation as an artist-in-residence at the Center for East Asian Studies in the School of Languages, Literatures, and Cultures at the University of Maryland, College Park. This was a wonderful experience and gave me access to the fabulous McKeldin Library and the marvel that is Interlibrary Loan. I am very grateful to Professor Margaret M. Pearson for facilitating the affiliation, and to Professors Michele M. Mason and Lindsay Yotsukura for hosting me so graciously. Michele M. Mason also generously shared with me

her deep understanding of the history and nature of Japanese colonialism. My thanks too to the staff of the Asian Reading Room at the Library of Congress.

From the start, I depended on the help of historians. As he has been for so many others who write about China, Professor Jeff Wasserstrom of the University of California, Irvine, has been a mentor and a constant source of inspiration and encouragement. My thanks also to scholars Victor Zatsepine, Jeff Kyong-McClain, Lara Netting, Kathryn Edgerton-Tarpley, Elizabeth Lawrence, and Justin Jacobs, all of whom helped with particular aspects of the narrative. I relied heavily on the published works of such eminent scholars as Geremie Barmé, Rana Mitter, Hans van de Ven, Parks Coble, Shana J. Brown, R. Keith Schoppa, and Peter Harmsen. University of British Columbia professor emerita Diana Lary's publications were particularly important to me as I tried to form some understanding of the lived experience of Chinese people during the Second World War. I am grateful to historian Morgan Rocks for casting his learned eye over the manuscript.

As ever, my deepest thanks go to my agent, Catherine Clarke, and to everybody at Felicity Bryan Associates for the constancy of their support and encouragement, and to agent Zoë Pagnamenta in New York. I have been truly fortunate to work with Clara Farmer, Greg Clowes, Amanda Waters, and Hugh Davis at Chatto & Windus in London, and with Peter Borland at Atria Books in New York. No one could ask for more thoughtful and engaged editors.

In the end, I have leaned most on those closest to me. Susan V. Lawrence planted the idea of the book and nurtured its growth throughout. She turned up vital source material, and was the manuscript's first editor. For her, and for Anna Brookes and Ned Brookes, no amount of gratitude could be enough.

List of Illustrations

Every effort has been made to trace copyright holders and obtain permission for use of copyright material. The author and publishers apologize for any omissions and would be grateful to be notified of any corrections that should be incorporated in future editions of this book.

p. 19: Chuang Yen (1899–1980), photographer unknown; p. 21: Na Chih-liang (1908–1998), photographer unknown; p. 28: Ma Heng (1881–1955), photographer unknown; p. 43: Workers of the Palace Museum sorting the Forbidden City's vast archives in the 1920s, photographer unknown; p. 48: Portrait of Ma Heng in pencil and charcoal by the artist Xu Beihong, photographer unknown; p. 50: Chiang Kaishek, leader of the Republic of China, photographer unknown; p: 71: In the Forbidden City, porters ready cases for evacuation from Peking, 1933, photographer unknown; p. 92: Ouyang Daoda (1893–1976), photographer unknown; p. 100: British sailors load cases aboard HMS *Suffolk* for the voyage to London, 1935 © Palace Museum, Beijing; p. 116: Chuang Yen and his wife, Shen Juo-hsia, who escorted the imperial collections on the Southern Route, in a photograph dating from the early 1930s, photographer unknown; p. 123: Soldiers of the Chinese Republic demonstrating the use of a French-made Hotchkiss machine gun against aircraft, photographer unknown; p. 126: The scene after a Chinese aircraft mistakenly bombed the Great World Entertainment Centre in Shanghai, August 1937, photographer unknown; p. 185: Japanese bombing in the region of Chongqing, 1940 © Michael Lindsay; p. 204: A truck loaded with cases is pushed up a hill, Northern Route, late 1930s, photographer unknown; p. 208: Boatmen pole trucks loaded with cases across a river, Northern Route, late 1930s © Palace Museum, Beijing; p. 219: Japanese troops fighting in Changsha, 1939, photographer unknown; p. 222: A street scene in Chongqing following a Japanese air raid, 1940 © Michael Lindsay; p. 241: Ouyang Daoda and family, pictured in Leshan in the 1940s, photographer unknown; p. 250: Japanese infantry attack in Henan province during Operation

Ichigo in 1944, photographer unknown; **p. 292:** Cases stacked at a storage facility after arriving in Taiwan, with the labels visible, photographer unknown; **p. 301:** Communist troops enter Shanghai, 1949, photographer unknown.

Plate section

Meridian Gate © Michael Lindsay

Detail from *The Stag Hunt*, attributed to Huang Zongdao, active ca. 1120 © Metropolitan Museum of Art, New York

Details from *Early Snow on the River*, Zhao Gan, active in the late 10th century © National Palace Museum, Taipei

Jadeite Cabbage with Insects, unknown artist © National Palace Museum, Taipei

Palace Museum staff pack objects in wooden cases © Palace Museum, Beijing

A soldier of the Republic of China, Shanghai, 1937 © Harrison Forman. From the American Geographical Society Library, University of Wisconsin-Milwaukee Libraries

Damage wrought by Japanese aerial bombing in Chongqing © Michael Lindsay

Communist troops on patrol © Michael Lindsay

Detail from *Herd of Deer in an Autumn Forest*, unknown artist © National Palace Museum, Taipei

Monk's cap ewer with red glaze © National Palace Museum, Taipei

One of the ten Stone Drums of Qin on display in the Palace Museum, Beijing © Siyuwj, published under a Commons Attribution-Share Alike 4.0 International license

Detail from *Inscriptions on the Stone Drums (Eastern Zhou dynasty, 5th century B.C.)*, unknown artist © Metropolitan Museum of Art, New York

Infantry of the Republic of China © Getty Images

Notes

Prelude: The Forbidden City

1 The Qing took its name in 1636; from the state's founding in 1616 until 1636 it was known as the Later Jin.
2 Geremie R. Barmé, *The Forbidden City* (Cambridge, MA: Harvard University Press, 2008), 74–87.
3 Wu Shizhou, 乾隆一日 *(A Day in the Life of Qianlong)*, vol. 2 (Taipei: Yuan-Liou Publishing Co., 2002), 219–28.
4 For a discussion of Qianlong's view of the imperial collections, see Nicole T. C. Chiang, *Emperor Qianlong's Hidden Treasures: Reconsidering the Collection of the Qing Imperial Household* (Hong Kong: Hong Kong University Press, 2019).

1: First Glimpse of the Imperial Collections

1 Pu Yi, *The Last Manchu: The Autobiography of Henry Pu Yi, Last Emperor of China* (New York: Skyhorse Publishing, 2010), 54.
2 "Who Will Rule in China?" *North China Herald*, November 8, 1924.
3 Pu, *The Last Manchu*, 54.
4 "The Peking Coup: Effort to Destroy Monarchism Sensation in City," *South China Morning Post*, November 7, 1924.
5 "The Ching Emperor," *North China Herald*, November 29, 1924.
6 Hermann Köster, "The Palace Museum of Peiping," *Monumenta Serica* 2, no. 1 (1936): 167–90.
7 Shi Shanyuan, 我与初创时期的故宫博物院 *(My Role in the Early Days of the Palace Museum)*, quoted in Yu Jianwei and Shen Songping, 马衡转 *(Biography of Ma Heng)* (Shanghai: Shanghai Educational Publishing House, 2007), 74.
8 Na Zhiliang, 典守故宫国宝七十年 *(Seventy Years of Managing and Protecting the Palace's National Treasures)* (Beijing: Forbidden City Publishing House, 2004), 15.
9 Jack Langlois, "Chuang Yan and the National Palace Museum," *Echo of Things Chinese* 2, no. 3 (March 1972).

10 Zhuang Yan, 前生造定故宫缘 *(The Palace's Predestined Fate)* (Beijing: Forbidden City Publishing House, 2006), 74.

11 Zhuang, *(The Palace's Predestined Fate)*, 27.

12 Na, *(Seventy Years)*, 16–17.

13 Johannes L. Kurz, *China's Southern Tang Dynasty, 937–976* (London: Routledge, 2011), 112.

2: The Shabby Professor

1 Ma Simeng, 金石梦故宫情: 我心中的爷爷马衡 *(Scholar's Dream, Palace Devotion: Remembering My Grandfather Ma Heng)* (Beijing: National Library of China Publishing House, 2009), 10–11.

2 Jason Kuo, *Word as Image: The Art of Chinese Seal Engraving* (New York: China Institute in America, 1992), 16.

3 "The Late Mr. Yeh Ching-Chong," *North China Herald*, January 3, 1900.

4 "International Recreation Club: Opening of the Club House," *North China Herald*, June 3, 1910.

5 Ma, *(Scholar's Dream)*, 41.

6 Ma, *(Scholar's Dream)*, 46.

7 Ma, *(Scholar's Dream)*, 42.

8 Yu Jianwei and Shen Songping, 马氏家族 *(The Ma Family)* (Ningbo: Ningbo Publishing House, 2011), 166–70.

9 Philip Short, *Mao: A Life* (New York: Henry Holt, 1999), 83–4.

10 Guolong Lai, "The Emergence of 'Cultural Heritage' in Modern China: A Historical and Legal Perspective," in Akira Matsuda and Luisa Elena Mengoni, eds., *Reconsidering Cultural Heritage in East Asia* (London: Ubiquity, 2016), 47–82.

11 Yü Ying-shih, "Changing Conceptions of National History in Twentieth-Century China" in *Chinese History and Culture* vol. 2, *Seventeenth Century Through Twentieth Century* (New York: Columbia University Press, 2016), 275–293.

3: Peace, and War

1 A small exhibition space had been open inside the imperial precincts since 1914. It was known as the Gallery of Antiquities or, colloquially, the Government Museum. It exhibited a selection of objects from outlying imperial palaces brought to Peking for safekeeping. Access to it was limited.

2 "Peking's Art Treasures," *North China Herald*, December 12, 1925.

3 Wan Boao, 我所认识的故宫掌门人—马衡 "(The Palace Leader I Knew—Ma Heng)," 文艺报 *(Literature and Arts Gazette)*, November 22, 2020.

4 "Fortune in Pearls Stolen from Tombs," *New York Times*, September 30, 1928.

5 Jay Taylor, *The Generalissimo: Chiang Kai-shek and the Struggle for Modern China* (Cambridge, MA: Belknap Press, 2011), 49.

6 "Nationalist Troops March into Peking as New Flags Rise," *New York Times*, June 9, 1928.

7 Okakura Kakuzō, *Ideals of the East: The Spirit of Japanese Art* (London: John Murray, 1903), 1–10.

8 Nitobe Inazō, "Post Bellum Work," in *Thoughts and Essays* (Tokyo: Teibi Publishing, 1909), 121.

9 Okakura, *Ideals of the East*, 1–10.

10 Nitobe, "Post Bellum Work," 120.

11 Sheldon H. Harris, *Factories of Death: Japanese Biological Warfare, 1932–1945, and the American Cover-up* (London: Routledge, 1994), 57–82.

12 Rana Mitter, *Forgotten Ally: China's World War II, 1937–1945* (Boston: Mariner, 2014), 64–7.

13 Donald A. Jordan, *China's Trial by Fire: The Shanghai War of 1932* (Ann Arbor, MI: University of Michigan Press, 2001), 12.

14 "Japanese Checked in Taking Shanghai," *New York Times*, January 29, 1932.

15 Christian Henriot, "Beyond Glory: Civilians, Combatants, and Society During the Battle of Shanghai," *War & Society* 31, no. 2 (August 2012): 106–35.

16 Henriot, "Beyond Glory," 106–35.

17 "Total Publishing House Losses Put at M$16,330,504," *China Press*, March 17, 1932.

18 "North Rail Station, Commercial Press Buildings in Ruins," *China Press*, January 30, 1932.

19 Na, *(Seventy Years)*, 61.

20 For an account of the porcelain industry in Jingdezhen, see Anne Gerritsen, *The City of Blue and White: Chinese Porcelain and the Early Modern World* (Cambridge, UK: Cambridge University Press, 2020).

21 Zhuang, *(The Palace's Predestined Fate)*, 121–2.

22 "Japan Threatens to Drive into China," *New York Times*, August 5, 1932.

23 "Plan to Sell Treasures of Peiping Charged by Savants," *China Press*, September 5, 1932.

4: Evacuation

1 "The Shanhaikuan Affair," *North China Herald*, January 18, 1933.

2 "Shanhaikuan Reactions: Wealthy Chinese Fleeing for Shelter: Museum Packed," *North China Herald*, January 25, 1933.

3 "Nanking Efforts Futile as Peiping Hugs Art Treasures," *China Press*, February 6, 1933.

4 Mark O'Neill, *The Miraculous History of China's Two Palace Museums* (Hong Kong: Joint Publishing, 2015), 89.

5 "Many Difficulties Postpone Removal of Peiping Treasures," *China Press*, February 2, 1933.

6 "Nanking Efforts Futile."

7 "Peking Treasures: Removal Delayed by Lack of Transport," *South China Morning Post*, February 7, 1933.

8 "2,100 Police Guard Moving of Art Relics," *China Press*, February 7, 1933.

9 Jacques Gernet, *A History of Chinese Civilization* (Cambridge, UK: Cambridge University Press, 1982), 512.

10 Paul French, *Carl Crow—A Tough Old China Hand: The Life, Times, and Adventures of an American in Shanghai* (Hong Kong: Hong Kong University Press, 2006), 117.

11 "Miss Aldrich Freed: Found in Tseetsun," *New York Times*, May 8, 1923.

12 Wu Ying, 故宫尘梦录 *(Dust and Dreams in the Palace)* (Beijing: Forbidden City Publishing House, 2005), 180–94.

5: Shanghai

1 Richard T. Phillips, "A Picturesque but Hopeless Resistance: Rehe in 1933," *Modern Asian Studies* 42, no. 4 (July 2008): 733–50.

2 "Jehol Is Lost," *China Weekly Review*, March 18, 1933.

3 "Twenty-Four Hour Ultimatum," *China Weekly Review*, February 25, 1933.

4 "North China a Powder Magazine," *China Weekly Review*, February 25, 1933.

5 "Disposal of Museum Art Undecided," *China Press*, January 22, 1934.

6 Chuang Ling, interview with the author, Taipei, May 2019.

7 Zhuang, *(The Palace's Predestined Fate)*, 191.

8 Gilbert L. Mattos, *The Stone Drums of Ch'in*, Monumenta Serica Monograph Series vol. 19 (Nettetal, DE: Steyler Verlag, 1988), 21.

9 Zhuang, *(The Palace's Predestined Fate)*, 191.

10 Mattos, *Stone Drums of Ch'in*, 196.
11 Translation by S. W. Bushell, quoted in Mattos, *Stone Drums of Ch'in*, 42.
12 Mattos, *Stone Drums of Ch'in*, 48.
13 Mattos, *Stone Drums of Ch'in*, 52.
14 Zhuang, *(The Palace's Predestined Fate)*, 192.
15 Zhuang, *(The Palace's Predestined Fate)*, 193.
16 Mattos, *Stone Drums of Ch'in*, 49.
17 "Yuan to Stand Firm in Probe of Officialdom," *China Press*, August 21, 1933.

6: To London

1 Stacey Pierson, *Collectors, Collections and Museums: The Field of Chinese Ceramics in Britain, 1560–1960* (Lausanne, CH: Peter Lang AG, 2007), 132–7.
2 The Chinese Organizing Committee, *Illustrated Catalogue of Chinese Government Exhibits for the International Exhibition of Chinese Art in London* (Shanghai: Shanghai Press, 1936), quoted in Jason Steuber, "The Exhibition of Chinese Art at Burlington House, London, 1935–36," *Burlington Magazine* 148 (August 2006).
3 Zhuang, *(The Palace's Predestined Fate)*, 128.
4 Frances Wood, "Paul Pelliot, Aurel Stein and Chinese Opposition to the International Exhibition of Chinese Art, 1935–36," in *Sir Aurel Stein, Colleagues and Collections*, ed. Helen Wang (London: British Museum, 2012).
5 Zhuang, *(The Palace's Predestined Fate)*, 127.
6 Zhuang, *(The Palace's Predestined Fate)*, 132.
7 "Peiping Treasures Leave for London: Burlington House Exhibition Opening," *North China Herald*, June 12, 1935.
8 Zhuang, *(The Palace's Predestined Fate)*, 132–136.
9 "Chinese Treasure: Warship's Precious Cargo Grip Imagination, Interest," *South China Morning Post*, July 27, 1935.
10 "China Treasures: Priceless Cargo Landed Intact in London, Smooth Voyage," *South China Morning Post*, August 14, 1935.
11 Zhuang, *(The Palace's Predestined Fate)*, 132–6.
12 James Cahill, "The Imperial Painting Academy" in Wen C. Fong and James C. Y. Watt, *Possessing the Past: Treasures from the National Palace Museum, Taipei* (New York: Metropolitan Museum of Art and Taipei: National Palace Museum, 1996), 161–3.
13 T. S. Eliot, *The Letters of T. S. Eliot*, vol. 7, 1934–1935, eds. Valerie Eliot and John Haffenden (London: Faber & Faber, 2017).

14 "At Burlington House," *The Times*, November 28, 1935.

15 Quoted in Robert Bickers, *Out of China: How the Chinese Ended the Era of Western Domination* (Cambridge, MA: Harvard University Press, 2017), 141.

16 "China's Great Art," *New York Times*, April 2, 1936.

17 Reuters, "In No Danger: Ranpura Still on Shoal," *South China Morning Post*, April 16, 1936.

18 Reuters, "In No Danger."

19 "Harbor to Be Busy Today and Tomorrow," *China Press*, May 17, 1936, and other newspaper reports.

20 "Nanking Bitter Over Japan Troop Increase: Stronger Garrisons in North," *China Press*, May 17, 1936.

21 "Itagaki Plans for 5,000,000 More Japanese in Manchuria," *China Press*, May 17, 1936.

22 "Museum Theft Investigation Reveals Clues," *China Press*, June 21, 1936.

23 "Another Huge Theft of Peiping Museum Treasures Discovered," *China Press*, June 20, 1936.

24 "Jade Now Missing from Peiping Palace Museum," *China Press*, August 30, 1936.

25 "Beiping Treasures: Modern Building Planned for Precious Relics," *South China Morning Post*, July 17, 1934.

26 "More Peiping Art Treasures Leave City," *China Press*, December 12, 1936.

27 Mitter, *Forgotten Ally*, 71.

7: The Southern Route

1 Hans van de Ven, *China at War: Triumph and Tragedy in the Emergence of the New China 1937–1952* (London: Profile, 2017), 66.

2 "Heavy Fighting in North China: Japanese and Chinese Armies Clash," *North China Herald*, July 14, 1937.

3 Fan Changjiang, ed., *Lunwang de Pingjin* (Hankou: Shenghuo Shudian, 1938), quoted in Parks M. Coble, *China's War Reporters* (Cambridge, MA: Harvard University Press, 2015), 21.

4 Mitter, *Forgotten Ally*, 80.

5 "Nankai University Destroyed by Japanese Bombers and Incendiaries," *China Weekly Review*, August 7, 1937.

6 Yuan Yidan, "The Moment When Peking Fell to the Japanese: A 'Horizontal' Perspective," *Journal of Modern Chinese History* 13, no. 1 (2019): 45–60.

7 "Solemn Peiping: Streets Deserted and Shops Close," *South China Morning Post*, August 19, 1937.

8 "Art Treasures in Peiping Safe," *North China Herald*, September 8, 1937.

9 *Dagong Bao* (Shanghai), quoted in Coble, *China's War Reporters*, 24.

10 R. Keith Schoppa, *In a Sea of Bitterness: Refugees During the Sino-Japanese War* (Cambridge, MA: Harvard University Press, 2011), 10.

11 Peter Harmsen, *Shanghai 1937: Stalingrad on the Yangtze* (Philadelphia: Casemate, 2015).

12 Mitter, *Forgotten Ally*, 105.

13 Mitter, *Forgotten Ally*, 106.

14 Speech on national radio, 1947, quoted in Ma, *(Scholar's Dream)*, 180.

15 Na, *(Seventy Years)*, 84.

16 "Japanese Air Squadron Bombs Nanking," *China Press*, August 16, 1937.

17 Mark R. Peattie, *Sunburst: The Rise of Japanese Naval Air Power, 1909–1941* (Annapolis, MD: Naval Institute Press, 2001).

18 Na, *(Seventy Years)*, 85.

19 Na, *(Seventy Years)*, 84–86.

20 文化抗战薪火不灭 ("The Cultural War of Resistance: Fuelling the Flames"), 贵州日报 *(Guizhou Daily)*, August 25, 2015.

21 Ouyang Daoda, 故宫文物避寇记 *(How the Palace Artifacts Escaped the Invader)* (Beijing: Forbidden City Publishing House, 2010), 54.

22 Speech on national radio, 1947, quoted in Ma, *(Scholar's Dream)*, 181.

23 Langlois, "Chuang Yen," 54.

8: Fleeing Nanjing

1 "Chinese Attacks Check Foes' Drive," *New York Times*, November 18, 1937.

2 Tatsuzō Ishikawa, *Soldiers Alive*, trans. Zeljko Cipris (Honolulu: University of Hawai'i Press, 2003). This is a novel, but the author draws his descriptions from his experiences as a war reporter.

3 Peter Harmsen, *Nanjing 1937: Battle for a Doomed City* (Philadelphia: Casemate, 2015).

4 "Kiating Occupied," *South China Morning Post*, November 14, 1937.

5 Timothy Brook, *Collaboration: Japanese Agents and Local Elites in Wartime China* (Cambridge, MA: Harvard University Press, 2007), 67.

6 Mitter, *Forgotten Ally*, 125.

7 "Chinese Attacks Check Foes' Drive," *New York Times*.

8 "Grim Throngs Quit Nanking as Troops Move to the Front," *New York Times*, November 19, 1937.

9 Han Lih-wu, 中華文物播遷記 *(The Evacuation of China's Cultural Artifacts)* (Taipei: Taiwan Commercial Press, 1980), 21–2.

10 Nanking Despatch no. 4216, March 5, 1938, in Second Historical Archives of China, Nanjing, file 689 (1), 14875.

11 John Rabe, *The Good Man of Nanking: The Diaries of John Rabe*, ed. Erwin Wickert, trans. John E. Woods (New York: Alfred A. Knopf, 1998).

12 "Nanking Fell, Seething Masses of Refugees," *Herald* (Melbourne), December 31, 1937.

13 The National Archives (Kew), "Peking Palace Art Treasures," FO 676/346.

14 Robert Bickers, *China Bound: John Swire & Sons and Its World, 1816–1980* (London: Bloomsbury Business, 2020), 259–60.

15 Graham Torrible, *Yangtze Reminiscences* (London: John Swire & Sons, 1990), 61.

16 "Peiping Treasures: Captain of B. & S. Coaster *Whangpu* Tells of Rescue," *South China Morning Post*, February 10, 1938.

17 Han, *(China's Cultural Artifacts)*, 21–2. John Rabe's diary suggests that Han Lih-wu knew in advance that he would be leaving Nanjing aboard the *Whangpu*, and that a "farewell" dinner was held for him on the evening of December 2.

18 Torrible, *Yangtze Reminiscences*, 61.

19 Rabe, *The Good Man of Nanking*, 47.

20 Robert Mamlock, *The International Medical Relief Corps in Wartime China 1937–1945*, Chapter 6 (Jefferson, NC: McFarland & Co., 2018).

21 Ma Wenchong, "缅怀先父马衡" ("A Remembrance of My Late Father Ma Heng"), 北京文史资料 *(Beijing Literary and Historical Materials)* (Beijing: Beijing Publishing House, 1995), 51.

22 Zhou Xiao et al., "故宫文物西迁档案史料选辑" ("Selected Archival Materials Relating to the Palace Museum's Evacuation to the West"), 档案史料 *(Archival Materials)*, China Number Two Historical Archive (2017).

23 Mitter, *Forgotten Ally*, 128.

24 Mitter, *Forgotten Ally*, 133.

25 Rabe, *The Good Man of Nanking*, 76.
26 Hua-ling Hu and Zhang Lian-hong, eds. and trans., *The Undaunted Women of Nanking: The Wartime Diaries of Minnie Vautrin and Tsen Shui-fang* (Carbondale: Southern Illinois University Press, 2010).
27 van de Ven, *China at War*, 98.
28 Mitter, *Forgotten Ally*, 142

9: The Central Route

1 "Yangtze Navigation Still Hazardous," *North China Herald,* December 29, 1937.
2 "Down the Yangtze in Capetown Convoy," *North China Herald*, December 29, 1937.
3 Joy Homer, *Dawn Watch in China* (Boston: Houghton Mifflin, 1941), 107.
4 S. Cornell Plant, *Handbook for the Guidance of Shipmasters on the Ichang–Chungking Section of the Yangtze River* (Shanghai: Statistical Dept. of the Inspectorate General of Customs, 1920), 4.
5 Ouyang, *(Invader)*, 59–60.
6 "Nippon Planes Bomb Ichang for 1st Time," *China Press*, January 25, 1938.
7 "Chungking Overflowing with Chinese Refugees from Down River," *China Weekly Review*, January 1, 1938.
8 Ouyang, *(Invader)*, 61.
9 Zhou, *(Archival Materials)*.
10 Hu Changjian, "故宫国宝流离重庆事略" ("A Brief Account of the Palace Museum National Treasures' Voyage to Chongqing"), 中国博物馆 *(Chinese Museum)* (April 1997): 13–18.
11 "Chinese Art Has Been a Major Casualty of the Japanese Occupation," *China Weekly Review*, December 28, 1940, quoting Hirota Koki in *Domei* report from March 23, 1938.
12 Mitter, *Forgotten Ally*, 152.
13 Walter E. Grunden, "No Retaliation in Kind: Japanese Chemical Warfare Policy in World War II," in Bretislav Friedrich et al., eds., *One Hundred Years of Chemical Warfare: Research, Deployment, Consequences* (New York: Springer, 2017), 265.
14 Mitter, *Forgotten Ally*, 159–63.
15 Kathryn Edgerton-Tarpley, "Between War and Water: Farmer, City, and State in China's Yellow River Flood of 1938–1947," *Agricultural History* 90, no. 1 (Winter 2016), 94–116.
16 "Japanese Bomb Chungking," *North China Herald*, January 18, 1939.

17 Ouyang, *(Invader)*, 68.

18 "News of the Week: The Bombing of Chungking," *China Critic*, May 11, 1939.

19 Peattie, *Sunburst*.

20 Wei Yixiong, "故宫文物存放乐山始末" ("A Complete Account of the Palace Museum Artifacts' Storage at Leshan"), 新西部 *(New West Magazine)*, no. 2 (2015).

21 Na, *(Seventy Years)*, 111–13.

22 Wei, ("A Complete Account").

23 "Foreigners Escape at Kiating: Third of City at Foot of Mount Omei Destroyed," *North China Herald*, August 30, 1939. Leshan was often called Kiating at this time.

24 Ouyang, *(Invader)*, 71.

10: The Northern Route

1 Ouyang, *(Invader)*, 82.

2 Na, *(Seventy Years)*, 87–90.

3 Tristan G. Brown, "Feasts of the Sacrifice: Ritual Slaughter in Late Imperial and 20th Century China," Middle East Institute, March 5, 2015, https://www.mei.edu/publications/feasts-sacrifice -ritual-slaughter-late-imperial-and-20th-century-china.

4 Na *(Seventy Years)*, 90–3.

5 "Japanese Aircraft Stage Many Raids," *North China Herald*, March 23, 1938.

6 Ouyang, *(Invader)*, 85.

7 Na, *(Seventy Years)*, 98–9.

8 Na, *(Seventy Years)*, 96.

9 Na, *(Seventy Years)*, 96.

10 Jeff Kyong-McLain, "National Treasures or Just Old Stuff? The Palace Museum's Evacuation to Sichuan," *Museum History Journal* 8, no. 2 (2015): 223–8.

11 Na, *(Seventy Years)*, 101–10.

12 Na, *(Seventy Years)*, 101–2.

11: A Sort of Sanctuary

1 Homer, *Dawn Watch in China*, 71.

2 "Anti–Air Raid Defences Built in Chungking," *China Press*, June 2, 1938.

3 Ying-kit Chan, "A Wartime Stampede: Renewing a Social Contract After the Great Tunnel Disaster of Chongqing," *International Journal of Asian Studies* 14, no. 1 (2017): 47–75.

4 "Girls in Air Raid," *South China Morning Post*, August 8, 1940.

5 Chan, "A Wartime Stampede."

6 Ma Simeng, 马衡年谱长编 *(An Extended Chronology of Ma Heng's Life)*, vol. 2 (Beijing: Palace Museum Publishing House, 2020), 784–5.

7 Zhou, *(Archival Materials)*.

8 Mitter, *Forgotten Ally*, 274–7.

9 "Kweichow Stories Breed Distrust," *North China Herald*, September 28, 1938.

10 "Aeroplanes Arrive in Kweiyang," *North China Herald*, November 10, 1937.

11 Chuang Ling, interview.

12 Zhou, *(Archival Materials)*.

13 Chuang Ling, interview.

14 "Exhibition of Chinese Art Opens in Moscow," *New York Times*, January 7, 1940.

15 "Arts Exhibition: Chinese Works Admired by Alexei Tolstoy," *South China Morning Post*, January 15, 1940.

16 Zhou, *(Archival Materials)*.

17 Liu Nannan, "故宫文物的赴苏之旅" ("The Palace Museum Artifacts' Journey to the Soviet Union"), 中国档案报 *(China Archives News)* no. 2, May 5, 2017.

18 Zhou, *(Archival Materials)*.

19 Gao Yong, "故宫文物迁安谷" ("The Palace Museum Artifacts Move to Angu"), 中国档案报 *(China Archives News)*, March 27, 2015.

20 Ouyang, *(Invader)*, 134–41.

21 Ouyang, *(Invader)*, 146.

22 Wei Yixiong, "警卫故宫南迁文物的部队" ("The Troops Guarding the Palace Museum Artifacts on Their Journey South"), 紫禁城 *(Forbidden City)*, April 15, 2011.

23 Na, *(Seventy Years)*, 116.

24 Kevin Landdeck, "Under the Gun: Nationalist Military Service and Society in Wartime Sichuan, 1938–1945" (PhD diss., University of California, Berkeley, 2011), 187–246.

25 Na, *(Seventy Years)*, 117–24.

26 Na, *(Seventy Years)*, 127.

27 Mitter, *Forgotten Ally*, 267.

28 Zhou, *(Archival Materials)*.

29 Chuang Ling, interview.

30 Zhou, *(Archival Materials)*.

12: The Unforgettable Day

1 Horace H. F. Jayne, "Yi P'in Ch'ang: A Report from China," *Metropolitan Museum of Art Bulletin* 4, no. 4 (December 1945): 97–100.

2 van de Ven, *China at War*, 203–5.

3 "Chiang Pledges Democracy; Bars All Political Armies," *New York Times*, September 4, 1945.

4 van de Ven, *China at War*, 209.

5 Na, *(Seventy Years)*, 133–47.

6 Ouyang, *(Invader)*, 119.

7 Meng Guoxiang, "故宫陷留南京文物损失之研究" ("Researching Damage Suffered by Palace Museum Artifacts Trapped in Nanjing"), 日本侵华史研究 *(Japanese Invasion of China History Research)* no. 4 (2016).

8 Ma, *(Scholar's Dream)*, 221.

9 Zhou, *(Archival Materials)*.

10 Huang Jin, "沦陷前后张庭济与'奉命维持'的北平故宫博物院事业" ("Zhang Tingji and His Dedication to the Palace Museum Before and After the Fall of Beiping"), 故宫博物院院刊 *(Palace Museum Journal)* no. 5 (2014).

11 Huang, ("Zhang Tingji").

12 Zhao Jianmin and Peter Li, "The Looting of Books in Nanjing," in *Japanese War Crimes: The Search for Justice*, ed. Peter Li (London: Routledge, 2001), 282.

13 Hans van der Hoeven and Joan van Albada, *Memory of the World: Lost Memory—Libraries and Archives Destroyed in the Twentieth Century* (Paris: UNESCO, 1996), 8.

14 Zhao and Li, "Looting," 281.

15 Ma, *(Scholar's Dream)*, 221.

16 Ma, *(Scholar's Dream)*, 217.

17 Diana Lary, *China's Civil War: A Social History, 1945–1949* (Cambridge, UK: Cambridge University Press, 2015), 38–47.

18 Lary, *China's Civil War*, 109–11.

19 "Changchun's Plight," *South China Morning Post*, August 9, 1948.

20 van de Ven, *China at War*, 248–9.

13: Exile?

1 "How Many Men? What is the Strength of China's Army?" *South China Morning Post*, February 23, 1948.

2 Han, *(China's Cultural Artifacts)*, 28–30.

3 Sung Chao-lin, "故宮文物遷臺紀實" ("An Account of the Palace Museum Artifacts' Move to Taiwan"), 故宮文物月刊 *The National Palace Museum Monthly of Chinese Art* no. 410 (May 2017): 5.

4 Sung, ("Artifacts' Move to Taiwan"), 5.

5 "Feeling of Impending Doom; Nanking Not Expected to Remain Safe for Long; Prepared to Evacuate," *South China Morning Post*, December 1, 1948.

6 Lary, *China's Civil War*, 138.

7 "Defence Line Pierced," *South China Morning Post*, December 9, 1948.

8 Sung, ("Artifacts' Move to Taiwan"), 8.

9 Craig L. Symonds, "The Unloved, Unlovely, yet Indispensable LST," *Navy Times*, June 6, 2019.

10 Sung, ("Artifacts' Move to Taiwan"), 9.

11 Na, *(Seventy Years)*, 150

12 "Air of Doom Over Nanking," *South China Morning Post*, January 15, 1949.

13 Sung, ("Artifacts' Move to Taiwan"), 13.

14 Suo Yuming, interview with the author, Taipei, May 2019.

15 Zhuang, *(The Palace's Predestined Fate)*, 130.

14: Hunting Tigers

1 Lary, *China's Civil War*, 145.

2 "The Fall of Peiping," *China Weekly Review*, February 5, 1949.

3 Taylor, *Generalissimo*, 397.

4 Ma Heng, 馬衡日記 *(The Diary of Ma Heng)* (Beijing: SDX Joint Publishing Company, 2018).

5 Dai Qing, "1948: How Peaceful was the Liberation of Beiping?," 68th Morrison Lecture, Australian National University, September 5, 2007, published in *China Heritage Quarterly* no. 14 (June 2008), http://www.chinaheritagequarterly.org.

6 "Conditions in Peiping," *South China Morning Post*, February 6, 1949.

7 Ma, *(The Diary of Ma Heng)*.

8 "Riot Interlude in Nanking," *New York Times*, April 24, 1949.

9 Jeannette Shambaugh Elliott and David Shambaugh, *The Odyssey of China's Imperial Art Treasures* (Seattle: University of Washington Press, 2005), 111–12.

10 Bruce Doar, "Shaping the Forbidden City as an Art-Historical Museum in the 1950s," *China Heritage Newsletter* no. 4 (December 2005), http://www.chinaheritagequarterly.org.

11 Michael M. Sheng, "Mao Zedong and the Three-Anti Campaign (November 1951 to April 1952): A Revisionist Interpretation," *Twentieth-Century China* 32, no. 1 (2006): 56–80.

12 Sheng, "Mao Zedong," 56–80.

13 Yu Jianwei and Shen Songping, 马氏家族 *(The Ma Family)* (Ningbo: Ningbo Publishing House, 2011), 166–70.

14 Dou Zhongru, "王世襄为什么被逐出故宫博物院" ("Why Wang Shixiang Was Driven Out of the Palace Museum"), March 16, 2019, https://new.qq.com/omn/20190316/20190316AoBX8S.html.

15 Ma, *(Ma Heng's Life)*, 436–530.

16 Yu and Shen, *(The Ma Family)*, 166–70.

17 Ma, *(Scholar's Dream)*, 332.

18 Sheng, "Mao Zedong," 56–80.

19 Ma, *(Scholar's Dream)*, 334.

20 Yu and Shen, *(The Ma Family)*, 166–70.

21 Ma, *(Scholar's Dream)*, 383.

22 Ma, ("Remembrance"), 39–41.

Selected Bibliography

Barmé, Geremie R., *The Forbidden City*, Cambridge, MA: Harvard University Press, 2008.

Bickers, Robert, *Out of China: How the Chinese Ended the Era of Western Domination*, Cambridge, MA: Harvard University Press, 2017.

Brown, Shana J., *Pastimes: From Art and Antiquarianism to Modern Chinese Historiography*, Honolulu: University of Hawai'i Press, 2011.

Chiang, Nicole T. C., *Emperor Qianlong's Hidden Treasures: Reconsidering the Collection of the Qing Imperial Household*, Hong Kong: Hong Kong University Press, 2019.

Coble, Parks M., *China's War Reporters: The Legacy of Resistance Against Japan*, Cambridge, MA: Harvard University Press, 2015.

Fong, Wen C. and James C. Y. Wyatt, *Possessing the Past: Treasures from the National Palace Museum, Taipei*, Metropolitan Museum of Art, New York and National Palace Museum, Taipei, 1996.

Han Lih-wu, 中華文物播遷記 (*The Evacuation of China's Cultural Artifacts*), Taipei: Taiwan Commercial Press, 1980.

Harmsen, Peter, *Nanjing 1937: Battle for a Doomed City*, Philadelphia: Casemate, 2015.

——, *Shanghai 1937: Stalingrad on the Yangtze*, Philadelphia: Casemate, 2015.

Lary, Diana, *China's Civil War: A Social History, 1945–1949*, Cambridge, UK: Cambridge University Press, 2015.

——, *The Chinese People at War: Human Suffering and Social Transformation, 1937–1945*, Cambridge, UK: Cambridge University Press, 2010.

Ma Heng, 马衡日记 (*The Diary of Ma Heng*), Beijing: SDX Joint Publishing Company, 2018.

Ma Simeng, 金石梦故宫情: 我心中的爷爷马衡 (*Scholar's Dream, Palace Devotion: Remembering My Grandfather Ma Heng*), Beijing: National Library of China Publishing House, 2009.

——, ed., 马衡年谱长编 (*An Extended Chronology of Ma Heng's Life*), Beijing: Palace Museum Publishing House, 2020.

Mattos, Gilbert L., *The Stone Drums of Ch'in*, Monumenta Serica Monograph Series vol. 19, Nettetal, DE: Steyler Verlag, 1988.

Mitter, Rana, *Forgotten Ally: China's World War II, 1937–1945*, Boston: Mariner, 2014.

Na Zhiliang, 典守故宫国宝七十年 (*Seventy Years of Managing and Protecting the Palace's National Treasures*), Beijing: Forbidden City Publishing House, 2004.

Ouyang Daoda, 故宫文物避寇记 (*How the Palace Artifacts Escaped the Invader*), Beijing: Forbidden City Publishing House, 2010.

Peattie, Mark R., *Sunburst: The Rise of Japanese Naval Air Power, 1909–1941*, Annapolis, MD: Naval Institute Press, 2001.

Peattie, Mark, Edward Drea, and Hans van de Ven, eds., *The Battle for China: Essays on the Military History of the Sino-Japanese War of 1937–1945*, Stanford, CA: Stanford University Press, 2013.

Pierson, Stacey, *Collectors, Collections and Museums: The Field of Chinese Ceramics in Britain, 1560–1960*, Lausanne, CH: Peter Lang AG, 2007.

Schoppa, R. Keith, *In a Sea of Bitterness: Refugees During the Sino-Japanese War*, Cambridge, MA: Harvard University Press, 2011.

Sung Chao-lin, 故宫院史留真 (*History of the Palace Museum*), Taipei: National Palace Museum, 2013.

Taylor, Jay, *The Generalissimo: Chiang Kai-shek and the Struggle for Modern China*, Cambridge, MA: Belknap Press, 2011.

van de Ven, Hans, *China at War: Triumph and Tragedy in the Emergence of the New China 1937–1952*, London: Profile, 2017.

Wu Shizhou, 乾隆一日 (*A Day in the Life of Qianlong*), Taipei: Yuan-Liou Publishing Co., 2002.

Wu Ying, 故宫尘梦录 (*Dust and Dreams in the Palace*), Beijing: Forbidden City Publishing House, 2005.

Yu Jianwei and Shen Songping, 马氏家族 (*The Ma Family*), Ningbo: Ningbo Publishing House, 2011.

Zhuang Yan, 前生造定故宫缘 (*The Palace's Predestined Fate*), Beijing: Forbidden City Publishing House, 2006.

Index

A

Academia Sinica, 48, 213, 283
aka-to, 174
alcohol, 20, 101, 131, 205, 211, 271
 fen, 195, 200, 266, 290
 gaoliang, 142
Aldrich, Lucy, 76
Almaty, Kazakhstan, 233, 236
American Civil War (1861–65), 30
American Revolutionary War (1775–83), 5
Anderson (company), 172
Angu, Sichuan, 180, 181, 186, 189, 191–92, 218, 227, 237–40, 260, 261, 263
Anhui Province, 92, 178–79, 183, 239
Anshun, Guizhou, 141–42, 218, 227, 228–33, 251–52, 263
anthrax, 55
antiquarianism, *see jinshixue*
ants, 177
Anyang, Henan, 213, 280
Art of War (Sunzi), 86
Austria-Hungary, 9
authoritarianism, 86
"Autumn Rain" (Ma Heng), 225–26

B

B&S, 154, 155, 167, 169
Bai Juyi, 215

bamboo rafts, 11, 261–62
bandits, 73, 75–77
Bank of China, 97, 221, 279
Baoding, Hebei, 270
Baoji, Shaanxi, 194–201
Barrabool, SS, 110
Battle of Changsha
 of 1939, 219, 219
 of 1944, 251
Battle of Nanjing (1937), 143–57, 160–64, 173, 193
Battle of Shanghai (1937), 124–29
Battle of Taierzhuang (1938), 174
beads, 66
bean curd, 199
bedbugs, 229–30, 263
beef, 197
Beihai, Peking, 310
Beijing, *see* Peking
Beijing Commission for the Preservation of Cultural Relics, 320, 321
Belpareil, 112
big tigers, 315–16, 320
biological weapons, 55, 174
Blue Express, 75–76
Boeing 281 Peashooters, 132
Bolshevik Revolution (1917), 15, 40
Book of Tea, The (Okakura), 52

books, 5, 10, 178, 198, 209, 211, 229, 263
 Siku Quanshu, 74–75, 78, 79, 80, 262
Boxer Indemnity, 148, 149, 227
Boxer Rebellion (1899–1901), 9, 19, 58, 96, 117–18, 148
British Museum, London, 44, 96
Bronze Age, 46, 85, 234
bronzes, 7, 35, 178, 196
 bells, 8, 178
 cannons, 269
 damage to, 263
 packing of, 59, 62, 66
 San Shi Pan, 96
bubonic plague, 55, 159
Buddhism, 6, 8, 19, 56, 105, 141, 173, 246, 265–66
 caves, 141, 173, 230
 Garland Sutra, 141
 Leshan Giant Buddha, 180, 182, 189, 190, 218, 237, 240, 261
 Ma Heng and, 303
 monk's cap ewer, 63, 65
 Mount Emei, 216, 218, 246
 Na Chih-liang and, 246, 265–66
 Nichiren sect, 56
 Qianlong Tripitaka, 66
 rock carvings, 206
 temples, 141, 173, 209, 216
 Tibetan, 65
 vegetarianism, 141, 210, 230, 246
Bureau of Cultural Relics, 312
bureaucratism, 311, 312, 313, 320, 321
Burlington House, London, 94, 103–8
Burma, 6, 250
"Burnt Norton" (Eliot), 106–7

C
cadre schools, 314–19
Cairo Conference (1943), 249

Caiyuanba, Chongqing, 172
calligraphy, 6, 10, 14, 31, 290, 309–10
 humidity and, 140, 172, 178, 198, 209, 230–32
 packing of, 66
Cambridge University, 94
camphor, 216
Cathay Hotel, Shanghai, 125
cattle, 147, 197, 252
caves
 at Anshun, 141–42, 228–33, 251–52, 263
 at Baoji, 197–98
censorship, 258, 269
Central Military Academy, Nanjing, 257
Central Museum, Nanjing, 283, 288, 289
Central People's Government, 304
Central Route, 151, 165–73, 177–83, 218, 237
 Chongqing–Yibin, 182–83, 186
 Leshan–Angu, 189–92
 Nanjing–Wuhan, 151, 154–64, 165–66
 Wuhan–Yichang, 167–69
 Yibin–Leshan, 186–89
 Yichang–Chongqing, 169–73, 177–79
Ceylon, 102
Ch'ienmen, Peking, 38, 70
Chang Xueshi, 312
Changchun, Jilin, 19, 273, 296
Changhong, 182
Changsha, Hunan, 130, 133–35, 138–39, 219, 219, 251, 267, 270
Chao Tian Palace, Nanjing
 Civil War (1946–49), 276, 280, 294, 300–301
 Japanese occupation (1937–45), 148–57, 160–64, 268–69

return to Beijing (1950), 305
storage (1936), 114–15, 123
Chapei, Shanghai, 56
chemical weapons, 174
Chen Duxiu, 40
Chen Kuo-fu, 221
Chen Li-fu, 221
Chengde, Hebei, 83
Chengdu, Sichuan, 204–16
Chiang Kai-shek, 49–51, 50, 221,
259, 275–76
Battle of Shanghai (1937), 124
Cairo Conference (1943), 249
Civil War, see Chinese Civil War
Communist Party, relations
with, 49, 50, 55, 99, 113
Great Tunnel disaster (1941),
223–24
Japan, relations with, 55, 113
Japanese surrender (1945), 258
London Exhibition (1935–36),
95
Lugou Bridge Incident (1937),
119
Manchuria, fall of (1931–32), 55
Mao Zedong, meeting with
(1945), 271–72
Nanjing, battle for (1937), 146,
160
Nanjing, capital moved to
(1927), 51
Northern Expedition
(1926–28), 49–50
Peking, capture of (1928), 50
resignation as president (1949),
296, 297
Soviet Union, relations with, 49
Taiwan, retreat to (1948–49),
278, 301
Xi'an Incident (1936), 115–16
Yellow River flooding (1938),
175–77
Chien Tung, 122
Chienkuo Lun, 131, 133

China Maritime Customs Service,
150
China Merchants Group, 79, 131,
150, 285
Chinese Army (Republic), 124,
219, 242–44, 248, 250
conscription, 243–44, 248, 250
diet, 128, 159
Eighth Division, 175
Eighty-Eighth Division, 124
Eighty-Seventh Division, 124
executions, 242
Fifth Special Services Division,
242
Fifty-Eighth Division, 127
pay, 250
scorched-earth tactics, 219
suicide attacks, 174
Twenty-Ninth Division, 119,
121, 242–43
Chinese Civil War, First
(1927–37), 50, 55
Long March (1934–35), 99
Xi'an Incident (1936), 115–16
Chinese Civil War, Second
(1946–49), 271–74, 275–304
Changchun siege (1948),
273–74, 296
Huaihai campaign (1948–49),
295
KMT Summer offensive (1946),
272
Nanjing, battle for (1949),
300–301
Peking, battle for (1948–49),
277–78, 279, 280–83,
286–87, 295–300
PLA Autumn offensive (1947),
273
Taiwan, KMT retreat to
(1948–49), 277–94, 297
Tianjin, fall of (1949), 295,
296
Xuzhou, fall of (1949), 295

Chinese Communist Party, 40, 46,
 259–60, 269, 271
 Civil War, *see* Chinese Civil
 War
 Cultural Revolution (1966–76),
 324
 feudalism, views on, 302, 303,
 306
 foundation of (1921), 40, 46
 Kuomintang, relations with,
 49, 50, 55, 99, 113, 271–72
 Long March (1934–35), 99
 Peking, capture of (1949),
 295–304
 People's Republic,
 establishment of (1949), 304
 Pu Yi, imprisonment of
 (1950–59), 272
 reform through labor, 323
 self-criticisms, 312–13, 316,
 318
 thought reform, 314
 Three Anti campaign
 (1951–52), 311–19
 tuichen chuxin, 306
 Xi'an Incident (1936), 115–16
 Yan'an period (1937–47), 220,
 259
 see also People's Republic of
 China
Chinese New Year, 287–88
Chiris, Antoine, 172
cholera, 128, 159, 228, 318
Chongqing, 170–73, 177–82,
 218, 220–28, 236, 252, 254,
 258
 air raid shelters, 222–24
 architecture, 221–22
 bombing of, 171–73, 179,
 180–81, 183–86, 185, 216,
 222–25, 222
 capital moved to (1937), 170
 Civil War (1946–49), 276
 climate in, 222

 Great Tunnel disaster (1941),
 223–24
 return journey (1946–47),
 261–63, 265
 Xiangjiapo, 261, 263
 Yipinchang, 251–53, 254–57,
 260
Christianity, 29–30, 148, 221
Chu Kingdom (c. 1030–223 BCE),
 179
Chuang Yen, 19, 116, 290–93
 Anshun, life in, 228–33,
 251–52
 death (1980), 292
 inventory (1924–25), 18–20, 27
 London Exhibition (1935–36),
 96–97, 98–99, 100–113
 Nanjing evacuation (1937),
 130, 131
 Peking evacuation (1932–33),
 59, 60, 61, 62, 65, 171
 Southern Route, 131, 133–42,
 218, 219
 Soviet exhibitions (1940–42),
 233–36
 Stone Drums of Qin packing
 (1933), 84–91, 278
 Taiwan, evacuation to (1948),
 277–78, 280, 282, 283–84,
 285, 290–93, 325
 United States exhibition
 (1961–62), 291–92
Chun Xi Street, Chengdu, 217
Chungting, 283–85, 288
Churchill, Winston, 249, 258
cigarettes, 18, 19, 60, 245
cinnabar, 267
Civil War, *see* Chinese Civil War
Cixi, Empress Dowager, 47
clocks, 195
coal, 53, 75, 83, 177, 190, 227
Colombo, Ceylon, 102
Commercial Press, Shanghai, 57,
 58, 270

Committee for the Disposition of
the Qing Household, 16, 44
Communist Party, *see* Chinese
Communist Party
concessions, 33–34, 40, 70, 77,
79, 81, 91, 93, 124, 127,
258
concubines, 9, 23
Confucianism, 6, 8, 31, 32, 39,
84, 86, 159, 173, 203, 207,
213, 322
conscription, 243–44, 248, 250
copper, 269
corruption, 51, 169, 205, 258,
243–44, 248, 250, 258, 260,
311–12
cotton, 204
court diaries, 66
Crabapple Brook, Chongqing,
226
cricket, 100
croakers, 136
cuisine, *see* food
Cultural Revolution (1966–76),
324
curios, 70, 105

D
Da Ci complex, Chengdu,
209–10, 214, 217
da hu, 315–16, 320
Daba mountains, 204–8
Dadu River, 180, 189–92, 212,
261–62, 264
Dalian, 52, 53
Danyang, Jiangsu, 146
Dao De Jing, 86
Daoism, 86, 173, 315
Datong, Shanxi, 143
David, Percival, 94–97, 104
democracy, 258, 264
Department of Military Affairs,
77–78
Dezhou, Shandong, 308

dialects, 73, 134, 135, 139, 140,
170, 174, 194
diarrhoea, 167
ding, 263
diphenylcyanarsine, 174
disappearances, 304
dog meat, 274
Dog Meat General, 14
Dongting Lake, 130
Dongyue Temple, Peking, 317
doufu, 199
Drake, Francis, 102
drugs, 55
Dujiachang, Leshan, 190
Dunne, John Hart, 9
Dushan, Guizhou, 251
dysentery, 159

E
Early Snow on the River (Zhao
Gan), 23–26, 58, 325
Huayan cave, storage in,
140–41, 218, 231
Nanjing, storage in, 115
Southern Route, 130, 138
Taiwan, evacuation to (1948),
277, 279, 289, 291
Yipinchang, storage in, 252–53
Eighth Division, Chinese Army,
175
Eighty-Eighth Division, Chinese
Army, 124
Eighty-Seventh Division, Chinese
Army, 124
Eliot, T. S., 106–7
Emei, Sichuan, 216–17, 218, 227,
240–46, 247–48, 260, 261,
263
Empress of Asia, 112
enamelware, 66
Enlightenment (c. 1637–1789),
39
Eumorfopoulos, George, 96
eunuchs, 3–4, 9

executions, 242
Exhibition of Italian Art (1930), 95

F
Fairbank, John King, 255
Fairbank, Wilma, 255
famines, 73, 177, 248, 250, 258, 259, 282
Fan Changjiang, 119, 315
Fan Kuan, 289–90
Fanjiang Pian, 36
fen liquor, 195, 200, 266, 290
Feng Yuxiang, 14–16
Ferguson, John, 45, 46
feudalism, 302, 303, 306
Fiat biplanes, 132
Fifth Special Services Division, Chinese Army, 242
Fifty-Eighth Division, Chinese Army, 127
Fitch, George, 148, 155, 157, 161, 162, 164
Five Dynasties and Ten Kingdoms (907–79), 24, 104
Five Peak Pass, Daba range, 206
Flayer (warlord), 82–83
food
 in Guangdong, 310
 in Guizhou, 139, 229
 monks, diet of, 210–11, 246
 in Peking, 5, 37–38
 in Shaanxi, 197–99, 201, 215
 in Sichuan, 211, 215
 shortages of, 73, 177, 199, 248, 250, 258, 259, 282
 soldiers, diet of, 128, 159
 vegetarianism, 19, 210, 246
Forbidden City, Peking
 burglary (1936), 113–14
 Communist takeover (1948–49), 277–78, 280–83, 286–87, 296–300, 302–304
 Gate of Divine Prowess, 17

Hall of Mental Cultivation, 3, 6, 13, 45
hollow flagstone, 20
inventory (1924–25), 17–27, 42–43, 44
Japanese invasion (1937), 122–23
Japanese occupation (1937–45), 269–70
Palace Museum, *see* Palace Museum
Palace of Earthly Tranquillity, 5
Palace of Fasting, 21–22
Palace of Heavenly Purity, 5–6, 18, 20
People's Republic period (1949–), 304–20, 322
return of artifacts (1946–47, 1950), 260–71, 305
Room of the Three Rarities, 6, 8, 25, 309
Taiwan, evacuation to (1948), 277–94, 325
Four Quartets (Eliot), 106–7
France
 Boxer Rebellion (1899–1901), 9, 32, 58
 Chiang Kai-shek, relations with, 49
 Japan, relations with, 52
 Opium War, Second (1856–60), 9
 Shanghai Concession (1849–1943), 33, 70, 77, 79, 81, 91, 93, 96, 124, 127, 258
Fu Zuoyi, 297
Fulda, 112
funerary objects, 66
furniture, 66
furs, 10, 37, 66
Futung, 186

G
G. E. Marden & Co. Ltd, 98
G3M planes, 184–86, 203

Gaokanzi, Sichuan, 266
gaoliang, 142
Gate of Divine Prowess,
 Forbidden City, 17
genealogies, 66
Germany, 52, 106, 112
 Boxer Rebellion (1899–1901), 9
 concessions, 34, 40
 Kuomintang, relations with,
 121, 124
 Nazi Party, 148, 162, 164
 World War I (1914–18), 40
 World War II (1939–45), 133,
 235
Gibraltar, 102, 109–10
Ginling College, Nanjing, 148, 163
gold, 5, 14, 66, 279
Golden Hind, 102
Grand Canal, 65
Great Depression (1929–39), 54
"Great Sword March, The,"
 232–33
Great Tunnel, Chongqing,
 223–24
Great Wall, 68–69, 173, 232
Great World entertainment center,
 Shanghai, 125, 126
grenades, 203
Guangxi Province, 138, 139
Guangyuan, Sichuan, 206
Guangzhou, Guangdong, 48, 310
Guizhou Province, 138–42, 218,
 228–33, 251–52
 Anshun, 141–42, 218, 227,
 228–33, 251–52, 263
 Dushan, 251
 Guiyang, 139–40
Guo Moruo, 321
guobao, 232
guokui, 198–99

H
Haihsing, 279
Haihu, 285–86

hairpins, 10
hairstyles, 32, 36
Haitangxi, Chongqing, 226
Hall of Mental Cultivation,
 Forbidden City, 3, 6, 13, 45
Han Empire (202 BCE–220 CE),
 322
Han Feizi, 86
Han Lih-wu, 148–57, 160–64,
 193, 276–77, 279–81, 284,
 285
Han Yu, 87
Hangzhou Bay, 128
Hankou, Hubei, 72, 118
Hanshui River, 202
Hanzhong, Shaanxi, 199–205,
 209, 211–14, 215
Harbin, Heilongjiang, 55
Harvard University, 48, 213, 255
Hawk II biplanes, 132
Hawkings, W. J., 98
He Kongcai, 310
He Siyuan, 296
He Yingqin, 257
Henan Province, 248, 250
Hengyang, Hunan, 251
*Herd of Deer in an Autumn
 Forest*, 104–7, 110, 141, 256,
 290
Hermitage, Leningrad, 235
heroin, 55
Hilliard, Hubert Duthy, 150
Hiroshima, atomic bombing of
 (1945), 257, 260
History of the Communist Party
 (Stalin), 322
hollow flagstone, 20
honey carts, 296
Hong Kong, 67, 154, 222, 258,
 309
Hong Xiuquan, 29
Hongqiao airport, Shanghai, 124
Hotchkiss machine gun, 123
Howard, R. G., 102

Hsiakwan station, Nanjing, 76,
 150, 152, 160, 264, 301
Hu Shih, 39, 40, 47, 280, 281–82,
 286
Hu Shuhua, 239–40
Huaihai campaign (1948–49),
 295
Huangpu River, 125
huangyu, 136
Huayan cave, Guizhou, 141–42,
 228–33, 251
Huayuankou, Henan, 175
humidity, 140, 172, 178, 198,
 209, 230–32, 263
Hunan University, 133
Huo Baolu, 89
Huxley, Thomas, 40
Hwatung, 183

I
illiteracy, 38, 190, 243
Imperial Academy, Peking, 84–91
imperial edicts, 66
*Imperial Rescript to Soldiers and
 Sailors* (1882), 145
India, 107–8
inflation, 227–28, 250, 258,
 282
insects, 177, 216, 227, 238, 260
Institute of Archaeology, Peking
 University, 41
Institute of Marxism-Leninism,
 313
International Exhibition of
 Chinese Art (1935–36),
 94–108
International Safety Zone,
 Nanjing, 147–57, 160–64
International Settlement,
 Shanghai, 33, 34
inventory (1924–25), 17–27,
 42–43, 44
Islam, 197–98
Italy, 9

ivory, 10, 66, 105
Izumo, 125

J
jade, 5, 7, 8, 10, 18, 37, 96, 102,
 105, 196
 cabbage carving, 51, 66
 Chu Kingdom, 179
 Jayne and, 256
 Na Chih-liang and, 293
 packing of, 59, 66
 Soviet exhibitions (1940–42),
 233–36
*Jade Illustrations from the Yizai
 Hall*, 211
Jade Marshal, 14
Japan, 51–58, 99, 112–13,
 117–33, 317
 atomic bombings (1945), 257,
 260
 Boxer Rebellion (1899–1901),
 9, 32, 117–18
 Chiang Kai-shek, relations
 with, 49
 Chinese War, First (1894–95), 52
 Chinese War, Second
 (1937–45), *see* Sino-Japanese
 War, Second
 concessions, 34, 40
 drug trade, 55
 emperor, 144
 funeral rites, 144
 *Imperial Rescript to Soldiers
 and Sailors* (1882), 145
 industrialization, 39
 isolation period (1603–1867), 5
 Korea, relations with, 52, 53
 Manchukuo (1931–45), 54, 66,
 113, 119, 258, 272
 Meiji period (1868–1912), 13
 Pacific War (1941–45), 224,
 248, 250, 257
 Pearl Harbor attack (1941),
 224, 248

Rehe attack (1933), 82–83
Shanghai incident (1932),
 56–57, 270
Shanhaiguan attack (1933),
 68–69, 82, 121, 232
Shinto, 144
slave labor, use of, 55
Soviet invasion (1945), 272
Taiwan colony (1895–1945),
 52, 258, 278
Unit 731 program, 55
Wang Jingwei puppet state
 (1940–45), 220, 269
warlords, support for, 14
World War I (1914–18), 40, 53
Japanese Army, 143–46, 219,
 250
 biological weapons, use of, 55,
 174
 chemical weapons, use of, 174
 funeral rites, 144
 *Imperial Rescript to Soldiers
 and Sailors* (1882), 145
 101st Division, 145
 ritual suicide, 257
Japanese Navy, 184
Jardine Matheson, 167, 169
Jayaatu Khan, 25
Jayne, Horace, 254–57, 290
jewelry, 66, 318
jewels, 10
Jiading, Shanghai, 145
Jiangwan, Shanghai, 34, 35, 319
Jiangyan, Jiangsu, 279
Jiangyin, Jiangsu, 284
Jieshou, Anhui, 245
Jin Empire (1115–1234), 25, 88
Jinan, Shandong, 143
Jingdezhen, 60, 64
jinshixue, 35–36, 41, 42, 48, 88,
 321
Jiujiang, Jiangxi, 268
Johnston, Reginald, 13, 15
jue, 171

K
kang, 3, 6, 25
kaolin, 64
Kazakhstan, 233, 236
Keelung, Taiwan, 279, 285
Khitan, 104
Kiangan Lun, 150–51, 154, 166
Kiangching, 79–80
Korea, 52, 53, 272, 311
koutou, 20
Kropotkin, Peter, 40
Kung Hsiang-hsi, 221
Kunlun, 287
Kunming, Yunnan, 172
kunqu, 142
Kuomintang (KMT), 48–51, 221,
 259, 316
 Cairo Conference (1943), 249
 Chongqing, capital moved to
 (1937), 170
 Civil War, *see* Chinese Civil
 War
 Communist Party, relations
 with, 49, 50, 55, 99, 271–72
 corruption, 51, 169, 205, 258,
 243–44, 248, 250, 258, 260
 Great Tunnel disaster (1941),
 223–24
 inflation and, 228, 250, 258
 Japan, relations with, 55, 113
 Japanese surrender (1945),
 257–59
 Japanese War (1937–45), *see*
 Sino-Japanese War, Second
 Manchuria, fall of (1931–32),
 55
 Nanjing, capital moved to
 (1927), 51
 Northern Expedition
 (1926–28), 49–50
 opponents, treatment of, 248
 Peking, capture of (1928), 50
 soldiers, treatment of, 242–44
 Soviet Union, relations with, 49

Kuomintang (KMT) (*cont.*)
 Taiwan, retreat to (1948–49),
 277–94, 297, 316
 taxation, 248
 Xi'an Incident (1936), 115–16
Kwantung Army, 53–54
Kwei Yung-ching, 284

L
labor camps, 259, 272, 323–24
lacquerware, 37, 66
Lake Palaces, Peking, 5, 304, 314,
 322
Lake Tai, 146
landing ship, tank (LST), 283–85
landslides, 201–2
lanterns, 37
Lanzhou, Gansu, 233, 236
laobing, 229
Laozi, 86
Legalists, 86
Legation Quarter, Peking, 69
Leningrad, Russia, 235
Leshan, Sichuan, 179–80, 182,
 189–91, 218, 237, 241
Letter to Boyuan, A (Wang Xun),
 309
Li Chi, 48, 213–15, 280
Li Dazhao, 40
Li Liantang, 312
Li Yu, King of Southern Tang, 24
Liang Sicheng, 255
Liang Tingwei, 190–91, 212, 264
Lianyun Transportation
 Company, 182, 186–89
Liao Empire (916–1125), 104
Liaodong Peninsula, 52, 53
libraries, 5, 10, 178, 198, 270
 Siku Quanshu, 74–75, 78, 79,
 80, 262, 272, 290
lice, 73, 159
Liddell Brothers, 166
lime, 227, 238
Lin Biao, 300

Lin Sen, 79
Lincheng Outrage (1923), 76
Lion's Peak, Sichuan, 183
literacy, 38, 190, 243
Liu Zhao, 239
Liulichang, Peking, 89, 230
Loess Plateau, 193, 198, 304
London, England, 94–108, 236, 256
Long March (1934–35), 99
Longtan, Sichuan, 267
looting
 Boxer Rebellion (1899–1901),
 9, 58
 Civil War (1946–49), 300–301
 Eastern Mausoleum (1928), 47
 Japanese War (1937–45), 122,
 146–47, 161, 259, 269–70,
 271, 272
 Opium War, Second (1856–60),
 9, 74
Looty (dog), 9
Louis XV, King of France, 5
Louvre, Paris, 44
Lugou Bridge Incident (1937),
 118–20
Luo Ge, 299
Luodian, Shanghai, 127
Luoyang, Henan, 77, 251

M
Ma Heng, 27, 28, 29–43, 46–48,
 48, 91–92, 218, 220–28,
 302–25
 Buddhism, 303
 burglary (1936), 114–15
 cadre school detainment
 (1952), 314–19
 Central Route, 151, 166–92
 Chongqing, life in, 220–26
 Communist takeover
 (1948–49), 277–78, 280–83,
 286–87, 296–300, 302–304
 confession (1952), 313–14
 death (1955), 322–23

denunciation (1949), 306–7, 309, 311, 316, 318
director accession to (1933–34), 91–93
dismissal as director (1952), 320
finances, 226–27
Hong Kong calligraphy purchase (1951), 309
Huayan cave management, 230, 251–53
identification system, 93
Institute of Archaeology establishment (1922), 41
inventory (1924–25), 27, 42–43, 44
Japanese invasion (1937), 121, 123, 128, 129
Jayne's visit (1945), 254–57
London Exhibition (1935–36), 96, 97, 109, 111
looting, campaign against, 46–47
Macao visit (1951), 309–10
May Fourth Movement (1919), 41
Nanjing evacuation (1937), 129–31, 149
Nanjing storehouse, 114–15, 129–31
New Culture movement, 39–41
Northern Route, 193–98, 203–10, 213–16
Palace Museum, 51, 58, 59, 60, 65–66
Peking evacuation (1932–33), 59, 60, 65–66, 83, 84
Peking University, 37–42, 46, 299
poetry, 206–7, 225–26, 271
return journey (1946–47), 261, 268–69, 271
seal cutting, 31, 36, 319–20
self-criticisms (1952), 312–13, 318

Southern Route, 129–31, 135, 137, 140, 142
Soviet exhibitions (1940–42), 233–36
Stone Drums of Qin packing (1933), 84
Sun Dianying, confrontation with (1928), 47
Taiwan, evacuation to (1948), 277–78, 280
Three Anti campaign (1951–52), 311–19
Wu Ying, relationship with, 73, 306–7, 309, 311, 316, 318
Xinzheng excavations (1923), 41–42
Yabao Lane home, 244, 269, 271, 275, 298, 314, 319
Yeh Wei-ch'ing, marriage to, 32, 33, 34–35, 47, 225–26, 303, 319
Yi P'ei-chi trial (1933), 91, 306, 311, 316, 318
Zhang Tingji, praise of, 270
Ma Wenchong, 158–59, 307–8, 313, 319, 320, 323–24
Ma Yanxiang, 154, 193, 194, 195, 271, 308–9, 320
Ma Yuan, 232
Macao, 258, 309–10
Magee, John, 162
majiang, 20, 34, 35, 80, 101, 102, 125, 287, 290
malaria, 159, 245
Malaya, 101
Manchu people, 4, 5, 10
Manchuria, 4, 14, 54
 Civil War (1946–49), 273–74, 275
 Japanese occupation (1931–45), 54–55, 66, 113, 119, 258, 272
 Soviet invasion (1945), 272
Manners, Errol, 99

Mao suits, 302
Mao Zedong, 259–60, 271–73,
 294, 298, 302, 311
 Chiang Kai-shek, talks with
 (1945), 271–72
 Civil War (1946–49), 272–73,
 274, 296
 Hiroshima, atomic bombing of
 (1945), 260
 Legalists, influence of, 86
 Long March (1934–35), 99
 Ma Heng's denunciation
 (1949), 307
 at Peking University, 40, 99
 People's Republic,
 establishment of (1949), 304
 Selected Works, 300
 Three Anti campaign
 (1951–52), 311–19
 Yan'an period (1937–47), 259
Marx, Karl, 40
Marxism-Leninism, 304, 305, 313
mathematics, 31
Mausoleum of Sun Yat-sen,
 Nanjing, 79
May Fourth Movement (1919), 41
Mayorga, Spain, 109
McKenzie, William, 154–57
measles, 230
medicine, 66
Meiji Japan (1868–1912), 13
Mencius, 86
Mianyang, Sichuan, 215
Miao people, 139
mica, 64
Mid-Autumn (Wang Xianzhi),
 309
Min River, 180, 182, 183, 186,
 187, 189, 261–62
Minfu, 183
Ming Empire (1368–1644), 4,
 17–18, 64, 65, 304
 paintings, 234
 porcelain, 64, 65, 171

Ministry of Culture (PRC), 306,
 309, 315, 323
Minsheng Industrial Company,
 169
Minte, 182
Missouri, USS, 257
Mitsubishi, 184–86
 A6M Zero, 223
Mongol Empire (1206–1368), 25,
 232
Mongolia, Mongolians, 6, 7, 37
monk's cap ewer, 62–64, 325
 Angu, storage in, 192, 218,
 237
 Central Route, 166, 169
 Nanjing, storage in, 115, 131,
 142
 Taiwan, evacuation to (1948),
 277, 279, 289, 291
 Yibin, storage in, 187
monks, 141, 209–10, 230, 246,
 266
Monuments Men program,
 254–57
morphine, 55
Moscow, Russia, 233–35
moths, 177, 216
Mount Emei, Sichuan, 216–17,
 218, 227, 240–46, 260, 261,
 263
Mozart, Wolfgang Amadeus, 5
Mukden Incident (1931–32), 54
Museum of Eastern Culture,
 Moscow, 233–35
Muslims, 197–98
Mutaguchi Renya, 117

N
Na Chih-liang, 20–22, 21, 26, 27,
 45, 51, 59, 60, 61, 65–67,
 293
 Buddhism, views on, 246,
 265–66
 Central Route, 188–89

Chongqing, bombing of (1939), 225
death (1998), 293
Emei, life in, 240–46, 247–48
inventory (1924–25), 20–22, 26, 27, 45, 51
jade, specialization in, 293
London Exhibition (1935–36), 98
Nanjing evacuation (1937), 130
Northern Route, 194–217, 218
Peking evacuation (1932), 59, 60, 61, 65–67
return journey (1946–47), 261, 263, 265–68
Southern Route, 131, 133–38
Taiwan, evacuation to (1948), 280, 282, 285–86, 290, 291, 325
Na Hu-hwei, 244–46
Nagasaki, atomic bombing of (1945), 257
Nakajima, 184
Nanchang, Jiangxi, 267
Nanjing, 50, 51, 72, 114–15, 132–33, 135–38, 142, 143–57, 160–64
artworks in, 73, 76–80, 114–15, 123, 129–31, 148–57, 160–64
capital moved to (1927), 51
Central Museum, 283, 288, 289
Chao Tian Palace, see Chao Tian Palace
Chiang Kai-shek's resignation (1949), 296
Civil War (1946–49), 275, 279–80, 283, 285, 287–88, 294, 295, 300–301
Hsiakwan station, 76, 150, 152, 160, 264, 301
International Safety Zone, 147–57, 160–64

Japanese invasion (1937), 129, 132–33, 142, 143–57, 160–64, 173, 193
KMT capture (1927), 38
massacre (1937), 162–63, 173
Mausoleum of Sun Yat-sen, 79
Purple Mountain, 79
return journey (1946–47), 263–65, 268–69
University of, 270
Nanjing Decade (1927–37), 51
Nankai University, 270
Nantong, Jiangsu, 284
Nanyang Public School, Shanghai, 32
national identity, 42–43, 140
National Palace Museum, Taipei, 291
nationalism, 10, 41–43, 49, 56, 140
Nazi Germany, 148, 162, 164
New Culture movement (1910s–20s), 39–41
New Statesman, 107
New York Times, 107
Nichiren sect, 56
Nicholas II, Emperor of Russia, 15
Ningbo, Zhejiang, 303
Ningqiang, Shaanxi, 212
Nitobe Inazō, 52, 53
Normandy landings (1944), 251, 283
North China Herald, 14, 16, 32
Northern Expedition (1926–28), 49–50
Northern Route, 152, 154, 165, 193–217, 204, 208, 218
Baoji–Hanzhong, 198–203
Chengdu–Emei, 216–17
Hanzhong–Chengdu, 204–216
Nanjing–Xuzhou, 154, 193
Xuzhou–Baoji, 193–98
Notoro, 56–57

O

Ode on Shanglin Park (Qiu Ying), 234
oilcloth, 75, 78, 79, 262
Okakura Kakuzō, 52, 53
Okamura Yasuji, 257
Ōmura, Japan, 132
"On the Old Jiange Road" (Ma Heng), 206–7
Operation Ichigo (1944), 249–51, 250
opium, 34, 35, 55, 94, 171, 228, 247, 320
Opium War
 First (1839–42), 9, 34
 Second (1856–60), 9, 34
oracle bones, 214
Oriental Library, Shanghai, 57, 58
Ouyang Daoda, 92, 140, 237–40
 Angu, life in, 237–40
 Central Route, 168, 169, 171, 173, 178, 179, 183, 186–92, 218
 Communist takeover (1948–49), 280, 290, 294, 300
 Huayan evacuation (1944), 251
 Northern Route, 195, 203, 204
 return journey (1946–47), 261, 263
 Taiwan, evacuation to (1948), 280
oxen, 147, 197, 252

P

P&O, 108
Pacific War (1941–45), 224, 248, 250, 257
packing, 58–62, 179
 bronzes, 59, 62, 66
 calligraphy, 66
 jade, 59, 66
 paintings, 59

porcelain, 59, 60, 62
seals, 66
stone artifacts, 62, 84–91
paintings, 5, 7, 8, 10, 14, 256
 Deer in an Autumn Forest, 104–7, 110, 141, 256, 290
 drying of, 178
 Early Snow on the River, see Early Snow on the River
 humidity and, 140, 172, 178, 198, 209, 230–32
 light exposure and, 235
 Ode on Shanglin Park, 234
 packing of, 59
 Pure and Remote View of Mountains and Streams, A (Xia Gui), 290
 Stag Hunt, The, 7, 31
 Travelers Among Mountains and Streams (Fan Kuan), 289–90
Palace Hotel, Shanghai, 125
Palace Museum, 43, 44–46, 48, 50–51, 58
 Antiquities Department, 51, 59, 317
 Archives Department, 59, 66, 93
 burglary (1936), 113–14
 Communist takeover (1948–49), 277–78, 280–83, 286–87, 296–300, 302–304
 evacuation (1932–33), 58–67, 68–81, 71, 82–93, 171
 Japanese occupation (1937–45), 269–70
 Library Department, 59, 66, 93
 London Exhibition (1935–36), 94–113
 People's Republic period (1949–), 304–20, 322
 return of artifacts (1946–47, 1950), 260–71, 305
 salaries, 229, 240, 245

Taiwan, evacuation to (1948), 277–94
Palace of Earthly Tranquillity, Forbidden City, 5
Palace of Fasting, Forbidden City, 21–22
Palace of Heavenly Purity, Forbidden City, 5–6, 18, 20
pan houses, 38
paper, 140, 178, 190, 198, 235, 237
 see also books; paintings
Pearl Harbor attack (1941), 224
Peikou, Taiwan, 291
Peiwen Yunfu, 262
Peking, 13–28, 29–43, 44–48, 58–67, 68–81, 230, 244
 autumn in, 122
 Ch'ienmen, 38, 70
 Commission for the Preservation of Cultural Relics, 320, 321
 Communist takeover (1948–49), 277–78, 279, 280–83, 286–87
 Imperial Academy, 84–91
 Japanese invasion (1937), 121–3, 143, 173, 207
 Japanese occupation (1937–45), 269–70
 KMT capture (1928), 38
 Lake Palaces, 5, 304, 314, 322
 Legation Quarter, 69
 pan houses, 38
 restaurants, 37–38
 spring in, 61
 summer in, 37
 Summer Palace, 74
 Temple of the White Cloud, 315–18
 traffic in, 38
 Tsinghua University, 96, 270
 University of, 16, 18, 19, 21, 27, 37, 41, 299
 winter in, 3–4, 17, 18, 21–22, 37, 71, 75
Peking Zhongnanhai, 304, 314, 322
People's Liberation Army (PLA), 272–74, 275, 277, 279, 297–300
 Autumn offensive (1947), 273
 brass band, 298
 Changchun siege (1948), 273–74, 296
 Huaihai campaign (1948–49), 295
 Nanjing, battle for (1949), 300–301
 Peking, battle for (1948–49), 277–78, 279, 280–83, 286–87, 295–300
People's Republic of China (1949–)
 Beijing demolitions, 305
 corruption in, 311
 Cultural Revolution (1966–76), 324
 disappearances, 304
 establishment (1949), 304
 Institute of Marxism-Leninism, 313
 Korean War (1950–53), 311
 reform through labor, 323
 self-criticisms, 312–13
 "speak bitterness" meetings, 311
 suicides, 304, 307, 310, 315
 thought reform, 314
 Three Anti campaign (1951–52), 311–19
 tuichen chuxin policy, 306
plague, 55, 159
poetry, 74, 84
 Bai Juyi, 215
 Chu Kingdom, 179
 Hu Shih, 39
 Li Yu, 24

poetry (*cont.*)
 Ma Heng, 206–7, 225–26, 271
 Qianlong, 6, 7
 Stone Drums of Qin, 84–91, 152
poison gas, 121
porcelain, 5, 7, 10, 14, 18, 21, 22,
 58
 damage of, 203, 263
 loan collateral, 94–95
 monk's cap ewer, *see* monk's
 cap ewer
 packing of, 59, 60, 62
 red glazes, 63–65, 166
 yellow glaze, 195, 263
Portsmouth, England, 102
poverty, 29, 38, 73, 75
Pravda, 234
press gangs, 243–44
Prosperous Spring Forest, Peking,
 37
prostitution, 195
Pu Xian, 216
Pu Yi, Qing Emperor, 10, 13–16,
 26, 45, 53, 54, 83, 272
Public Safety Bureau, 113
Public Security Cadre Schools, 314
*Pure and Remote View of
 Mountains and Streams, A*
 (Xia Gui), 290
Purple Mountain, Nanjing, 79

Q
Qian Qing Gong, *see* Palace of
 Heavenly Purity
Qianjiang School, Anshun, 229
Qianlong, Qing Emperor, 3–8, 25,
 43, 45, 203, 305, 309
 calligraphy, love of, 309
 seal, 7, 25, 31
 Siku Quanshu, 74–75, 78, 79,
 80, 262, 272, 290
 Stag Hunt, admiration of, 7, 31
 tomb, 46–47
 Tripitaka, 66

Qing Empire (1636–1912), 3, 4,
 8, 29, 45, 304
 Boxer Rebellion (1899–1901),
 9, 32, 58, 96
 Burmese War (1765–69), 6
 debts, 94–95
 decline of, 9
 ethnic groups in, 6
 Japanese War (1894–95), 52
 Opium War, Second (1856–60),
 9
 Peking, conquest of (1644), 4
 porcelain, 65, 94–95
 queues, 32, 36
 Taiping Rebellion (1850–64),
 29–30, 74
 Xinhai Revolution (1911–12),
 10, 33
Qinling mountains, 199–202, 218
Qiu Ying, 234
Queen Mary, 108
qunzhong, 302

R
Rabe, John, 148, 155, 157, 161,
 162, 164
Ranpura, SS, 108–13
Raphael, Oscar, 96
red candles, 174
refugees, 220, 258
 Changsha, 137
 Chongqing, 170, 252
 Guiyang, 139
 Nanjing, 131, 147, 149, 150,
 155–57, 160, 161, 163
 Peking, 244
 Shanghai, 127, 139
 Tianjin, 120
 Wuhan, 135, 166, 197
 Yellow River flooding (1938),
 177
 Yichang, 167
 Zhejiang, 125
Rehe Province, 82–83

Republic of China (1912–49), 10,
 33
 CCP, foundation of (1921), 40,
 46
 Chongqing, capital moved to
 (1937), 170
 corruption, 51, 169, 205, 258,
 243–44, 248, 250, 258, 260
 Feng Yuxiang coup (1924),
 14–17
 Great Tunnel disaster (1941),
 223–24
 inflation, 227–28, 250, 258, 282
 Japanese War (1937–45), *see*
 Sino-Japanese War, Second
 KMT government proclaimed
 (1925), 48–49
 Lincheng Outrage (1923),
 75–76
 London Exhibition (1935–36),
 95
 Nanjing, capital moved to
 (1927), 51
 Northern Expedition
 (1926–28), 49–50
 Pu Yi, 13–16, 26, 45, 53, 54, 83
 Shanhaiguan conflict (1933),
 68–69, 82, 121, 232
 Taiwan, retreat to (1948–49),
 277–94, 297
 Warlord era (1916–28), 13, 14,
 46, 47, 258
 Xi'an Incident (1936), 115–16
Restaurant of Accumulated
 Virtue, Peking, 37
restaurants
 Chengdu, 211
 Peking, 37–38
Reuters, 109
rice, 29–30, 128, 142, 159, 173
 husks, 60, 130, 179
 noodles, 139
 payment in, 142, 190
 straw, 61, 83, 130, 179, 262

rickshaws, 37, 72, 134
ritual objects, 66, 87, 171, 178
robes, 10
Rockefeller, John, 76
Room of the Three Rarities,
 Forbidden City, 6, 8, 25, 309
Roosevelt, Franklin, 249
roundworm, 159
Royal Academy of Arts, 94–108
Royal Asiatic Society, 270
rubbings, 35, 88, 290
Russian Empire
 Boxer Rebellion (1899–1901), 9
 Japanese War (1904–5), 52
 Revolution (1917), 15, 40

S
San Shi Pan, 96
Sassoon family, 94–95
scorched-earth tactics, 219
Scout, HMS, 108
seals, 25, 26, 31, 267
 cutting of, 31
 Jayaatu Khan, 25
 Ma Heng and, 31, 36, 319–20
 Na Chih-liang, 267
 packing of, 66
 Qianlong, 7, 25, 31
 Zhangzong, 25
Selected Works (Mao Zedong),
 300
self-criticisms, 312–13, 316, 318
Shaanxi Province, 86, 151, 154,
 193–215
 Baoji, 194–201
 Hanzhong, 199–205, 209,
 211–14, 215
 Xi'an, 77, 115–16, 151, 194,
 197
 Yan'an, 220, 259
Shandong Province, 53
Shang period (c. 1600–1046 BCE),
 214, 280
Shang Yang, 86

Shanggao, Jiangxi, 267
Shanghai, 27, 29, 31–32, 33–37
 artworks in, 70–81, 96, 97,
 98–99, 112, 114, 306
 Commercial Press, 57, 58, 270
 Communist takeover (1949),
 301
 exhibition (1935), 97, 98
 French Concession
 (1849–1943), 33, 70, 77, 79,
 81, 91, 93, 96, 124, 127, 258
 Great World entertainment
 center, 125, 126
 International Settlement
 (1863–1941), 33, 34, 70, 77,
 79, 93, 124, 125, 127, 258
 January 28 incident (1932),
 56–57, 270
 Japanese invasion (1937), 124
 Jiangwan racecourse, 34, 35,
 319
 KMT capture (1927), 38
 libraries, destruction of, 270
 Nichiren riots (1932), 56
 Oriental Library, 57, 58
 Race Club, 34
 Royal Asiatic Society, 270
 Taiwan evacuation to
 (1948–49), 279
Shanhaiguan, 68–69, 82, 121, 232
Shen Juo-hsia, 84, 99, 116, 142,
 228, 229, 233, 252, 284,
 286, 291
Shibati, Chongqing, 223
Shimizu Setsuro, 118
Shinto, 144
Shu Road, Daba range, 206
Sichuan Oil Exploration Agency,
 261
Sichuan Province, 38, 166, 167,
 169–92
 Angu, 180, 181, 186, 189,
 191–92, 218, 227, 237–40,
 260, 261, 263

Chengdu, 204–16
Chongqing, 170–73, 177–82,
 218, 220–28, 236
Emei, 216–17, 218, 227,
 240–46, 247–48, 260, 261,
 263
Leshan, 179–80, 182, 189–91,
 218, 237, 240, 241
Siku Quanshu, 74–75, 78, 79,
 80, 262, 272, 290
Yibin, 182–83, 186–89
silk, 10, 66, 140, 178, 190, 198,
 216, 231, 235, 237
silver, 5, 14
sing-song girls, 147
Sino-British Cultural Association,
 148, 149
Sino-Japanese War, First
 (1894–95), 52
Sino-Japanese War, Second
 (1937– 45), 117–42, 143–64,
 165–92, 193–217, 218–53,
 254–57
 biological weapons, use of, 55,
 174
 Cairo Conference (1943), 249
 Changsha, battle for (1939),
 219, 219
 Changsha, bombing of (1938),
 142
 Changsha, fall of (1944), 251
 chemical weapons, use of, 174
 Chengdu, bombing of, 211,
 217
 Chongqing, bombing of,
 171–73, 179, 180–81,
 183–86, 185, 216, 222–25,
 222
 Datong, fall of (1937), 143
 Dushan, fall of (1944), 251
 Hangzhou Bay landings (1937),
 128
 Hanzhong, bombing of, 203, 213
 Hengyang, fall of (1944), 251

Jinan, fall of (1937), 143
Leshan, bombing of, 191
looting, 122, 146–47, 161, 259,
 269, 270, 272
Lugou Bridge Incident (1937),
 118–20
Luoyang, fall of (1944), 251
Nanjing, battle for (1937), 129,
 132–33, 142, 143–57,
 160–64, 173, 193
Northern offensive, 198
Operation Ichigo (1944),
 249–51, 250
Peking, fall of (1937), 121–23,
 143, 173
railways, bombing of, 195
Shanghai, battle for (1937),
 124–29
suicide attacks, 174
surrender of Japan (1945),
 257–59
Taierzhuang, battle of (1938),
 174
Taiyuan, fall of (1937), 143
Tianjin, fall of (1937), 143
Wang Jingwei puppet state
 (1940–45), 220, 269
Wuhan, fall of (1938), 176
Yellow River flooding (1938),
 175–77, 248
Yichang, bombing of, 167, 169
slave labor, 55
Smith, Adam, 40
smoking, 18, 19, 60, 245
snake soup, 310
sneezing gas, 174
snuff bottles, 10, 105
Song clan, 239
Song Empire (960–1279), 24, 25,
 45, 113, 232, 256, 262
"Song of Everlasting Regret, The"
 (Bai Juyi), 215
Soong May-ling, 221
Soong, Tse-vung, 79, 82, 221

sorghum, 195, 273
South China Morning Post, 15, 278
Southern Route, 117–42, 218
 Changsha–Guiyang, 138–42
 Nanjing–Changsha, 129–38
Southern Tang (937–76), 24, 26
Soviet Union, 14, 46, 233–36,
 269, 300, 322
 Chiang Kai-shek, relations
 with, 49
 Chinese Art Exhibition
 (1940–41), 233–36
 German invasion (1941), 235
 Japanese War (1945), 272
 Operation Bagration (1944), 251
"speak bitterness" meetings, 311
Spring and Autumn period
 (770–476 BCE), 41, 86
Stag Hunt, The, 7, 31
Stalin, Joseph, 116, 249, 258,
 272, 322
Standard Oil, 31
stone artifacts, 35, 179
 packing of, 62
Stone Drums of Qin, 84–91, 325
 in Emei, 218, 241
 in Nanjing, 115, 131, 142, 152,
 268, 277, 279, 288, 290, 294
 Northern Route, 152, 193,
 199, 201, 218
 packing, 84–91, 278
 return journey (1947–50),
 265–68, 305
Studio of Convivial Delight,
 Peking, 5
Studio of Distinguished Antiquity,
 Peking, 89
Suffolk, HMS, 97–102, 100
suicide attacks, 174
suicides, 304, 307, 310, 315, 318
Summer Palace, Peking, 74
Sun Dianying, 47
Sun Meiyao, 75–76
Sun Yat-sen, 79

Sunzi, 86
Suo Yuming, 288–89
Suzhou, Jiangsu, 270
Sverdlovsk, Russia, 236
swallows' nest soup, 5
Sweden, 172
swords, 66
syphilis, 55

T

Tai Li, 221
Taicang, Jiangsu, 146
Taichung Sugar Corporation, 291
Taierzhuang, Shandong, 174
Taipei, Taiwan, 291
Taiping Rebellion (1850–64),
 29–30, 74
Taiwan, 52, 258, 276, 277–94,
 297, 305, 316
Taiyuan, Shanxi, 143
Tang (warlord), 82–83
Tang Empire (618–907), 86, 178,
 215, 256
Taoism (Daoism), 86, 173, 315
tapestries, 10
taxation, 248
tea, 66, 228
teapots, 66
Temple of the War God, Emei,
 216, 241, 247–48
Temple of the White Cloud,
 Peking, 315–18
Ten Year Civil War (1927–37),
 50, 55
termites, 177, 216, 238–39
thought reform, 314
Thousand-Buddha Cliff,
 Guangyuan, 206
Three Anti campaign (1951–52),
 311–19
Thrift Inspection Committee, 312
Tiananmen, Peking, 121, 304
Tianjin, 15, 47, 75, 118, 143,
 270, 275, 295, 296, 312

tianxia, 42
Tibet, Tibetans, 4, 6, 65
tie qiu biao, 122
Tienfu, 183
Tiger of the North, 14
tiger-beating teams, 315–16, 320
Times, The, 107
Tolstoy, Aleksey, 234
Torrible, Graham, 156, 157
trackers, 168
*Travelers Among Mountains and
 Streams* (Fan Kuan), 289–90
Truman, Harry, 258
Tsinghua University, 96, 270
tuberculosis, 318
tuichen chuxin, 306
tung oil, 203, 227, 238, 239
Tungusic tribes, 4
Twenty-Ninth Division, Chinese
 Army, 119, 121, 242–43
typhoid, 159, 167, 318
typhus, 159

U

Ukraine, 235
Unit 731 program, 55
United Kingdom
 alcohol in, 101
 Boxer Rebellion (1899–1901),
 9, 32, 58, 96, 148
 Cairo Conference (1943), 249
 Chiang Kai-shek, relations
 with, 49
 Exhibition of Italian Art
 (1930), 95
 International Exhibition of
 Chinese Art (1935–36),
 94–108, 256
 Japan, relations with, 52, 224,
 248
 Japanese surrender (1945), 258
 monarchy, 14
 Nanjing evacuation (1937),
 154–57

Normandy landings (1944), 251

Opium War, Second (1856–60), 9

Pacific War (1941–45), 224, 248, 250, 257

Shanghai Concession (1845–1941), 33, 70, 77, 79, 93, 124, 127, 258

Sino-British Cultural Association, 148, 149

women in, 101

United States

Boxer Rebellion (1899–1901), 9, 32, 58

Cairo Conference (1943), 249

Civil War (1861–65), 30

exhibition in (1961–62), 291–92

Hiroshima and Nagasaki, atomic bombing of (1945), 257, 260

Japan, relations with, 52, 224, 248

Japanese surrender (1945), 257–58

Lincheng Outrage (1923), 76

Monuments Men program, 254–57

Normandy landings (1944), 251, 283

Pacific War (1941–45), 224, 248, 250, 257

Pearl Harbor attack (1941), 224

Revolutionary War (1775–83), 5

Shanghai Concession (1848–1941), 33, 70, 77, 79, 93, 124, 127, 258

universities, 41, 170, 270

University of Wuhan, 237

Urumqi, Xinjiang, 233, 236

V

Valley of the Flying Angels, Chongqing, 254

Vautrin, Minnie, 148, 153, 154, 161, 162, 163, 164

vegetarianism, 19, 210, 246

W

Waiter Wang, 72

Wang Bishu, 315

Wang Jingwei, 220, 269

Wang Meng, 232

Wang Shixiang, 255, 317–18, 320

Wang Xianzhi, 309

Wang Xun, 309

Wanping, Peking, 118–19

Warlord era (1916–28), 13, 14, 46, 47, 258

Warring States period (481–221 BCE), 86

water buffalo, 147

Watt, James, 5

Wenchow, 160

Whangpu, 154–57, 166

White Horse Pass, Sichuan, 265

World War I (1914–18), 40, 53

writing materials, 66

Wu Ying, 73–81, 82, 306, 309, 316

Wu Yuzhang, 201

Wuhan, Hubei

Central Route, 151, 154, 157–60, 166–67, 174

Japanese invasion (1938), 176

Northern Route, 194, 195–56

Southern Route, 133, 135–36

X

Xi'an, Shaanxi, 77, 151, 194, 197

Chiang Kai-shek kidnapping (1936), 115–16

Xia Gui, 290

Xiangjiapo, Chongqing, 261, 263

xianhong, 63

Xikou, Zhejiang, 301
Xiling Seal Society, 36
Xinhai Revolution (1911–12), 10, 33
Xinjiang, 233, 236
Xinzheng, Henan, 41–42
Xu Beihong, 47, 48, 297
Xuande, Ming Emperor, 64
Xuzhou, Jiangsu, 75–77, 151, 193, 245, 295

Y
Yabao Lane, Peking, 244, 269, 271, 275, 298, 314, 319
Yan'an, Shaanxi, 220, 259
Yangzi River
 Central Route, 151, 165–73, 182–83
 delta region, 127, 145, 146, 159, 161
 floods (1935), 99
 mines in, 165
 Nanjing, 136
 Southern Route, 131, 133, 135, 136
 trackers, 168
Ye Haowu, 30
Ye Jianying, 271, 298
Yeh Ch'eng-chung, 31–32, 33
Yeh family, 31–32, 35, 36, 37, 225
Yeh Wei-ch'ing, 32, 33, 34–35, 47, 225–26, 303, 319
Yellow River, 175–77, 248
Yi P'ei-chi, 50, 58, 61, 66, 67, 71–72, 91, 93, 306, 311, 316, 318

Yibin, Sichuan, 182–83, 186–89
Yichang, Hubei, 167–69
Yijiang Gate, Nanjing, 161
Yin (ancient city), 213–14, 280
Yipinchang, Chongqing, 251–53, 254–57, 260, 261, 317
Yiyang, Hunan, 267
YMCA (Young Men's Christian Association), 148, 164
Young Marshal, see Zhang Xueliang
yu gong, 33, 93
Yuan Empire (1271–1368), 25, 232

Z
Zero planes, 223
Zhai Gong, see Palace of Fasting
Zhang Tingji, 120, 270, 277
Zhang Xueliang, 115–16
Zhangzong, Jin Emperor, 25
Zhao Gan, 23–26
Zhejiang Province, 125, 194
Zhengzhou, Henan, 196
Zhenjiang, Jiangsu, 284
Zhongnanhai, Peking, 304, 314
zhongshanzhuang, 302
Zhou period (1045–256 BCE), 86–87, 152, 179, 214, 263
Zhu De, 300
Zhu Jiajin, 312
Zhu Jialian, 312
Zhu Xuekan, 182–83, 186
Zunyi, Guizhou, 252